LIGHTING THE NUDE

Top photography professionals share their secrets

RotoVision

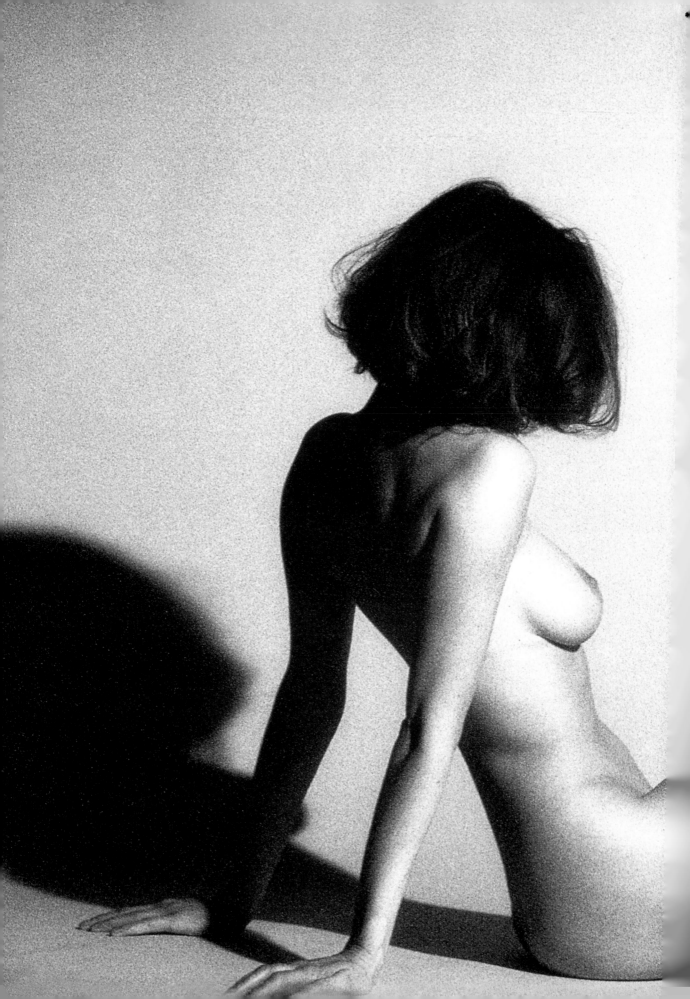

LIGHTING THE NUDE

Top photography professionals share their secrets

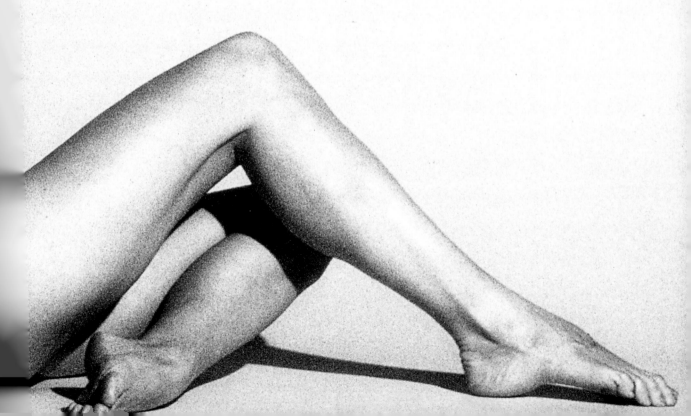

A RotoVision Book

Published and Distributed by RotoVision SA
Route Suisse 9
CH-1295 Mies
Switzerland

RotoVision SA, Sales & Editorial Office
Sheridan House, 114 Western Road
Hove, East Sussex, BN3 1DD, UK
Tel: +44 (0) 1273 72 72 68
Fax: +44 (0) 1273 72 72 69
E-mail: sales@rotovision.com
Web: www.rotovision.com

10 9 8 7 6 5 4 3

ISBN (10 digits): 2-940378-10-X

ISBN (13 digits): 978-2-940378-10-4

Book re-design by
Design Revolution

Reprographics in Singapore by ProVision Pte.
Tel: +65 6334 7720
Fax: +65 6334 7721

Printed in Singapore by Star Standard Industries (Pte) Ltd

CONTENTS

ABOUT THIS BOOK

The most common response from the photographers who contributed to this book, when the concept was explained to them, was "I'd buy that". The aim is simple: to create a library of books, illustrated with first-class photography from all around the world, which show exactly how each individual photograph in each book was lit.

Who will find it useful? Professional photographers, obviously, who are either working in a given field or want to move into a new field. Students, too, who will find that it gives them access to a very much greater range of ideas and inspiration than even the best college can hope to present. Art directors and others in the visual arts will find it a useful reference book, both for ideas and as a means of explaining to photographers exactly what they want done. It will also help them to understand what the photographers are saying to them. And, of course, "pro/am" photographers who are on the cusp between amateur photography and earning money with their cameras will find it invaluable: it shows both the standards that are required, and the means of achieving them.

The lighting set-ups in each book vary widely, and embrace many different types of light source: electronic flash, tungsten, HMIs, and light brushes, sometimes mixed with daylight, flames and all kinds of other things. Some are very complex; others are very simple. This variety is very important, both as a source of ideas and inspiration and because each book as a whole has no axe to grind: there is no editorial bias towards one kind of lighting or another, because the pictures were chosen on the basis of impact and

(occasionally) on the basis of technical difficulty. Certain subjects are, after all, notoriously difficult to light and can present a challenge even to experienced photographers. Only after the picture selection had been made was there any attempt to understand the lighting set-up.

The book features a wide range of erotic imagery from the 'fine art' look to the blatant fetish end of the spectrum. The commercial possibilities for provocative shots are many and varied but it is no surprise that many photographers experiment in this area too, and the shots featured include the imaginative extremes of this experimental output.

The structure of the books is straightforward. After this initial introduction, there is a brief guide and glossary of lighting terms. Then, there is specific introduction to the individual area or areas of photography which are covered by the book. Sub-divisions of each discipline are arranged in chapters, inevitably with a degree of overlap, and each chapter has its own introduction. Finally, there is a directory of those photographers who have contributed work.

If you would like your work to be considered for inclusion in future books, please write to RotoVision SA, Sheridan House, 112–116A Western Road, Hove,

East Sussex, BN3 1DD. UK. DO NOT SEND PICTURES, either with the initial inquiry or with any subsequent correspondence, unless requested; unsolicited pictures may not always be returned. When a book is planned which corresponds with your particular area of expertise, we will contact you. Until then, we hope that you enjoy this book; that you will find it useful; and that it helps you in your work.

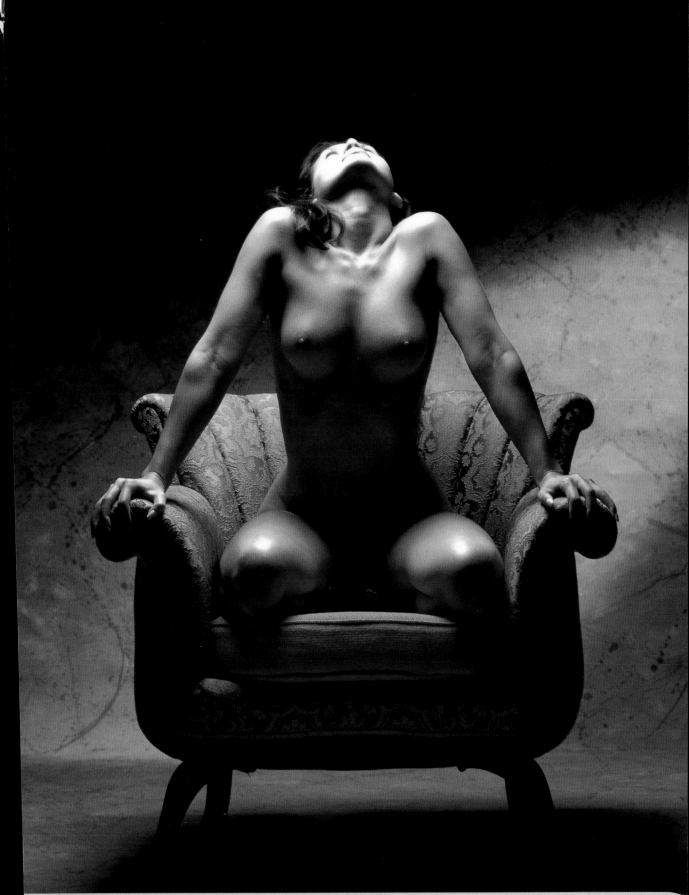

HOW TO USE THIS BOOK

The lighting drawings in this book are intended as a guide to the lighting set-up rather than as absolutely accurate diagrams. Part of this is due to the variation in the photographers' own drawings, but part of it is also due to the need to represent complex set-ups in a way which would not be needlessly confusing.

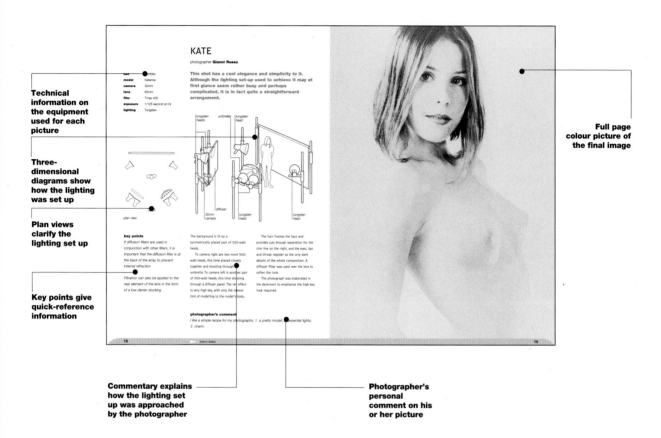

Technical information on the equipment used for each picture

Three-dimensional diagrams show how the lighting was set up

Plan views clarify the lighting set up

Key points give quick-reference information

Commentary explains how the lighting set up was approached by the photographer

Photographer's personal comment on his or her picture

Full page colour picture of the final image

Distances and even sizes have been compressed and expanded: and because of the vast variety of sizes of soft boxes, reflectors, bounces and the like, we have settled on a limited range of conventionalized symbols. Sometimes, too, we have reduced the size of big bounces, just to simplify the drawing.

None of this should really matter, however. After all, no photographer works strictly according to rules and preconceptions: there is always room to move this light a little to the left or right, to move that light closer or further away, and so forth, according to the needs of the shot. Likewise, the precise power of the individual lighting heads or (more important) the lighting ratios are not always given; but again, this is something which can be "fine-tuned" by any photographer wishing to reproduce the lighting set-ups in here.

We are however confident that there is more than enough information given about every single shot to merit its inclusion in the book: as well as purely lighting techniques, there are also all kinds of hints and tips about commercial realities, photographic practicalities, and the way of the world in general.

The book can therefore be used in a number of ways. The most basic, and perhaps the most useful for the beginner, is to study all the technical information concerning a picture which he or she particularly admires, together with the lighting diagrams, and to try to duplicate that shot as far as possible with the equipment available.

A more advanced use for the book is as a problem solver for difficulties

you have already encountered: a particular technique of back-lighting, say, or of creating a feeling of light and space. And, of course, it can always be used simply as a source of inspiration.

The information for each picture follows the same plan, though some individual headings may be omitted if they were irrelevant or unavailable. The photographer is credited first, then the client, together with the use for which the picture was taken. Next come the other members of the team who worked on the picture: stylists, models, art directors, whoever. Camera and lens come next, followed by film. With film, we have named brands and types, because different films have very different ways of rendering colours and tonal values. Exposure comes next: where the lighting is electronic flash, only the aperture is given, as illumination is of course independent of shutter speed. Next, the lighting equipment is briefly summarised — whether tungsten or flash, and what sort of heads — and finally there is a brief note on props and backgrounds. Often, this last will be obvious from the picture, but in other cases you may be surprised at what has been pressed into service, and how different it looks from its normal role.

The most important part of the book is, however, the pictures themselves. By studying these, and referring to the lighting diagrams and the text, you can work out how they were done.

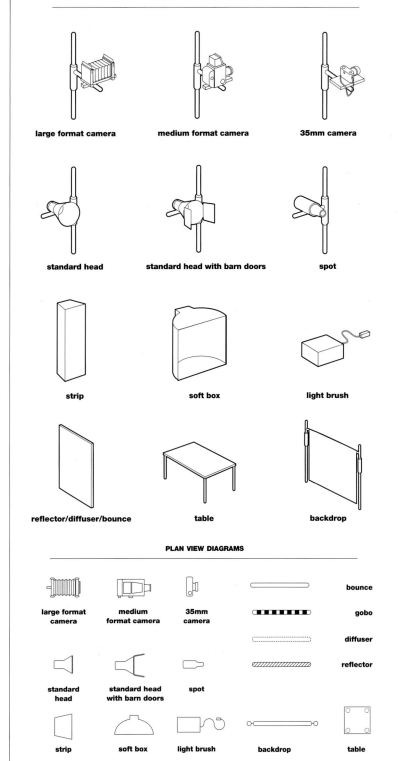

DIAGRAM KEY

The following is a key to the symbols used in the three-dimensional and plan view diagrams. All commonly used elements such as standard heads, reflectors etc., are listed. Any special or unusual elements involved will be shown on the relevant diagrams themselves.

THREE-DIMENSIONAL DIAGRAMS

large format camera medium format camera 35mm camera

standard head standard head with barn doors spot

strip soft box light brush

reflector/diffuser/bounce table backdrop

PLAN VIEW DIAGRAMS

large format camera medium format camera 35mm camera bounce

standard head standard head with barn doors spot gobo

diffuser

reflector

strip soft box light brush backdrop table

GLOSSARY OF LIGHTING TERMS

Lighting, like any other craft, has its own jargon and slang. Unfortunately, the different terms are not very well standardised, and often the same thing may be described in two or more ways or the same word may be used to mean two or more different things. For example, a sheet of black card, wood, metal or other material which is used to control reflections or shadows may be called a flag, a French flag, a donkey or a gobo – though some people would reserve the term "gobo" for a flag with holes in it, which is also known as a cookie. In this book, we have tried to standardise terms as far as possible. For clarity, a glossary is given below.

LIGHTS AND STANDS

Boom
Extension arm allowing a light to be cantilevered out over a subject.

Effects light
Neither key nor fill; a small light, usually a spot, used to light a particular part of the subject. A hair-light on a model is an example of an effects (or "FX") light.

Fish fryer
A small soft box.

Flash head
see Head

Fluorescent lighting
A non-incandescent source with a discontinuous colour temperature but a cool physical temperature (cool to the touch). However, fluorescent heads are now available which offer control of the colour temperature to give a flicker-free continuous light.

Head
Light source, whether continuous or flash. A "standard head" is fitted with a plain reflector. A

Electronic flash: Monoblock (Elinchrom)

Powerpack (Elinchrom)

head with built-in power supply and setting controls is called a Monoblock (as opposed to a head which has to be plugged into a remote power pack/control panel).

Electronic flash: light brush "pencil" (Hensel)

Electronic flash: light brush "hose" (Hensel)

HMI
Rapidly-pulsed and effectively continuous light source approximating to daylight and running far cooler than tungsten.

Incandescent lighting
see Tungsten

Light brush
A light source "piped" through a fibre-optic lead. Can be used to add highlights, delete shadows and modify lighting, literally by "painting with light".

Monoblock
see Head

Pantograph
A suspension device for positioning lights by means of extendable concertina construction. Can be motorised for easy control.

Electronic flash: soft box (Elinchrom);

Electronic flash: octabox (Elinchrom)

Projection spot
Flash or tungsten head with projection optics for casting a clear image of a gobo or cookie. Used to create textured lighting effects and shadows.

Ring flash

A circular flash tube placed around the camera lens. Gives distinctive circular catchlights and typically a shadowless shot.

Electronic flash: strip light with removable barn doors (strobes)

Soft box

Large, diffuse light source made by shining a light through one or two layers of diffuser. Soft boxes come in many shapes (for example,

Tungsten head with shoot-through umbrella (Photon Beard)

octagonal, strip, and full-length rectangular boxes) and many sizes (from about 30x30cm to 120x180cm and larger). Some soft boxes are rigid; others are made of fabric stiffened with poles resembling fibreglass fishing rods. Also known as a northlight or window light, though these can also be created by shining standard heads through large diffusers.

Standard head

see Head

Strip or strip light

see Soft box

Tungsten

Incandescent lighting. Photographic tungsten runs at 3200 °K or 3400 °K, as compared with domestic lamps which run at 2400–2800 °K.

UV
(ultra-violet or "black light")

Light with wavelengths of less than about 390nm.

Window light

Apart from the obvious meaning of light through a window, or of light shone through a diffuser to look as if it is coming through a window, this is another name for a soft box.

REFLECTORS AND FLAGS

Acrylic sheeting

Hard, shiny plastic sheeting, usually methyl methacrylate, used as a diffuser ("opal") or in a range of colours as a background.

Bounce

A passive reflector, typically white (but also available in, for example, silver and gold), from which light is bounced back on to the subject. Also used in the compound term "Black bounce", meaning a flag used to absorb light rather than to create a shadow.

Flag

A rigid sheet of metal, board, foam-core or other material used to absorb light or to create a shadow. Many flags are black on one side and white or silver on the other so that they can be used either as flags or reflectors. To "flag" means to control where the light falls (e.g. to control spill or to prevent flare). A French flag is mounted on the camera itself.

Flat

A large bounce, often made of a thick sheet of expanded polystyrene or foam-core (for lightness).

Kill spill

A large flat used to block spill.

Mirror

Exactly what its name suggests. The only reason for mentioning it here is that reflectors are rarely mirrors, because mirrors focus light and create "hot spots" while reflectors diffuse light. Mirrors (especially, for example, small shaving mirrors) are, however,

widely used, almost in the same way as effects lights.

Umbrella

Exactly what its name suggests. Umbrellas may be used as reflectors (with the light shining into the umbrella; they are available in silver and gold as well as white) or as diffusers (with the light shining through the umbrella). The cheapest way of creating a large, soft light source.

MODIFIERS

Acetate

see Gel

Barn doors

Adjustable flaps affixed to a lighting head to shade light from a particular part of the subject.

Barn doors

Cookie

see Gobo

Diffuser

Translucent material used to diffuse light. Includes tracing paper, frost, scrim, umbrellas, translucent plastics such as Perspex and Plexiglass, and more.

Gel

Transparent or (more rarely) translucent

coloured material used to modify the colour of a light. It is an abbreviation of "gelatine (filter)", though most modern gels for lighting use are actually made of acetate.

Gobo

As used in this book, synonymous with cookie: a flag with cut-outs, to cast interestingly shaped shadows; also used in projection spots.

"cookies" or "gobos" for projection spotlight (Photon Beard)

Honeycomb

Grid of open-ended hexagonal cells, closely resembling a honeycomb. Increases the directionality of light from any head.

Scrim

Heat-resistant diffuser used to soften lighting.

Honeycomb (Hensel)

Snoot

Conical restrictor, fitting over a lighting head. The light can only escape from the small hole in the end and is therefore very directional.

Tungsten head with conical snoot (Photon Beard)

TERMINOLOGY

Black light

Another name for UV (ultra-violet) light.

Continuous lighting

What its name suggests: light which shines continuously rather than being a brief flash.

Contrast

see Lighting ratio

Fill

Extra light, either from a separate head or from a reflector which "fills" the shadows and lowers the lighting ratio.

Fresnel

Ridged lens for use on lighting heads. Key or key light. The dominant or principal light; the light that casts the shadows.

Lastolite

Company name, commonly used to mean the flexible, portable reflectors that they manufacture.

Lighting ratio

The ratio of the key to the fill, as measured by an incident light meter. A high lighting ratio (8:1 or above) is very contrasty, especially in colour; a low lighting ration (4:1 or less) is flatter or softer. A 1:1 lighting ratio is completely even all over the subject.

Modelling

Graduated shadows over a curved surface giving a strong impression of its three-dimensional form.

Perspex

Brand name for acrylic sheeting.

Plexiglass

Brand name for acrylic sheeting.

Spill

Light from any source which ends up other than on the subject at which it is pointed. Spill may be used to provide fill or to light background, or it may be controlled with flags, barn doors, gobos etc.

Spot

Directional light source. Normally refers to a light using a focusing system with reflectors or lenses or both (known as a "focusing spot") but also loosely used as a reflector head rendered more directional with a honeycomb.

Swimming pool

A very large soft box.

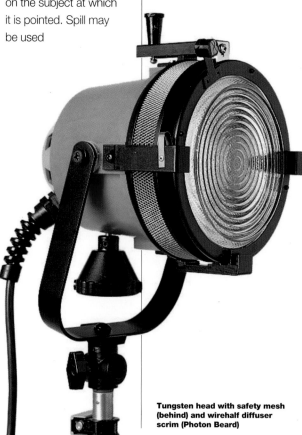

Tungsten head with safety mesh (behind) and wirehalf diffuser scrim (Photon Beard)

NUDES

From the very earliest days of photography, and indeed from the earliest days of representational art, the portrayal of the nude and partially nude human form has exercised an enduring fascination. By the early 1850s there were numerous daguerreotypists in Paris in particular who were noted for their photography of the nude: Auguste Bellocq, Bruno Braquehais, Jean-Louis-Marie-Eugène Durieu, F. Jacques Moulin, Louis Camille d'Olivier and more.

Some of this early work was nothing more nor less than pornography, but co-existing with this was an artistic tradition which stretched back hundreds or even thousands of years: a representation of a nude can after all be attractive without being erotic, or erotic without being pornographic. What is surprising, to the modern eye, is how many of the early photographers seem to have made no particular distinction: Moulin, in particular, produced some quite charming pictures, and others which even his most ardent admirers would be hard pressed to defend on aesthetic grounds.

This is the central problem in all nude photography: which pictures are "acceptable", and to whom. There are no doubt many who would like to see even this book burned, while there are others who will be unable to see why a single image in here could upset anyone. Art, like depravity, is something which is easier to recognize than to define.

This is not, however, the place for such a debate. Nor is it the place for a discussion of why individual photographers take pictures of nudes. You have presumably bought the book, or you are contemplating buying it, and so it is our job to give you as much guidance as possible on how to photograph the nude – which for our purpose includes the partially nude, as a book containing nothing but total nudity would be more use as an anatomy book than as a book on photography. We have drawn work from photographers from numerous countries, all with their own unique styles and ways of working. Our job has been merely to learn from them how they work, to organize that information, and to make it as useful and informative as possible.

Studios and Settings

It might have been useful – though, unfortunately, it would not have been practical – to include a chapter of historical images in this book. It could have begun with the static nineteenth-century nudes in their stuffy studios; moved on to the Edwardians, with their naturalistic studio sets and locations; then gone on to the period between World War One and World War Two, the heyday of the geometrical nude and the semi-abstract "figure study"; taken in the 1950s, with their emphasis on the outdoors, and the 1960s with their gritty photo-realism; and the self-indulgence which characterized so much of the 1970s...

Of course, as we come nearer to our own times it becomes harder and harder to recognize underlying trends. There also seems to be more diversity than ever before. In this book there are very simple studio nudes, shorn of context or with only the simplest of backdrops, but there are also nudes in natural (or naturalistic) settings; in abandoned buildings; out of doors and indoors; photographed with the utmost in romanticism, or in the grittiest of realism. Unlike the case of some other books in the PRO LIGHTING series, generalizations are very hard to make: photographing the nude is one of the most intensely personal forms of photography.

Photography and Painting

More than in almost any other area of photography, the link between the photographed nude and the painted nude is abundantly clear, and the photographer who looks only at the works of other photographers and ignores the works of painters is making a serious mistake. There are pictures in these pages which are reminiscent of Alma-Tadema, Balthus, Hockney and even Liechtenstein. A tour of any art gallery, or a few books on painting, can be worth as much as a visit to a photographic gallery, even if it is showing the works of an

acknowledged master such as Bill Brandt, Helmut Newton, or Jock Sturges.

Clothes, Props and Make-up

As already remarked, the totally unclothed nude is unusual; and there is quite a lot of fashion and personal originality in what he or she may be clothed with. Diaphanous draperies were always popular with the painters of yore, and, within the bounds imposed by the greater literalness of photography, the same may also be found in these pages: lengths of fabric, and even sheets, are pressed into service on a regular basis. More conventional clothes may be partially undone, or underwear may be revealed, or clothes normally regarded as essential for decency may be omitted.

When it comes to props and backgrounds, there is a long tradition of geometrical or semi-abstract nudes, where props normally look out of place; but there is no doubt that in the vast majority of nude studies props are an essential part of the picture. This is true whether you are considering the irreverent humour of Michèle Francken or the almost apocalyptic intensity of some of Stu Williamson's pictures; and in one of Struan's most notable pictures, the model herself is essentially a prop because the picture was commissioned as an advertising photograph for a shoe.

As for hair and make-up, this is something which dates far faster than most people (especially most men) realize. Examples like the old "bee-hive" hairdo are obvious, but compare the heavy eye make-up and often unnatural but often dramatic lipsticks of the 1960s with the more naturalistic eye-make-up and washed-out lipsticks of the late 1970s and early 1980s. This is one reason why timeless-looking young girls with long hair are often preferred by photographers. Another is that gravity has taken less of a toll of their figures.

Cameras, Lenses and Film for Nudes

Commercially, roll-film cameras have it all: they offer a bigger image than 35mm, with commensurately better quality, and the old argument of "big fee – big camera" has a certain logic to it.

What is interesting, though, is how many photographers choose 35mm for their personal work. In particular, even when Struan has been shooting commercially with his Hasselblad, he may switch to 35mm for his personal shots, several of which appear in here. Likewise, Julia Martinez said of one set of pictures (of which two appear in this book), "I was just working with 35mm, and the freedom was wonderful; no big, heavy cameras and no lights to move around. The model felt more relaxed, too."

Going in the other direction, very few photographers shoot large format nudes any more, although there is a handful of 4x5in shots in this book. Longer-than-standard lenses are very much the norm, although there are also plenty of wide-angle shots in the book: Struan with 35mm and even 28mm on 35mm, Guido Paternò Castello with 50mm on 6x6cm, Peter Goodrum with 90mm on 4x5in.

As for films, a surprisingly high proportion of pictures in this book were shot on black and white – or perhaps it is not quite such a surprise, given the way in which so many photographers shoot nudes for fun, rather than for profit. Many photographers still have a sneaking suspicion that monochrome is more "real" than colour, while others simply maintain that it gives them more control and better enables them to realize their personal photographic vision. There seems to be no overall preference for a particular type or even brand of black and white film, and Stu Williamson makes a particular point of using a wide range of monochrome films for different tonal effects.

Lighting Equipment for Nudes

Yet again, generalizations are impossible: unlike (for example) food or pack shots, there are not even any particularly common lighting set-ups. In these pages you will find everything from available light to monster soft boxes to on-camera flash, taking in a number of quite complex lighting set-ups on the way.

A basic kit would probably consist of three heads, two of which would be used for lighting the background, though everything from single-light pictures to those using four or five lights will be found in this book. It is also worth mentioning Stu Williamson's ingenious Tri-Flector, which is described more fully on page 24.

And, of course, many photographers shoot nudes only by available light; you will find plenty of examples of these, too.

The Team

Most photographers of the nude work on their own most of the time. There are two main reasons for this. The first is simple economics: a lot of nude photography is done for personal or portfolio work, and the budget simply does not stretch to an assistant. There are exceptions, as when a personal shot is grafted onto a commissioned shoot, but this is the exception rather than the rule.

The other reason is that nude

photography requires a certain rapport between the subject and the model, and it is often difficult to establish that rapport if a third person is present. On the one hand, the third person may reassure the model – this is especially true if the third person is of the same sex as the model – on the other, he or she may seem like an intrusion: the photographer is, as it were, licensed to see the model in the nude, but other people are not.

The Nude Photography Session

Because nude photography is so intensely personal, and because models vary so widely in temperament and attitude, only a few general remarks are appropriate.

The most important ones concern the facilities for the model. She should be able to dress and undress in privacy, because nude modelling is not the same as doing a strip-tease. This privacy can be a changing room, or a car with a sheet draped over the windows and weighted or taped down at the corners. She should be able to keep warm between shots: a clean, soft blanket is a useful thing to have to hand. She should of course have been warned beforehand not to wear tight clothing, as marks on the skin can take hours to disappear.

Other people should be excluded as far as possible, though a few models seem to be born exhibitionists and

d'Antibes most certainly does not go in the Bois de Boulogne.

Finally, remember this. More than most kinds of photography, taking pictures of nudes is a matter of mood. That mood may be timeless, or deliberately confrontational, or erotic, or innocent, or a hundred other things; but if the mood you want is not the same as the mood you are getting, this more than anything else will stop you taking the pictures you envisioned.

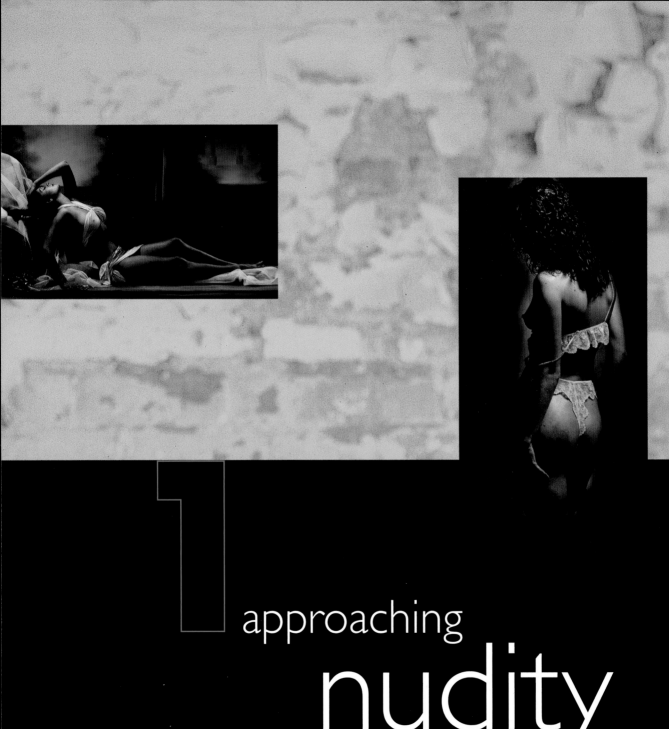

1 approaching
nudity

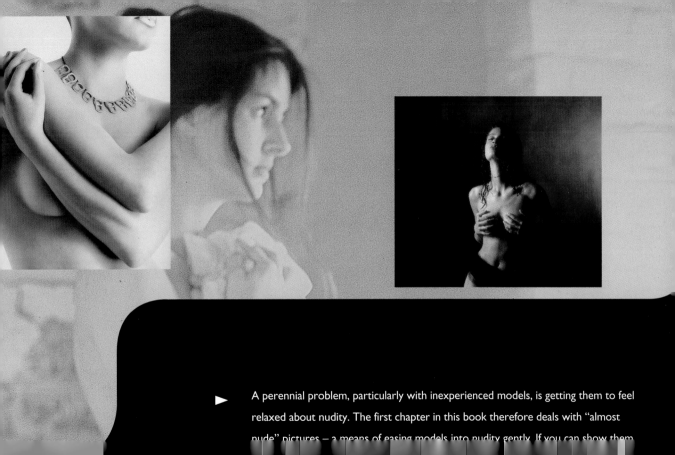

A perennial problem, particularly with inexperienced models, is getting them to feel relaxed about nudity. The first chapter in this book therefore deals with "almost nude" pictures – a means of easing models into nudity gently. If you can show them

Photographer: **Michèle Francken**

Client: **Mac 3 Company**

Use: **Advertising**

Camera: **6x6cm**

Lens: **110mm with Softar screen**

Film: **Kodak Ektachrome EPP 100**

Exposure: **f/8**

Lighting: **Electronic flash: 1 head**

Props and set: **Hand-painted backdrop**

Plan View

N U D E

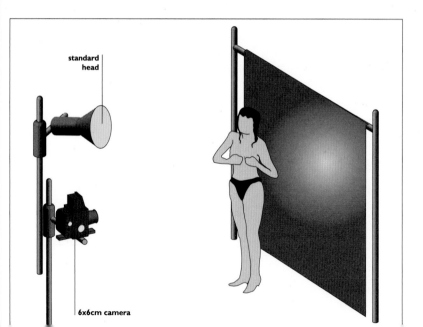

standard
head

6x6cm camera

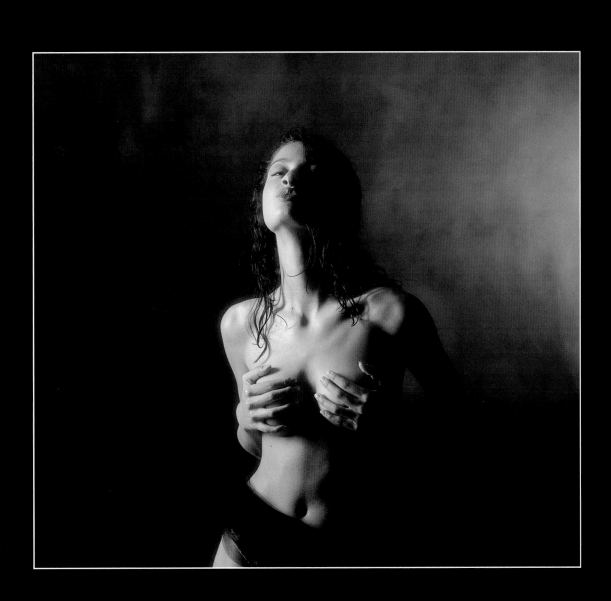

Photographer: **Bob Shell**

Use: **Personal work**

Model: **Audra Fregia**

Camera: **645**

Lens: **80mm**

Film: **Ilford FP4**

Exposure: **1/60 sec at f/8**

Lighting: **Available light**

Props and set: **"My office window!"**

Plan View

▼

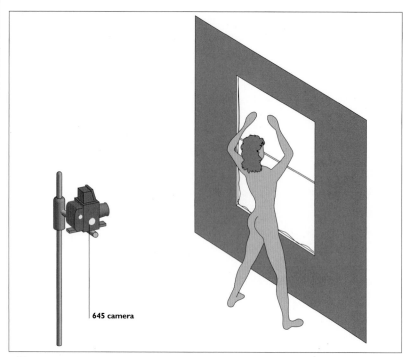

645 camera

Perhaps the most important thing to note here is that the window is covered with frosted Mylar, making it a natural soft box and also making it opaque so that the model cannot be seen from the street.

This sort of silhouette, combined with transillumination of the peignoir, can be extremely effective while still showing remarkably little that could offend any but the most prudish viewer. The shape of the model is beautifully illustrated, and the contrast between the lace of the curtains and the lace of the peignoir is doubly effective. Flare is of course a potential problem and unless the intention is to make a feature of it, the lens must be scrupulously clean; even then, there is some evidence of flare around the model's fingers.

► *Frosted Mylar and Kodatrace are both superb diffusion materials, but in colour Kodatrace introduces a very slight green cast*

► *There is a significant difference between a window receiving direct sun (like this one, which faces north-west) and a window which is illuminated only by sky-light*

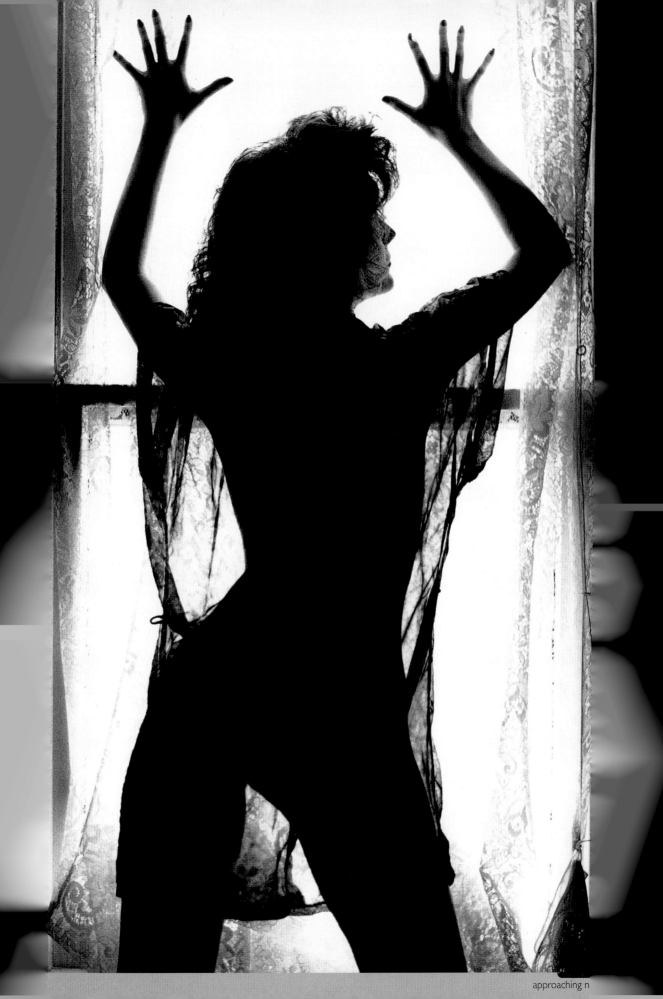

approaching n

Photographer: **Ron McMillan**

Client: **Beauty Products Catalogue**

Use: **Catalogue**

Model: **Emma Noble**

Assistant: **Paul Cromey**

Camera: **6x6cm**

Lens: **120mm + Softar II soft-focus**

Film: **Kodak Panther X100**

Exposure: **f/16**

Lighting: **Electronic flash: 2 striplights**

Props and set: **Seamless background**

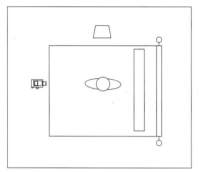

Plan View

E M M A

▼

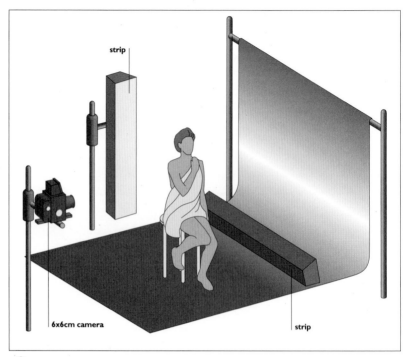

OFTEN, A NUDE SHOT FOR ADVERTISING MUST REVEAL VERY LITTLE; IT MUST LOOK NATURAL AND CHARMING, BUT NOT REVEALING. THIS IS A TIMELESS PICTURE WHICH MIGHT ONCE HAVE SEEMED RISQUÉ BUT WHICH IS ENTIRELY ACCEPTABLE IN THE LATE 20TH CENTURY.

The lighting is certainly simple: a vertical strip light to camera left, illuminating the model's back, and a horizontal strip light on the floor behind the model, illuminating the background and in the process providing a modest amount of fill on the model's arm and on the towel. Compared with the model, the vertical light is very slightly nearer the camera, to provide a glancing light rather than a pure side-light. As so often, it is not the complexity of the lighting which is important, but its appropriateness; and analyzed more carefully, this profile semi-high-key approach is unusual and effective. The use of a white towel on the dark side of the model, away from the light, saves it from being too dark as well as suggesting natural, unaffected beauty.

► *Strip lights are more directional than soft boxes, at least in the short axis*

► *This is an interesting example of white-on-white; the towel is lighter than the background on the left, and darker than the background on the right*

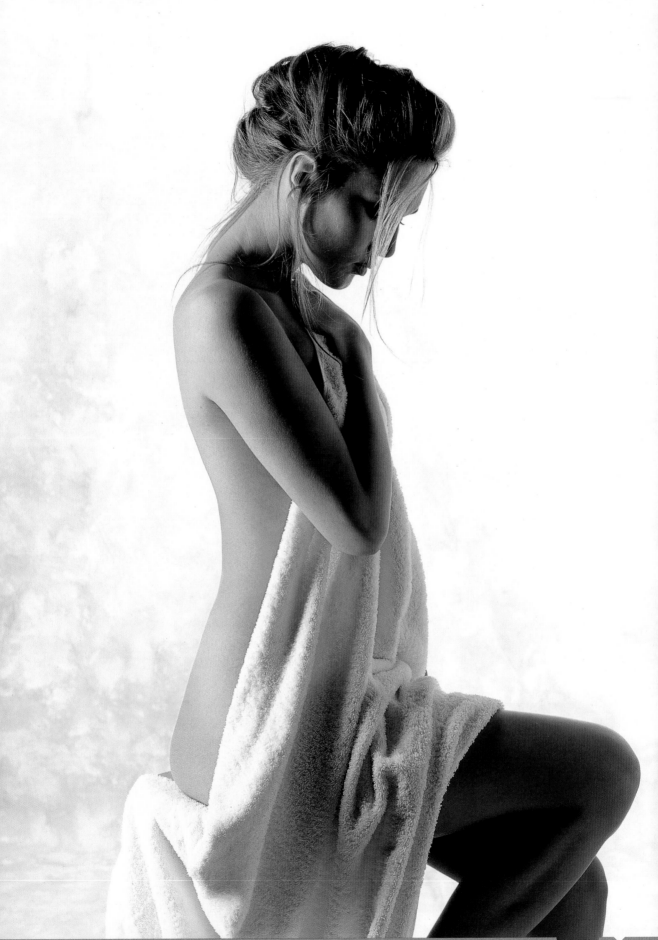

Photographer: **Stu Williamson**

Client: **Andrea (model)**

Use: **Portrait**

Camera: **6x7cm**

Lens: **140mm**

Film: **Ilford FP4**

Exposure: **f/11**

Lighting: **Electronic flash: one head**

Props and set: **Lastolite "Thunder" painted backdrop**

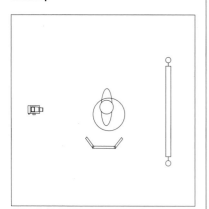

Plan View

► *Large reflectors give a different quality of light from soft boxes*

► *Hand colouring can add impact to a monochrome nude*

► *The contrast between tanned and untanned areas (if the model has not got an overall tan) can be used to good effect in some shots*

ANDREA

▼

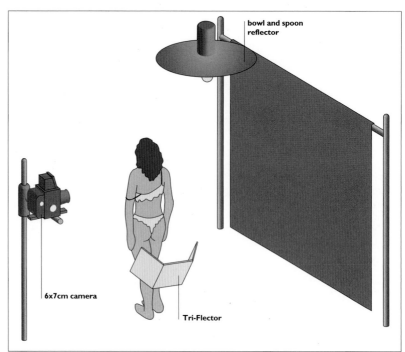

bowl and spoon reflector

6x7cm camera

Tri-Flector

THE SINGLE LIGHT HERE IS A LARGE DISH OF THE TYPE SOMETIMES CALLED A "BOWL AND SPOON" – A LARGE-DIAMETER SHALLOW REFLECTOR WITH A DIFFUSER CAP OVER THE LAMP ITSELF.

This light is well above the model and to camera right, as may be seen from the shadows; but Stu also used his trademark "Tri-Flector" (which he invented and which is manufactured by Lastolite). This has a central panel flanked by two "wings" which allow the light to be directed with considerable precision. The picture was then printed with dramatic dodging – Stu prints all his own work – and the pink colour was added with Fotospeed dyes. The shaped background is more an effect of printing than of lighting.

Photographer's comment:

The model wanted a picture for her boyfriend. It had to be intimate and revealing, without being too revealing.

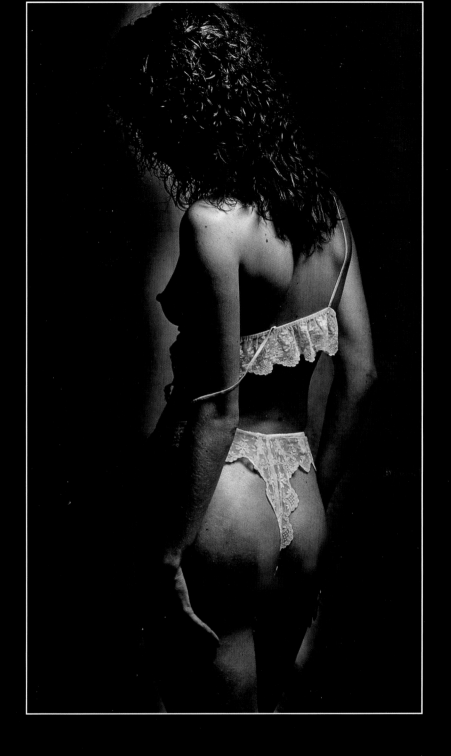

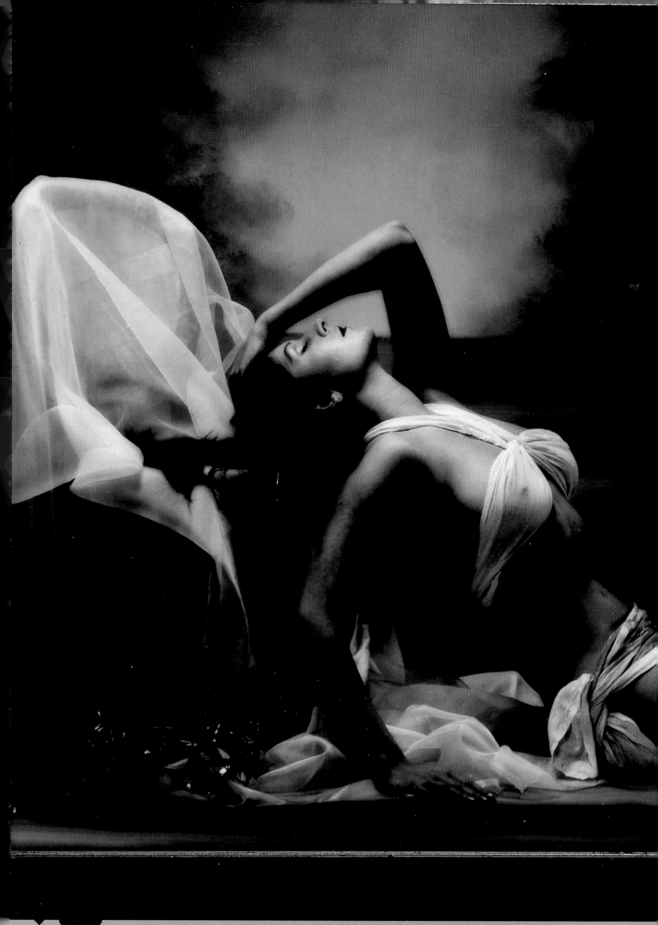

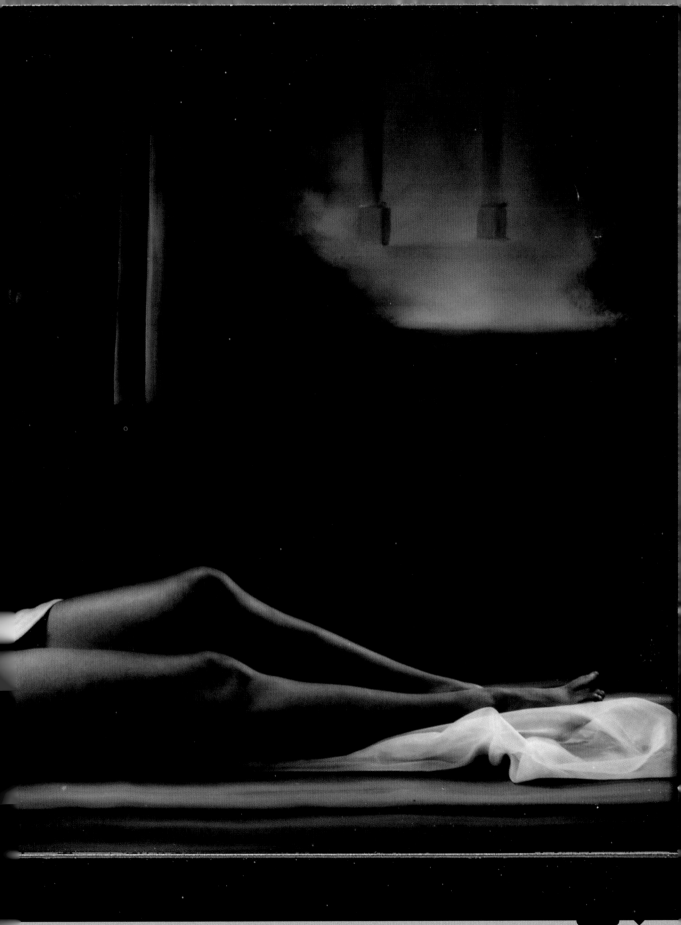

Photographer: **Stu Williamson**

Client: **Tanya**

Use: **Portrait**

Camera: **6x7cm**

Lens: **90mm**

Film: **Ilford Pan F**

Exposure: **f/11**

Lighting: **Electronic flash: 4 heads**

Props and set: **Colorama hand-painted b/g; crown by Terry English, armourer**

Plan View

T A N Y A

▼

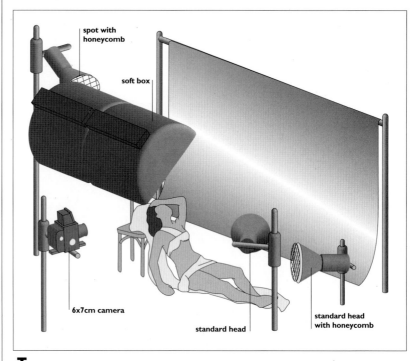

spot with honeycomb

soft box

6x7cm camera

standard head

standard head with honeycomb

THE MODEL IS SURPRISINGLY FULLY CLOTHED, BUT BECAUSE OF THE WAY THE "CLOTHES" ARE ARRANGED, SHE LOOKS LESS DRESSED THAN SHE IS. THE SEMI-CLASSICAL POSE AND BACKDROP CONTRIBUTE STILL MORE TO THE OVERALL AURA OF SENSUALITY.

The lighting is of course important too. The key is the honeycombed spot to camera left, above the model's head, illuminating (in particular) her face and chest. This is supplemented by another honeycombed head to camera right, rimlighting the model's legs. A large soft box, just above the camera, acts as a general fill and provides some of the illumination of the background, which is also lit with a fourth head coming in from camera right.

This is a good example of a second light being added to the key to create the illusion of one light: the key and the rimlight combine flawlessly, creating the impression of a single light source.

► *If a single light will not do what you want, ask yourself what it would illuminate if it were doing what you want*

► *Painted backdrops can have more than one centre of interest – or two backdrops can sometimes be combined*

Photographer's comment:

I use a wide variety of different black and white films for different tonalities.

Photographer: **Julia Martinez**

Use: **Personal work**

Model: **Sarah**

Camera: **6x7cm**

Lens: **300mm**

Film: **Fuji RDP ISO 100 rated at EI 125 and processed in C41 chemistry**

Exposure: **1/30sec at f/11**

Lighting: **Available light**

Props and set: **Location**

Plan View

SARAH

▼

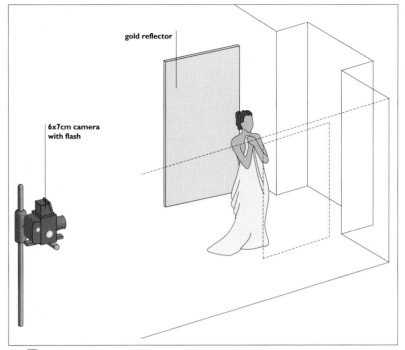

gold reflector

6x7cm camera with flash

THIS IS AN AVAILABLE-LIGHT SHOT. SUN THROUGH THE WINDOW TO THE RIGHT WAS SUPPLEMENTED BY A LARGE GOLD REFLECTOR TO CAMERA LEFT TO PROVIDE SOME FILL ON THE MODEL'S BACK: IT WAS ABOUT 180CM (6FT) SQUARE.

The lighting, therefore, was as much a matter of selection as anything else: finding the right location, the right window on the right side of the building – but there is a story behind it:

In the photographer's words, "This was shot in a derelict mental hospital. We had to climb several flights of stairs, as the windows on the lower floors were boarded up. At the end of the shoot, we heard noises downstairs, and the model panicked: she dropped the sheet and stood there stark naked in terror. It took me some time to get her to cover up again. We came to no harm: it was homeless people, though the hospital is supposed to be haunted."

► *Derelict buildings are a favourite set for photographers, but they have their own dangers*

► *Cross-processing adds to the eeriness of the scene*

Photographer's comment:

I was lucky with the sun coming through the window like that.

Photographer: **Julia Martinez**

Use: **Personal work**

Model: **Becky**

Camera: **645**

Lens: **300mm**

Film: **Kodak T-Max 100**

Exposure: **f/11**

Lighting: **Electronic flash: 3 heads**

Props and set: **White background – and see Photographer's comment**

Plan View

RECESSION DRESSING

▼

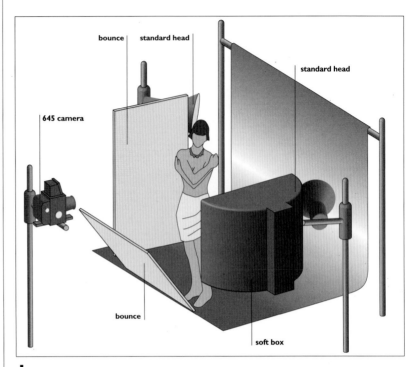

J ULIA MARTINEZ WAS AT FIRST BEST KNOWN FOR HER GENTLE AVAILABLE-LIGHT PICTURES BUT, AS THE PHOTOGRAPHS IN THIS BOOK SHOW, SHE IS ALSO QUITE AT HOME WITH OTHER LIGHT SOURCES — IN THIS CASE STUDIO FLASH.

The key and indeed only light on the subject is a 120×120cm (4×4ft) soft box to camera right, beside the model. Two bounces, one to camera left and the other below the camera's line of sight, even out the light considerably while still maintaining strong modelling. Finally, a couple of lights on the background create a classic high-key effect. The printed image was toned blue using Fotospeed materials.

The overall effect is classical and simple. It illustrates, as do most good pictures, that the single most important thing is the photographer's eye. Why is the image framed this way? Would you have framed it this way? And why does it "work" so well?

► *Chiaroscuro and high key are less incompatible than they might seem*

► *Some photographers' style is intimately bound up with their lighting technique; others are more recognizable from their compositional approach*

Photographer's comment:

This was shot for a college assignment on "recession dressing". The necklace is made of Coca-Cola can pulls….

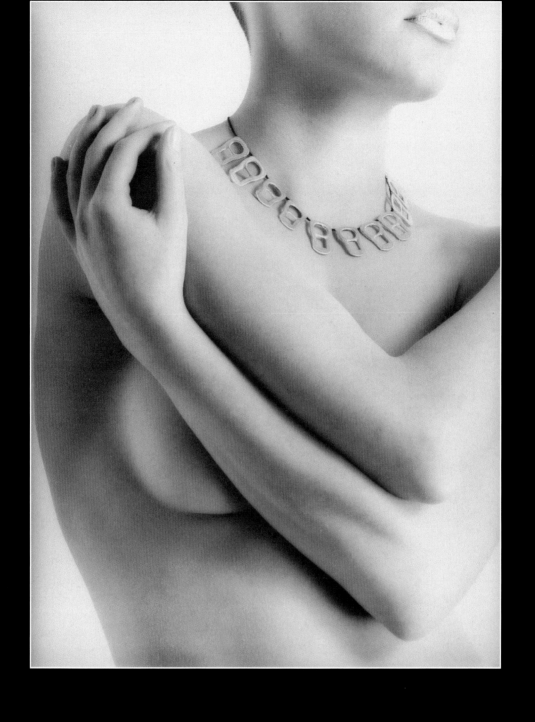

Photographer: **Frank P. Wartenberg**

Use: **Portfolio**

Camera: **35mm**

Lens: **85mm**

Film: **Polaroid Polagraph**

Exposure: **Not recorded**

Lighting: **Late sun**

Props and set: **Location (beach)**

Plan View

▼

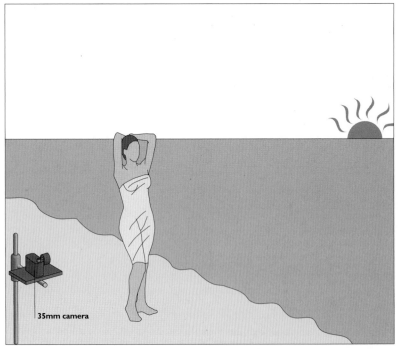

35mm camera

Mᴀɴʏ ᴘʜᴏᴛᴏɢʀᴀᴘʜᴇʀs ᴜsᴇ Pᴏʟᴀʀᴏɪᴅ Pᴏʟᴀᴘᴀɴ ғᴏʀ ɪᴛs ᴜɴɪ𝚚ᴜᴇ ᴀɴᴅ ʀᴀᴛʜᴇʀ ᴏʟᴅ-ғᴀsʜɪᴏɴᴇᴅ ᴛᴏɴᴀʟɪᴛʏ — ᴡʜɪᴄʜ ɪs ᴏғᴛᴇɴ ᴍᴏʀᴇ ɪᴍᴘᴏʀᴛᴀɴᴛ ᴛʜᴀɴ "ɪɴsᴛᴀɴᴛ" ᴘʀᴏᴄᴇssɪɴɢ — ʙᴜᴛ ᴛʜᴇ ᴍᴏʀᴇ ᴇxᴘᴇʀɪᴍᴇɴᴛᴀʟʟʏ ᴍɪɴᴅᴇᴅ ʜᴀᴠᴇ ᴅɪsᴄᴏᴠᴇʀᴇᴅ ᴊᴜsᴛ ᴡʜᴀᴛ ɪᴛs ʜɪɢʜᴇʀ-ᴄᴏɴᴛʀᴀsᴛ ᴄᴏᴜsɪɴ, Pᴏʟᴀʀᴏɪᴅ Pᴏʟᴀɢʀᴀᴘʜ, ᴄᴀɴ ᴅᴏ.

Frank Wartenberg is particularly fond of this film and as he demonstrates here, there is no need to take seriously the warning that it is not intended for general-purpose photography. Even in the relatively contrasty conditions of direct sunlight, it can deliver an excellent tonal range and remarkable subtlety.

Exposure must however be very precise if the highlights are not to be "blown" or the shadows too extensive. Like any high-contrast product, it can be used to expand any part of the tonal range at the expense of both lighter and darker areas; and this is what has been done here

► *With a high-contrast material, the important thing is to know exactly which tones to expand*

► *Polaroid instant-process 35mm films have very tender emulsions and should only be sent out as dupes*

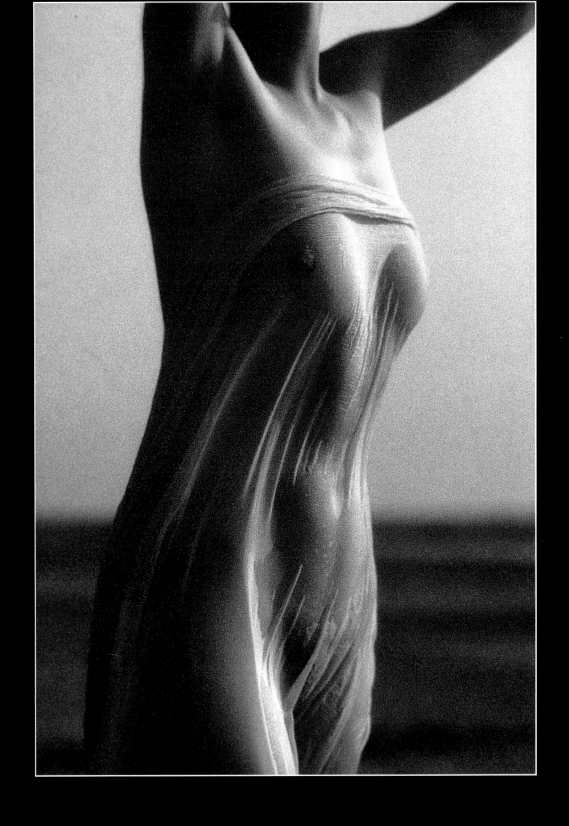

Photographer: **Struan**

Use: **Personal work**

Model: **Krista**

Camera: **35mm**

Lens: **105mm**

Film: **Kodak Tri-X Pan**

Exposure: **1/25 sec at f/4**

Lighting: **Available light**

Props and set: **White studio wall**

Plan View

► *Daylight is a wonderful medium but hard to control*

► *Because of its colour, north light is often of more use in monochrome than in colour*

► *Contrast what people expect with what they don't expect, for arresting effect*

J E A N S

▼

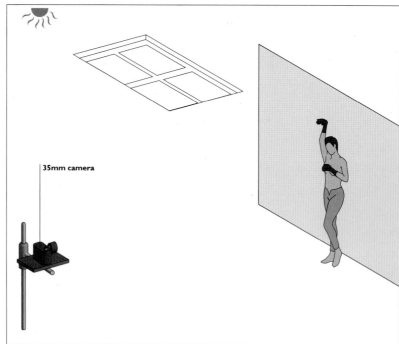

35mm camera

THIS SUCCESS OF THIS PICTURE DERIVES IN LARGE PART FROM ITS PLAYFULNESS. THE MODEL IS DEFINITELY "STRIKING A POSE", BUT THE WOOLLY GLOVES TURN HER INTO A REAL PERSON RATHER THAN JUST A SYMBOL.

Time and again the virtues of our ancestors' daylight studios are revealed: a traditional daylight studio with skylights and blinds is not to be sniffed at. This picture is lit from a skylight on an overcast day.

On the minus side, daylight is less versatile and controllable than artificial light. There are no spotlights, unless it is a sunny day and the windows are in exactly the right place; you need a large studio, in order to take the greatest advantage of light from different directions; light intensity can vary rapidly as clouds blow across the sun; and light colour can vary widely from warm to cold, necessitating filtration in colour.

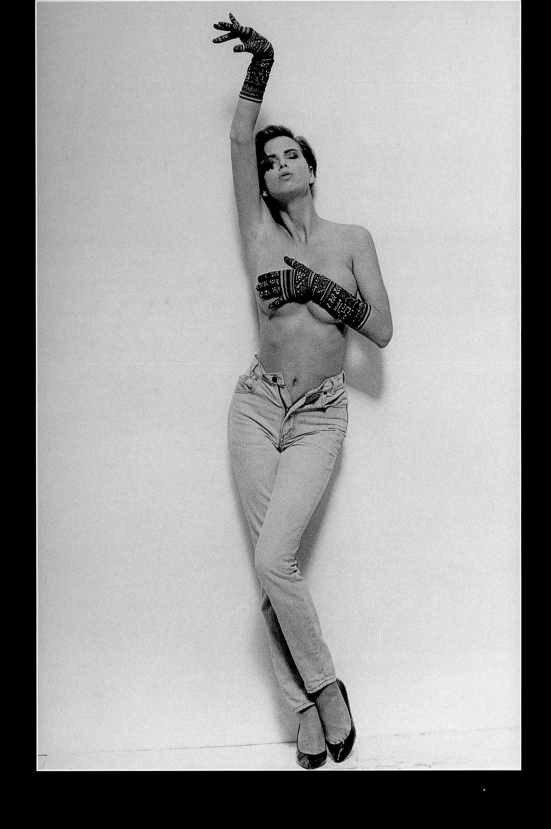

2
classical
nudes

▶ Like many categories in photography, the term "classical nude" defies simple definition. Normally – though far from invariably – the background and setting are both relatively simple, but this simplicity can range from seamless background paper, to the worn floor of a photographer's studio, to a painted fabric background (a very popular choice), to the rugged, rough-finished metal used by Frank Wartenberg. A separate tradition, of which only a single example appears in this chapter, creates a much more luxurious ambience, though still with simple props: Stu Williamson's Marie is very much in the 19th-century style of Alma-Tadema and the other painters of classical scenes.

Traditionally, this is also a field in which lighting is kept fairly simple, because the photographer is often playing with light as much as he (or she) is exploring the graphic possibilities of the nude: half the pictures in this chapter employ only a single light source, and it is not unusual to use two lights together to create the effect of a single, larger light. Rod Ashford's Kay uses a single light on the subject, and another on the background.

The majority of pictures in this chapter were shot on roll-film, with about one-third on 35mm and one on 4x5in. For this kind of image, where texture and gradation are at a premium, 35mm may be a less appropriate choice unless (like the photographers whose work is seen here) you have a particular reason to use it.

Photographer: **Mike Dmochowski**

Use: **Self-promotion**

Model: **Dawn (who also acted as stylist)**

Camera: **35mm**

Lens: **150mm + warming filter**

Film: **Kodak Ektachrome EPP**

Exposure: **f/11**

Lighting: **Electronic flash: 2 heads, filtered**

Props and set: **Black velvet/black paper**

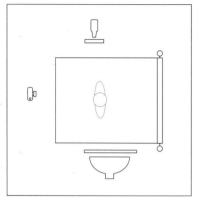

Plan View

► *Gold body-paint smears very easily and can be difficult for a model to apply evenly all over*

► *Strong warming filters such as an 81EF can be extremely effective with golden subjects of any kind*

► *There is no truth in the rumour (which originates from a James Bond movie) that gold body-paint is dangerous when applied all over. It can be worn for many hours without any risk*

GOLD FEMALE SCULPTURE

▼

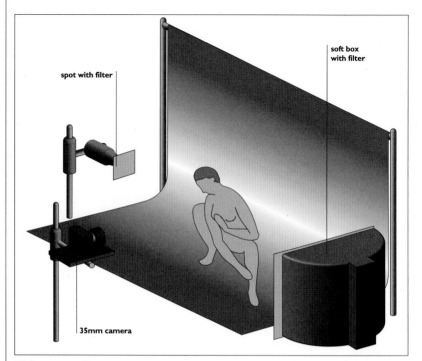

spot with filter

soft box with filter

35mm camera

Wʜᴀᴛ ʏᴏᴜ sᴇᴇ ɪs ᴡʜᴀᴛ ʏᴏᴜ ɢᴇᴛ: ᴀ ᴍᴏᴅᴇʟ ᴘᴀɪɴᴛᴇᴅ ᴡɪᴛʜ ɢᴏʟᴅ ʙᴏᴅʏ-ᴘᴀɪɴᴛ. Wʜᴀᴛ ʏᴏᴜ sᴇᴇ ɪs ᴀʟsᴏ ᴇᴍᴘʜᴀsɪᴢᴇᴅ ᴡɪᴛʜ ᴛʜᴇ ʜᴇʟᴘ ᴏꜰ ᴅᴏᴜʙʟᴇ sᴛʀᴀᴡ ꜰɪʟᴛᴇʀs ᴏᴠᴇʀ ᴛʜᴇ ʟɪɢʜᴛɪɴɢ ᴀɴᴅ ᴀ ᴡᴀʀᴍɪɴɢ ꜰɪʟᴛᴇʀ (ᴠᴀʟᴜᴇ ᴜɴʀᴇᴄᴏʀᴅᴇᴅ) ᴏᴠᴇʀ ᴛʜᴇ ʟᴇɴs ꜰᴏʀ ᴀ ʀᴇᴀʟʟʏ ʀɪᴄʜ ɢᴏʟᴅ.

The key light comes from camera left, and is a Fresnel spot about 1.8m (6ft) from the subject and about 60cm (2ft) above the floor. It is at right angles to the line of sight of the camera. The exposure reading, pointing the meter directly at the light source, was f/11.

Fill is supplied by a 1×1m (40×40in) soft box to camera right, directly opposite the key and about 1.2m (4ft)

from the model. The exposure reading from this light, again pointing the meter straight at the light from the position of the model, was f/5.6–1/2 (f/6.8).

The model is on black velvet, with a black seamless paper sweep behind her: the velvet is more illuminated than the paper, but it reflects about 1 stop less light and so reads as completely black.

Photographer's comment:

Exposure is very subjective in this sort of picture. My preference would be for a dark exposure, but unlike a lot of subjects where exposure is critical, on this there was at least a 3-stop latitude.

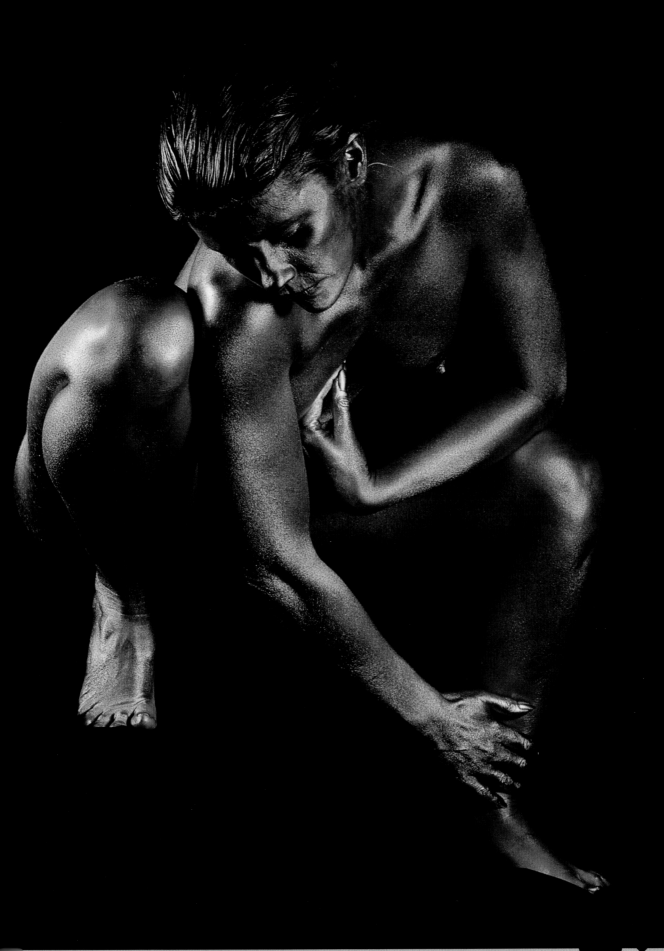

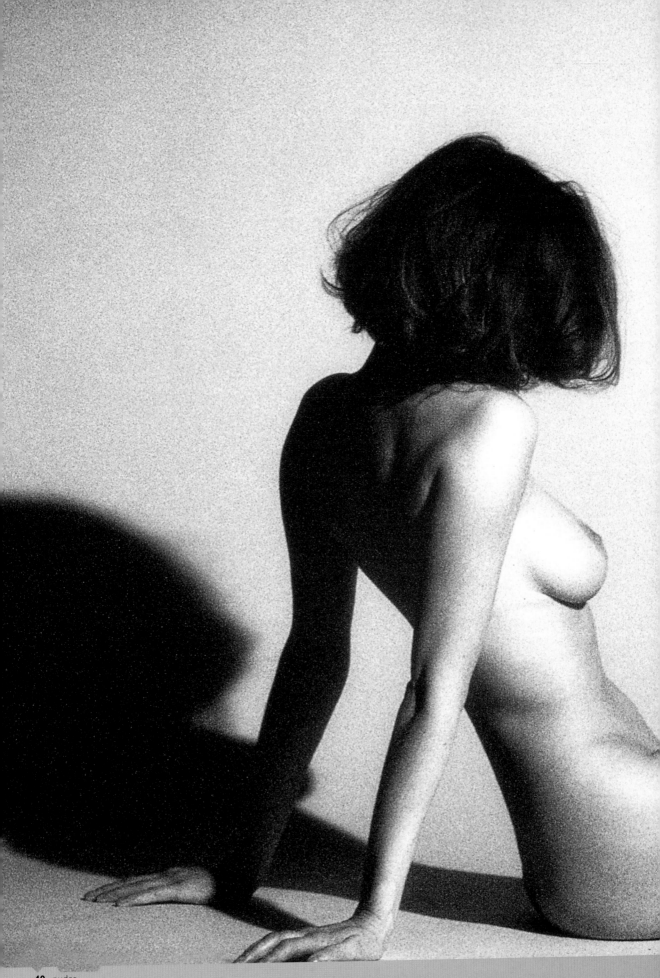

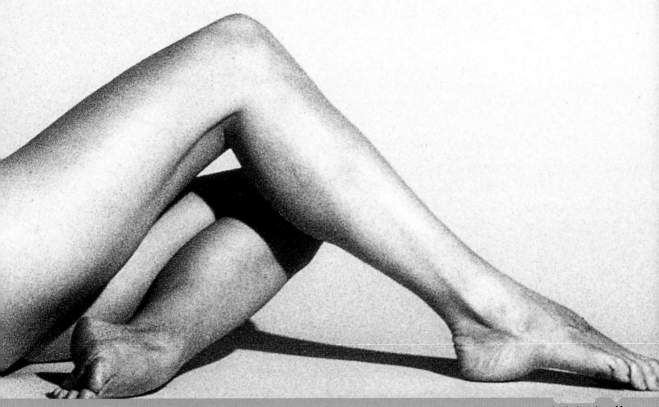

Photographer: **Terry Ryan**

Client: **Jane (the model)**

Use: **Self-promotion**

Camera: **35mm**

Lens: **105mm macro**

Film: **Polaroid Polagraph 400**

Exposure: **1/60sec at f/8**

Lighting: **Tungsten**

Props and set: **White seamless paper**

Plan View

▼

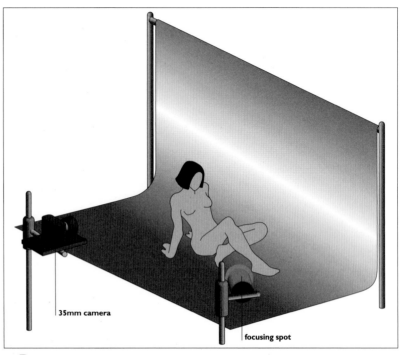

35mm camera

focusing spot

POLAROID POLAGRAPH IS A HIGH-CONTRAST INSTANT-PROCESS SLIDE FILM WHICH CAN NEVERTHELESS BE USED FOR GENERAL PHOTOGRAPHY — *IF* YOU GET THE EXPOSURE ABSOLUTELY SPOT-ON; IN WHICH CASE SOME VERY DRAMATIC HIGH-KEY EFFECTS ARE OBTAINABLE.

The lighting compounds the requirement for ultra-precise exposure: a highly directional 2K tungsten focusing spot creates dramatic chiaroscuro and must be positioned with exquisite care if the outline of the model is to be distinguishable at all points from the background. It is set fairly low, or the tops of the legs would be burned out, and it is fairly oblique in order to create the dramatic shadow which is very much an integral part of the composition. In contrast with most studio pictures, the model must be quite close to the background in order for the shadow to read: normally, of course, one is more concerned with losing shadows than with using them.

► *In any high-key picture there must be some dark tones – and, as this picture illustrates, a high-key picture can even contain a lot of dark tones*

► *When it comes to exposure using high-contrast materials, experience is the best guide, coupled with generous bracketing and (of course) Polaroid tests: a test film can be processed and mounted in a few minutes*

Photographer: **Stu Williamson**

Client: **Marie**

Use: **Portfolio shot for modelling**

Camera: **6x7cm**

Lens: **140mm**

Film: **Ilford FP4 Plus**

Exposure: **f/11**

Lighting: **Electronic flash: three heads**

Props and set: **See text**

Plan View

▼

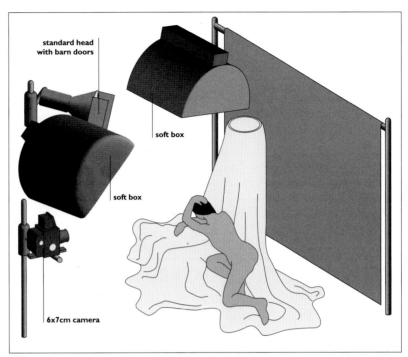

standard head with barn doors

soft box

soft box

6x7cm camera

T HERE ARE MORE THAN OVERTONES OF 19TH-CENTURY ODALISQUES IN THIS PICTURES; IT IS REMINISCENT OF THE PAINTINGS OF ALMA-TADEMA, WHO WAS FAMOUS FOR HIS VOLUPTUOUS MAIDENS IN CLASSICAL OR EXOTIC SETTINGS.

The key light is from above, almost directly over the model and to her right. The effect is of sunlight streaming through a window. A soft box in front of the model, just above the camera, provides fill. A third light, a standard head with barn-doors, illuminates the background.

The hanging, veil-like material was specially made up by a wedding supply store. It is sewn to a hoop of the kind typically carried by bridesmaids and decked with flowers; as the photographer somewhat unromantically says, "It is like an enormous mosquito net." This hangs in front of a Colorama painted background. To complete the 19th-century effect, the picture was printed through a "Craqueleur" texture screen.

► *Photographers can often learn as much from painters as they can from other photographers*

► *Lighting, pose and props are all complemented by the texture screen*

► *Dramatic chiaroscuro characterizes many seraglio scenes*

Photographer's comment:

The texture screen is made in the United States and used to be imported into the UK by my father through his business, World Wide Promotions.

Photographer: **Kay Hurst, K Studios**

Use: **Portfolio**

Model: **Catherine Richardson**

Camera: **4x5in**

Lens: **360mm**

Film: **Polaroid 55 P/N at EI 25**

Exposure: **Not recorded**

Lighting: **Electronic flash: one head**

Props and set: **White background paper**

Plan View

E L E G A N C E

▼

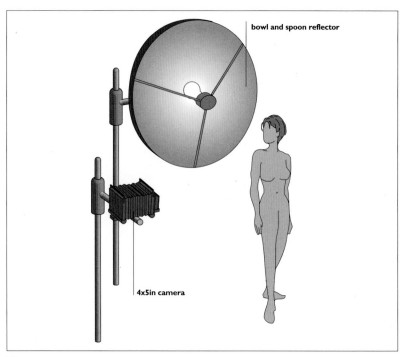

bowl and spoon reflector

4x5in camera

THE LIGHTING IS SIMPLE: A BROAD REFLECTOR ("BOWL AND SPOON") TO CAMERA LEFT, CLOSE TO THE MODEL. YOU CAN WORK THIS OUT FOR YOURSELF FROM THE SHADOWS AND FROM THE LACK OF EXTRA BACK LIGHTING.

The large (90cm/3ft) "bowl and spoon" gives a "hotter" light than a soft box, especially when used close to the subject, as here. The overall effect of the image is, however, much influenced by the afterwork.

The image was printed onto Kentmere Art Classic, which was then sepia toned, colour photocopied and transferred onto Fabriano Canaletto natural art paper; after treatment with a suitable solvent, the colour copy was burnished down onto the paper. By varying the pressure a solarized effect can be created in the black areas: the pre-treatment is necessary in order to achieve this effect.

► *Quality of light is easier to recognize than to describe, but it is much affected by reflector size and degree of diffusion*

► *Processes such as this are highly idiosyncratic and may require considerable experiment with different papers, toners, photocopiers and transfer papers*

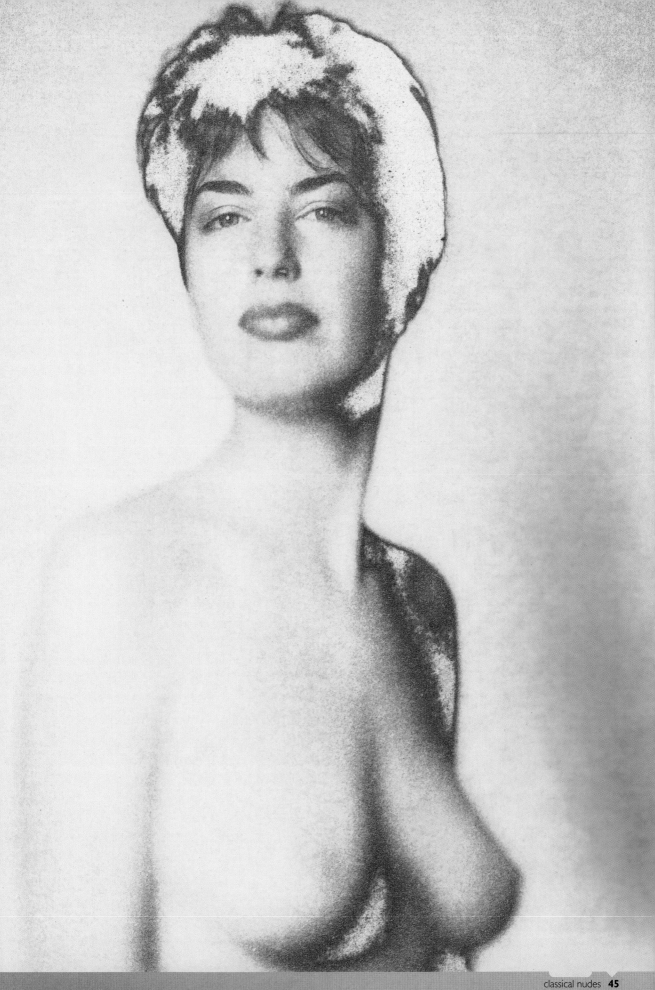

Photographer: **Frank Wartenberg**

Use: **Portrait**

Camera: **6x7cm**

Lens: **350mm + light blue filter**

Film: **Fuji Velvia**

Exposure: **f/5.6**

Lighting: **Mixed: 5 heads (see text)**

Props and set: **Blue painted canvas backdrop**

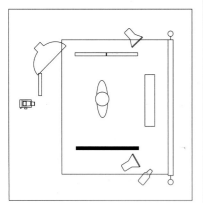

Plan View

► *Textured canvas creates a mood very different from plain background paper*

► *Evenly illuminating a background can require a great deal of light*

► *The "negative space" around the model creates a good deal of the mood of the picture*

BLUE

▼

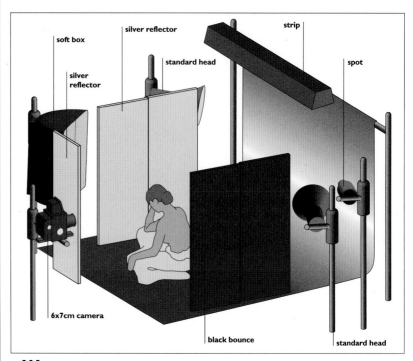

WEAK BLUE FILTRATION ON THE CAMERA LENS AND A BLUE BACKDROP ARE NOT THINGS THAT WOULD OCCUR TO EVERYONE AS BEFITTING A CLASSICAL NUDE; BUT THE RESULT IS A CURIOUSLY EFFECTIVE COMBINATION OF COLDNESS AND WARMTH.

The key light is a large soft box to camera left, with silver reflectors on either side. The soft box is clearly directional but the big silver bounces on either side of it throw back blue-tinted spill from the other lights to create the illusion of a still larger source. To camera right, large black bounces ensure that the shadow side (the model's back) is as dark as it can be. The remaining lights – two standard flash heads, an overhead strip light, and a daylight (HMI) spot – all combine to illuminate the background fairly evenly but with a small darker area in the upper left to provide a little more variation than comes from the painted canvas alone.

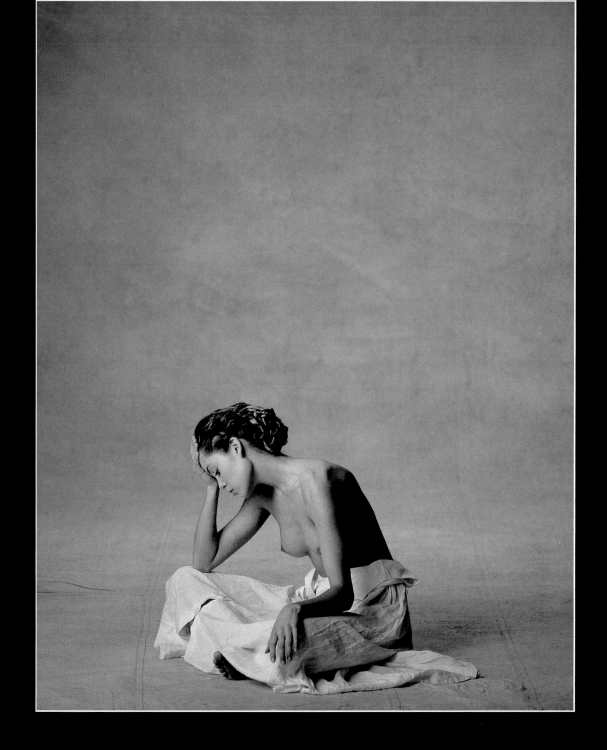

Photographer: **Frank P. Wartenberg**

Use: **Portfolio**

Camera: **RB67**

Lens: **Not recorded**

Film: **Not recorded**

Exposure: **Not recorded**

Lighting: **Daylight plus HMI spot**

Props and set: **White seamless background**

Plan View

H I G H K E Y

▼

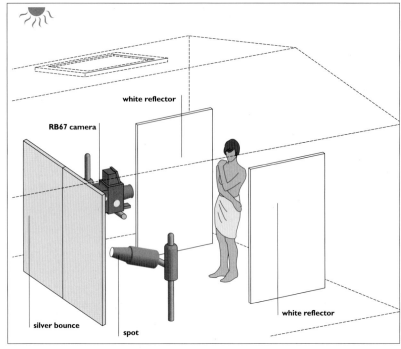

white reflector

RB67 camera

silver bounce spot white reflector

MUCH OF THE POWER OF THIS PICTURE COMES FROM THE MODEL'S DIRECT, CHALLENGING STARE: THE MOOD IS AT ONCE EROTIC AND HUMAN, RATHER THAN DEPERSONALIZING THE MODEL INTO AN EMPTY FANTASY.

Unusually, this was shot in a daylight studio: a large roof window provided the fill. Although such studios are rare today, and although the windows must be capable of being covered when they are not needed, a true daylight studio can be remarkably versatile, as our Victorian ancestors repeatedly demonstrated.

Here, though, the daylight was supplemented by a daylight (HMI) spot bounced off two big silver bounces over the top of the camera to create a very flat, classically high-key light. Two large white reflectors, one on either side of the model, completed the high-key set-up.

► *Normally – though not invariably, as seen here – there are small areas of maximum black even in a high-key picture*

► *The background in a high-key picture is almost invariably lighter than the subject*

► *Generous use of large bounces is commonplace in high-key photography*

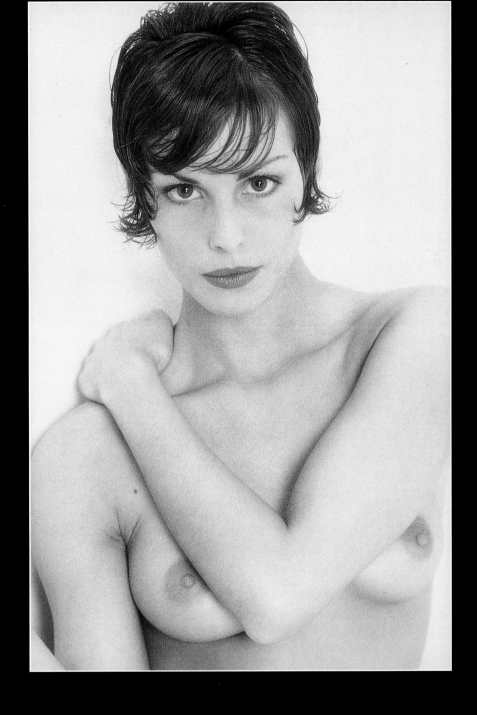

Photographer: **Frank P. Wartenberg**

Use: **Portfolio**

Camera: **6x7cm**

Lens: **185mm with deep blue filter**

Film: **Kodak Ektachrome EPT tungsten balance**

Exposure: **Not recorded**

Lighting: **Large soft box**

Props and set: **Ground metal**

Plan View

► *In addition to its colour, make-up can greatly affect the reflectivity of skin*

► *Sometimes two separate paths have to be pursued in order to create an intense effect; in this case, blue filtration and the use of tungsten-balance film with daylight-balance lighting*

B L U E M E T A L

▼

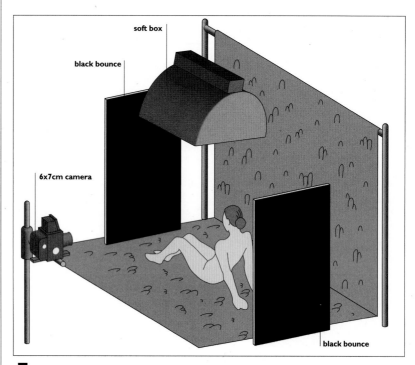

THE SET IS DRAMATIC IN ITS OWN RIGHT: ROUGHLY WORKED METAL. THIS IS NOT THE MOST COMFORTABLE SURFACE TO SIT ON! TO ADD TO HER DISCOMFORT, THE MODEL WAS COVERED WITH SILVER MAKE-UP. THE OVERALL EFFECT IS HOWEVER VERY MEMORABLE.

Tungsten-balance film with daylight-balance flash makes for a very blue image, which is further enhanced here with a deep blue filter. A big soft box is suspended over the model, which explains the shadows: in effect, only the upper part of her body is illuminated, though there is some fill from the reflected light off the background. The flash-back from the background itself

burns out the area around the model, creating a semi-silhouette effect.

Painting the model silver may seem curious in the context of a blue picture, but the simple truth is that even the matte silver which is normally attained with make-up is significantly more reflective than normal skin. This is what adds the apparent very high contrast to the figure.

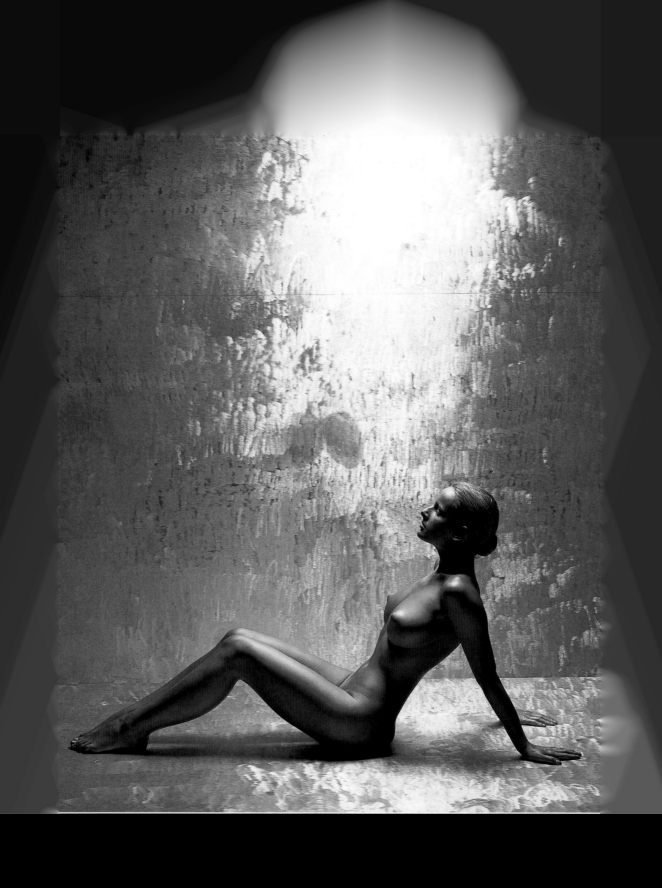

Photographer: **Stu Williamson**

Client: **Correna**

Use: **Model portfolio**

Camera: **6x7cm**

Lens: **105mm**

Film: **Kodak Plus-X Pan**

Exposure: **f/8**

Lighting: **Electronic flash: one spot**

Props and set: **Lastolite hand-painted background**

Plan View

C O R R E N A

▼

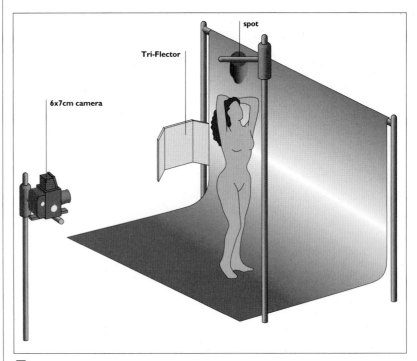

THIS IS THE SORT OF PICTURE WHICH ANY AMATEUR PHOTOGRAPHER COULD TAKE – GIVEN A BEAUTIFUL GIRL, A SPOTLIGHT, AN OFF-THE-SHELF BACKGROUND, ENOUGH TALENT AND A PAINSTAKING ATTENTION TO DETAIL.

It shows that rules are made to be broken – the "rule" in this case being that the model should be a long way from the background so that she casts no shadow. If you are going to break a rule it is often as well to break it thoroughly: Stu used a very hard light to cast a clear, strong shadow which echoes the model's shape on the background. A "Tri-Flector" (see page 24) provides some fill.

The light is very high over the camera, as can be seen from the shadow, and the light is harsh; and yet the modelling is exquisite. The choice of Plus-X Pan, an "old technology" film, allowed maximum control of tonality in development.

► *If there is insufficient room between the model and the background, consider making a feature of the model's shadow*

► *If you want a shadow, it is often best to use the hardest light available to you*

► *Many photographers use a "palette" of films for different effects*

Photographer's comment:

The picture was toned using Fotospeed Sepia toner.

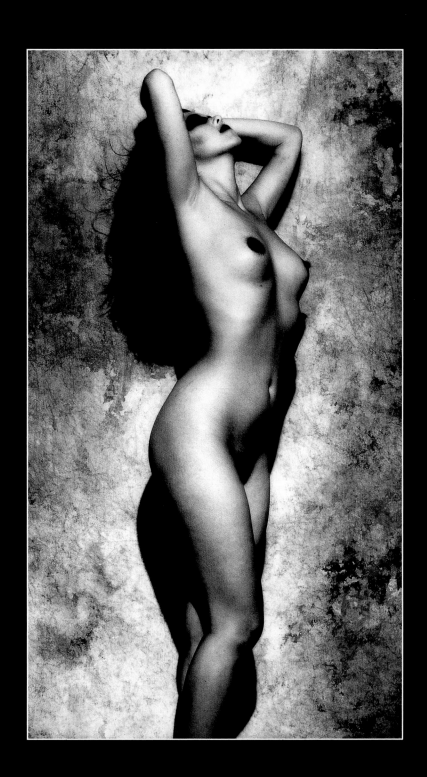

Photographer: **Rod Ashford**

Client: *Professional Photographer* **magazine**

Use: **Review of toners; subsequently used as book cover in Norway**

Model: **Kay Holmes**

Hair/Make-Up: **Sandra Ashford**

Camera: **35mm**

Lens: **70–210mm**

Film: **Ilford FP4 Plus**

Exposure: **f/16**

Lighting: **Electronic flash: 2 heads**

Props and set: **Painted background by Fantasy Backgrounds, Eastbourne**

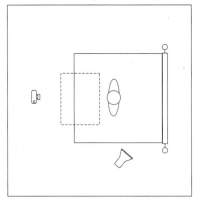

Plan View

► *As with many of the monochrome pictures in this book, this one owes a great deal to the printer (who was also the photographer)*

► *With split toning and "freeze grey", a neutral grey can appear warm toned when contrasted with a cold blue*

K A Y

▼

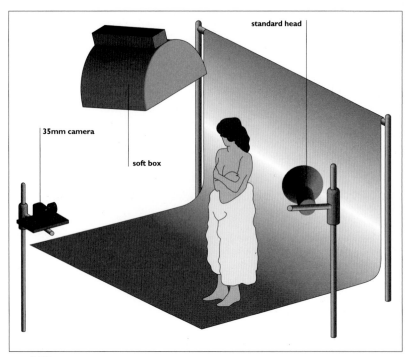

standard head

35mm camera

soft box

WHEN MOST MAGAZINES TEST TONERS, THEY USE BORING SHOTS FROM THEIR FILES. *PROFESSIONAL PHOTOGRAPHER* HIRED A REAL PHOTOGRAPHER WHO CAN ALSO WRITE, AND GOT HIM TO TEST COLORVIR TONERS IN REAL-WORLD CONDITIONS.

Rod used two lights, a 40x50cm (16x20in) Photoflex Litedome soft box and a standard head. The standard head was used as a background light, while the soft box was the key and only light on the model; as can be seen from the shadows, it was high above the camera and very slightly to the left. Both lights, he notes, were Bowens Esprit units, which he particularly likes.

Contrary to immediate appearances, the background light was not snooted or tightly honeycombed behind the model's head. There was some gradation, but it was much enhanced in printing and then further enhanced (somewhat to the photographer's surprise) by the toning chemistry: a brief dip in "freeze grey" held the highlights, followed by blue toning for the shadows.

Photographer's comment:

The model, Kay Holmes, had contacted the editor of the magazine, asking how to become a model. He referred her to me, and this was from the very first session.

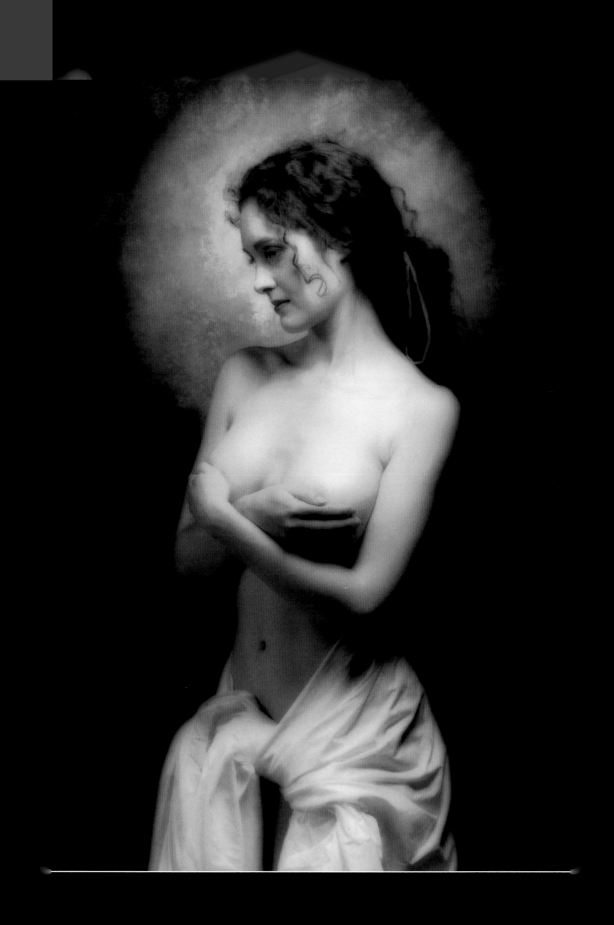

Photographer: **Frank P. Wartenberg**

Use: **Portfolio**

Camera: **6x7cm**

Lens: **185mm**

Film: **Agfa Scala**

Exposure: **Not recorded**

Lighting: **Large soft box**

Props and set: **Ground metal**

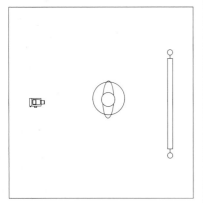

Plan View

S I L V E R

▼

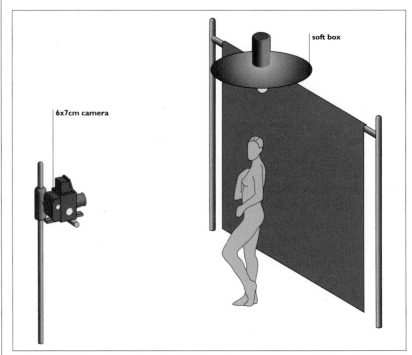

THIS PICTURE CLEARLY ILLUSTRATES THE RELATIONSHIP BETWEEN HIGH CONTRAST AND HIGH KEY. IN ONE SENSE, THE TWO ARE QUITE DIFFERENT; AND YET IN ANOTHER, EFFECTIVE HIGH KEY DEPENDS ON EFFECTIVE HIGH CONTRAST.

Also, there is a great deal of difference between a picture with a full tonal range, but where the main interest lies in the extremes of tone, and one which lacks mid-tones and is reduced to 'soot and whitewash'. Controlling contrast means controlling lighting.

Here the sole light is a big soft box which is suspended over the model. She is painted silver in order to bring her reflectivity up to that of the background.

Roughly equal (and high) reflectivities of subject and background are one of the essential requirements of a high-key picture. In effect, only the upper part of her body is illuminated, though the highly reflective rough-ground metal background provides fill. Choice of film was important: the long tonal range of a transparency film allows more subtlety, more easily, than using a print film.

► *With long tonal ranges, a low-contrast material is essential*

► *With high-contrast materials, low-contrast lighting is essential if you want a good tonal range*

► *Compare this with the picture on page 55, which is lit the same way but uses colour transparency film*

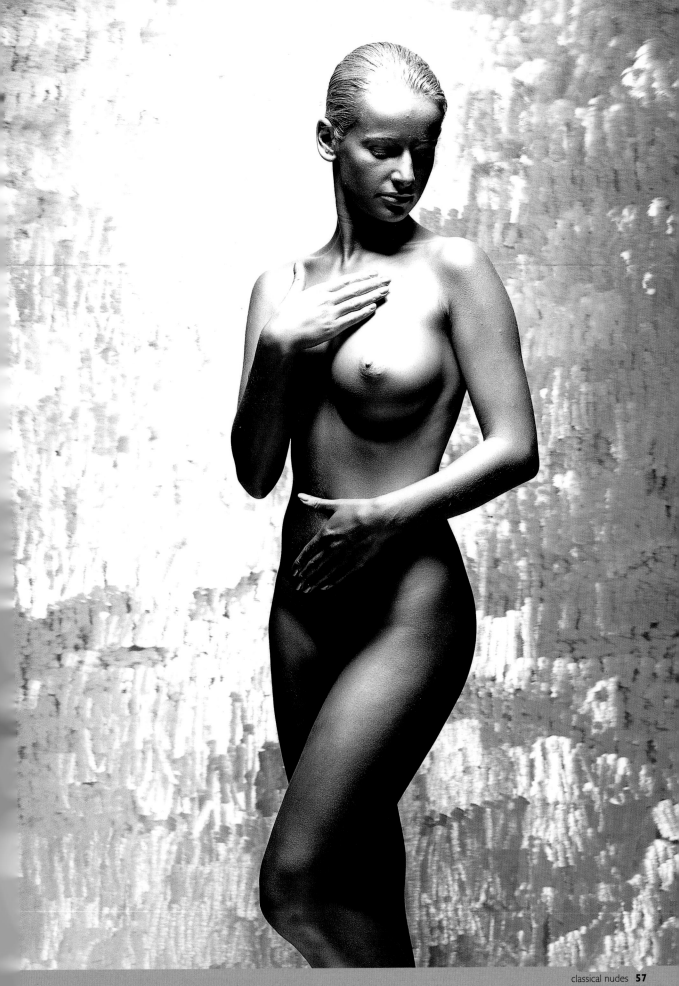

3

the
semi-domestic
nude

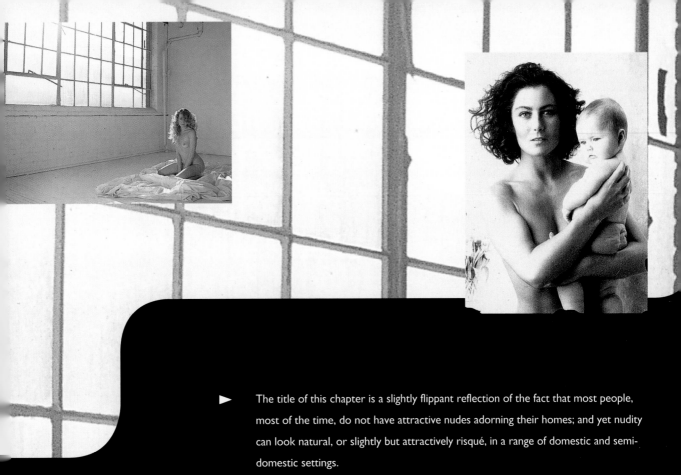

The title of this chapter is a slightly flippant reflection of the fact that most people, most of the time, do not have attractive nudes adorning their homes; and yet nudity can look natural, or slightly but attractively risqué, in a range of domestic and semi-domestic settings.

Inevitably, the definition has been stretched: Frank Wartenberg's Nude with Chair is photographed against a plain fabric backdrop, but was included because it is essentially a picture which could have been taken at home; Terry Ryan's Mother and Child is a studio picture taken against a white background which is included because of the implications of domesticity inherent in motherhood. Often any picture in any chapter in this book could as well be assigned to another chapter; but as long as the pictures are attractive in themselves it is more important that they are included, rather than that they should precisely reflect the title of the chapter.

There is a wide variety of lighting, from daylight (used in half the shots in the chapter) through a single artificial light source to complex set-ups, particularly in Morning Tea from Jordi Morgadas, where the "bedroom" is actually a built set with big soft boxes outside the windows. In general, it must be said, daylight is harder to handle than it looks and such subterfuges as white furnishings (see Peter Barry's Room) are needed to even out the light.

Photographer: **Jordi Morgadas**

Client: **Penthouse Magazine**

Use: **Editorial**

Model: **Karin**

Make-up: **Susana Muñoz**

Stylist: **Maria Rowen**

Camera: **35mm**

Lens: **85mm with A-2 filter**

Film: **Kodak Ektachrome EPR ISO 64**

Exposure: **f/16**

Lighting: **Electronic flash: 3 heads**

Props and set: **Built set**

Plan View

► *Very large umbrellas can be a convenient alternative to soft boxes for some applications*

► *Tight lighting ratios can still exhibit a surprising degree of modelling if one light is very diffuse and the other is more directional*

M O R N I N G T E A

▼

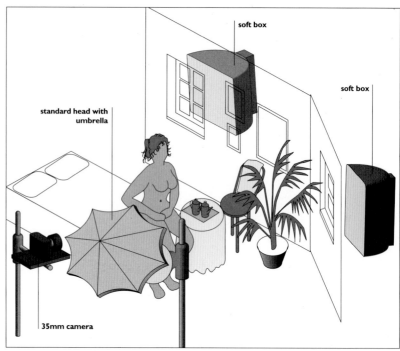

T HE BUILT SET, WITH SOFT BOXES SHINING THROUGH WINDOWS, IS A MORE COMMON PLOY THAN MOST AMATEURS IMAGINE: IT GIVES THE PROFESSIONAL THE MAXIMUM POSSIBLE CONTROL, WITHOUT WORRYING ABOUT WEATHER OR TIME OF DAY.

Here there are two "windows", one of which is in shot and the other of which is clearly implied by the light from camera right. Both are transilluminated by large soft boxes, each 100×200cm (40×80in), and they create the many highlights on the model.

If these had been the only lights, however, there would have been very little rendering of the exquisite skin textures, and the drapes of the table beside the bed would have been flat and lifeless. A giant 2m (80in) umbrella to camera right therefore provided what is arguably the key light, although it is only marginally so because the overall lighting ratio is so tight. This picture clearly demonstrates that quality of light – directionality or harshness – can define which light is a key and which are fills or effects lights.

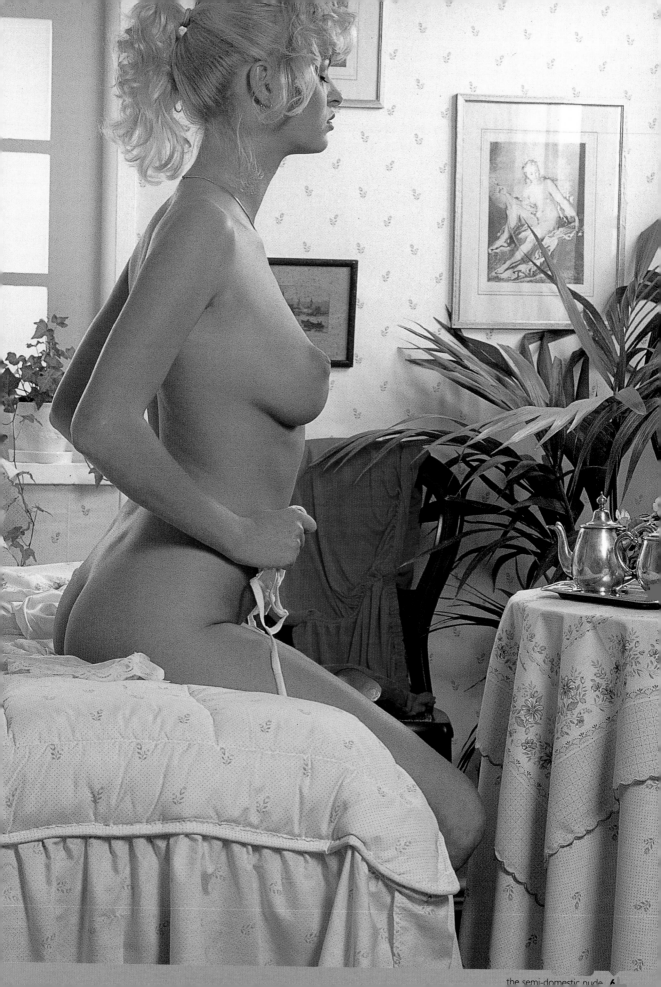

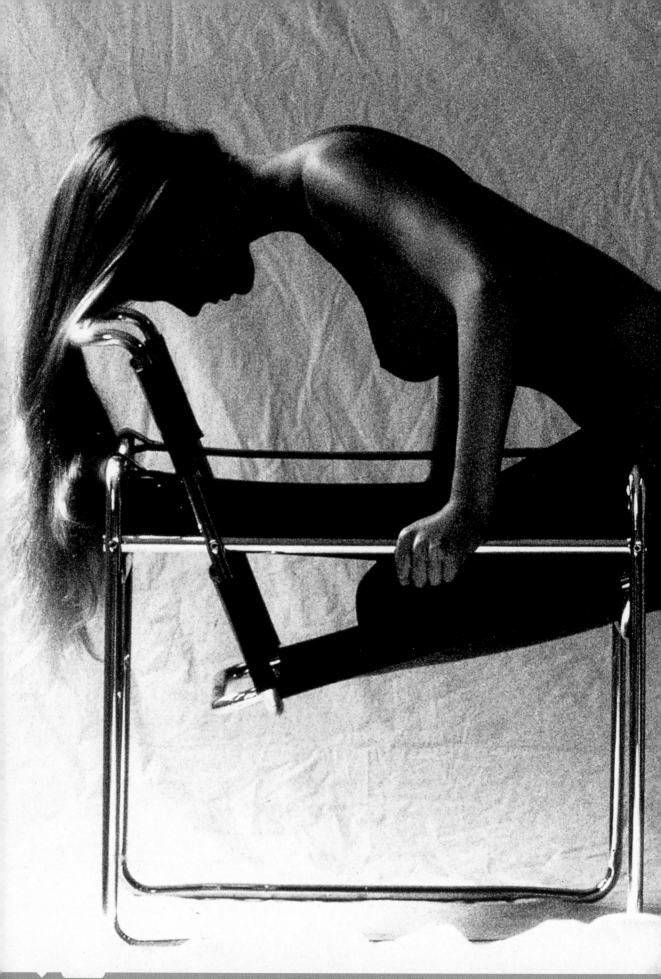

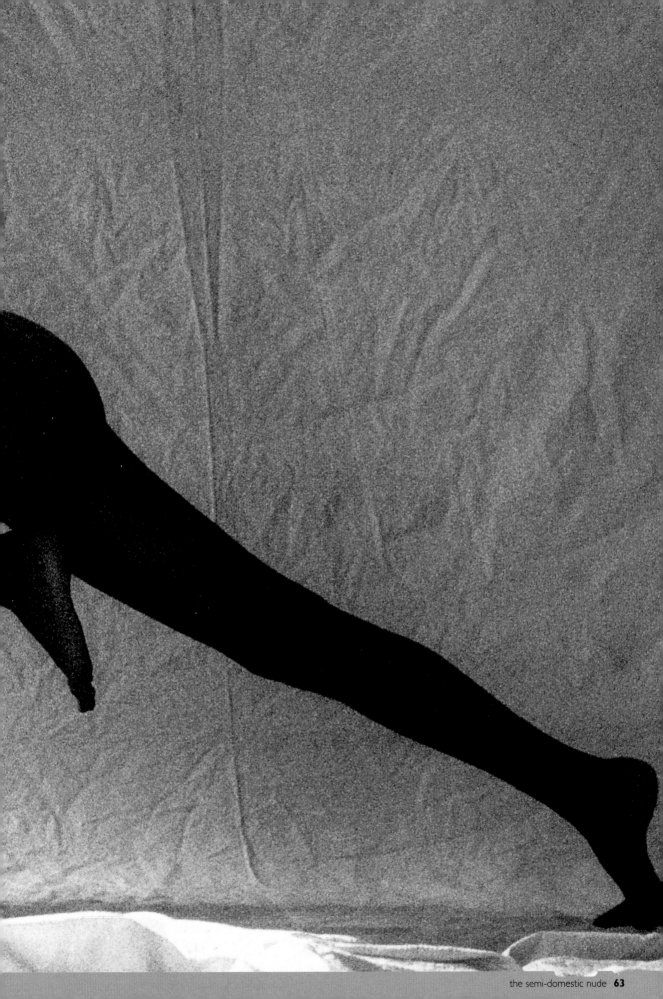

Photographer: **Frank P. Wartenberg**

Use: **Portfolio**

Camera: **35mm**

Lens: **200mm**

Film: **Polaroid Polagraph**

Exposure: **Not recorded**

Lighting: **Daylight**

Props and set: **Natural canvas, chair**

Plan View

N U D E W I T H C H A I R

▼

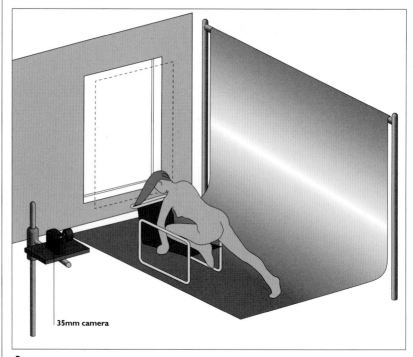

35mm camera

A DAYLIGHT STUDIO REQUIRES MORE THAN JUST DAYLIGHT. IT ALSO NEEDS ENOUGH SPACE TO ENABLE ONE TO CHOOSE THE BEST ANGLE FOR THE LIGHT AND THE CAMERA — WHICH IS ONE OF THE REASONS DAYLIGHT HAS FALLEN OUT OF FAVOUR.

When daylight is feasible, though, it can be delightful: big, soft light sources (and no running costs!). This is shot in front of one of the windows in Frank Wartenberg's studio, with a diffuser over the window to soften the light still more: the model's head is towards the window. It is, however, worth adding that while daylight can work superbly with monochrome, it can vary quite widely in colour from distinctly warm to quite cold and unpleasant.

Although the Victorians were fond of elaborately painted backdrops, they sometimes used plain canvas, as here. The combination of shapes is superbly executed: the timelessness of the human form against the formal chrome-and-leather chair.

► *The use of high-contrast Polagraph film has accentuated the contrast between the form of the model and the background*

► *Daylight studios generally require plenty of room for manoeuvre*

► *A long lens emphasizes graphic form*

Photographer: **Struan**

Client: **Amanda**

Use: **Portrait**

Camera: **35mm**

Lens: **35mm**

Film: **Kodak Ektachrome EPN ISO 100**

Exposure: **1/125sec at f/8**

Lighting: **Available light**

Props and set: **Large daylight studio**

Plan View

▼

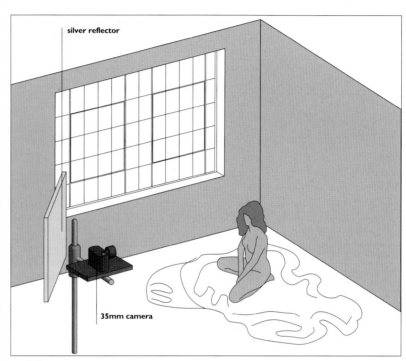

silver reflector

35mm camera

MODERN STUDIOS OFTEN BEAR MORE RESEMBLANCE TO A FACTORY THAN TO A 19TH CENTURY ARTIST'S *ATELIER*. SOME PHOTOGRAPHERS PAINT THEIR WINDOWS BLACK OR OTHERWISE BLOCK THEM PERMANENTLY, WHILE OTHERS FIT BLINDS TO ALLOW THE OPTION OF DAYLIGHT.

Here, sunlight is supplemented by a 120×120cm (4×4ft) silver movie-type reflector to camera left. One might have expected another reflector to be to camera right to provide fill on the side away from the window, but the white interior of the studio took care of this. Besides, this is a much more directional reflector than a white bounce: you can see the secondary shadow behind the model on the wall. Its purpose is to fill the front of the model: without it, the choice would be between wildly overexposing the sunlit portions, or underexposing the model.

The model is kneeling on a white sheet, almost one of Struan's trade-marks; he always carries a few white sheets with him, as props, backgrounds, reflectors, screens for the model to change behind, and so forth.

► *Silver (and gold) reflectors are much more directional than white*

► *Different films have different responses to wide lighting ratios*

► *A white sheet can have numerous uses*

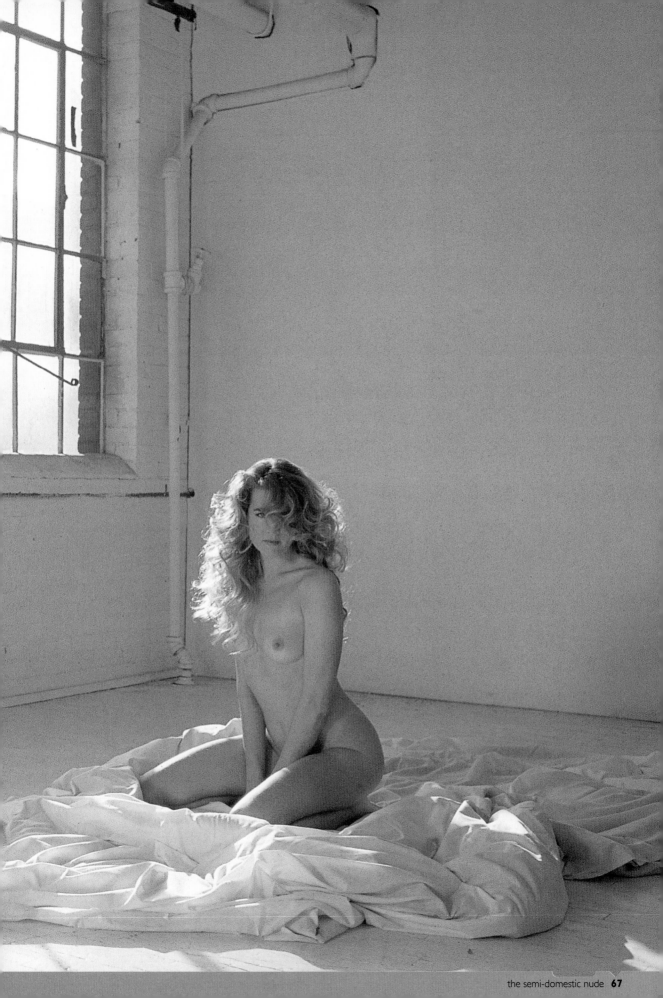

Photographer: **Peter Barry**

Use: **Model test**

Camera: **6x6cm**

Lens: **80mm**

Film: **Kodak Ektachrome EPR ISO 64**

Exposure: **1/4sec at f/4**

Lighting: **Available light**

Props and set: **Location**

Plan View

▼

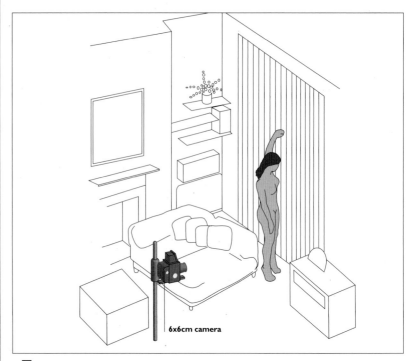

6x6cm camera

THE LIGHTING HERE IS SO SMOOTH, AND THE MODELLING SO GOOD, THAT IT IS HARD TO BELIEVE THAT IT IS "ONLY" AVAILABLE LIGHT. BUT THERE IS MORE HERE THAN MEETS THE EYE….

Two important factors are the vertically slatted window blinds and the light-coloured chair and cushions behind the model. The slatted blinds can create a surprisingly directional light, and they can also be angled so that the direction can be controlled. These two factors together help to explain a great deal of the success of the photograph.

Exposure is critical and a film of relatively low contrast is needed if the highlights are not to burn out and be "blown"; some modern films would be too contrasty to handle this sort of tonal range. Also, extreme neutrality is needed: some films run slightly blue, others slightly magenta, and, with flesh tones and light highlights, colour casts would soon become very obvious.

► *Do not neglect the possibilities of manipulating blinds and curtains to control "available" light*

► *Over-exposure would "blow" the highlights, but under-exposure would not give adequate skin tones*

► *The tiptoe pose and outstretched arm of the model echo the verticality of the blind*

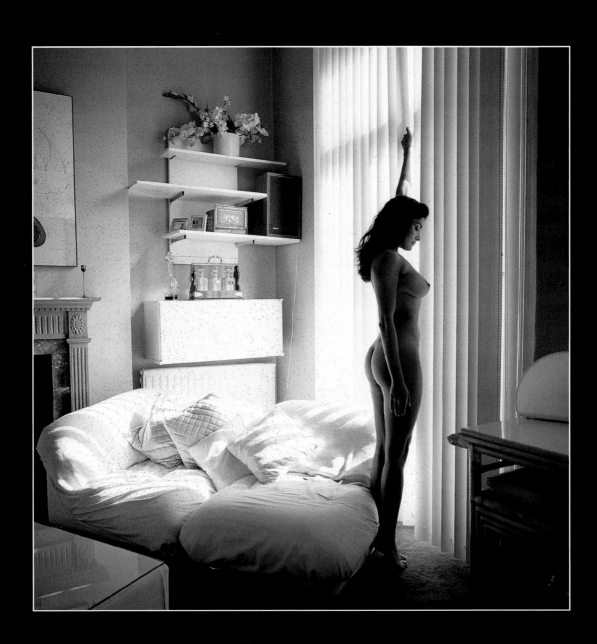

Photographer: **Terry Ryan**

Use: **Self-promotion**

Model: **Amanda Benson**

Camera: **35mm**

Lens: **105mm**

Film: **Polaroid Polagraph 400**

Exposure: **f16**

Lighting: **Electronic flash: 1 head**

Props and set: **White background paper**

Plan View

▼

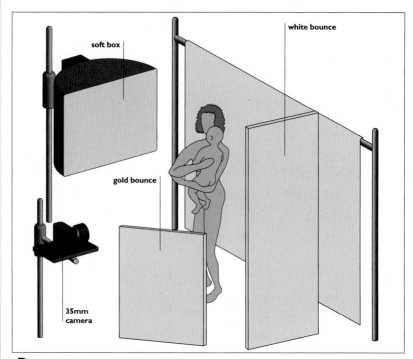

soft box

white bounce

gold bounce

35mm camera

Polaroid's ISO 400 Polagraph film is designed for technical use, but Terry Ryan has developed considerable expertise in exploiting its unique tonality for general photography. The secret lies in a very tight lighting ratio and extremely careful exposure.

The only light here is a big "swimming pool" soft box to camera left, but immediately to camera right there is a big white bounce – a 120x240cm (4x8ft) sheet of expanded polystyrene – and a gold bounce as well. The background, which looks burned out and high-key, as if it were illuminated separately, is in fact very close to the model and is lit only by spill from the key light.

A problem with all Polaroid emulsions is that they are very, very tender and easily scratched, so it makes sense to duplicate them immediately and never to send out originals to clients. In this case the scratches and the processing artifacts (the marks around the edge of the image) are presented as a part of the image – as though it were an old picture that had been rediscovered.

► *High-contrast films require very tight lighting ratios*

► *Lighting backgrounds with spill is not always easy*

► *Flaws and marks can be an integral part of a picture*

Photographer's comment:

This shot was taken whilst working on a shot for Boots the Chemist plc. It was decided to use Polagraph, and although a series of shots was taken, the effect on this particular frame – the borders, etc – seemed to me to add that extra something to the shot.

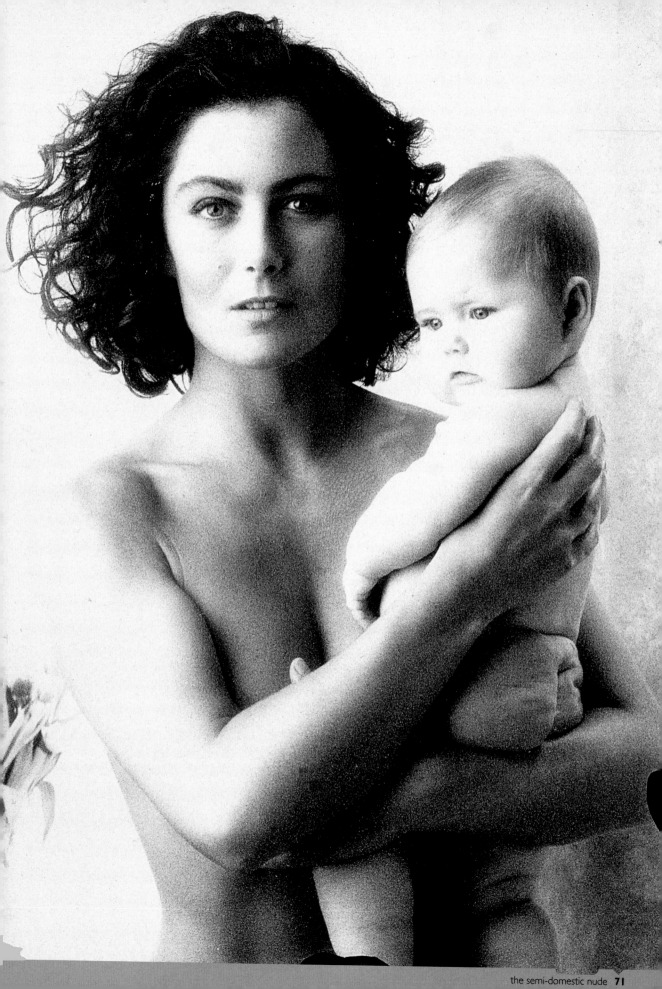

Photographer: **Struan**

Use: **Personal work**

Model: **Lorraine**

Camera: **35mm**

Lens: **50mm**

Film: **Kodachrome 64**

Exposure: **f/11**

Lighting: **Electronic flash: 3 heads**

Props and set: **Bath, tile flats**

Plan View

R E D B A T H T U B

▼

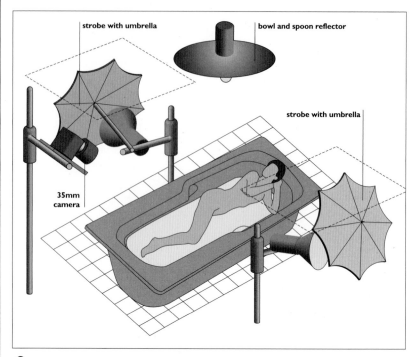

STRUAN SAYS: "WE HAD HIRED THE BATH-TUB FOR A BUBBLE-BATH SHOT, AND AS IT WAS IN THE STUDIO, I WANTED TO TRY SOME MORE SHOTS WITH IT. IF YOU HAVE PAID FOR IT, YOU MIGHT AS WELL USE IT."

He continues: "We bought a couple of sheets of 240x120cm (8x4ft) tile board for the "floor". There's a single light over the top – my big, circular reflector, 90cm (3ft) across – and then there's a strobe on either side with an umbrella to light the tiles. I tried it without but there was too much shadow beside the bath."

The big round reflector creates the highlights on the model and (even more importantly) on the bath, and choosing Kodachrome really "pops" the red – Kodachrome is famous for its reds.

Baths are normally shot "landscape", which emphasizes their stability and restfulness. Adopting the unusual technique of shooting from one end gives a much more energetic composition.

► *Vivid colours sometimes speak for themselves, but they can also be enhanced by skillful lighting*

► *Portrait (vertical) compositions are often more energetic than landscape (horizontal)*

Photographer's comment:

I shot this on both 35mm and with the Hasselblad; the Hasselblad shot won second prize in a national Hasselblad contest.

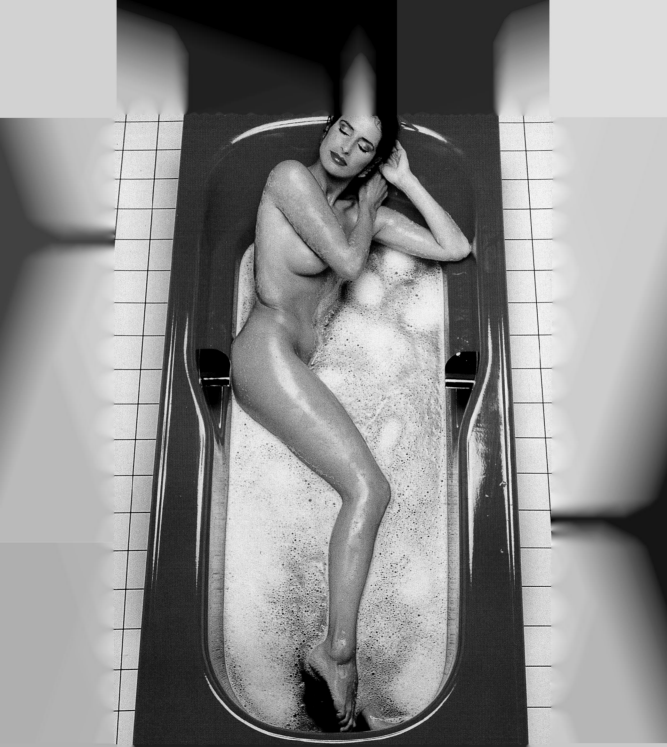

4

fantasies

The pictures in this chapter run from the gentlest of fantasies – Struan's Sylvia, for example – through more radical visions such as Günter Uttendorfer's No Name to the stuff of dreams and nightmares. In some the camera is simply made to lie, while preserving its ostensible realism. In others, the idiosyncracies of the photographic process, or the possibilities for manipulation during printing, are the secret. Yet others are simply straight shots: the secret lies in the set-up (and, of course, in the lighting).

Some are definitely disquieting, while others are curiously tranquil; and which ones seem disquieting to a particular person, and which ones seem tranquil, will depend very much on that individual's outlook on life. All illustrate the necessity of learning to meld vision and technique, as either on its own is insufficient: far too many pictures are spoiled by an absence of one or the other, so that a good idea is poorly realized or faultless execution betrays a woeful lack of aesthetic feeling.

Rollfilm and 35mm are neck and neck, with one 4x5in shot. It is particularly interesting to compare two superficially similar pictures, Stu Williamson's Vicky and Günther Uttendorfer's No Name, to see how technically and stylistically different they are – as well as to see that on closer examination, the content and pose of the two pictures differ considerably more than they at first seem.

Photographer: **Harry Lomax**

Use: **Promotional card**

Model: **Jo**

Camera: **4x5in**

Lens: **65mm and 360mm**

Film: **Fuji RDP ISO 100**

Exposure: **f/16 double exposure: see text**

Lighting: **Flash: see text**

Props and set: **Dragon "set"; girl on seamless paper**

Second Exposure

D R A G O N

▼

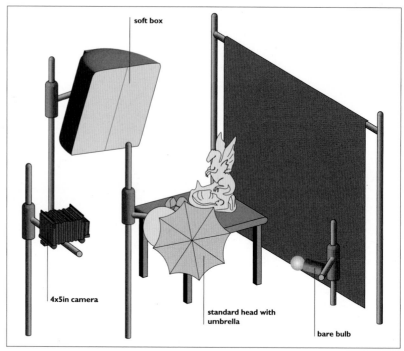

soft box

4x5in camera

standard head with umbrella

bare bulb

Electronic image manipulation is so commonplace nowadays that we may forget how a good photographer can often obtain better results, faster and more economically, using traditional photographic techniques. This is a double exposure.

The dragon "set" is a sculpture less than 30cm (12in) high, with a foreground of moss and pebbles and a graduated background. The key light is a big soft box to camera left, very slightly back lighting the subject, while fill comes from an umbrella to camera right set one stop down from the key. A bare bulb behind and below the dragon differentiates the background. The area to be occupied by the girl is masked off and marked on the ground glass. This was shot with a 360mm lens. The girl was then shot through a "keyhole" screen so that only she recorded on the film, the rest going black. The lighting was similar – a soft box to camera left, an umbrella to camera right and a bare bulb behind her – but lighting distances were adjusted to compensate for the fact that she was shot with a 65mm lens in order to get the scale right.

► *Switching focal lengths is a useful way to control image size in a multiple exposure, provided perspective is not a problem*

► *When switching focal lengths, the relative distances of lights and subject may need to be changed to maintain consistent lighting – although the orientations should remain as constant as possible*

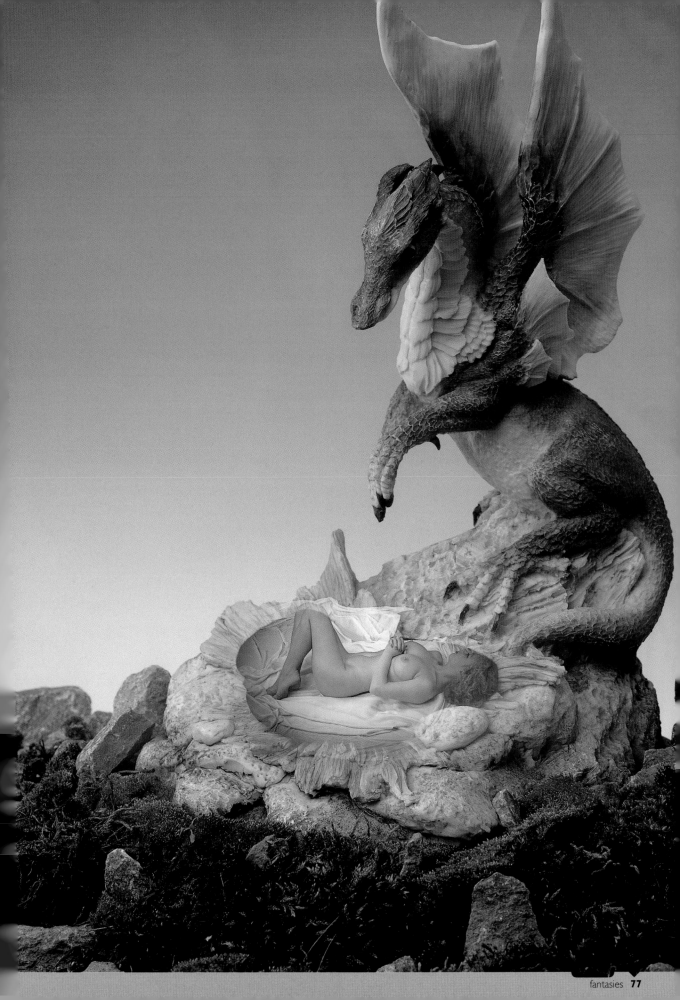

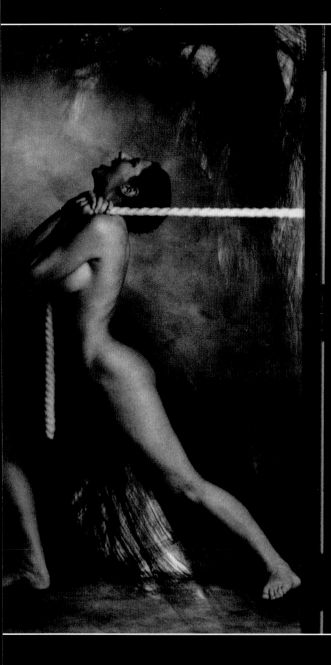
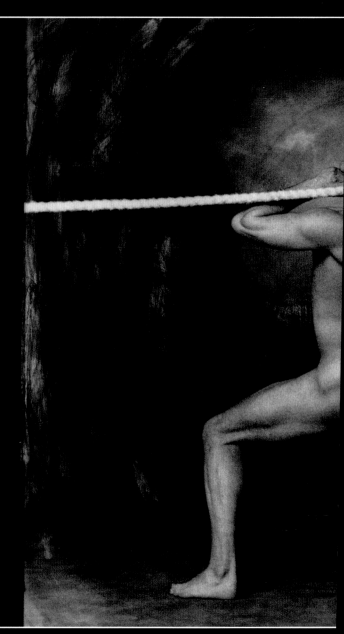

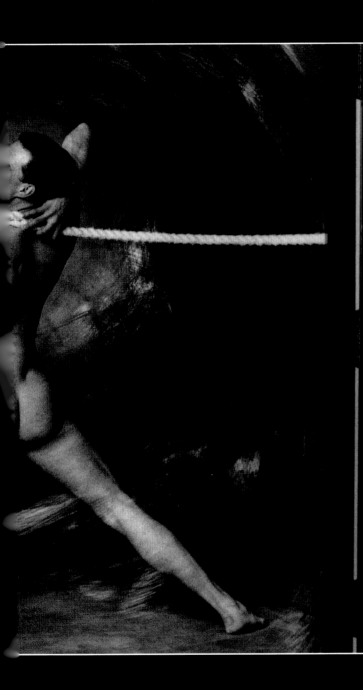
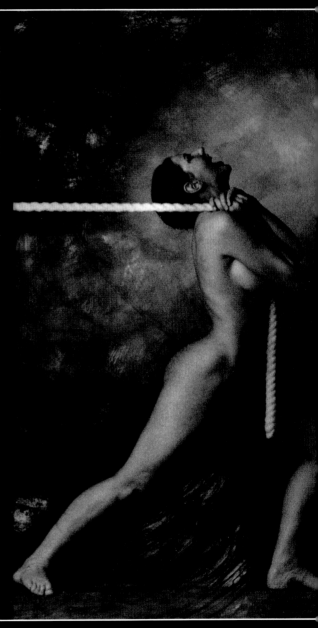

Photographer: **Benny De Grove**

Use: **Exhibition**

Assistant: **Astrid van Doorslaer**

Stylist: **An De Temmerman**

Camera: **6x6cm**

Lens: **150mm**

Film: **Kodak T-Max ISO 400**

Exposure: **f/8**

Lighting: **Electronic flash**

Props and set: **Painted background; rope**

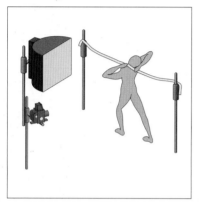

Centre panel

RELATIONS

▼

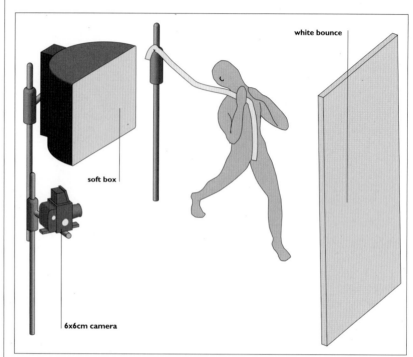

white bounce

soft box

6x6cm camera

THE TRIPTYCH IS AN UNUSUAL FORM IN PHOTOGRAPHY, BUT IN THIS CASE IT SOLVED A TECHNICAL PROBLEM AS WELL AS MEETING AN AESTHETIC REQUIREMENT. THE TRIPLE PANEL (PREVIOUS PAGE) IS THE TRIPTYCH OPEN; THE DOUBLE PANEL (OPPOSITE) IS THE SAME THING CLOSED.

► *Like any other form of composite image, a triptych must be internally consistent in its lighting*

► *The triptych form allows pictures which would otherwise require more studio space than is available, and also allows supports, etc., to be used out of shot but in the middle of the picture*

► *Although the traditional form of the triptych is in folding "icon" style like this, there is no reason why it has to be*

Making the picture in one shot was not possible: the tension of the rope and the sheer scale of the picture made this impracticable. It was therefore shot as two images, one of the man and one of the woman. Both were lit with a single 80x80cm (32x32in) soft box to camera left, supplemented by a white bounce to camera right in the case of the woman; the woman pulling in the other direction

(towards camera right) is merely a flopped image of the woman pulling towards camera left, so the same image is used in effect four times, twice right-way-around and twice flopped.

Getting the level of the rope precisely right in the picture of the man was the most difficult part: it had to match with the level of the rope in the other two pictures.

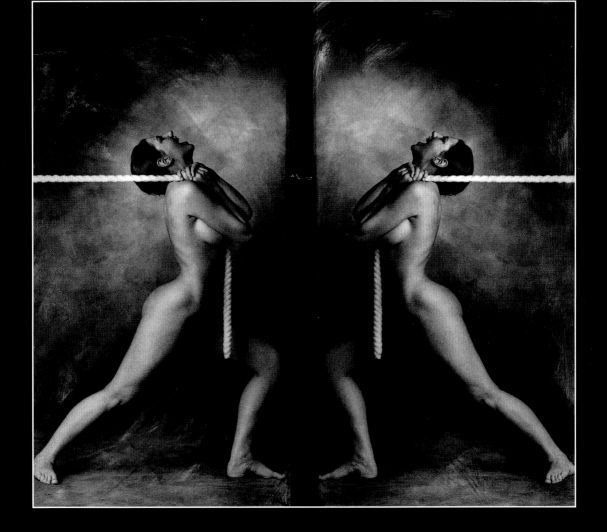

PAISLEY NUDE

▼

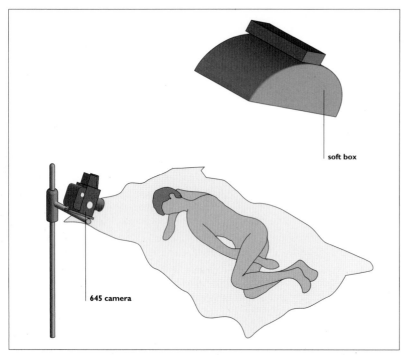

soft box

645 camera

Photographer: **Kay Hurst, K Studios**

Use: **Portfolio**

Model: **Julia Spencer**

Camera: **645**

Lens: **75mm**

Film: **Ilford FP4**

Exposure: **f/11**

Lighting: **Electronic flash: single large soft box**

Props and set: **Curtain material; print heavily reworked**

THIS IS FAIRLY TYPICAL OF THE KIND OF PORTRAIT AND NUDE WORK PRODUCED BY K, THOUGH IT IS ACTUALLY A VERY EARLY EXAMPLE OF THE STYLE FOR WHICH SHE HAS SINCE BECOME KNOWN: IT WAS MADE WHEN SHE WAS AT COLLEGE.

The sole light is a large soft box, back lighting the model slightly from camera right and mounted high: the model is lying on "some curtain material which I still have and which I am still using – good value, that!" The print was made on a Kentmere document paper without any baryta layer, which makes for an interesting texture. It was printed through a piece of patterned glass of the type sold for bathroom doors and windows: the print was sized so that the curves of the pattern matched the shape of the model.

The next stage involved floating oily inks on the wet print, manipulating them with cotton swabs. Finally, the distressed or aged effect was added with different-coloured water-based pigments, using special techniques for both application and removal.

► *Printing through textured glass is a well-established technique, but matching the texture to the subject in this way is another matter*

► *Different types of brushes create different effects when laying down and removing colour: consider stiff brushes for laying down, and soft Japanese brushes for removal*

Plan View

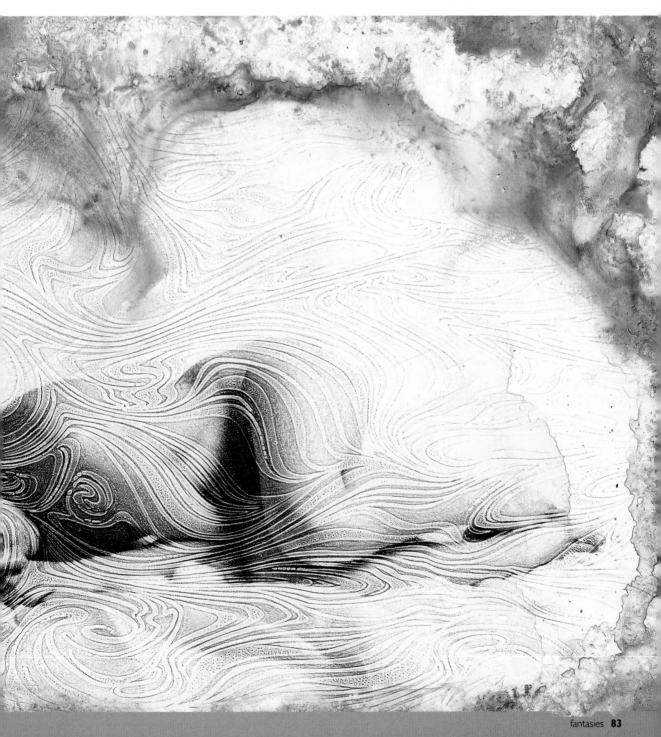

Photographer: **Günther Uttendorfer**

Client: **Mögges Chair Factory**

Use: **Poster**

Model: **Svetlana Hassanin**

Assistant: **Jürgen Weber**

Stylist: **Genevieve Hawtry**

Art director: **Florian Lehner**

Camera: **35mm**

Lens: **55mm**

Film: **Polapan 35**

Exposure: **Not recorded**

Lighting: **Electronic flash: 2 heads**

Props and set: **Built set: metal sheeting, chains, water spray**

Plan View

N O N A M E

▼

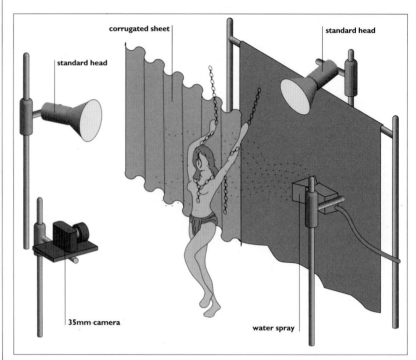

"THIS WAS SHOT AS AN IMAGE-POSTER FOR ONE OF MY CLIENTS. THEY HATED THE IDEA OF NORMAL, STERILE, PREDICTABLE ADVERTISING — SO WE DECIDED TO SHOOT SOMETHING DIFFERENT, SOMETHING MORE LIVELY."

There are only two lights, a 500 Joule unit to camera left at about 45° to the line of sight and about 2m (6ft) from the model, and another 500 Joule unit back lighting the model (and the water spray) some 4m (13ft) from the model. Both lights are set above the model's eye line, the key only slightly above and the back light well above. The key light has a standard head with a honeycomb and a frost, whereas the back light has barn doors and a frost.

The set is built of galvanized corrugated iron sheeting and black fabric. Clearly, when mixing water and electronic flash, considerable care must be taken to avoid the risk of potentially fatal shock.

► *Modern studio flash units typically have a flash duration of 1/300 to 1/800sec, which will not fully "freeze" spraying water*

► *The tonality of Polaroid Polapan has a Hollywood quality to it*

Photographer's comment:

Most of the time I use direct lighting with standard reflectors, honeycombs and frost filters.

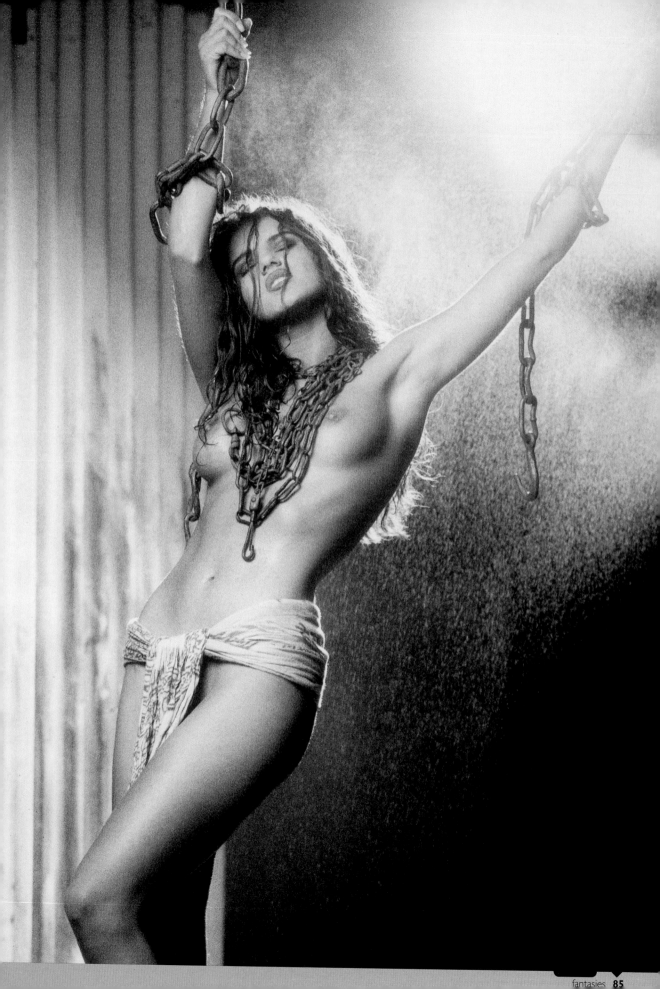

Photographer: **Stu Williamson**

Client: **Vicky**

Use: **Model portfolio**

Camera: **6x7cm**

Lens: **105mm**

Film: **Ilford Pan F**

Exposure: **f/11**

Lighting: **Electronic flash: 2 heads**

Props and set: **Rope;·Lastolite hand-painted background**

Plan View

V I C K Y

▼

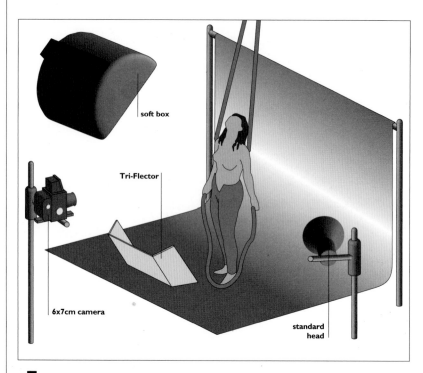

soft box

Tri-Flector

6x7cm camera

standard head

THIS PICTURE IS ALMOST ICONIC, PORTRAYING THE EMERGENCE OF THE ETERNAL FEMININE FROM A WELTER OF SYMBOLS SUCH AS ROPES, JEANS, CHAINS (AROUND HER NECK), THE CROSS AND THE FINGERLESS GLOVES.

► *Lighting creates chiaroscuro and modelling, while photographic technique (and the use of the 6x7 format) captures texture and detail*

► *By all but concealing the model's face, the photographer has portrayed Woman instead of a woman*

► *The sky-gazing pose is open to many interpretations by the viewer*

There are only two lights, and one of those is no more than a background light; but the key, a soft box almost directly over the camera, is supplemented by a "Tri-Flector".

Invented by the photographer, the Tri-Flector (see page 24) is made in a number of different reflectivities to allow a range of lighting effects from hard to soft. The enterprising photographer may be able to improvise an imitation for himself, from cardboard and gaffer tape, but the purpose-made item is more durable and much easier to use. Because it is (or can be) so directional and so controllable, it functions almost as another light.

Photographer's comment:

I suppose one background is much the same as another, but I prefer Lastolite. They are hand-painted in India and they have a certain vibrancy which I find lacking in some others.

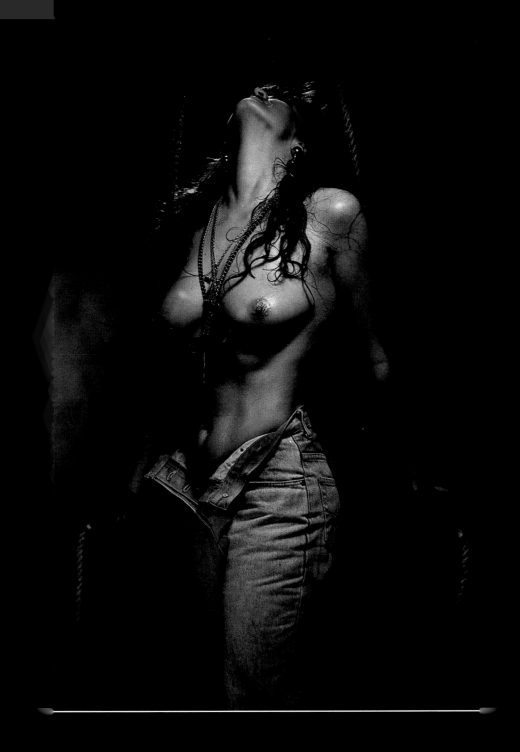

Photographer: **Peter Barry**

Use: **Model test**

Assistant: **Jon Sturdy**

Camera: **6x6cm**

Lens: **110mm with soft screen**

Film: **Kodak Ektachrome EPR**

Exposure: **f/8**

Lighting: **Electronic flash: one very large soft box**

Props and set: **White background; white fabric as "dress"**

Plan View

JUMPING NUDE

▼

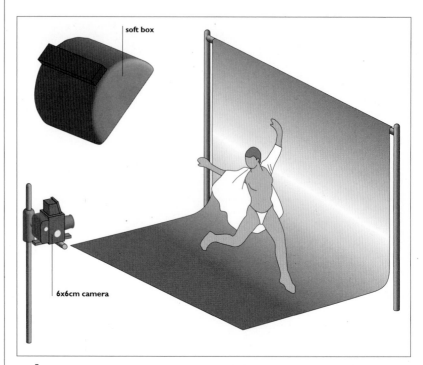

soft box

6x6cm camera

J UMPING MODELS CAN BE VERY ATTRACTIVE IF THEY ARE WELL DONE – AS, OF COURSE, PETER BARRY'S SHOT IS. YOU NEED PLENTY OF ROOM, THOUGH: A WIDE BACKGROUND, AND A LONG LENS, SO YOU NEED A FAIR-SIZED STUDIO.

The light is a very large "Wafer" soft box directly above the camera and very slightly to the left, so the shadows are very soft but the modelling is surprisingly good. Because the source is so big, it also lights the background with minimal shadowing.

Shooting this sort of motion – or any sort of action, for that matter – with a rollfilm SLR requires a certain amount of experience, as the delay between pressing the shutter release and taking the picture can be as much as 1/10sec. At least with flash lighting you can see whether the model was in more or less the right position as the flash goes off: with continuous light, early attempts at action can be very hit-or-miss.

► *Very large soft boxes create a different quality of light from smaller ones*

► *Anticipation and experience are important when shooting movement*

Photographer's comment:

The Quad unit I used has quite a long flash time – about 1/700sec – so there is a tiny bit of blur which I find to be very attractive.

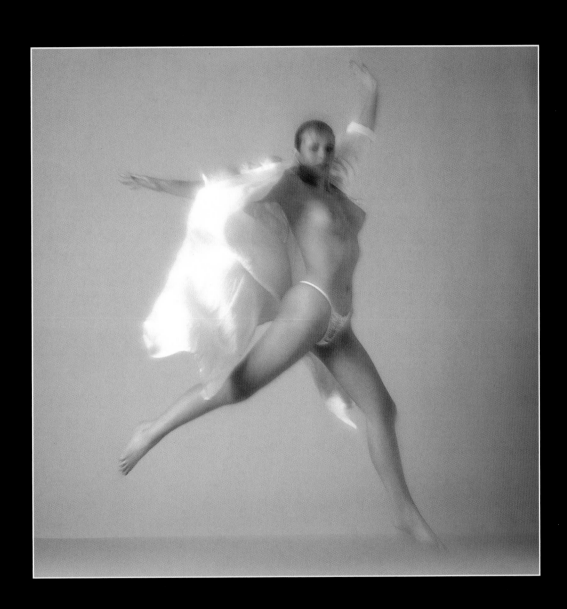

Photographer: **Struan**

Use: **Personal work**

Model: **Sylvia**

Camera: **35mm**

Lens: **105mm**

Film: **Kodak Ektachrome EPN ISO 100**

Exposure: **f/8**

Lighting: **Electronic flash: 2 heads**

Props and set: **Painted background;**
gloves; jewellery

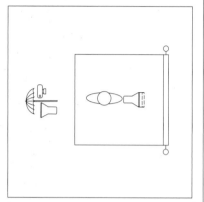

Plan View

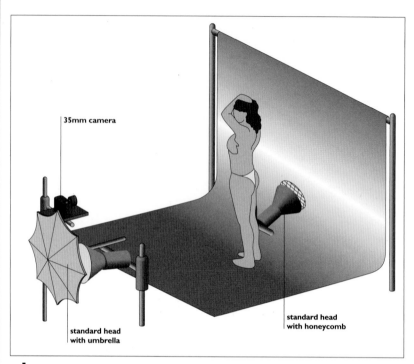

35mm camera

standard head
with honeycomb

standard head
with umbrella

SYLVIA

▼

Lighting from below is often known as "horror film" lighting, and beginners'
books on portraiture caution against it in the strongest terms;
but if it is a big, soft light, it can work.

In this case it is an umbrella just below the camera, and it works very well indeed: look at the contrast between the model's face and the upper part of her arm, or at the small of her back. The modelling is quite unlike what you would expect from fairly diffuse frontal lighting, but this is precisely because the light is below the camera. The lighting plot is completed by another light on the background, with a modest honeycomb (maybe 30°) to limit the spread and grade the light across the background from bottom to top. Note the contrast between the small of Sylvia's back and the background.

► *Point sources are often recommended to give jewels "fire", but large sources can sometimes work better*

► *Exoticism (the gloves and the jewels) can "punch up" even quite modest nudity*

► *Direct eye contact is literally eye-catching*

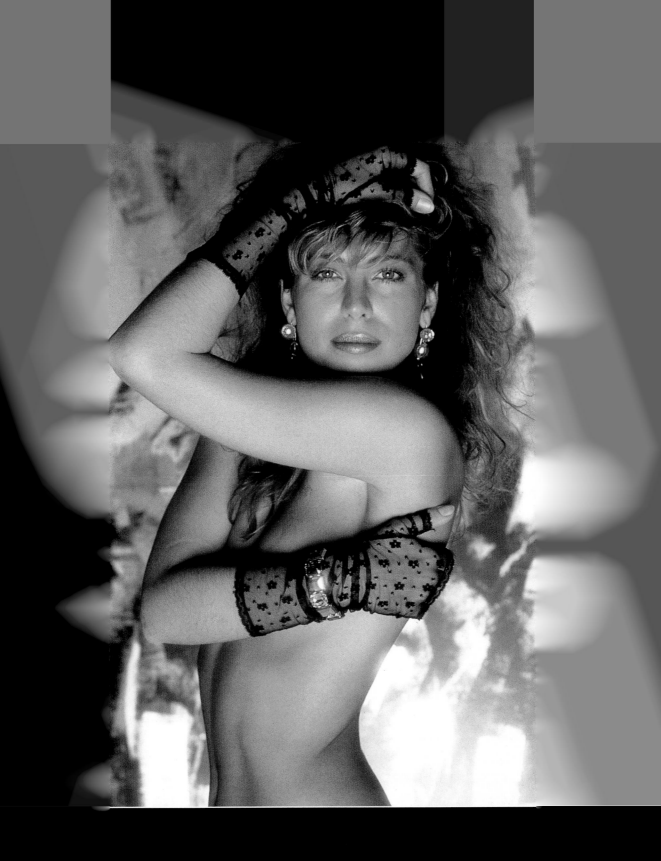

Photographer: **Struan**

Client: **Adagio**

Use: **Lingerie advertising**

Model: **Brenda**

Assistant: **James Fraser**

Camera: **35mm**

Lens: **50mm**

Film: **Kodak Tri-X Pan**

Exposure: **1/60sec at f/1.4**

Lighting: **Electronic flash: 2 heads (but see text)**

Props and set: **Black background**

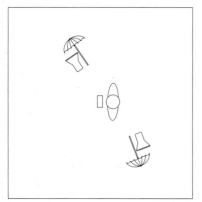

Plan View

► *Differential focus with standard and wide-angle lenses requires very wide apertures*

► *Blur, whether from focus or from movement, is more acceptable to some clients than to others*

► *Strong contrasts often work best on out-of-focus images*

ADAGIO

▼

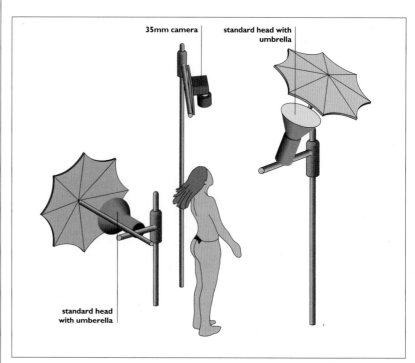

35mm camera

standard head with umbrella

standard head with umberella

Sᴛʀᴜᴀɴ ʜᴀs sʜᴏᴛ ᴀ ɢᴏᴏᴅ ᴅᴇᴀʟ ᴏꜰ ᴀᴅᴠᴇʀᴛɪsɪɴɢ ᴍᴀᴛᴇʀɪᴀʟ ꜰᴏʀ Aᴅᴀɢɪᴏ, ᴀɴᴅ ᴛʜɪs ɪs ꜰʀᴏᴍ ᴀ Eᴜʀᴏᴘᴇᴀɴ ᴄᴀᴍᴘᴀɪɢɴ. Exᴘᴇʀɪᴍᴇɴᴛᴀʟ ɪɴᴛᴇʀᴘʀᴇᴛᴀᴛɪᴏɴs, ʟᴇss ʟɪᴛᴇʀᴀʟ ᴛʜᴀɴ sᴛʀᴀɪɢʜᴛ sʜᴏᴛs, ᴀʀᴇ ᴏꜰᴛᴇɴ ᴍᴏʀᴇ ʀᴇᴀᴅɪʟʏ ᴀᴄᴄᴇᴘᴛᴇᴅ ɪɴ Eᴜʀᴏᴘᴇ ᴛʜᴀɴ ɪɴ Nᴏʀᴛʜ Aᴍᴇʀɪᴄᴀ.

The lighting here was intended to be by flash, using two umbrellas: one directly above the model (look at the shadows) and one to illuminate the rose on the lingerie. But (in Struan's words) "I just kept turning the lights down and down, to allow shooting Tri-X at f/1.4, and suddenly I realized that the modelling lights were all I needed."

The model was asked to keep tossing her head to make her hair fly out – in such circumstances, one has to "shoot for the percentages", selecting the best from a large number of shots – and the image was printed conventionally. The bow was then hand-coloured to match its actual colour as closely as possible.

Photographer's comment:

Adagio are among my favourite clients. They just send me the lingerie and trust me to shoot it, which is always a great way to work.

Photographer: **Struan**

Use: **Personal**

Camera: **35mm**

Lens: **28mm with lens shade for 35mm lens**

Film: **Kodachrome 64**

Exposure: **f/16**

Lighting: **Electronic flash: 2 heads**

Props and set: **Built set**

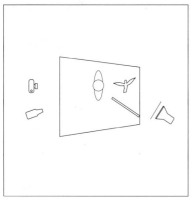

Plan View

▼

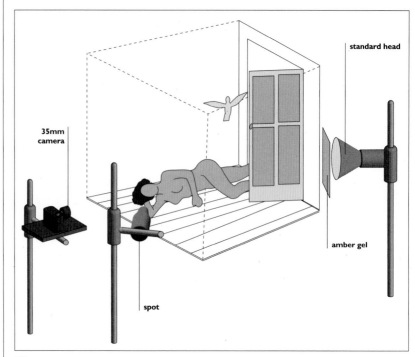

standard head

35mm camera

amber gel

spot

THIS IS ONE OF A NUMBER OF IDEAS WHICH STRUAN TRIED OUT WHEN HE WAS WORKING ON SURREAL AND DREAMLIKE IMAGES. THE SET IS BUILT OUT OF FOAMCORE; THE LINES ARE RIBBONS PINNED TO THE FLOOR; AND THE DARK AREAS ARE GREY BACKGROUND PAPER.

The set is, of course, built in exaggerated perspective, including the cut-out "door". Using ribbons for the lines between the "floorboards" allowed them to be moved so that they could be set to camera for the most convincing effect.

As for the lights, there is a tight (20°) grid spot on the model's face and an open-head flash outside the "door".

A 28mm lens provided the necessary exaggerated perspective. The shading in the corners comes from using the lens shade from a 35mm lens: Struan originally shaded the lens with his hand; he liked the cut-off effect, and used a shade from a lens of longer focal length to create it.

► *Building sets in exaggerated perspective is often a question of building "to camera"*

► *Birds' wings move very fast – too fast to freeze with most flash units*

► *An amber gel on the flash outside the door creates "sunlight"*

Photographer's comment:

We once had a shoot where we needed birds. We couldn't hire them – they were ring-necked turtle doves – so we bought them. We then spent $200 on an aviary and kept them for 15 years, until the last one died. This is one of those birds.

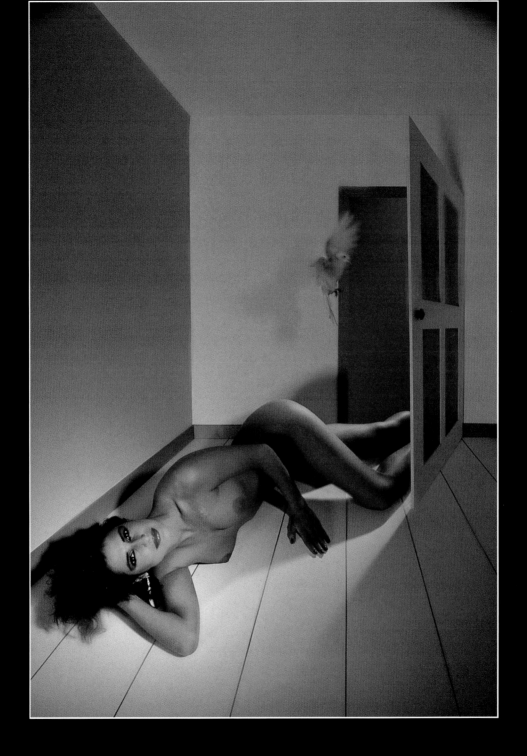

5

male nudes
and couples

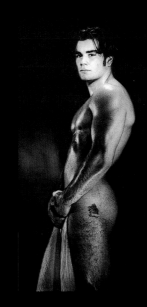

The male nude is a much less common subject than the female nude, and when we were putting the book together we were concerned that there might be a dearth of photographers who chose to submit male nudes; but we need not have worried.

An intriguing point is that all eight of the nudes and couples in this chapter were shot in monochrome, though subsequent toning was the exception rather than the rule. We did receive some male nudes in colour, and they were every bit as good as the black and whites, but they were considerably outnumbered by monochrome.

There is one calendar shot, and one advertising shot, while the others are either personal work or portfolio shots for male models. This indicates that there is still a smaller commercial demand for male nudes than for female; even so, it shows that photography of the male nude is not as rare as it might seem.

Full male nudity is however considerably rarer than full female nudity, and frontal male nudity without benefit of a strategically placed towel or something similar is very rare indeed – an interesting comment on what is "acceptable", and to whom. For all that it is a sexist cliché, it seems true that there are more men who are willing to go out of their way to look at a nude woman than there are women who can be bothered to go out of their way to look at nude men, though this is not the same as saying that women are averse to pictures of nude men.

Photographer: **Mike Dmochowski**

Use: **Self-promotion (poster)**

Models: **Dawn & Del**

Camera: **35mm**

Lens: **150mm**

Film: **Kodak T-Max 100**

Exposure: **1/125sec at f/11**

Lighting: **Electronic flash: Fresnel head**

Props and set: **Black seamless paper background (Colorama)**

Plan View

► *Fresnel flash heads provide about the most directional lighting that is available from general-application flash equipment*

► *The danger with highly directional light sources and black backgrounds is that the dark side of the subject can merge into the background — an effect which may or may not be desired*

BLUE TONE OF WOMAN AND MAN

▼

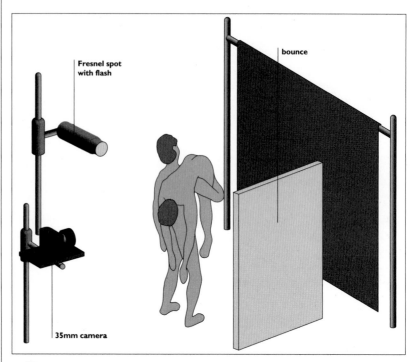

Fresnel spot with flash

bounce

35mm camera

THIS POWERFUL IMAGE IS RATHER LIKE A RORSCHACH DIAGRAM: YOU CAN READ INTO IT WHATEVER YOU LIKE. LOVE … SUPPORT … WAR … LOSS — IT IS BOTH HEAVEN AND HELL. TECHNICALLY, THE ORIGINAL MONO IMAGE WAS PRINTED WITH A BLUE CAST ONTO COLOUR PAPER AND THEN COPIED ONTO TRANSPARENCY.

Going via the Kodak C-type introduced the original colour while the duplication onto 4x5in Kodak Ektachrome EPP further "popped" both contrast and colour. A Fresnel head flash some 8 feet (2.4 metres) to camera left created the highly directional lighting: a Fresnel flash is harder than even the tightest honeycomb or snoot. A 240x120cm (8x4ft) bounce to camera right, about 1m (3ft) from the models, provided a degree of fill and stopped them from merging with the black background, which was of black paper and well behind the models — 240cm (8ft) again — so that it would not be lit by spill.

The tall, thin crop further emphasizes the originality of the image: everything is taken to extremes to create a very eye-catching photograph.

Photographer's comment:

The objective was to create a sensual, sculptural image.

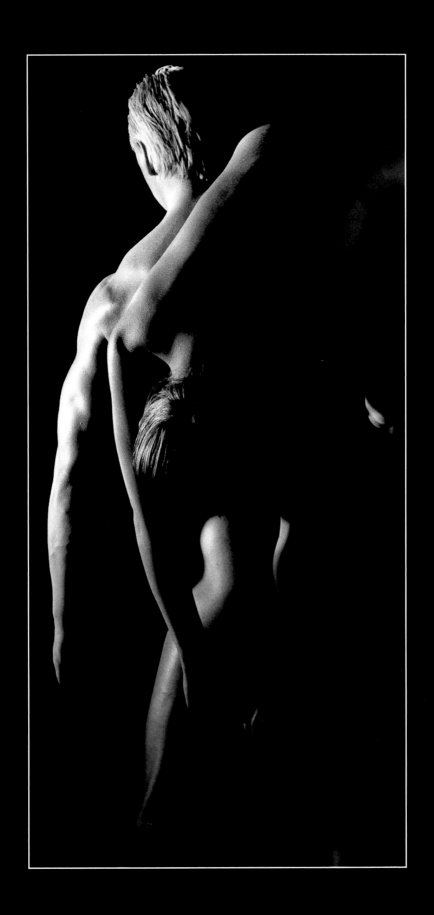

Photographer: **Nick Wright**

Client: **Directors' Cut '95**

Use: **Calendar**

Model: **Kenny**

Assistant: **Al Deane**

Art director: **Wayne Campbell**

Camera: **6x7cm**

Lens: **90mm**

Film: **Kodak T-Max 100**

Exposure: **f/16**

Lighting: **Electronic flash: single head**

Props and set: **White seamless paper**

Plan View

K E N N Y

▼

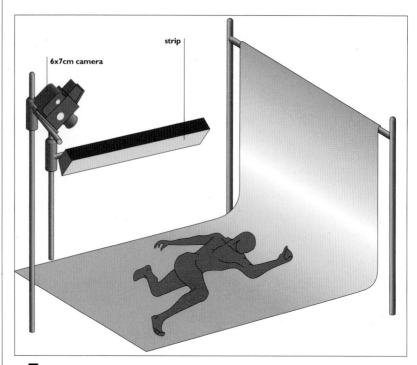

THIS TIMELESS NUDE IS LIT SURPRISINGLY SIMPLY, BUT GETTING A TOTALLY CLEAN, WHITE GROUND WAS A PROBLEM: IN THE EVENT, THE PRINT HAD TO BE MADE VERY CAREFULLY IN ORDER TO LOSE A COUPLE OF MARKS ON THE PAPER.

There is a single light, but it is a 120cm (4ft) long strip light, only about 20cm (8in) wide. Once you know this, you can work out exactly where the light is: in essence, parallel with Kenny's right arm and set at the right height to give the most dramatic shadow; note also how

neatly it delineates the face. A linear light source like this gives much sharper shadows than a soft box, but without the splaying of shadows that you would get with a standard reflector. It also gives beautifully controllable highlights.

► *Strips are normally associated with large studio lights such as Strobex, but they can be approximated with appropriately-shaped soft boxes on standard heads*

► *Careful control of exposure and development is needed to control gradation in a shot like this*

Photographer's comment:

I was standing on a ladder with a high tripod, but Kenny is a very big man and I needed the 90mm to get him in.

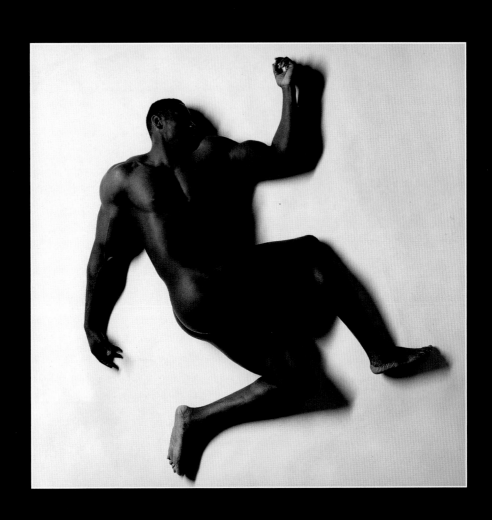

Photographer: **Stu Williamson**

Client: **Brendon**

Use: **Modelling portfolio**

Camera: **35mm**

Lens: **85mm**

Film: **Ilford HP5 Plus**

Exposure: **f/8**

Lighting: **Electronic flash: 4 heads**

Props and set: **Lastolite black background**

Plan View

▼

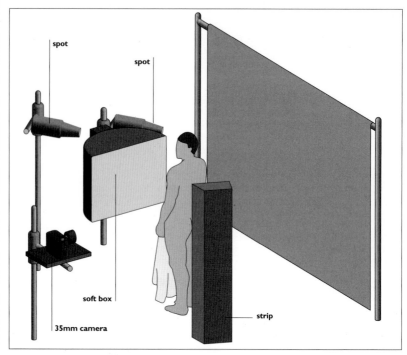

spot

spot

soft box

35mm camera

strip

A MODERN MALE MODEL MAY BE CALLED UPON TO PORTRAY ALL KINDS OF ROLES, FROM VULNERABLE TO TOUGH, FROM FASHION ICON TO FASHION VICTIM. THIS IS A REMARKABLY VERSATILE PICTURE WHICH SUGGESTS SEVERAL ASPECTS OF THE MODEL'S CHARACTER AT ONCE.

The lighting is surprisingly complex. A strip light to camera right delineates the model's back and buttocks, while a soft box to camera left provides the modelling on his front; notice the change of emphasis in the shadows between the upper part of his body, so that both the strength of his legs and the breadth of his shoulders are emphasized. Then, a spot lights his face only, for personality and eye contact. Finally, a small snooted spot on the background creates the highlight to camera left, in front of the model. Cover that up, and suddenly the picture is clinical, or perhaps voyeuristic, instead of a nude portrait.

► *Body shape and facial expression often require very different types of lighting*

► *Mimicking naturalness with complex lighting is often more effective than genuinely natural lighting, which can be unidirectional*

Photographer's comment:

I normally use 6x7cm but in 35mm I love my Contax, especially with the 85mm f/1.4 lens.

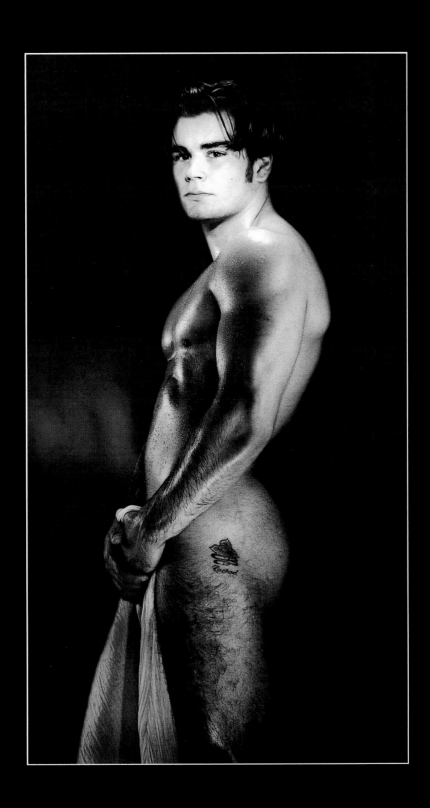

Photographer: **Stu Williamson**

Client: **Simon**

Use: **Model portfolio**

Camera: **6x7cm**

Lens: **140mm**

Film: **Ilford HP5 Plus**

Exposure: **f/11**

Lighting: **Electronic flash: 3 heads**

Props and set: **Lastolite black background, pickaxe handle**

Plan View

► *Direct overhead lighting is not normally recommended for photographing people but it can be made to work*

► *Strip lights can be useful for delineation*

► *Not everyone can look convincing in ripped jeans, partially undone; Simon can*

B O D Y W O R K

▼

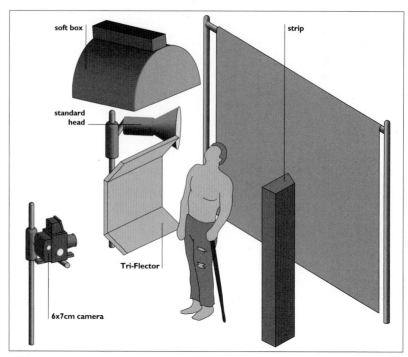

THERE ARE ECHOES HERE OF SOCIALIST REALISM — THE OLD STALINIST PICTURES OF HEROIC STAKHANOVITES TOILING FOR THE MOTHERLAND. THE POSE, THE PROPS AND THE LIGHTING ALL CONTRIBUTE TO THIS.

The jutting jaw is emphasized by the key light, which is a soft box almost directly over the model's head. The brightly lit face has quasi-religious overtones: seeing the light, a brighter tomorrow. The glancing light also emphasizes the texture of the torn jeans and the contours of the muscles and the veins. A strip light to camera right delineates Simon's left arm and provides a (very) modest amount of fill, while a "Tri-Flector" (see page 24) to camera left evens out the lighting somewhat on the model's right side. The background is separately lit with a standard head. Using HP5 Plus, a fast "old-technology" film (as distinct from the "new-technology" Delta series), gives a surprisingly long tonal range.

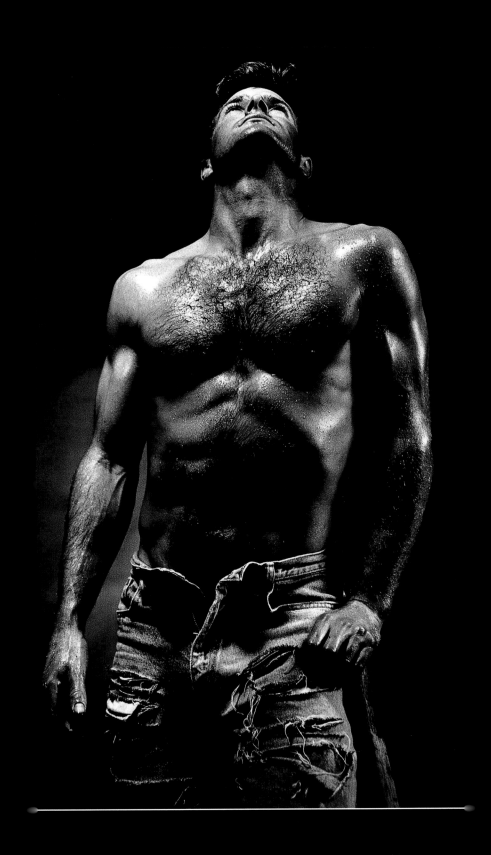

Photographer: **Stu Williamson**

Clients: **Simon & Correna**

Use: **Modelling portfolio**

Camera: **6x7cm**

Lens: **105mm**

Film: **Kodak Plus-X Pan**

Exposure: **f/11**

Lighting: **Electronic flash: 2 heads**

Props and set: **Rope; muslin; Lastolite hand-painted background**

Plan View

▶ *With a transparency the image is effectively finished when it is printed; with a print, as Ansel Adams said, "the negative is the score and the print is the performance"*

▶ *Exercises with two lights — one on the subject, one on the background — should be an essential part of every photographer's education*

S I M O N A N D C O R R E N A

▼

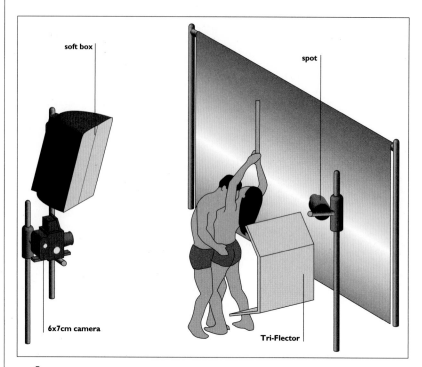

soft box

spot

6x7cm camera

Tri-Flector

AS WITH MANY OF STU WILLIAMSON'S PICTURES, THE RESONANCES HERE ARE OUTSIDE PHOTOGRAPHY: THE SHAPE OF SIMON'S BACK IS REMINISCENT OF NIJINSKY IN *L'APRÈS-MIDI D'UNE FAUNE*, WHILE THE OVERALL POSE BRINGS TO MIND CALIBAN AND *THE TEMPEST*.

The lighting is remarkably simple. A large soft box to camera left is the key, and indeed the only light on the subject. It is however supplemented by a "Tri-Flector" (see page 24) to camera right, low behind Correna; look at the light on the cloth around her hips. A second light, a standard head, illuminates the Lastolite painted background. The film – Kodak Plus-X Pan – was carefully chosen and developed to give the appropriate tonality. After that a good deal of the impact depended on the printing: Stu prints all his own pictures, as this is an integral part of his vision.

Photographer's comment:

The loin-cloths are just muslin; I have various ways of dyeing and ageing cloth – in effect, of getting it "dirty" under controlled conditions.

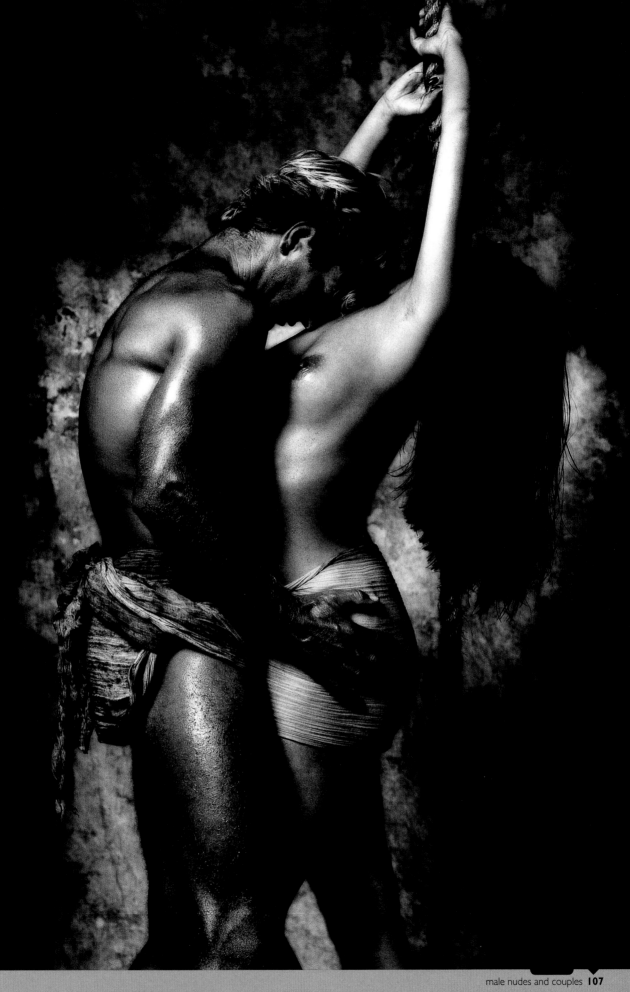

Photographer: **Julia Martinez**

Client: **Christiaan**

Use: **Model portfolio**

Camera: **35mm**

Lens: **50mm**

Film: **Kodak T-Max ISO 100**

Exposure: **f/11**

Lighting: **Available light plus on-camera flash**

Props and set: **Location: very small shower**

Plan View

CHRISTIAAN IN THE SHOWER

▼

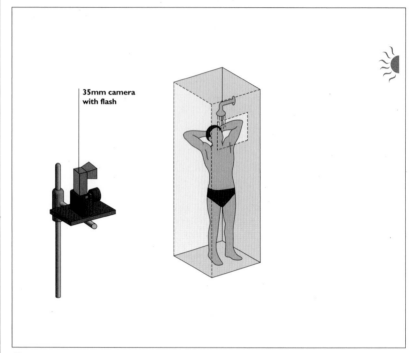

35mm camera
with flash

IT IS A COMMON JOKE AMONG PHOTOGRAPHERS THAT THE ONLY TIME THAT AN ON-CAMERA FLASH DELIVERS ITS FULL RATED GUIDE NUMBER IS IN A VERY SMALL WHITE-PAINTED BATHROOM — WHICH IS WHERE JULIA SHOT THIS PICTURE. IN HER WORDS:

"I say it's an available light shot, but really the flash is doing all the work. It's one of those tiny Spanish showers, with white-painted concrete walls. It was difficult to keep the camera dry, because I was getting splashed, but it was good to work with the bare minimum of equipment." You can see the highlights on Christiaan's chest, and the shadows on the wall behind him. There was a small window, rather above the model to camera right, which explains why the shadow above his head is paler than the shadow beside him. The white walls of the shower evened out the light considerably. The print was made on Kentmere Art Classic and selenium-toned.

► *On-camera flash can be a medium worth experimenting with*

► *Plenty of reflectors can even out the hardest light*

► *Electronic flash and water can be a dangerous combination*

Photographer's comment:

Christiaan is my best friend and wanted some pictures for his modelling portfolio.

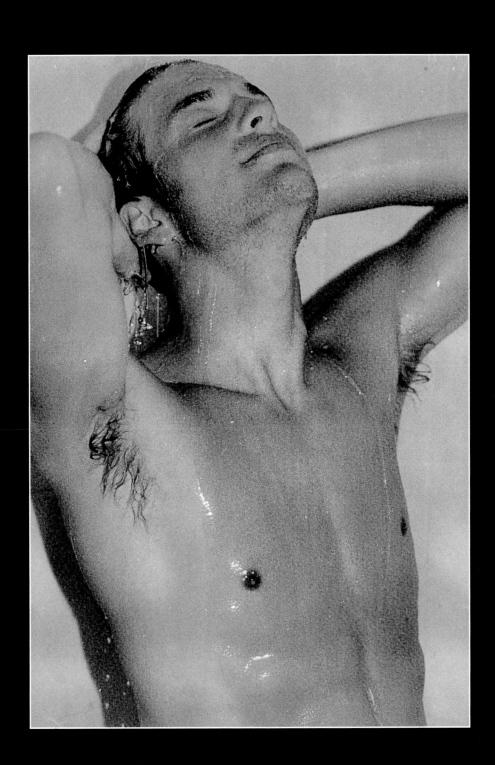

Photographer: **Julia Martinez**

Client: **Christiaan**

Use: **Model portfolio**

Camera: **35mm**

Lens: **50mm**

Film: **Kodak T-Max ISO 100**

Exposure: **f/11**

Lighting: **Available light plus on-camera flash**

Props and set: **Location: white-painted concrete shower**

Plan View

▼

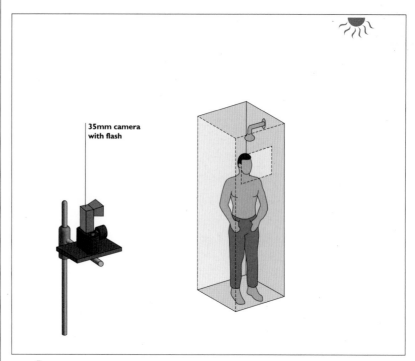

35mm camera
with flash

As soon as you compare this with the picture "Christiaan in the shower" (page 113) you can see that while the lighting is all but identical, the effect is very different.

The key light is an on-camera flash, as evidenced by the hard shadow on the model's right side (camera left) but the streak of sunlight on the background makes a considerable difference: the picture was shot around noon, when the sun was very high in the sky. As with the other picture, the small size of the shower cubicle and the highly reflective walls have made for a very different effect from what you would expect with on-camera flash, much more even but still with superb delineation of texture. Moreover, the water-slicked skin in the other picture is considerably more reflective than the dry skin in this shot.

► *Baby oil is the classic medium for making skin glisten, but water will do the same*

► *Separating the photographic potential of a shower cubicle from its everyday use is a step many might fail to take*

Photographer's comment:

We tried a number of shots in the shower.

Photographer: **Struan**

Client: **Karl Lagerfeld**

Use: **Advertising ("Photo" cologne for men)**

Model: **Rob Simpson**

Camera: **35mm**

Lens: **105mm**

Film: **Kodak Tri-X Pan**

Exposure: **f/11**

Lighting: **Electronic flash: 1 head**

Props and set: **Black wall sprayed with moisture**

Plan View

P H O T O

▼

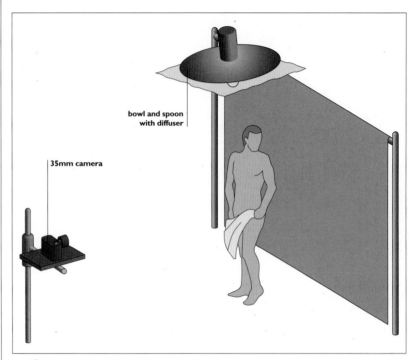

bowl and spoon
with diffuser

35mm camera

A NEW MEN'S COLOGNE CALLED "PHOTO" ... BLACK AND WHITE PHOTOGRAPHY ...
A DYNAMIC ACTOR/MALE MODEL LOOK — THE LOGIC IS CLEAR ENOUGH. BUT IT
TAKES A GOOD PHOTOGRAPHER TO CONVERT THE LOGIC INTO A PICTURE.

The lighting is surprisingly simple: a 500mm (20in) reflector on a standard head, mounted on a boom arm directly above the model and diffused with a sheet of tracing paper.

Overhead lighting may be of limited use out of doors, but it can be very effective in the studio. It can be particularly useful when the background is an integral part of the picture, as it is here: without the moisture on the wall (which was painted with black latex paint), the background is too bleak. The white towel completes the slightly diagonal composition of the picture; without it, the tones would simply peter out towards the bottom.

► *Use things like towels, books, flowers and so forth as areas of tone to complete a composition*

► *Light items like the towel must not be too near the light source or they may burn out*

► *White fabric is between five and ten times as reflective as skin*

Photographer's comment:

For the launch of Lagerfeld's new cologne/after-shave I arranged for six female photographers and two male (including myself) to provide our own interpretations of the product.

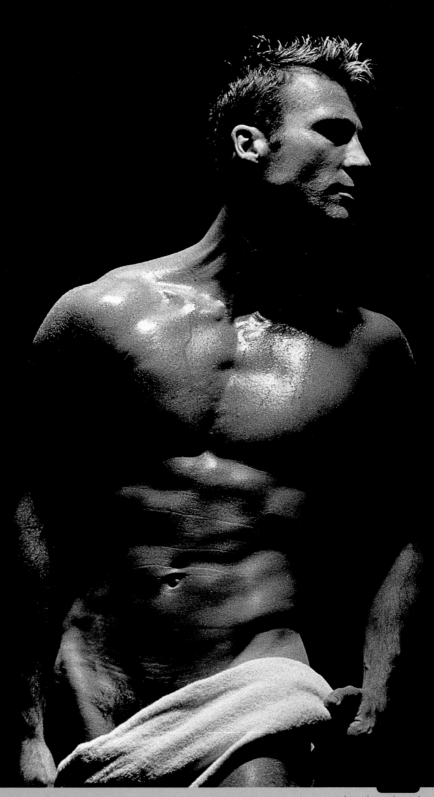

6

the
outdoor
nude

When you think about it, the rigid prohibitions on public nudity which exist in so many societies are pretty illogical. Those who go beyond an automatic prohibition will often advance the aesthetic argument, "Most people do not look very attractive without any clothes on", which completely ignores the fact that an awful lot of people do not look very good with clothes on, either.

There are two strands to the aesthetic of the outdoor nude, one of which owes more to natural nudity, and the other of which owes more to fantasy. Natural nudity reflects something that most people must feel like doing sometimes: feeling the wind and the sun on their skin, untrammelled by local conventions of what may be revealed and what may not. Inevitably, there are degrees of naturalness, with something like Struan's Blue Pool or Frank Wartenberg's Nude with Car looking as if the photographer just happened to take a picture of a girl who just happened to have taken her clothes off, while Harry Lomax's Outdoor Nude or Bob Shell's Heidi in the Palmetto are more self-consciously posed.

The fantasy nude is perhaps typified by Mike Dmochowski's Nude on Chair with Table, where a beautiful girl waits at a café table. Many men might wish that they were away from their desks on a rainy day, and sipping a cappuccino or a kir on a shady sidewalk by a sunny street. The girl simply expands the fantasy. Struan's Window and Shutters is another enduring fantasy: the beautiful nude glimpsed at a window.

Photographer: **Mike Dmochowski**

Use: **Glamour video**

Model: **Nella**

Camera: **6x6cm**

Lens: **150mm + warming filter**

Film: **Kodak Ektachrome EPP 120**

Exposure: **1/125sec at f/11**

Lighting: **Electronic flash: 3 heads**

Props and set: **Built set**

Plan View

MODEL ON CHAIR WITH TABLE

▼

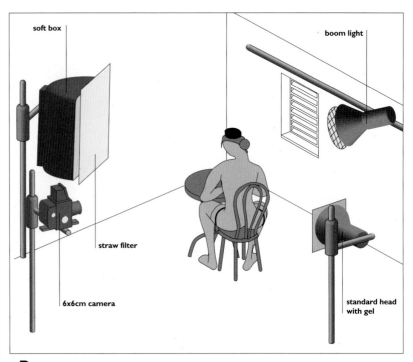

soft box

boom light

straw filter

6x6cm camera

standard head with gel

BUILT SETS ARE ONE OF THE SECRETS OF MANY SUCCESSFUL GLAMOUR PHOTOGRAPHERS — THEY ALLOW FULL CONTROL OF THE AMBIENCE AND LIGHTING, WITHOUT FEAR OF ONLOOKERS — BUT LIGHTING IS ANOTHER. THIS FORMS PART OF A LARGE NUMBER OF PICTURES SHOT FOR A VIDEO *CAPTURED SECRETS*, WHICH MIKE PRODUCED.

► *The illusion of sunlight is often harder to create than might be expected. Plenty of power will make it easier*

► *A good set will create its own expectations as far as lighting goes, and the eye will "read" whatever seems most appropriate*

► *Incident-light metering with a flat receptor (not a dome) makes it easier to determine lighting ratios*

A direct side light with a wide honeycomb, set to camera right and slightly back lighting the model, creates the impression of sunlight coming in under an awning or onto a balcony. This light is some 120cm (4ft) from the model and 150cm (5ft) above the floor. The exposure reading from this alone, pointing the meter at the light from the subject position, was f/11.

A small, square soft light with a straw filter provides the highlights on the left: this creates the impression of sunlight bouncing off ancient stucco. Again this is about 120cm (4ft) from the model, and about 150cm (5ft) from the floor.

Finally, a boom light some 240cm (8ft) above the ground provides a back light. Like the fill, the reading from this alone was f/8.

Photographer's comment:

This video is still available; my address is at the back of the book, in the Directory section.

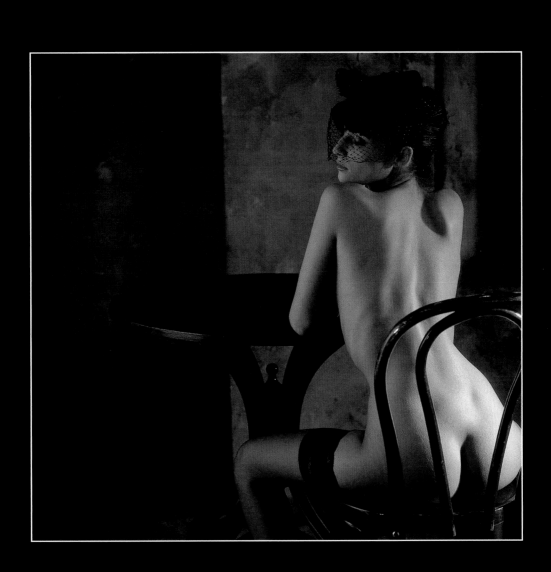

HEIDI IN THE PALMETTO

▼

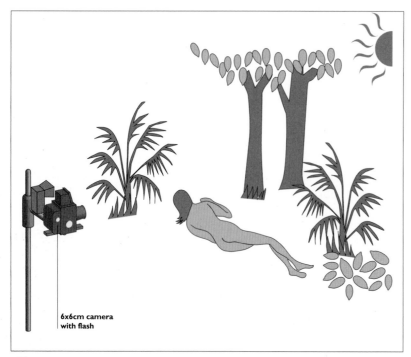

**6x6cm camera
with flash**

Photographer: **Bob Shell**

Client: **Hove Books**

Use: **Editorial (Mamiya Guide)**

Model: **Heidi Guenther (acted as own stylist)**

Assistant: **Roger Bansemer**

Camera: **6x6cm**

Lens: **75mm**

Film: **Kodak T-Max 100**

Exposure: **1/30sec at f/11 ('I think!')**

Lighting: **Daylight + flash**

Props and set: **My friend Roger Bansemer's
back yard**

Dappled sunlight is less of a problem in monochrome than in colour because of the inherently greater tonal range which monochrome can record; but without some degree of fill the contrast can quickly degenerate into "soot and whitewash".

The direction of the sun – clearly the key light – can be seen here: it is effectively over the photographer's right shoulder. Fill for the dappled shadows came from an on-camera Vivitar 283 bounced into a Lumiquest, and from the white wall of the house immediately behind the photographer, reflecting indirect sky light. While painted walls can make excellent bounces, they can also introduce colour casts if they are any colour other than white – a point which is easy to forget, as the eye adapts easily to colour casts.

Rangefinder medium-format cameras can be remarkably effective for nude and glamour photography as they allow the photographer to establish an easier rapport with the subject, although long lenses (over about 180mm) are not very convenient.

► Lumiquests and similar small bounce diffusers can be extremely valuable for lowering contrast in this sort of situation as well as for adding catchlights in the eyes of portraits

► It does not matter in monochrome, but in colour, foliage can introduce an unattractive greenish cast

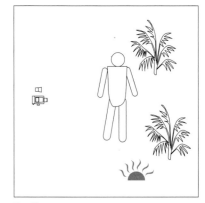

Plan View

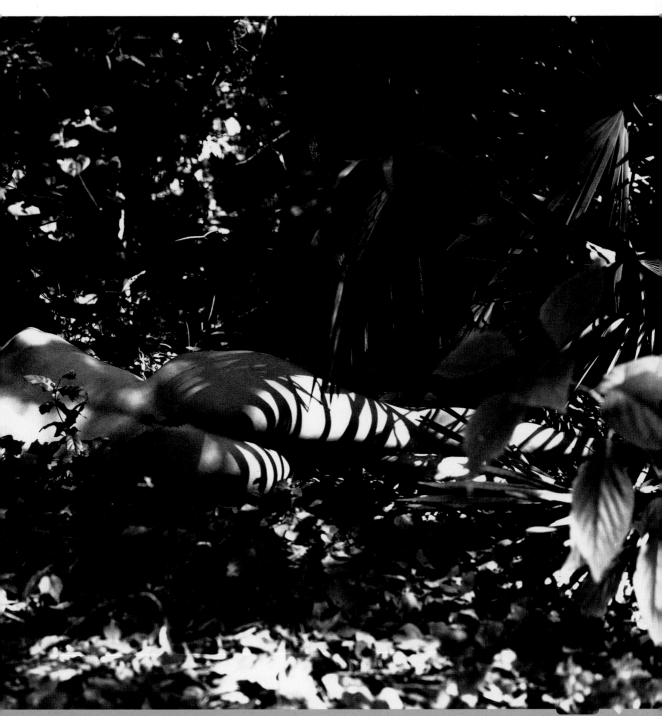

Photographer: **Harry Lomax**

Use: **Library**

Model: **Claire**

Camera: **6x6cm**

Lens: **150mm**

Film: **Fuji RDP ISO 100**

Exposure: **1/30sec at f/11**

Lighting: **Daylight plus flash**

Props and set: **Location**

Plan View

OUTDOOR NUDE

▼

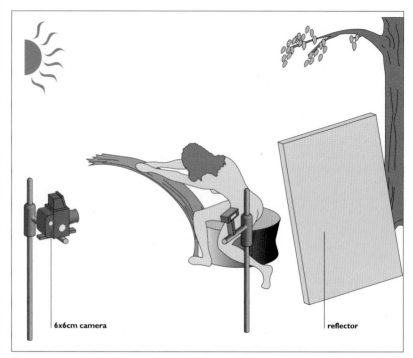

6x6cm camera reflector

THE SURPRISE IN THIS ATTRACTIVE AND NATURAL-LOOKING PICTURE IS HOW MUCH DIFFERENCE CAN BE MADE BY A RELATIVELY WEAK FLASH AND A REFLECTOR AT QUITE A CONSIDERABLE DISTANCE – 4.5M (15FT) – FROM THE SUBJECT.

The key light is arguably sunlight from camera left, but it is supplemented by a Metz 45 CT flash bounced off a reflector (size not recorded) mounted about 2m (6½ft) off the ground to camera right. The reason for the flash was almost the opposite of a fill: the aim was to throw the inner curves of the model's body more fully into the shadow. The two sources are almost exactly equal in value.

A great deal of control is however afforded by the way in which flash is affected only by aperture, but ambient light is affected by both aperture and exposure time. Thus, if this same picture had been shot at 1/60sec instead of 1/30, the flash would have been dominant, but if it had been shot at 1/15 the daylight would have been dominant.

► *Aperture alone controls flash exposure, but aperture and exposure duration control ambient-light exposure*

► *Using flash reduces the problem of dappled sunlight and also reduces the greenish cast which is sometimes introduced by foliage*

► *A very weak magenta filter (CC05M) can counter a greenish cast without looking too obvious*

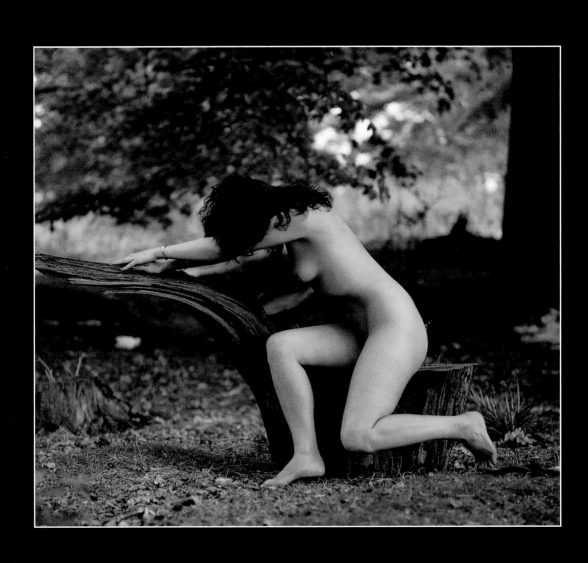

Photographer: **Frank P. Wartenberg**

Use: **Portfolio**

Camera: **35mm**

Lens: **105mm with orange filter**

Film: **Polaroid Polagraph**

Exposure: **Not recorded**

Lighting: **Early morning sunlight**

Props and set: **Car**

Plan View

NUDE WITH CAR

▼

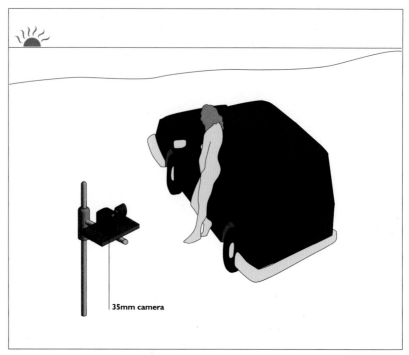

35mm camera

THE MODEL IS LEANING ON A CAR, WITH THE EARLY MORNING SUN BEHIND HER; SHE IS BACK LIT, WITH NO REFLECTOR TO ACT AS A BOUNCE. AS IS CLEAR FROM THE DIRECTION OF THE SHADOWS, THE SUN HAS JUST RISEN.

Very early morning sun has a wonderful quality, but the effect is short-lived – there are no more than a few minutes of that almost liquid red light – and the lighting changes very rapidly, doubling and doubling again as the sun rises; this makes metering difficult, and practically demands extensive bracketing. Also the initial light levels are surprisingly low, and long exposures may be called for. It is often as well to have several bodies loaded (or several backs, in the case of roll film) to obviate the need for reloading.

► *It may be as well to load several bodies with different films, to compare the different effects*

► *Alternatively, exhaustive exploration of a particular film stock may prove more rewarding*

► *You may need to use extensive bracketing, or have an assistant taking continuous readings, or (if you trust it) you can use automatic exposure*

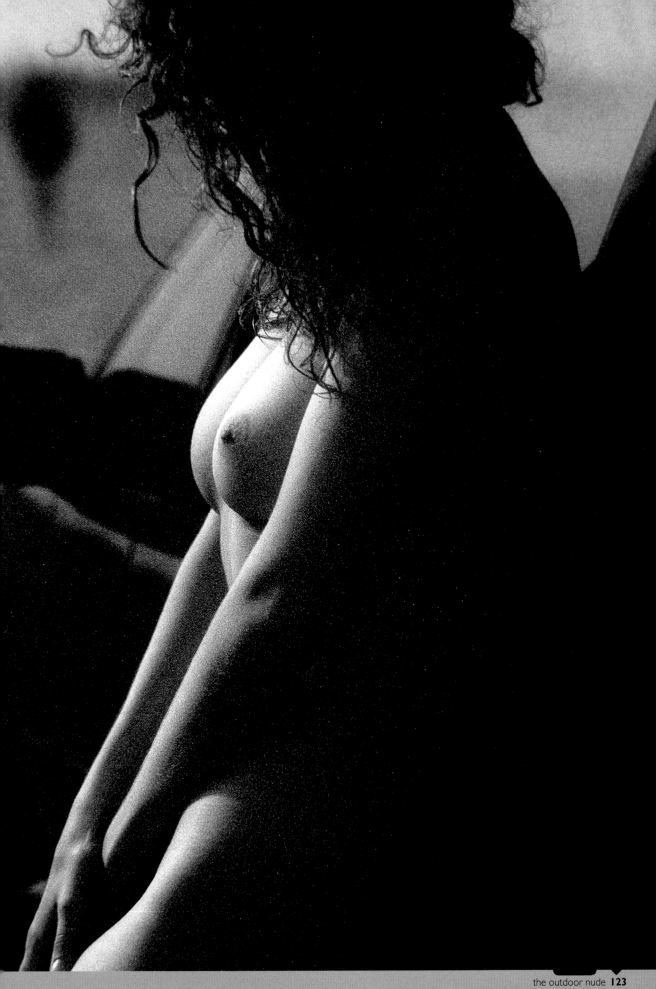

Photographer: **Struan**

Use: **Personal work**

Model: **Coralie**

Camera: **35mm**

Lens: **35mm**

Film: **Kodak Tri-X Pan rated at EI 200**

Exposure: **1/60sec at f/5.6**

Lighting: **Available light**

Props and set: **Salt, sheet**

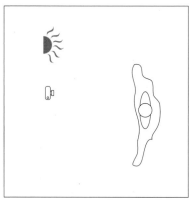

Plan View

SALT DUNES

▼

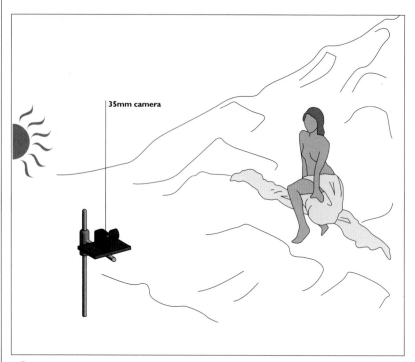

35mm camera

CONTRARY TO APPEARANCES THESE HUGE DUNES ARE NOT OF SAND BUT OF SALT. STRUAN
HAD BEEN SHOOTING A BLACK DRESS FOR A CLIENT EARLIER THAT DAY;
THIS WAS PERSONAL WORK, SHOT BY THE DYING LIGHT.

As he puts it, "When the paid shoot was finished, and everyone else was going home, I asked the model if she minded staying behind for some more portfolio shots. The sun was very low, and the evening was beginning to get hazy: a few minutes later, it was too dark to shoot. It was really nice light, though. Earlier, it had been rather harsh and contrasty, but this was really good".

The salt acts as a giant reflector, bouncing light everywhere and creating a very even light in these conditions, and one of Struan's trusty all-purpose sheets (see pages 69) was pressed into service as well.

► Late-afternoon light is often hazy

► In the last quarter hour or so before the sun sets, the light changes very rapidly indeed

► The very red quality of the setting sun often seems to create an unusual effect in monochrome

Photographer's comment:

If you just pack up and go home when the commercial shoot is finished, you can miss some really good personal shots.

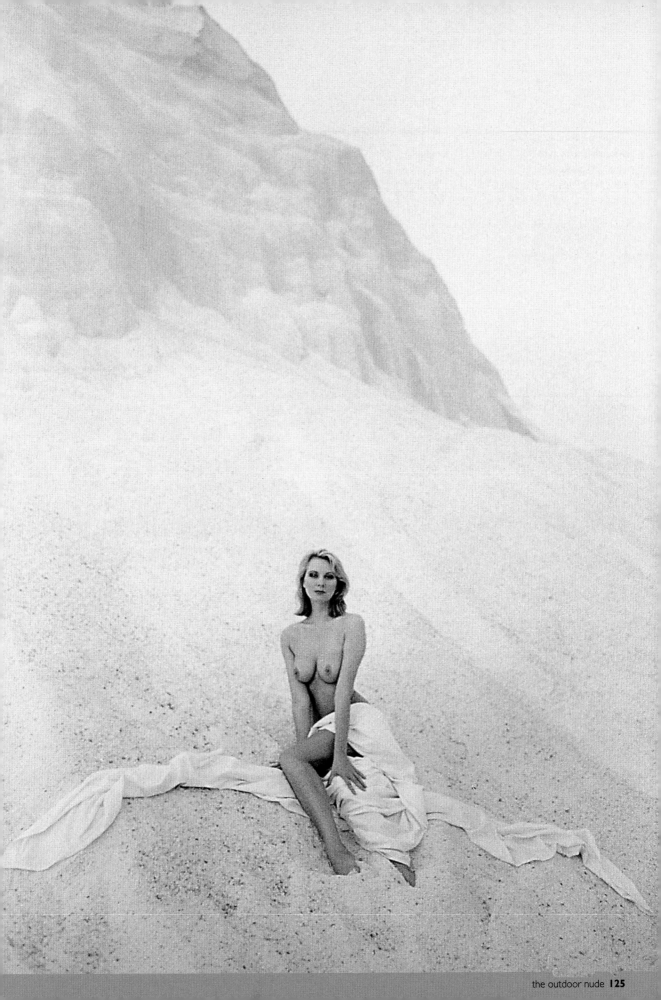

Photographer: **Struan**

Use: **Personal work**

Model: **Alex**

Camera: **35mm**

Lens: **35mm**

Film: **Kodak Ektachrome EPN ISO 100**

Exposure: **1/60sec at f/4**

Lighting: **Available light**

Props and set: **Li-Lo type bed; sheets**

Plan View

B L U E P O O L

▼

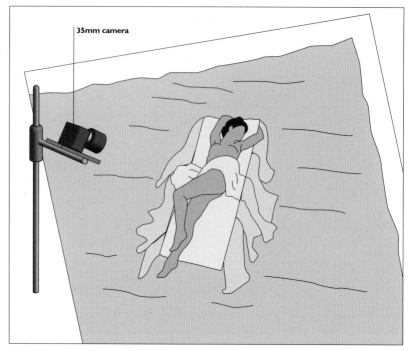

THE MODEL WAS AN ACTRESS VISITING FROM LOS ANGELES. STRUAN BORROWED A FRIEND'S POOL AS A GOOD SETTING. ONE SHEET WAS DRAPED OVER THE FLOATING BED, AND A SECOND SHEET WAS USED AS A PARTIAL DRAPE FOR THE MODEL.

The lighting was overcast daylight at about 3 to 4 pm. It was sufficiently diffuse that, in Struan's own words, "I had a reflector with me, but it wasn't doing anything".

It was therefore a matter principally of pose and of composition. This picture well illustrates that partial veiling is often more attractive than complete nudity, and the diagonal composition in a vertical frame has a very different mood from what could have been achieved with a horizontal composition. The generous amount of blue water above the model's head includes reflections as a part of the composition. The 35mm lens makes the subject's legs look even longer, but note how the toes are pointed to avoid making her feet seem too big.

► *Whether filtration is needed on an overcast day, and how much is needed, can depend very much on the film in use*

► *When the contrast of colours is strong, as here, there may be little need for filtration*

► *Sometimes a wide angle is necessary just to get enough in: it is not always used merely to make legs look longer*

Photographer's comment:

I find my sheets extremely useful for all kinds of things, though my laundry bills are sometimes pretty high.

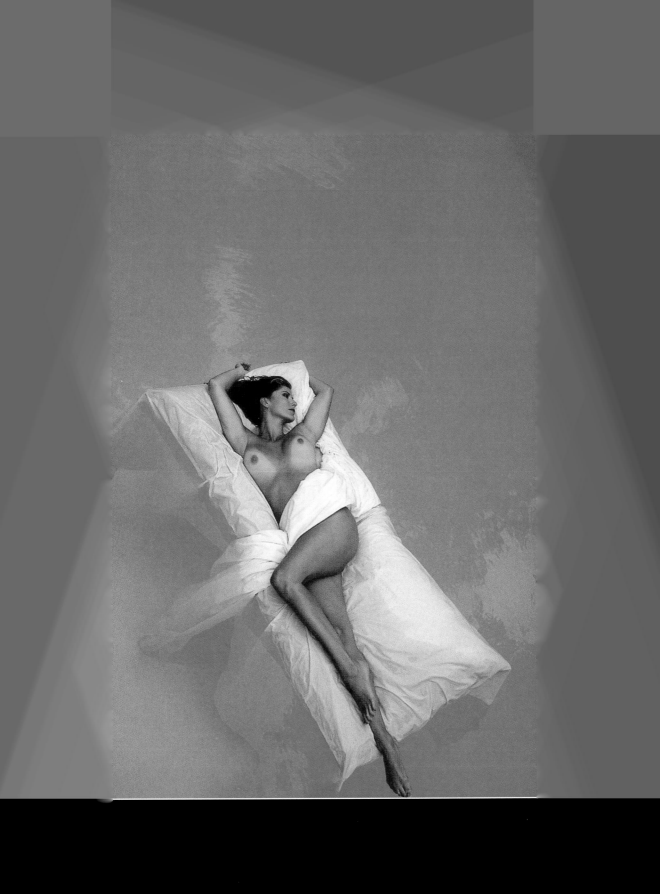

WINDOWS AND SHUTTERS

▼

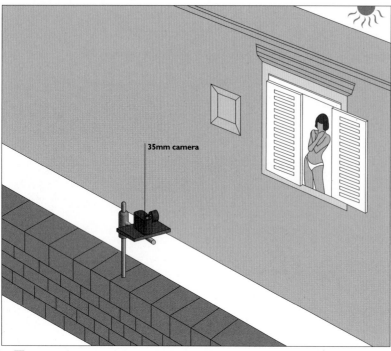

35mm camera

Photographer: **Struan**

Use: **Poster out-take from magazine editorial shoot**

Assistant: **Michael Lee**

Camera: **35mm**

Lens: **85mm plus warming filter**

Film: **Kodachrome 64**

Exposure: **1/60sec at f/5.6**

Lighting: **Daylight, about 3–4 pm**

Props and set: **Location (Dubrovnik)**

T HIS WAS SHOT AT THE END OF A 10-DAY SHOOT IN DUBROVNIK, IN WHAT WAS THEN YUGOSLAVIA. STRUAN WAS INTRIGUED BY THE OCHRE WALLS OF THE HOUSE, AND IN ORDER TO GET THE SHOT HE GOT UP ON THE CITY WALLS.

He had to walk several hundred yards to get to the nearest steps; then climb them; then walk back to be opposite the window. The model was the one who had been modelling clothes during the shoot. Behind her there is a curtain; behind that are the art director, etc., drinking wine and celebrating a successful end to the shoot. Above the girl, out of shot, there were three young men on a balcony. One of them was leaning out in an attempt to see her. He almost fell: his friends had to haul him in by his jacket.

Apart from the warming filter, there was little Struan could do to modify the light, though opening and closing the shutters made quite a difference to the shot

Photographer's comment:

The shoot was over and the temptation was to relax. But I wanted this shot: I knew that if I didn't take it, I'd regret it.

▶ If the light is "wrong", there are always warming filters

▶ One advantage of standardizing on a limited range of films is that you know how they will behave under different lights

Plan View

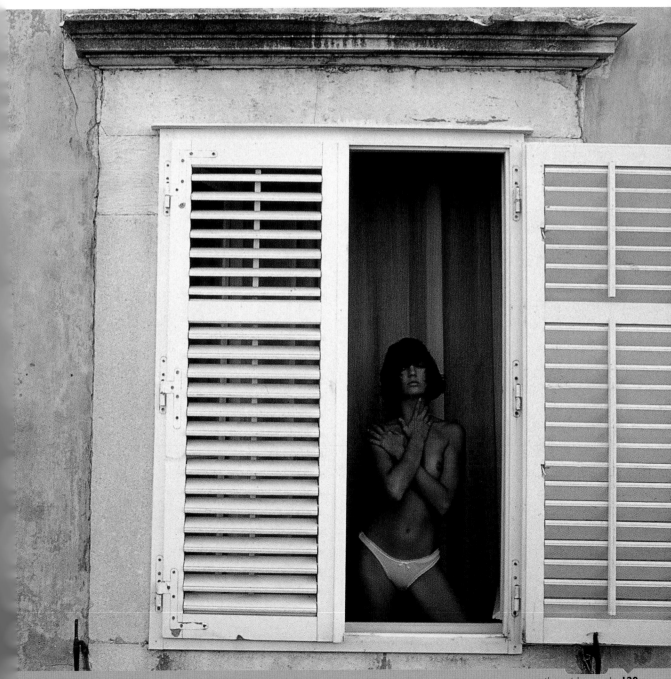

7

symbols
and
experiments

In most of the Pro-Lighting books to date, the seventh chapter has been made up mainly of pictures which defy classification elsewhere; and this is no exception. Some are very simple, both in concept and in execution, while others verge on the bizarre.

Perhaps the best word to describe the underlying similarities between them is that they tend to be to some extent surreal. In other words, they are not like the fantasies of Chapter 4; the twist which they impart to reality is often subtler, whether it be the architectural curve of a model above a shoe in Struan's advertisement for Charles Jordan, the uncertain presence of a ghostly model in Peter Goodrum's Infra-Red Nude, the abstraction of form and contour in Mike Dmochowski's Gold Close Up, or the impression of looking into another time in Ben Lagunas and Alex Juri's Maniki.

In this chapter 35mm predominates: the actual figures are four 35mm, three roll film, and (rather surprisingly) two on 4x5in. Extensive manipulation of the images – by toning, by hand colouring, or even by computer – renders it somewhat irrelevant which films were used; and the same could be said of the equipment. In fact, the message once again is that, always and above all, it is the photographer's eye that makes the picture. We hope that as you embark on this, the last chapter, you have been fired with new ideas and that you will find this book as much a source of inspiration as of information.

Photographer: **Ben Lagunas & Alex Kuri**

Client: **Private Art**

Use: **Gallery**

Assistant: **Isak de Ita**

Art director: **Ben Lagunas**

Stylist: **Alex Kuri**

Camera: **35mm**

Lens: **180mm**

Film: **Kodak LPP**

Exposure: **f/22**

Lighting: **Electronic flash: 4 heads**

Props and set: **White backdrop; flowers**

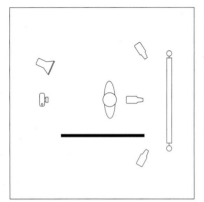

Plan View

C A R A T T I F L O W E R S

▼

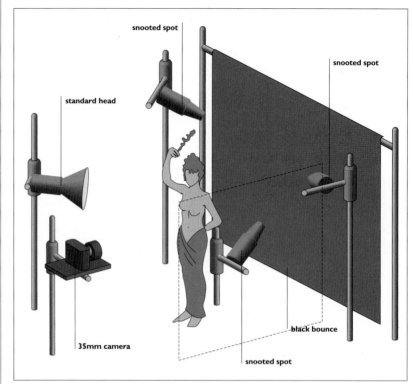

TONING AND DYEING CAN CONSIDERABLY INFLUENCE THE IMPACT OF A PICTURE — AND OFTEN, A TONED OR DYED IMAGE (BOTH TECHNIQUES WERE USED HERE) WILL CALL FOR CONSIDERABLY MORE DRAMATIC LIGHTING THAN WOULD BE USUAL IN A MORE CONVENTIONAL PHOTOGRAPH.

The lighting is actually quite simple. Three snooted spots illuminate the background brilliantly — lens flare from the brightness of the background reduces the model's raised arm to a sculptural mass — while the key light is a standard head to camera left. The extremely directional nature of the key light is emphasized still further by the use of a large black bounce to camera right, so there is no fill to speak of: this bounce absorbs light both from the key and from the background.

► *There are often several number of routes to a given effect. Instead of trying to duplicate an effect exactly, why not try another approach?*

► *Remember the possibilities for selective (limited-area) bleaching, toning, etc.*

► *Consider using lith films, printing mono negatives on colour paper, solarizing and more*

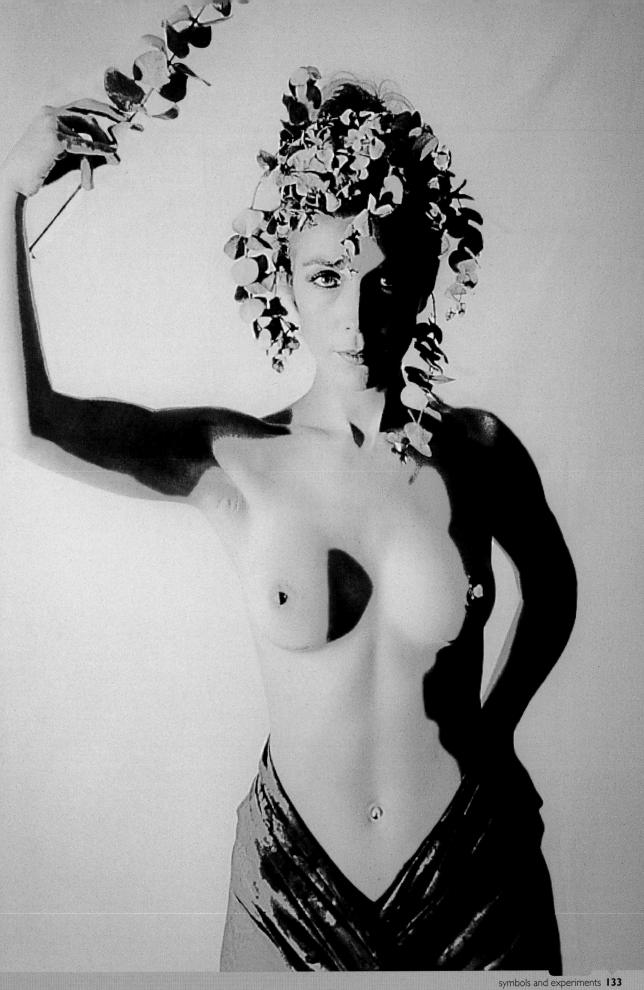

Photographer: **Ben Lagunas & Alex Kuri**

Client: **Private Art**

Use: **Gallery**

Model: **Kate**

Assistant: **Isak de Ita**

Stylist: **Manolo**

Camera: **35mm**

Lens: **180mm**

Film: **Kodak Ektachrome EPT**

Exposure: **1/60sec at f/8**

Lighting: **Tungsten: 4 heads**

Props and set: **Black background; colour introduced with gels**

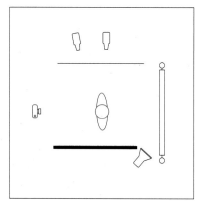

Plan View

K A T E

▼

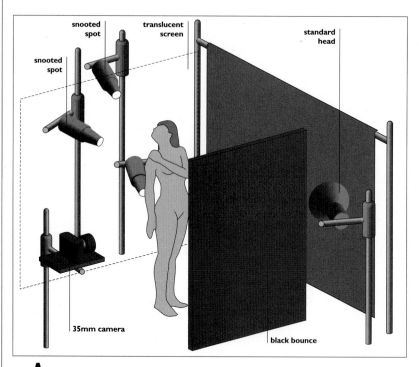

AGAIN AND AGAIN, PHOTOGRAPHERS DEBATE THE QUESTION OF LITERALNESS VERSUS INTERPRETATION. THERE IS NO DOUBT THAT INTERPRETATION IS RISKIER, BECAUSE A LITERAL IMAGE CAN BE JUDGED BY OBJECTIVE CRITERIA; BUT AN INTERPRETED IMAGE OFTEN HAS SOMETHING WHICH IS MISSING FROM A MERE LIKENESS.

The key light is a big, soft source created by shining three snooted spots through a translucent screen to camera left. Snooted spots may seem an odd choice until you realize that they allow the accurate placement of diffused light: the effects obtainable are quite different from what one would get with a large, uniform diffused light source. A black bounce to camera right darkens the side of the model which is away from the light, while a fourth light introduces just enough light to the background to differentiate the model's figure from it. Despite the differences in technique, this resembles some of Brandt's pictures taken with an ultra-wide lens on large format.

► *Different focal lengths render an out-of-focus image in different ways*

► *Dramatic side lighting is often most effective with deliberately out-of-focus images*

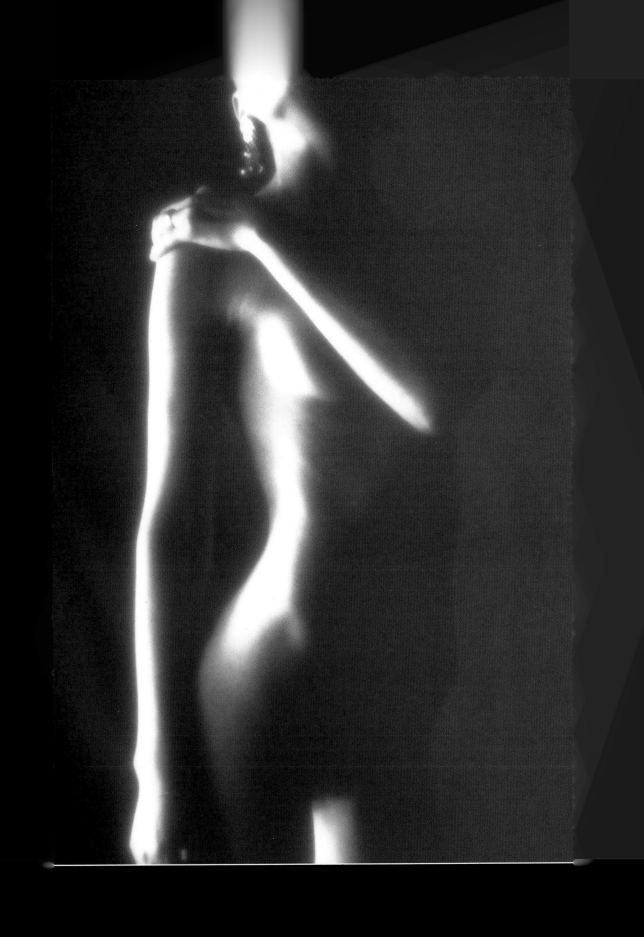

Photographer: **Ben Lagunas & Alex Kuri**

Client: **Private art**

Use: **Gallery**

Model: **Andrea**

Assistant: **Isak de Ita**

Stylist: **Michel**

Camera: **4x5in**

Lens: **210mm**

Film: **Kodak monochrome; image subsequently coloured**

Exposure: **f/16**

Lighting: **Electronic flash: 4 heads**

Props and set: **Dress, mannikin**

Plan View

M A N I K I

▼

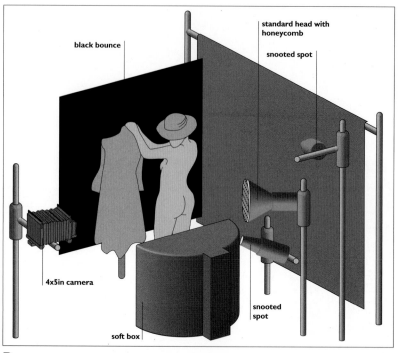

black bounce

standard head with honeycomb

snooted spot

4x5in camera

snooted spot

soft box

PARADOXICALLY, PHOTOGRAPHY CAN OFTEN SAY MORE ABOUT A SUBJECT (AND SAY IT MORE REALISTICALLY) BY MEANS OF CONTRIVANCE AND ARTIFICE THAN CAN BE SAID WITH A LITERAL LIKENESS USING ULTRA-REALISTIC COLOUR FILMS.

This is a monochrome image which has been toned, dyed and hand-coloured, but it manages to create a dream-like atmosphere which would be very hard to convey with a more conventional image.

The lighting from camera right is highly directional: a standard head with a honeycomb back lights the model very slightly (look at the shadows) while a soft box softens the directionality of the light slightly. A third light, this time a snooted spot, grazes the background to create the light patch above the model's head while a fourth (a snooted spot again) differentiates the side of the dress from the very dark background. A black bounce to camera left emphasizes the directionality of the lighting, ensuring that there is no fill to speak of.

► *Some photographers never use black bounces; others use them all the time. What could they do for your pictures?*

► *Use extra effects lights to differentiate small areas such as the side of the dress*

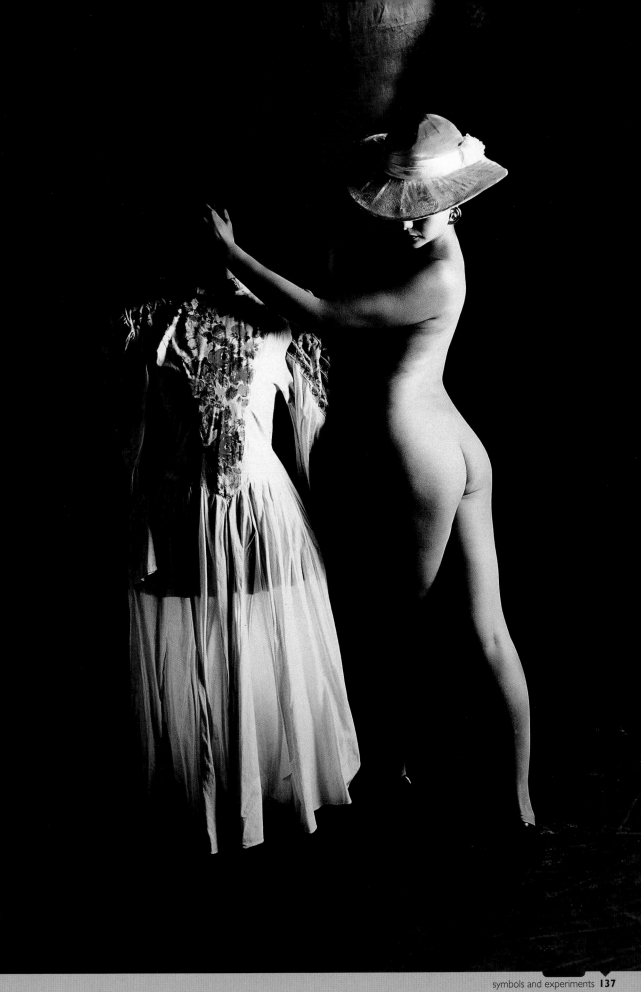

Photographer: **Mike Dmochowski**

Use: **Self promotional**

Model: **Dawn (who also acted as stylist)**

Camera: **35mm**

Lens: **200mm with warming filter**

Film: **Kodak Ektachrome EPP**

Exposure: **f/11**

Lighting: **Electronic flash: 1 head, filtered**

Props and set: **Gold body paint, black velvet,
black paper**

Plan View

G O L D C L O S E U P

▼

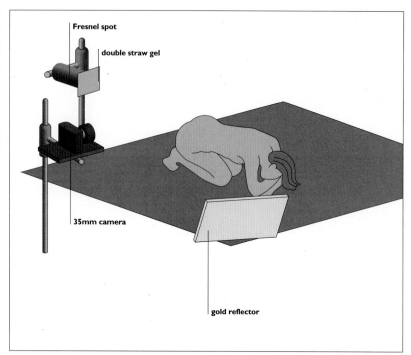

Fresnel spot

double straw gel

35mm camera

gold reflector

THERE ARE NO FIXED BOUNDARIES IN PHOTOGRAPHY. IS THIS A CLASSICAL NUDE? AN
EXPERIMENT? AN ABSTRACT? FOR THAT MATTER, SOME WOULD NO DOUBT RAIL AGAINST IT
BECAUSE IT DEPICTS THE NUDE HUMAN FORM. BUT THE DEFINITIONS DO NOT MATTER.
IT IS A GOOD PHOTOGRAPH.

The model is painted gold with body-paint. A Fresnel flash to camera left is the key, and indeed the only, light. It is filtered with a double straw gel, and sits about 30cm (12in) above the floor, some 120cm (4ft) from the model. The fill comes from camera right, a gold reflector (size not recorded) about 30cm (12in) from the model. A warming filter over the lens adds still more to the intensity and warmth of the gold – and it is interesting to speculate what effects might have been obtained with other film stocks.

► *Black velvet photographs about a stop
darker than black seamless background
paper*

► *Gold can be intensified by colouring the
lights; by filtration over the camera lens;
by film choice; by exposure; and by push
processing*

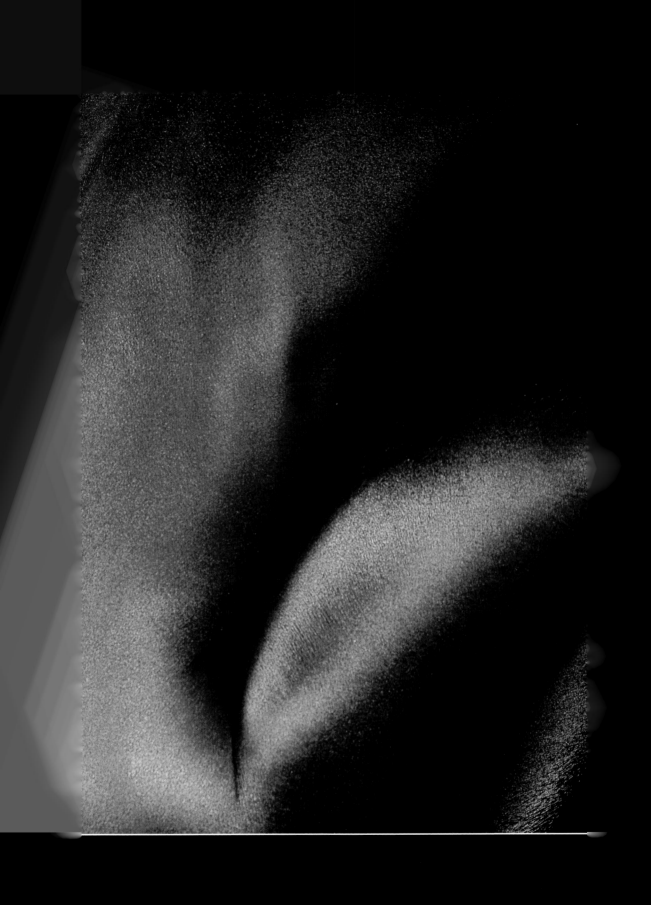

Photographer: **Peter Goodrum**

Use: **Portfolio**

Model: **Jo Rowden**

Camera: **4x5in**

Lens: **90mm**

Film: **Kodak Infrared**

Exposure: **32sec at f/6.8**

Lighting: **Available light**

Props and set: **Location: Brean Down fort**

Plan View

INFRARED NUDE

▼

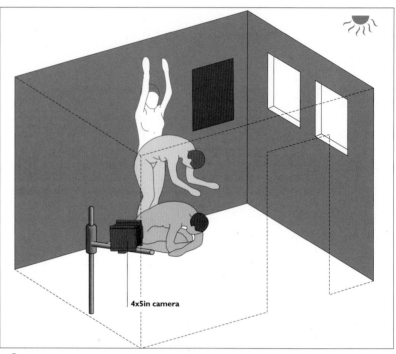

4x5in camera

OLD SCHNEIDER ANGULONS ARE NOT SUPPOSED TO BE USED WIDE OPEN: THEY ARE NOT SHARP UNTIL ABOUT F/16. INFRARED IS NOT NORMALLY THE FILM OF CHOICE FOR NUDES. NOT MANY SHOOT NUDES ON 4X5IN.

Peter Goodrum let none of this stand in his way. This picture was shot purely by available light, from the two window apertures and a door behind the camera. At the beginning of the long exposure, the model was curled up in a ball on the floor. Next, she stood up so that her legs were more or less in the position recorded, but her body was at right angles to the wall: she was bowed at the waist. Finally, she straightened up, but moved her arms and head quite vigorously so that they would not record at all.

The flare around the windows is characteristic of infrared materials, which give a sort of liquidity to the light, and the effect is accentuated by the softness of the lens when used wide open.

► Infrared can give impressive flare and halation

► Pictures involving movement may need a good deal of rehearsal

► Polaroid tests are invaluable for checking the effects of movement

Photographer's comment:

I made the print on Cotman watercolour paper coated with Silverprint Cold Tone emulsion, over-exposed a couple of stops and then bleached back before toning in Rayco Varitone Sepia.

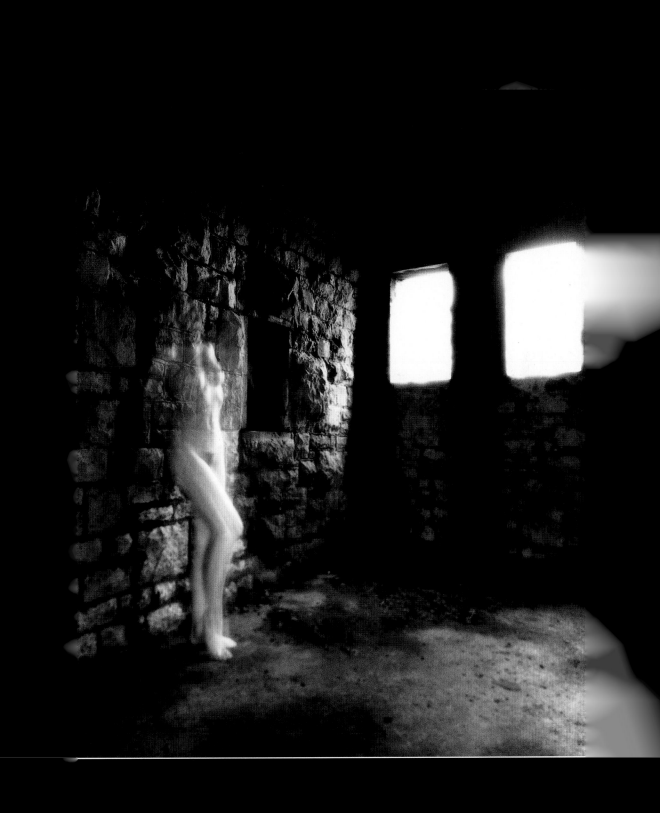

Photographer: **Rod Ashford**

Use: **Personal work, later sold as a book cover**

Model: **Geraldine Barrett**

Camera: **35mm**

Lens: **70-210mm**

Film: **Ilford FP4**

Exposure: **f/11**

Lighting: **Electronic flash: 1 head**

Props and set: **Sunflower**

Plan View

► *Many good photographers are critical of their own pictures, even if those pictures receive unqualified praise elsewhere*

► *Naturalistic colouring of green foliage is not as easy as one might hope*

► *Half-close your eyes and note the distribution of tones in this picture; it is superb*

G E R A L D I N E A N D T H E F L O W E R

▼

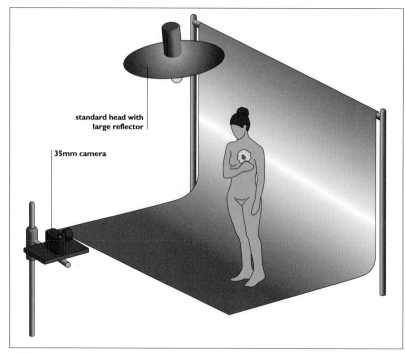

standard head with large reflector

35mm camera

Rod Ashford is fond of hand colouring, although, as his work demonstrates, hand colouring is most effective if you have a good picture to begin with. It also has an affinity with sepia.

There is only one light in this picture, a single large-reflector head set high and to the model's right (camera left): from the shadows, you can see quite clearly where it was. The quality of this light, sold as a 65-degree reflector, is subtly different from that of a soft box: it is about 45cm (18in) in diameter, and it is not highly polished on the inside.

There is no bounce at all to camera right because Rod wanted dramatic chiaroscuro, although he says, "I may have overdone this – I think I had to bring her left side up a little in printing".

Photographer's comment:

This was sold as a poster under the name "Passion Flower" but I like my working title better.

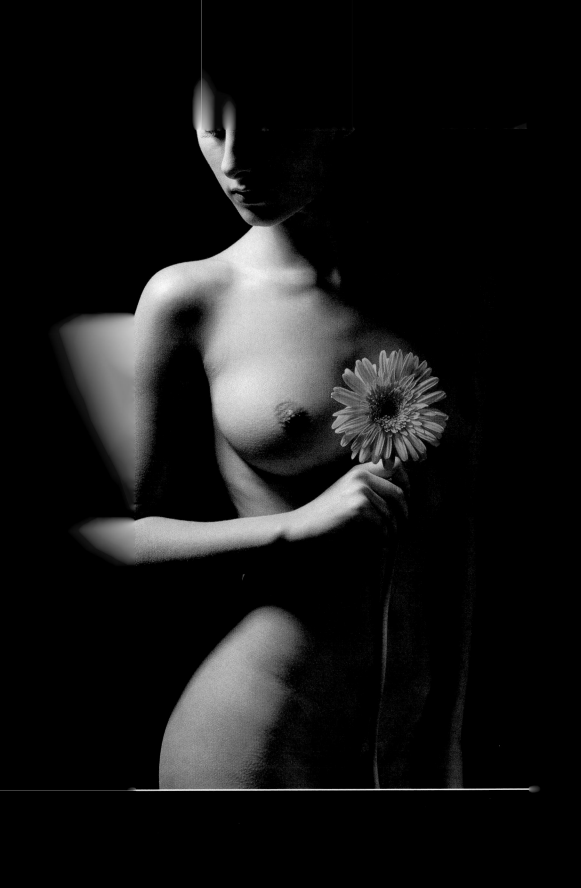

PAINTED LADY

▼

Photographer: **Struan**

Client: **Creative Source (out-take)**

Use: **Poster advertising**

Camera: **6x6cm**

Lens: **150mm**

Film: **Kodak Ektachrome EPN ISO 100**

Exposure: **f/11**

Lighting: **Electronic flash: 2 heads**

Props and set: **Green canvas (and see text)**

standard head in large reflector

6x6cm camera

standard head with honeycomb

THIS IS ONE OF THOSE SHOTS WHICH TOOK SIX HOURS TO PAINT AND MAKE UP, AND ABOUT HALF AN HOUR TO SHOOT. THE MODEL WAS PHOTOGRAPHED IN VARIOUS POSES, AND THIS IS ONE OF THE ONES WHICH WAS NOT USED.

The lighting is straightforward. The key light is a standard head in a 90cm (3ft) round reflector, pretty much directly over the model: look at the shadows. The only other light is a standard head with a 40° honeycomb for the background.

Otherwise, what you see is what was there. The model was made up to match the background, and her head-dress was made up from plasticine and plaster of Paris – the same stuff that is used for arm casts. Only skilled and experienced make-up technicians should apply this stuff: if it sets into the model's hair, it can mean trouble.

► *Professional make-up is sometimes the only realistic way to get a picture*

► *Make-up and paints can reflect different amounts of UV, making for a mismatch on film*

► *Some pictures are the result of an evolutionary process; others must be fully visualized before they are taken*

Plan View

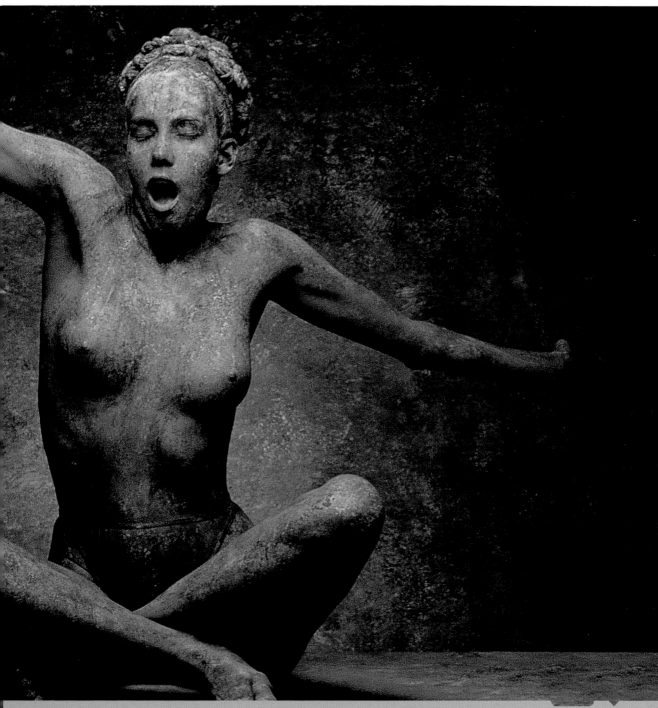

Photographer: **Guido Paternò Castello**

Use: **Self-promotion**

Model: **Telma Merces dos Santos**

Assistant: **Fernando Ribiero**

Camera: **6x6cm**

Lens: **50mm**

Film: **Kodak Verichrome Pan**

Exposure: **f/11**

Lighting: **Electronic flash: 3 heads**

Props and set: **White background paper**

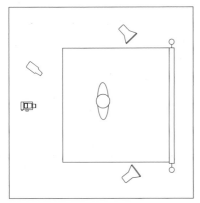

Plan View

▼

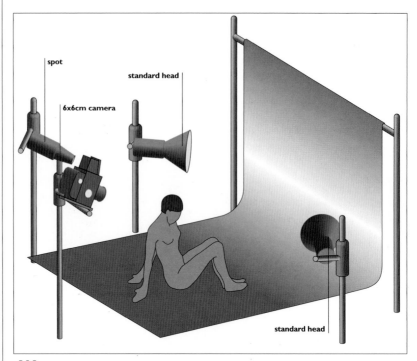

WIDE-ANGLE DISTORTIONS IN NUDE PHOTOGRAPHY HAVE BEEN EXPLORED BY MANY GREAT PHOTOGRAPHERS — BILL BRANDT SPRINGS TO MIND — BUT THEY ARE VERY HARD TO DO SUCCESSFULLY WITHOUT LOOKING AWKWARD OR (WORSE STILL) GROTESQUE.

A large part of the secret, as in most kinds of nude photography, lies in suppressing unwanted detail. Guido Paternò Castello achieved this by shooting on Verichrome black and white film; inputting the resultant image to a Power Mac; and then shooting the image off the screen using colour film.

The dramatic lighting emphasizes the graphic shape of the model's pose and makes her shadow an integral part of the composition. It is simple but effective: two standard heads on the background for a classic high-key effect, and one spot on the model herself from high on the camera left. The unusual camera angle makes it unclear at first whether the picture should be "portrait" (as printed here) or "landscape", with the model's head to the right and hands to the left.

► *Extreme wide-angle lenses can create fascinating distortions*

► *Be relentlessly self-critical with distorted nudes; compare your work with the very best*

► *Note how many successful nude distortions make use of out-of-focus areas in the image*

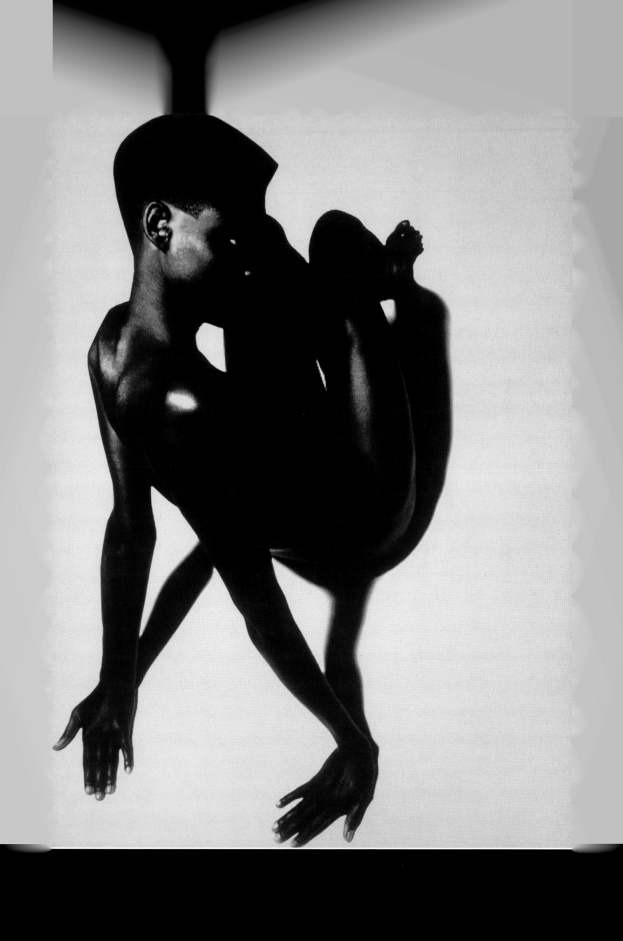

CHARLES JORDAN

Photographer: **Struan**

Client: **Charles Jordan**

Use: **Billboard**

Camera: **6x6cm**

Lens: **150mm**

Film: **Kodak Ektachrome EPN**

Exposure: **f/11**

Lighting: **Electronic flash: 3 heads**

Props and set: **White paper and black Mylar**

▼

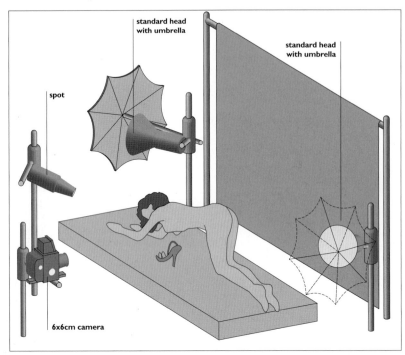

THIS IS AN EXCELLENT ILLUSTRATION OF HOW A CONCEPT EVOLVES, OFTEN VIA LOTS OF POLAROID TESTS. ORIGINALLY, THE MODEL'S LEG WAS TO HAVE PARALLELED THE HEEL, AND THE SHOE WAS TO HAVE STOOD ON SILVER OR WHITE MYLAR; BUT NEITHER IDEA WORKED.

The model's pose had to be changed or it would have been next to impossible to keep a reasonable balance between her and the shoe: it was a question of scale. Also, the shoe just did not reflect properly, so black Mylar was substituted – and that is what you see here. Because Mylar is highly reflective, even black Mylar reflects the brightly-lit white background

perfectly, while the reflection is much more saturated.

As for the actual lighting, there were two umbrellas on the white background to light it 2 stops up from the shoe, and a very tight spot (a narrow angle grid, maybe 10°) to illuminate just the shoe, not the model.

Photographer's comment:

When I first showed this to the client he didn't realize there was a nude in it. The image is now in the National Archives of Canada.

► Always be prepared to modify a concept if it does not work

► With highly reflective plastics, black can often give better saturated colour in a reflection than you would get from silver or white

► Very tight honeycomb grids can be even more versatile than focusing spots for some shots

Plan View

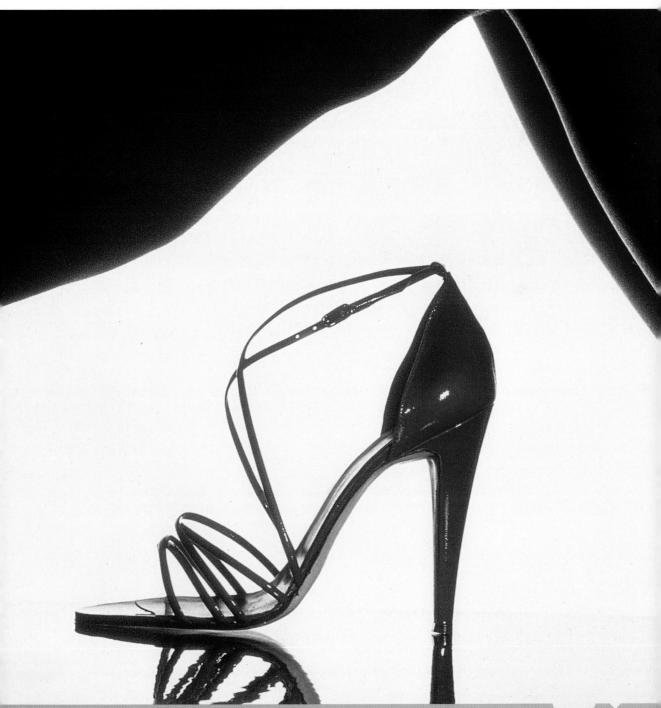

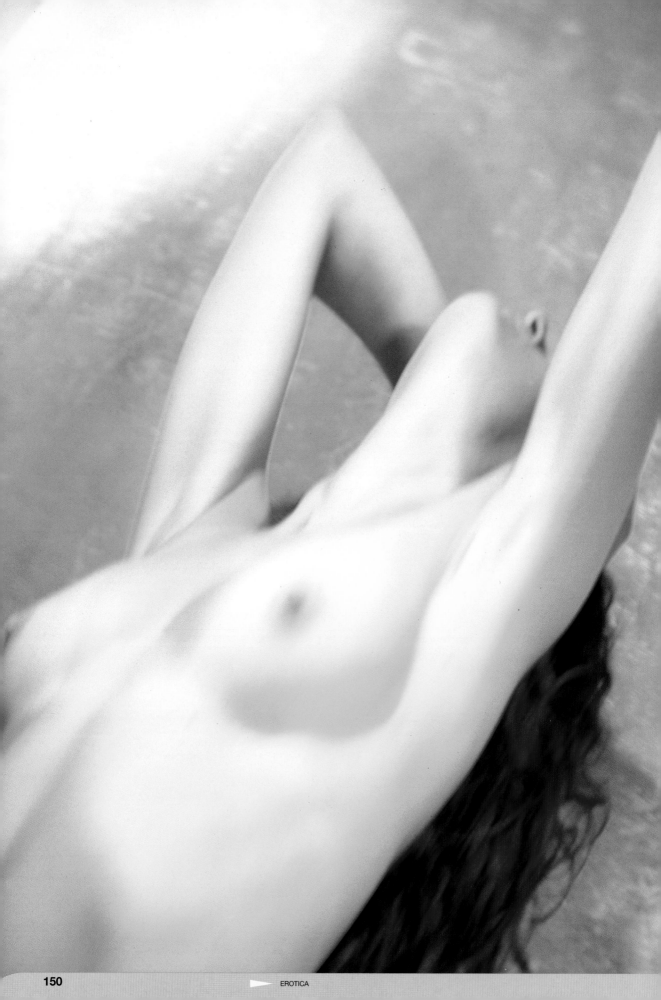

EROTICA

The word 'erotic' derives from Eros, the Greek god of love, who is also known within Roman literature as Cupid. Eros is the son of the Greek goddess of love, Aphrodite (or Venus, in the Roman tradition).

Eros traditionally has a dual nature: he is young and beautiful, but also playful. In the guise of Cupid he is often blindfolded and so his victims are chosen at random the targets of his arrows of passion.

Eros is symbolic of carnal desire. The fact that he is blindfold represents the random factor – how different people are struck in different ways by different sources of stimulation. What appeals to any one person is a very individual thing, what they find interesting and attractive, and, indeed, erotic, may be very specific to themselves, but some images will cover a broad spectrum of people. The point and purpose of erotic imagery is of course to appeal to the carnal interests of the viewer and in this respect the images must have that certain *frisson,* or sexual charge, in order to hit their mark.

It is never easy to please a potential audience because every person will like and be stimulated by something different. Although there are some themes that appeal to a wide range of people, some will have more esoteric tastes. Erotic imagery often explores what may for others seem quite unlikely areas of erotic interest. This is the point at which the genre specialises into particular fetish themes. There is room for the work of both the generalist and the specialist in erotic photography. The aim of erotica is, of course, to "tickle the fancy", as the phrase has it. What is surprising is that many may not even know they find something erotic until they see it; in

this respect the viewer has to depend on the imagination of the artist-photographer for imaginative stimulus and fresh ideas, especially since many areas of erotic imagery have become so familiar as to be stale clichés. There is therefore always a demand for new approaches, ideas and new styles of image.

The erotic shot has to work as a picture in its own right. Although it is tempting to think that the power of an erotic shot derives primarily, if not solely, from its subject matter, it is important to recognise that composition, lighting and the fundamental elements of form, line, tone, texture and colour all contribute immensely to the overall impact and success of an erotic shot.

The lighting and set can and should be used to establish a mood. The same subject matter could be presented in many different ways: even the same model in the same pose, the same setting and the same costume can be photographed in different ways to give a whole range of entirely different moods, purely by use of lighting. A soft focus low-key set-up will give the dewy romantic look at one end of the spectrum, while the brash, stark high-key "in your face" effect is at the other.

The uses of erotic photography

Sex sells. Powerful and sexy images of beautiful people are at the core of much advertising, and so the skills of the photographer of erotica are often called for. It is essential in this situation to have a good understanding

of mood: the moods that the client wants as well as the technicalities of how to establish or create any given mood with the lighting.

Another major use for the erotic shot is the ever growing market for fine art photographic post cards, wall posters and prints. In this case the shot is essentially decorative, whether decorating the shabby walls of a student residence or the intimate corners of a high-class hotel or restaurant. But as well as being an item of decoration, the shot is also a commodity. It will only get the chance to serve its decorative purpose if it succeeds as a commodity. For this market the general subject matter has to be pitched for broad general appeal and it can not be too explicit if it is to go on sale in high-street stationers, art shops and so on.

At the other extreme is the specialist market, where the subject matter will appeal to a much smaller audience with a very particular and defined kind of taste. It is also likely to be sold in a more specialist environment and may well have a more overtly sexual content.

The key is to produce the appropriate image for the purpose. Defining and understanding the brief is essential if the photographer is to produce the image required and if the client is to get the "feel" and style of picture they have in mind. With a subject area such as erotica it may be particularly difficult for a client to identify the exact look they want so it is all the more important for the

photographer to approach this varied and complex subject with care and diligence.

Studio or Location?

Shooting on location can be a tricky business where an erotic shot is concerned. An outdoor location is risky if the photographer, and indeed the model, wish to work unhampered by the astonished and curious gaze of passers-by. It is important to create a good working atmosphere and to build up a rapport with the model and this may generally best be done in a private and intimate atmosphere away from the prying stares of outsiders. If the model is not at ease, nothing will make him/her appear so in the final shot.

In some situations though a location may add to the context or offer the quality of daylight that will work best. It can also contribute a provocative element by the very fact that it is set in an apparently public place.

The studio, on the other hand, offers the immediacy that may be lacking on location as well as full control over the lighting. This may well be the key factor when deciding how and where to arrange the shoot.

Film, cameras, and lenses

Erotic photography is more than likely to involve a considerable amount of bare skin and variety of clothing fabrics from shiny PVC and leather at one end of the spectrum to fine lace and chiffon-type fabrics at the other. The choice of film stock is bound to be influenced by the exact nature of the subject and composition.

Flesh tone studies are an important exercise for the photographer who wishes to work seriously in this area. There is such a vast array of film stocks available on the market that it is essential to experiment and see how different stocks work with the almost endless variety of human skin tones and colours. In the not so distant past, a certain amount of filtration was often required to achieve good neutral skin tones but film stocks today are more neutral. More film stocks also offer a naturally warm tone, a great boon for working with bare-flesh subjects.

A current vogue is "incorrect" processing techniques, more commonly known as cross-processing; that is, processing C41 colour negative stock in an E6 transparency process, and vice versa. Common results of this are increased contrast, more vivid and intense colours, often a cyan tinge in the low-lights, amongst other (sometimes somewhat unpredictable) features. Another technique is to put films such as Ilford's XP2 black and white stock, which is normally processed in C41 chemistry, to give black and white or sepia tone tints, through a pushed or pulled E6 process, to give instead a blue or green tinted black and white transparency.

The choice of camera format and lens for the shoot will be determined by the end result required. For example, if a grainy look is wanted, a 8x10 inch format would be an unlikely choice since the strength of this format is its ability to produce a large, crystal-clear transparency. That is not to say that it would not be possible to achieve a grainy image in that format, but much more convenient would be the choice of a 35mm camera. On the other hand, it is important to remember what the use of the image will be beyond the photography stage. If the transparency is to be used for a poster billboard, for example, it is going to be enlarged a great deal and it may then be preferable to work with an initially less grainy but larger image via an 8x10 inch, in the knowledge that the grain will inevitably become more apparent by the extreme enlargement. As ever, the circumstances and requirements will dictate the choice of camera and technique.

The same can be said of lenses. A wide-angle lens will accentuate the length of legs and may elongate the image, therefore making a model look slimmer; if this is what is required it is important to know which tool will produce the effect. Alternatively, it may be that a close-in and intimate look is wanted, in which case a long lens may be a more obvious choice for filling the frame and reducing depth of field without crowding the model, but allowing the photographer to work from a greater distance. This would also make it easier to light the subject. While a similar effect might theoretically be achieved by working in closer proximity and using a standard lens, neither the model nor the lighting are going to be so comfortable if the photographer is too close.

Clothes, props and make-up

The essence of many an erotic shot rests on clothing and costume. The array of possible costumes is endless: lingerie, stiletto shoes, stockings, suspenders, even chain-mail and armoury for a bondage-type image all come into their own in the erotic image. Make-up is equally important and can establish anything from an innocent, youthful, natural look (which is in fact anything but un-made-up), to the glossy and extrovert look of the raunchy sex queen.

The work of the make-up artist is crucial. The make-up must be expertly applied and well judged in relation to

the mood of the image – in fact careful attention must be paid to all aspects of the styling. The clothing has to be in keeping with the look of the model, the hair and make-up in order to establish the right feel.

The choice of props is another crucial factor. Not only must the right item be selected for the shot, but it must be exploited in the most effective way. In erotic photography, that often will be the least obvious way, as in Salvio Paris's "Unhard rock!" where a model wears a garter belt as a mask. Many erotic shots will be to some extent narrative images, suggesting an ongoing situation and scene, and the props will be vital. Again, the viewer depends on the photographer's imagination to present something stimulating and unexpected, and using a familiar prop in an unfamiliar way can have this kind of impact.

Lighting equipment and mood

There are no hard and fast rules about lighting erotic shots, but establishing the right mood for the shot is crucial. The photographer may need access to a whole range of lighting equipment to facilitate creating that mood.

The beauty of the hard source is that it can be adapted to become a soft source whereas the reverse is not so easy; the hard source is a more versatile starting-point, therefore. Standard heads with soft box attachments are always a good investment, along with a range of modifying items such as gels, gobos, barn doors, and so on. These attachments need not be expensive. In many cases home-made improvisations can be just as effective as professionally made items; for example using cut out paper for gobos, and coloured fabric or coloured paper as a reflector instead of more expensive gels. (It is important to remember, though, if improvising with equipment to be used near light sources, safety must always be maintained: lights can get extremely hot and fire hazards must be avoided at all times.)

The erotic session

The "erotic session" may be a rather misleading description for a shoot for an erotic image. It is not meant to imply that the shoot is itself intended or expected to be primarily an erotic experience; the subject matter is by no means any excuse for the photographer (or indeed the model) to expect anything other than a completely professional method of working. An intimate atmosphere could be a great help during the shoot, but this has to be established according to well-defined methods of working, whereby both the photographer and the model know what to expect of each other and have agreed on a way of achieving the desired result. It is important for the model to be at ease, and developing a rapport with the model and a working intimacy at just the right level is a very subtle skill in itself. The photographer must judge what will put the model at ease, what will make the shoot go well, and what will enable the model to give the performance required in front of the camera. It is essential to get the parameters agreed before the shoot begins; there is obviously a great deal of vulnerability implicit in an erotic shoot, and this has to be dealt with professionally.

The presence or absence of other crew may or may not help to establish the correct balance between the necessary professional approach and the all-important intimate atmosphere that will surely show through on the film. Again, consultation with the model is important and a mutually agreeable arrangement must be arrived at.

EROTIC FANTASY

08

This chapter shows a very wide range of influences, from Man Ray to Picasso. There are definite similarities in the elements of surrealism and the unexpected in many of the shots. An aspect of fantasy is that it has little or nothing to do with reality, and many of the shots in this chapter have either no context or a quirky, surreal one, giving free rein to the imagination of the viewer.

At the other extreme is the more blatant and ostentatious realism which is more an expression of how one might wish reality to be: not a fantasy in the sense of the intangible and imaginary but, rather, as an almost attainable version of reality; a form of wishful thinking that is brought to life by the photographer.

HEATHER

photographer **Craig Scoffone**

use	model portfolio test
model	Heather
camera	35mm
lens	45–125mm
film	Pan-X
exposure	not recorded
lighting	available light
props and	
background	light grey wall

This shot uses natural light. The straightforward simplicity of the model's expression and hair and make-up styling continue this theme of a natural look, though the clothing has been chosen to add an erotic element to an otherwise quite innocent feel.

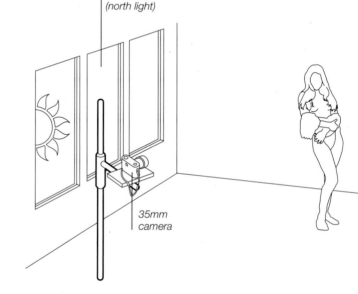

windows
(north light)

35mm
camera

plan view

key points

A bright blue north sky can have a colour temperature of up to 18,000° Kelvin

It is possible to get a north light simulator which is obviously an indirect source

The sunlight enters the studio from the large windows to the left of camera, and the model stands sideways on to the window and fairly close to the light grey back wall. The tightness of crop, combined with her proximity to the wall, means that little or no shadow is visible on the wall behind her. Although this is a side-lit shot, there is no strong sense of directionality because of the diffuse nature of natural and even north light. This is evident in the low level of modelling across the curves of the model's features.

photographer's comment

This was a portfolio test shot for Heather. It shows good use of the beauty of north light.

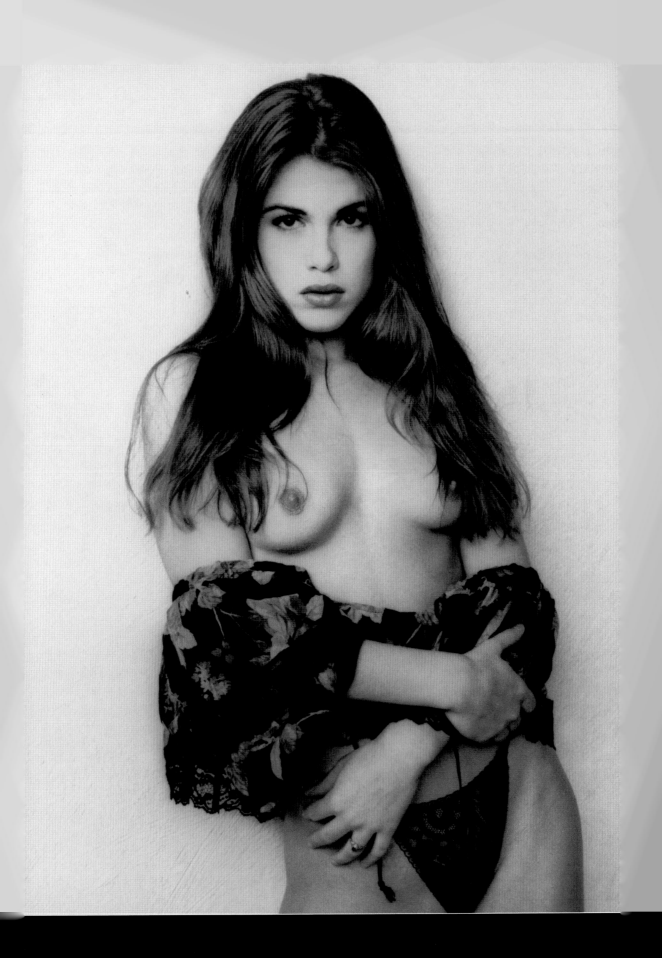

UNTITLED

photographer **Antonio Traza**

use	personal portfolio
camera	6x7cm
lens	127mm and anamorphic lens
film	Kodak EPR 100 ISO
exposure	1/30 second at f/8
lighting	electronic flash and tungsten
props and background	hand-painted background reminiscent of Picasso

In this shot the model appears to be lying back. In fact, the photographer has stood the model very close to the background and has chosen a very low camera angle with the addition of an anamorphic adapter.

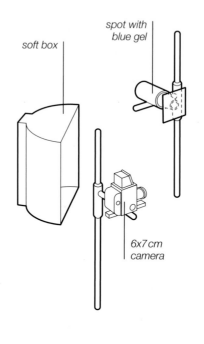

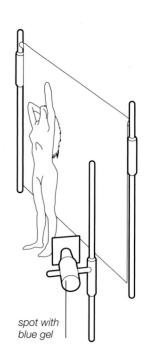

plan view

key points

The anamorphic lens can be a little difficult to use because of the narrow depth of field and focusing ring in the lens

Mixing tungsten and flash can be a fun way to create secondary colours

"The lighting was easy," says Italian photographer Antonio Traza. "Two tungsten heads (modified by a red and a blue gel), one at either side of the model, create the ring light necessary for the colour effect on the lower edges of the body. The flash with small soft box freezes the image and softens the shadows. The tungsten gives form and colour and creates the white lines around the model."

photographer's comment

This picture was inspired by Picasso's "Demoiselles d'Avignon". I wanted to create that "stretch" in the image for which I used an anamorphic lens. The background and gels are reminiscent of the "blue" and "rose" periods of Picasso.

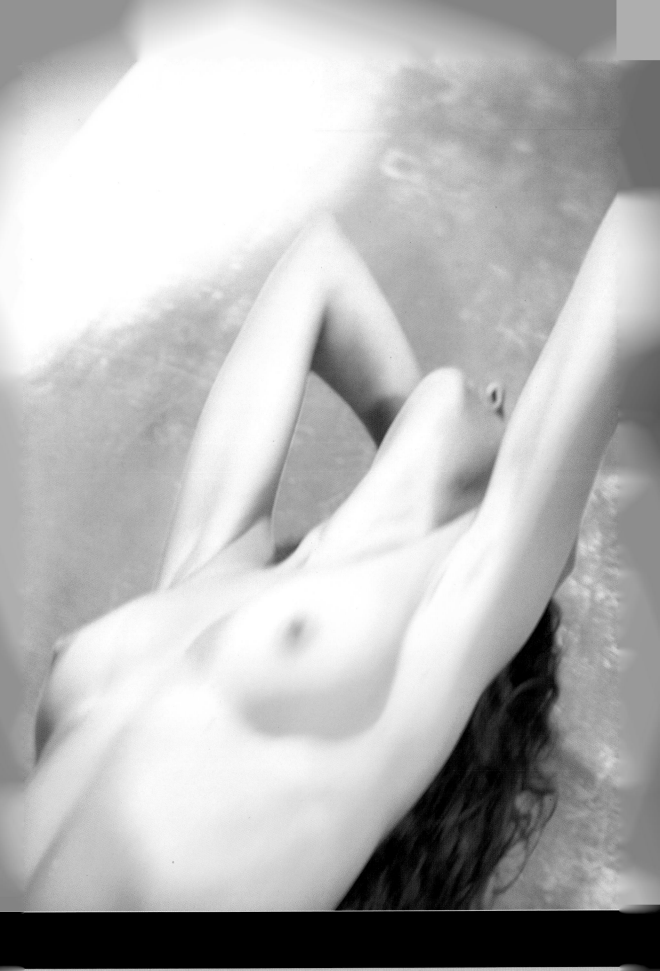

WAITING FOR YOU

photographer **Ben Lagunas and Alex Kuri**

client	private art
use	gallery
assistants	Isak, Christian, Paulina, Janice
art director	Ben Lagunas
stylist	Vincent St Angelo
camera	6x6cm
lens	210mm
film	Kodak Tmax
exposure	1/125 second at f/16
lighting	electronic flash

This is a classic example of a carefully crafted studio shot made to look like a location. The set dressing is immaculate, with close attention to detail establishing an authentic feel.

plan view

black bounce

standard head

spot

6x6cm camera

back bounce

soft box

spot

key points

It is important to anticipate any possible problems with flare and to flag effectively to control this

Foreground props can add more shape and interest to the composition

The model stands against a dark background with a black panel behind her. Another black panel to the right of the camera prevents any spill light from falling on the lens. To the right of this panel is a soft box which gives fill light. Two focusing spots key the model's body, and a standard head illuminates the area behind her to give the tiniest amount of "lift" and separation.

The dramatic chiaroscuro look creates a romantic fantasy mood. Classically, the chiaroscuro effect consists of a single light used in contrast with darkness, but this shot is a good example of how to make a series of lights appear to be one source. It takes tremendous skill and judgment to pull this off.

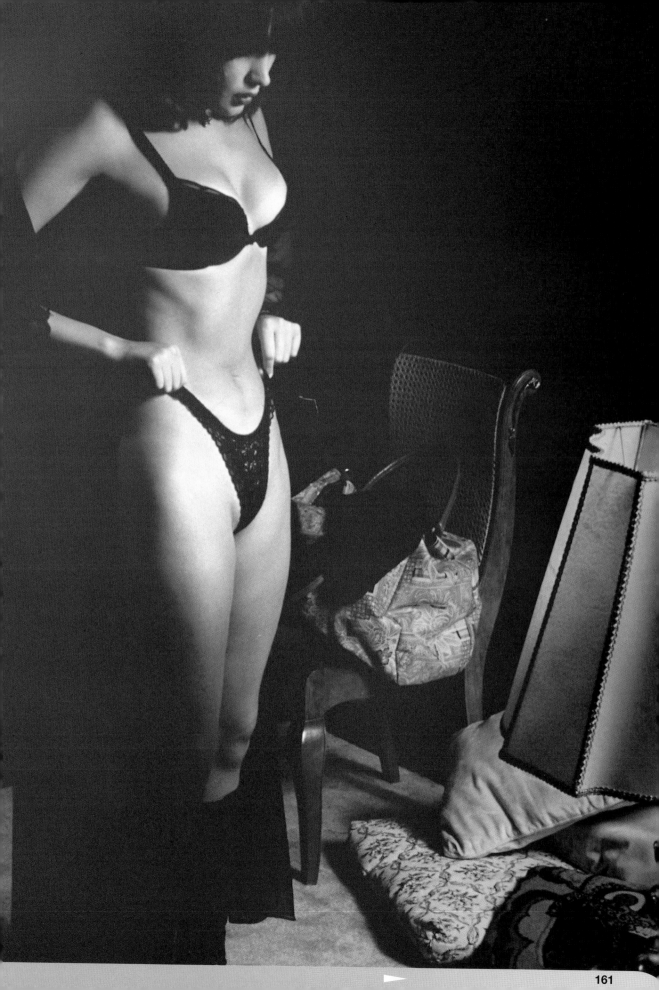

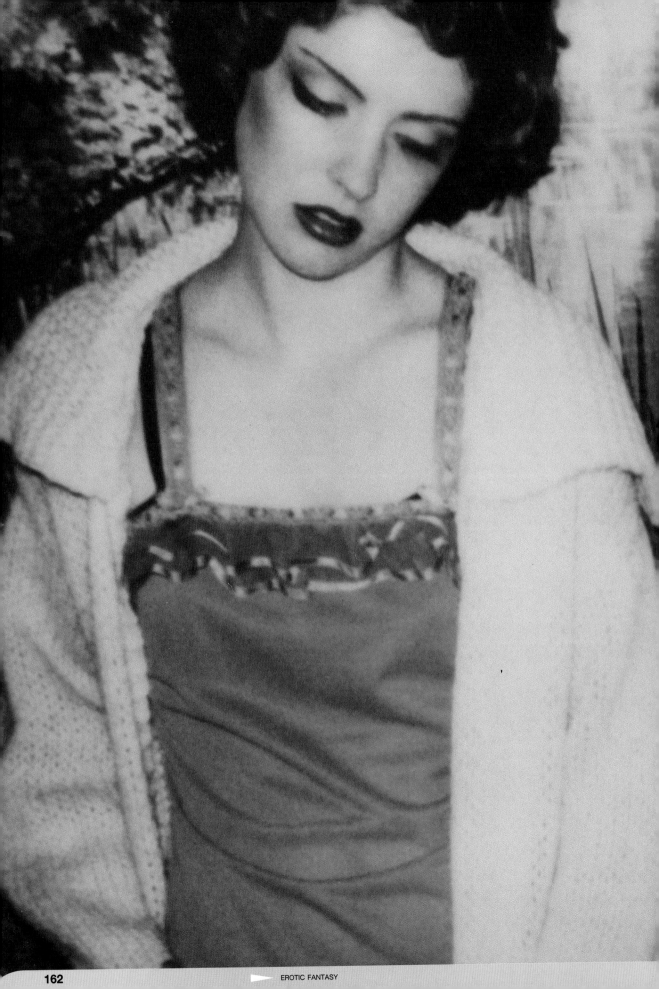

SWAMP

photographer **Corrado Dalcò**

use	personal Work
model	Manici Patrizia
assistant	Passeri Francesca
art director	Corrado Dalcò
stylist	Caterina
hair	Caterina
camera	Polaroid Instant 600
lens	38mm
film	Polaroid 600
exposure	not recorded
lighting	electronic flash
props and	
background	home in Parma

This gritty and direct image is a fine example of the work of Corrado Dalcò.

polaroid camera

plan view

key points

To be able to break rules effectively, it is essential to be fully conversant with the rules in the first place!

Polaroid, although normally used as a device for testing, has its own wonderful qualities for an end result

The basic rules of any discipline are there to be broken, or, at least, to be experimented with, and this ultra-contemporary work displays how very stunning the end result can be, and for the right reasons.

This shot is lit purely by the on-camera flash directly above the camera lens and virtually on the same axis. However, the whole nature of the image is to be ostentatious and direct so this relatively unflattering approach to the lighting is, in practice, the most appropriate.

The bright but yet not cheerful colour of the outfit, combined with the uncomfortable expression of the model, and the scary almost surreal background combine to produce a powerful, stimulating image.

PAINTED EYES

photographer **Wolfgang Freithof**

use	personal work
model	Ford
make-up and	
eye painting	Nikki Wang
camera	6x6cm
lens	80mm
film	Fuji Velvia
exposure	1/125 second at f/8
lighting	electronic flash
props and	
background	red backdrop

The dramatic hair, make-up and styling are shown off to good effect by this equally dramatic, though relatively straightforward, lighting set-up.

standard head

6x6cm camera

plan view

key points

A hard source can be modified to become a softer source, but this does not work so readily in reverse

Continuity in terms of styling is very important, however as always lighting is the key factor

Wolfgang Freithof used nothing more complicated than a standard head, shot through an umbrella. The light was straight on to the model, at front centre and directly above the camera. Although the umbrella diffuses the light somewhat, this is still a fairly directional source giving highlights on the upper and front-most facing parts of the model and allowing good fall-off on the undersides; notice the strong separation of the chin from the body behind, for example, and the clear modelling on the arm.

The high position of the light source gives highlights on individual strands of the hair, the curling strands being carefully styled to echo the radiating pattern painted around the eyes.

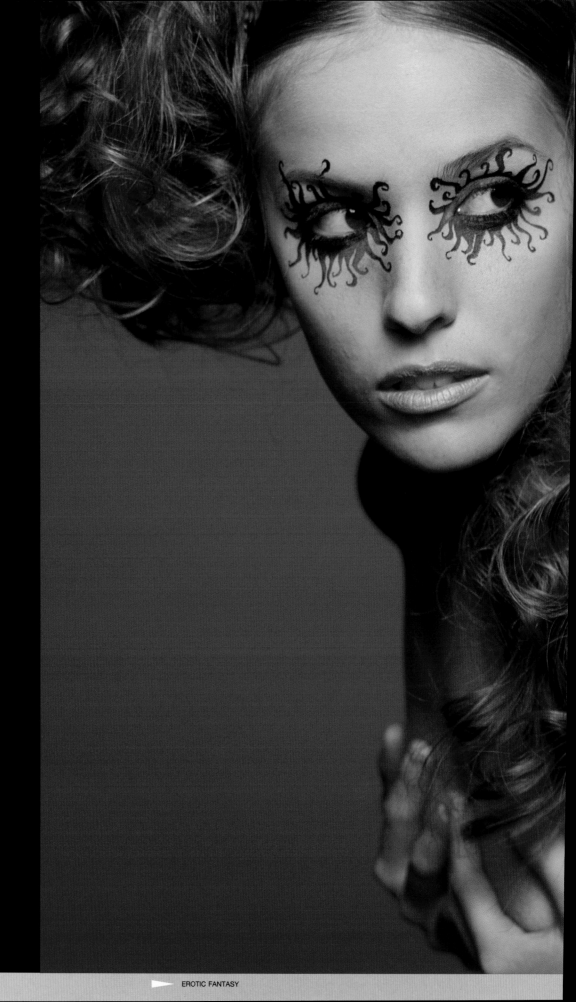

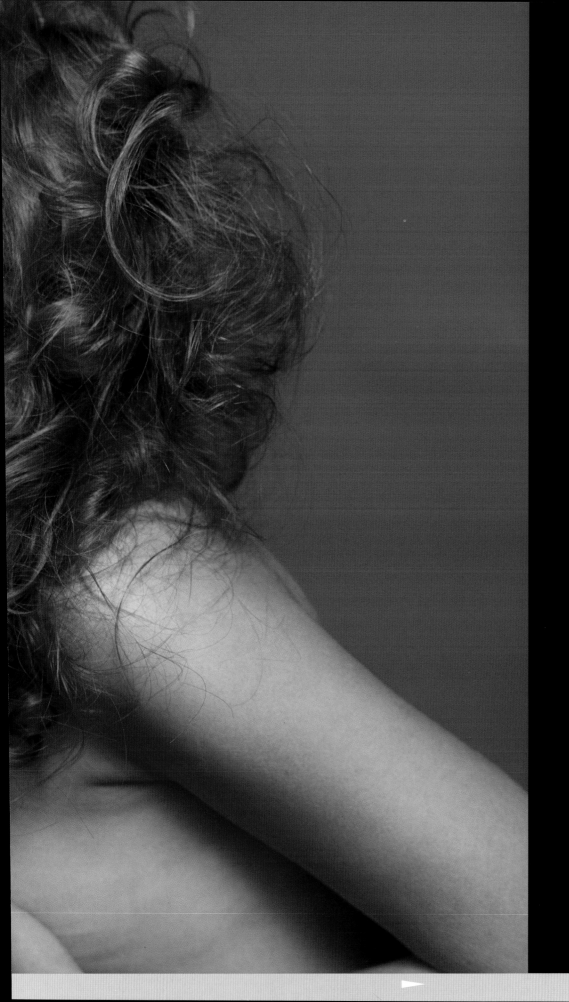

NUDE ON STAIRCASE

photographer **Marc Joye**

client	Portfolio
model	Margret
camera	35mm
lens	35mm
film	Kodak Tri X
exposure	1/60 second at f/11
lighting	electronic flash and sunlight

An unusual viewpoint of an unusual pose can create considerable interest, challenging the eye to work out exactly what it is looking at.

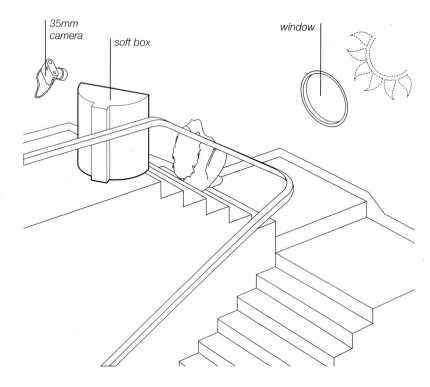

plan view

key points

Hand-tinted and self-sensitised paper images should be re-shot on to transparency as a precaution against fading or damage to the materials used

Contrast can be controlled to the nth degree by use of a light meter and judicious adding to or modifying of sources

This graphically engaging sense of disorientation is enhanced here by hand-sensitised paper demonstrating strong brushstrokes and bold hand-tinting.

The small window, facing the camera but just out of view at the top of the image, with harsh sunlight streaming through, naturally gives high contrast. To counter this, Marc Joye has introduced a soft box behind the camera, opposite the window, to reduce subject contrast.

The sunlight gives the hard edges to the stairs. The strong lines of the staircase, handrail and model pose combine to reinforce the expert graphic composition, which has become Marc Joye's signature.

photographer's comment

Photographed on 35mm Tri X film and printed on designer paper made sensitive with Fuji Art emulsion and hand-coloured on the stairs and handrail with red water-colour dye.

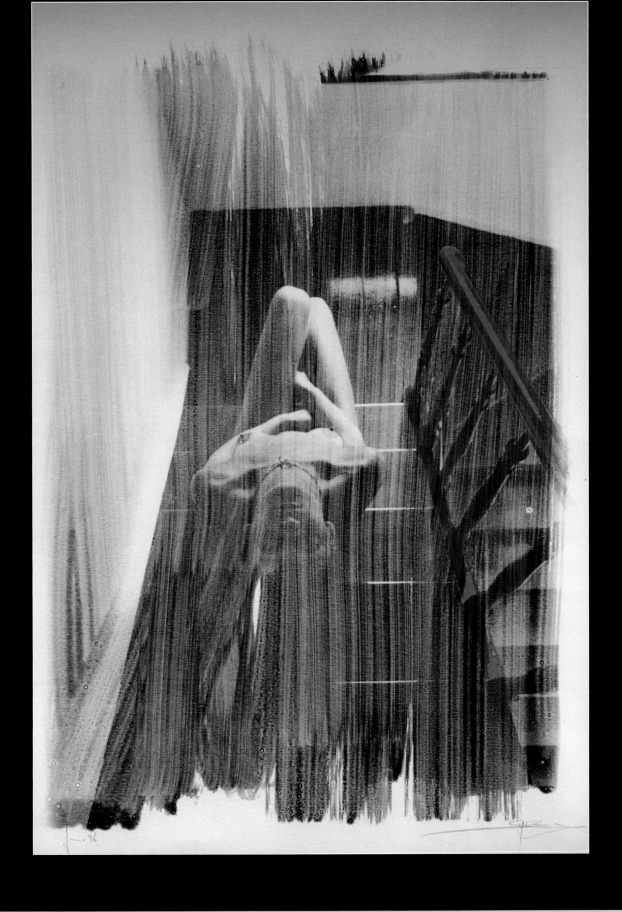

BLACK WOMAN TONGUE

photographer **Frank Wartenberg**

use	publicity
camera	6x7cm
lens	360mm
film	Fuji Velvia
exposure	not recorded
lighting	electronic flash

The most important element in this shot is the overhead soft box, which highlights the model's long tongue.

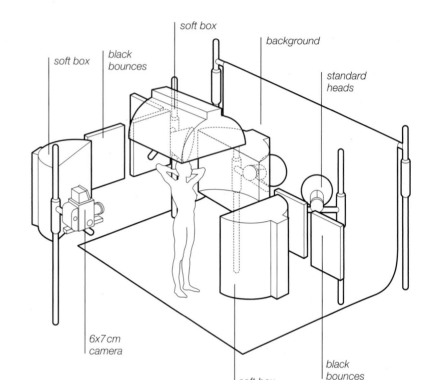

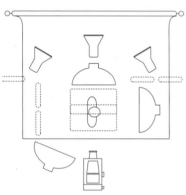

plan view

key points

Darker skins can be very absorbent of light, reflected light readings are essential

Light and shade is what photographic lighting is all about

The background is strongly lit by three standard heads providing a white even glowing backdrop. Overall light is supplied by a large soft box slightly to the left of the camera and a soft box opposite the model illuminates what is visible of the torso. Black panels behind the subject make sure that the focus of light emanates from a very specific place. This shot also demonstrates that a balance to a composition can transform a strong shot into a very stunning and startling impactful image.

LIEU

photographer **Bob Shell**

use	stock
camera	35mm
lens	90mm
film	Fuji Provia
exposure	Not recorded
lighting	available light with on-camera flash
props and background	parasol and pool

The sun is beating down on this oriental beauty as she takes refuge under a parasol and tries to cool off in the pool. But both items are more than props: they are, in effect, pieces of lighting equipment

35mm camera with flash and bounce diffuser

plan view

key points

Rippling water can be used as a gobo to create interesting light and shade, and of course texture

The parasol acts as a flag for the model's eyes: the shade it provides prevents her squinting against the brilliance of the sun

The rippling water provides a mirror-like reflector below. The parasol diffuses the light from above giving a good amount of modelling to the curves of the model's body and emphasises the gleaming derrière as the focus of erotic interest.

The highlights on the shirt and position and depth of the shadow indicate the position and intensity of the sun. Although it might seem odd to use a flash in such bright daylight, the bounced on-camera flash adds just enough fill-in to the face, which is in the most shaded area of the composition: note the texture in the dark mass of hair and deep, velvety eyes, which would otherwise be lost.

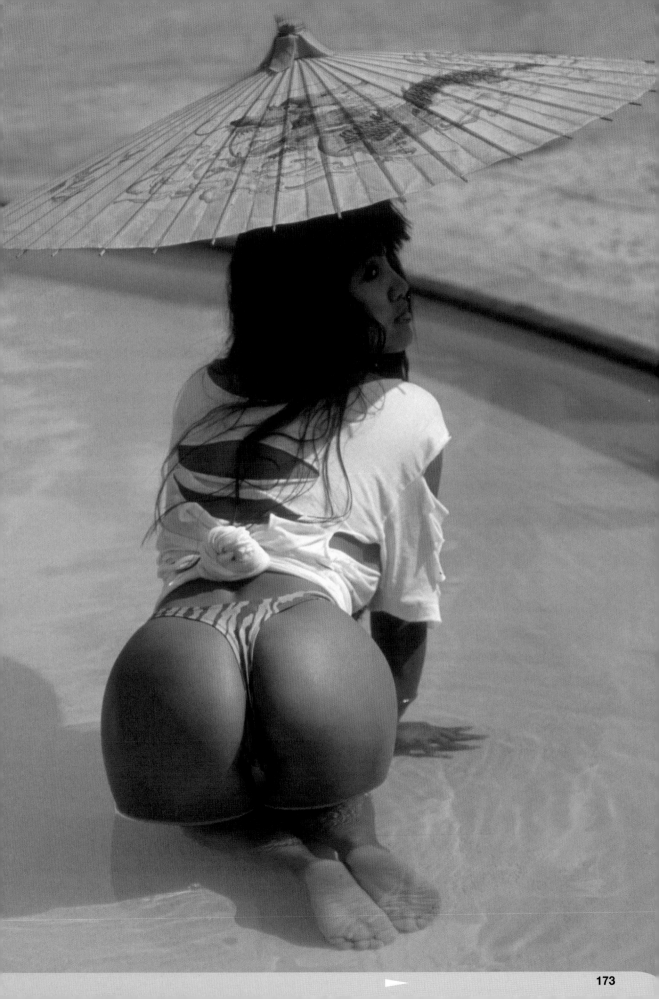

WOMAN

photographer **Ricardo de Vicq de Cumptich**

use	exhibition
model	Patricia
assistant	Ednaldo de Sousa Ramos
camera	4x5 inch
lens	210mm
film	Tmax 100
exposure	f/32
lighting	electronic flash and light brush

This solarised look is reminiscent of the Surrealist movement of the 1930s and the work of such "greats" as Man Ray and Laslo Maholy-Nagy.

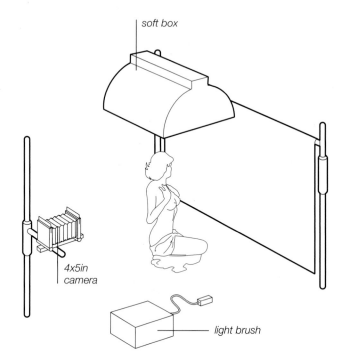

soft box

4x5in camera

light brush

plan view

key points

It is invaluable experience to emulate the work of the Great Masters

A comfortable model pose that can be held still for some length of time is very important for long exposures and light painting

In this instance, however, the glowing tones emanate not from darkroom technique, but from the use of a light brush. The initial exposure uses a large overhead soft box, which is further softened by a diffuser to ensure an extremely low-contrast look. The light brush work picks out areas on the upper edges of the torso for additional exposure, giving a silvery, surreal gleam to the skin.

It is interesting to compare the lower back and the profile of the face to see how different amounts and types of minuscule movement by the model lead to different results. The black line outline along the curve of the back represents a slight change of position between the flash and the light brush work, while the ghostly softness of the face and hands indicate greater movement during the light painting.

photographer's comment

This photograph was chosen to be in Graphics Photo 94 in the portrait category.

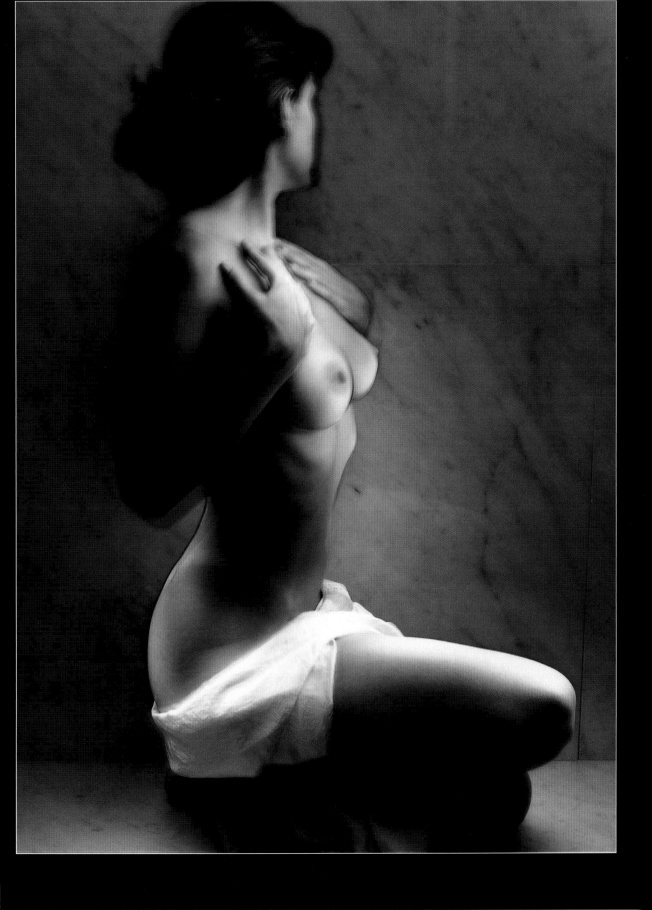

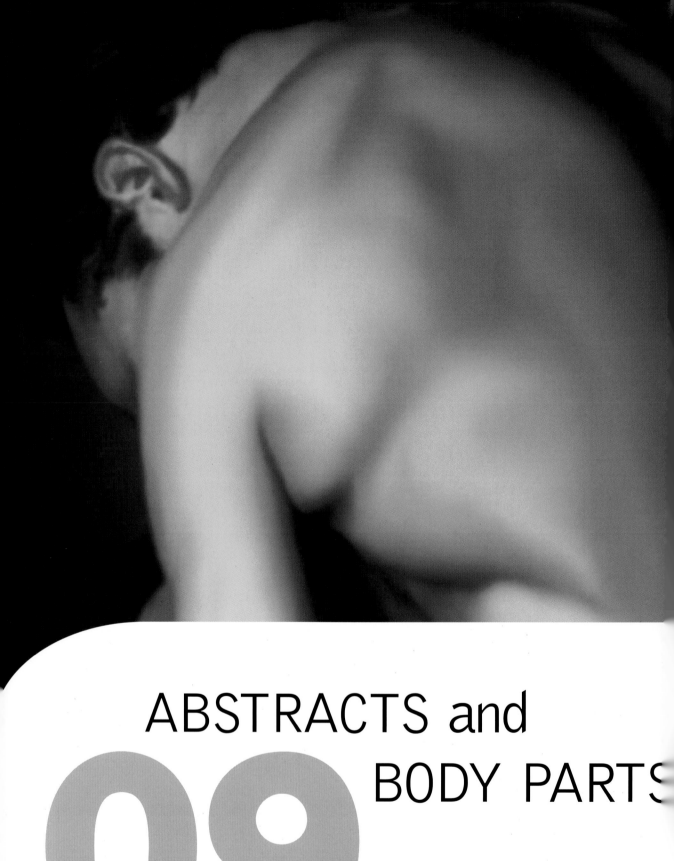

ABSTRACTS and
09 BODY PARTS

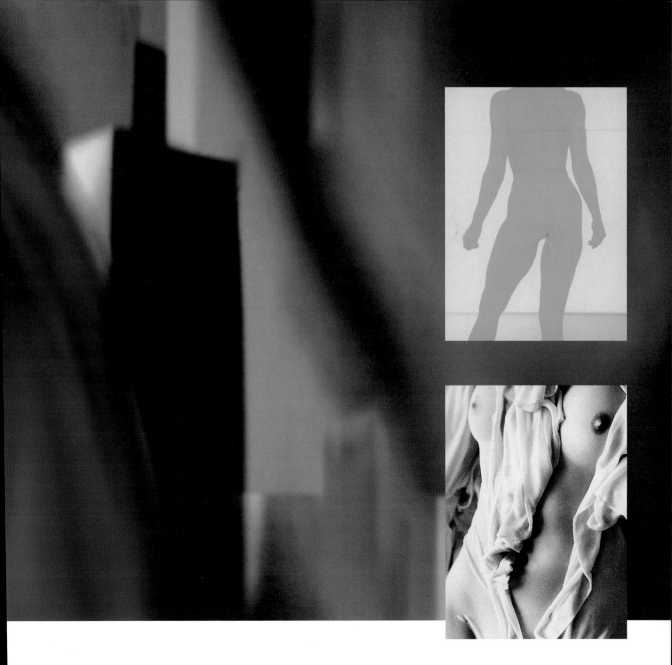

What makes a model-based image abstract? Looking at the selection of photographs in this chapter, one key element seems to be to depersonalise the shot by not depicting the head or face. This is a stark and clear-cut way of drawing attention to form rather than personality; to aesthetic composition rather than to emotive narration. Abstract experimentation also embraces a range of techniques for depersonalising the already anonymous body parts that are the subject of these studies. While some of the images here represent bodies in clear detail, choice of black-and-white stock, such as that favoured by Gerard de Saint-Maxent, is one way of distancing us from the model as a real person; use of silhouette and colour-wash techniques is another, as Craig Scoffone's work demonstrates. What is important, though, is the focus and concentration on the aesthetics – and the erotic charge – of body parts out of context.

GREY ASH

photographer **Craig Scoffone**

camera	35mm
lens	45–125mm
film	Agfa APX
exposure	not recorded
lighting	available light
props and	
background	white seamless paper

Sunlight diffused above the subject was the only light source used for this photograph, yet basically it is as if the model is standing inside a giant soft box.

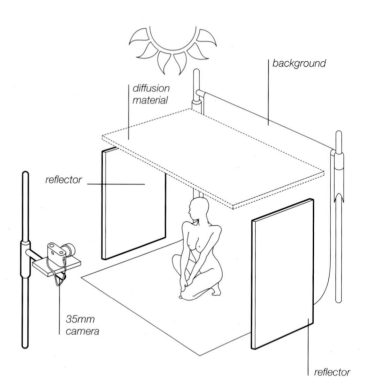

plan view

key points

The choice of slow film contributes to a low-contrast image

Down-rating a film combined with pull-processing will generally give more shadow detail

The white paper background and the white reflectors at each side comprise the walls, while the silk of the "soft box" is made up of the diffusion material suspended above the model. But instead of light emanating from the soft box, it is filled with natural overhead sunlight.

The only really dark area is the neck, and this is caused by the shadow of the chin. The illusion of a weathered, textured statue, created by the use of ash on the model's body, is enhanced by shooting in black-and-white and by keeping the lighting very soft.

photographer's comment

Ash from my fireplace was used to cover the subject's body and make the surface appear like a statue.

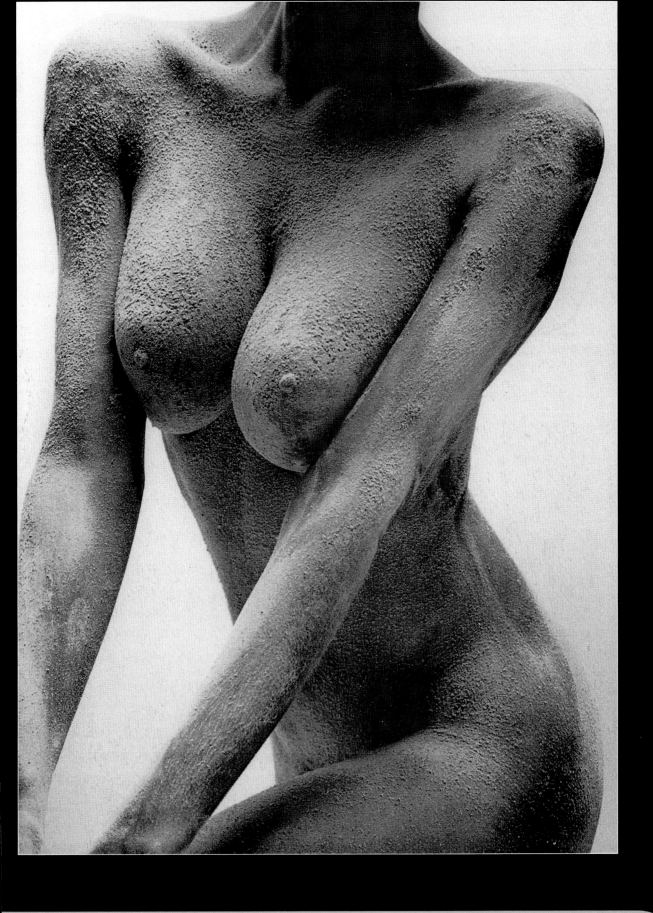

ACHILLES

photographer **Patrick Coughlin**

Achilles is of course best remembered for his proverbial heel, the one vulnerable part of his body, according to Greek mythology. The subject matter here recalls the ancient story, with the all-important heel firmly in the foreground.

use	personal work
model	John Palmer
assistant	Nick Austin
art director	Steve Foster
camera	RB67
lens	50mm wide angle
film	Kodak EPP 100 ISO
exposure	f/11
lighting	electronic flash
props and background	painted background of various rectangular shapes

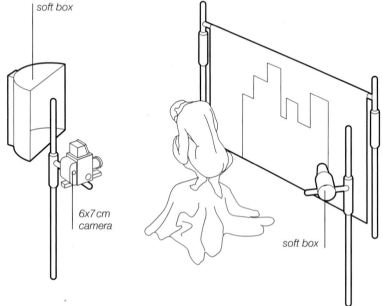

soft box

6x7 cm camera

soft box

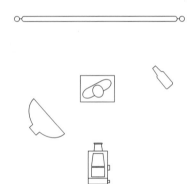

plan view

key points

The wide-angle lens is used to give a distorted effect to the body, and this necessitates the use of a very large backdrop – some 20 feet high, in fact, here

Lighting effects can be incorporated into the design of a backdrop

The styling follows the theme of classical hero, with the sculptural pose, the magnificent physique of the model, and the golden colouring (created by the use of warm-up filters on both lights and lens) giving the impression of a gilded statue. The high-key areas on the near side of the body are achieved by placing the soft box close to the model.

The background has rectangular shapes painted on it, giving the impression of three-dimensional blocks. The positioning of the light on the model is essential for this illusion, so that actual highlights and lowlights in the foreground accord with the apparent ones painted on the background.

photographer's comment

Achilles has been slightly distorted on image manipulator to emphasise the style of Tamara-de-Lempicka.

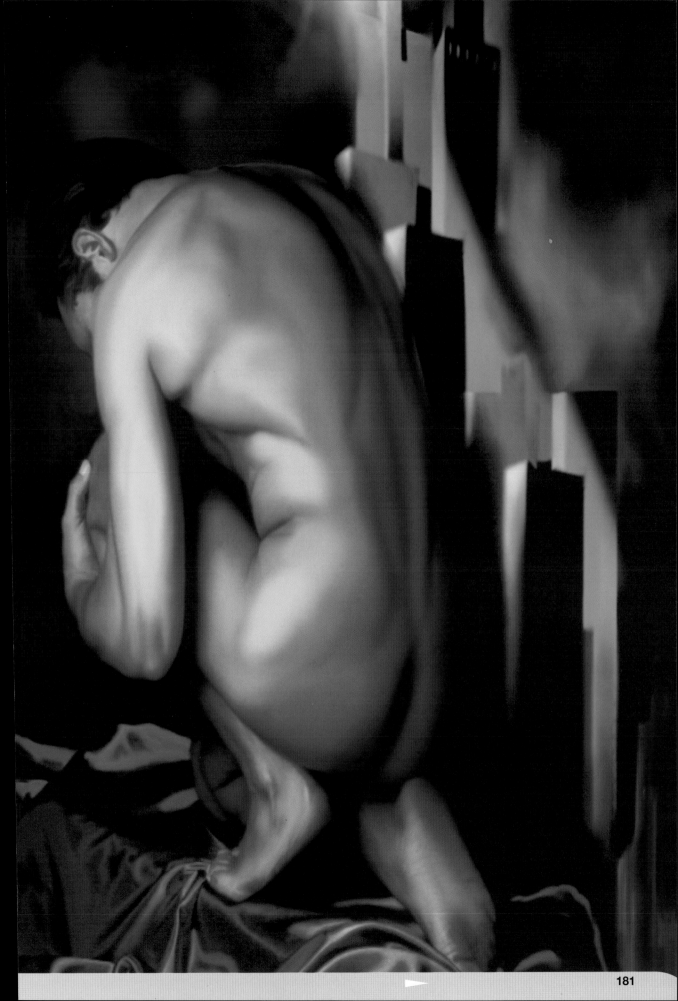

DRAPED NUDE

photographer **Gérard de Saint-Maxent**

use	editorial
camera	Mamiya 645
lens	105mm
film	Tmax 400
exposure	1/30 second at f/5.6
lighting	available light

It is amazing what a stunning but simple effect can be achieved with just a model, a drape and available light in conjunction with the right film stock.

Mamiya 645

plan view

key points

Tight lighting ratios are required for higher contrast films

Lighting from above with rapid fall-off can give an interesting effect

The fine silvery look of this shot is typical of Gerard de Saint-Maxent's work, as is the delicate composition, tending to the abstract body study. This is simplicity at its most effective.

Notice the careful positioning of the model to allow the play of sunlight to fall quite remarkably distinctly on each breast, giving a different look and effect in each case. The far breast is very high-key and deliberately slightly bleached out, while the nearer breast is away from the light source in much deeper shade. The arrangement of the drape is also important. In places it clings to the undulating landscape of the torso and emphasises every rise and fall of the body; elsewhere it is positioned in apparently careless ruffles, which are actually carefully contrived in order to catch the play of light. It thus adds to the textural interest as it plays against the smooth sleekness of the model's body.

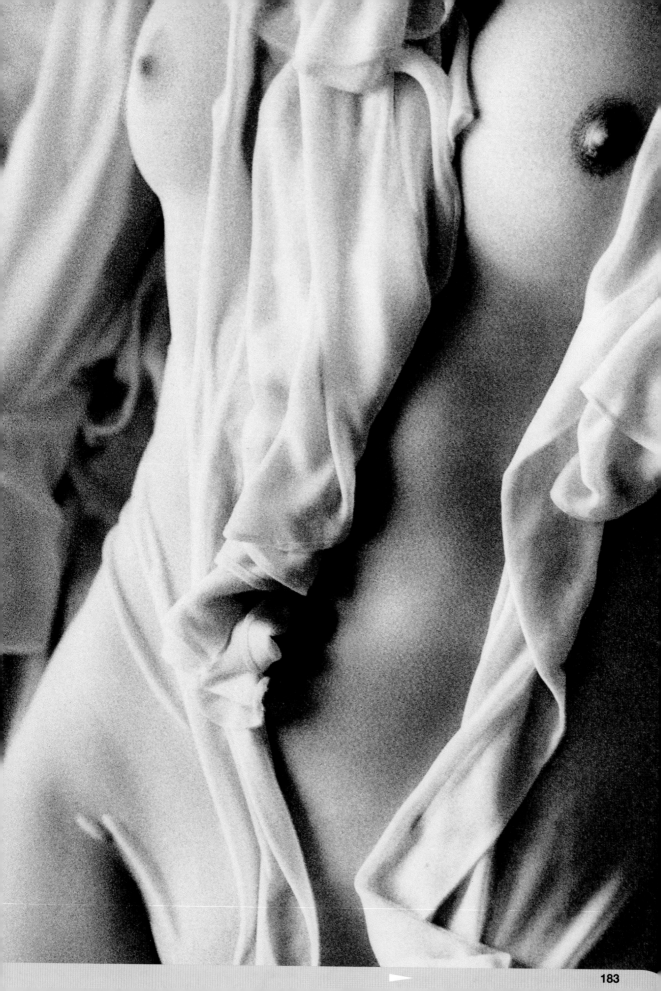

ABSTRACTS and BODY PARTS

WALL SHADOW

photographer **Craig Scoffone**

use	personal work
camera	35mm
lens	75–125mm
film	Fuji Provia 100
exposure	not recorded
lighting	slide projector
props and	
background	textured white wall

This fascinating mixture of texture, light and shade, form and shadow is created simply by placing a model close to a textured white wall and skimming a transparency depicting wood grain sidelong across the model's body.

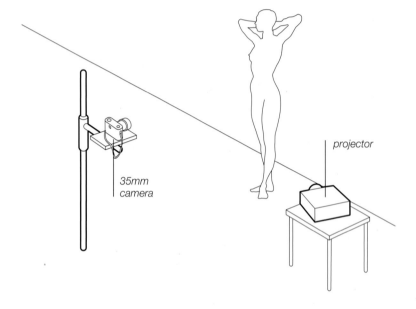

plan view

key points

The specula on the belly are from the point source, which is the projector bulb

The rich golden warmth to this picture derives from the low colour temperature of the light source when recorded on daylight film

The wood grain image makes the body look like a wood carving sculpture. The transparency is projected from a far sidelong position, so the image undergoes a certain amount of distortion from right to left. This is exaggerated by the natural curvature of the model's body, giving a broad sweep of patterning on the surface of the skin.

Beyond the model, the compositional interest continues as the oblique angle of light casts a hugely distorted profile shadow on the textured wall.

photographer's comment

The sole light source was the slide projector with a transparency of wood grain projecting on the body of the subject and the wall.

ABSTRACTS and BODY PARTS

SILHOUETTE SEASHORE

photographer **Craig Scoffone**

use	personal work
camera	35mm
lens	45–125mm
film	Kodak Tri-X
exposure	not recorded
lighting	available light
props and	
background	out-rushing wave along the seashore in the background

This is a situation where the natural elements of the location can inspire the look of a shot, if the photographer is alert and opportunistic.

plan view

35mm
camera

key points

It is important not to meter off the subject when a silhouette is required.

The photographer has very effectively used the lighting conditions, combined with correct exposure and the deliberate absence of reflectors, to emphasise the beauty of the silhouetted form of the model. As the light hits the water rippling over the texture of the sand, it glistens in different directions. This sparkling look can be clearly seen in both foreground and background.

Three features of the shot are particularly noteworthy: the highlight on the bottom, the highlight, form and definition of the breast and the bold triangular space formed by the legs with the sea behind.

photographer's comment

The sun was situated a bit past mid-afternoon. Its brilliant refractions off the water made a great backdrop for the silhouetted model.

ABSTRACTS and BODY PARTS

BLUE WALL

photographer **Craig Scoffone**

use	personal work
camera	35mm
lens	45–125mm
film	Fuji Provia 100
exposure	not recorded
lighting	electronic flash
props and	
background	textured white wall

A single electronic flash was suspended above the subject who was posed against a white wall, providing a cool shower of light.

standard head with blue filter

35mm camera

plan view

key points

It is a considered decision whether to place a gel over a light or a filter over the lens

Even the most familiar subject can be given an abstract form

The cascade of light down the wall turns the backdrop into a pane of indirect back light. In front of it the model stands out in silhouette against the sharply defined triangle of light, bounded by the shadows that her arm creates. The small amount of stray light that falls on the model gives a rim-light definition to the hair details and extremes of the hips and body.

The colour comes from a blue gel over the standard head. This works well with the textured white wall as the movement of the wall surface results in different shades of blue due to a drop in colour temperature in the shadow areas.

Most important to the composition is the tiny, neat triangle of light between the thighs – this small detail provides a hugely erotic surge.

photographer's comment
Good lighting is like cooking: you add only when there is good reason to add. In this photo a single light source says more than any other number of lights could ever say.

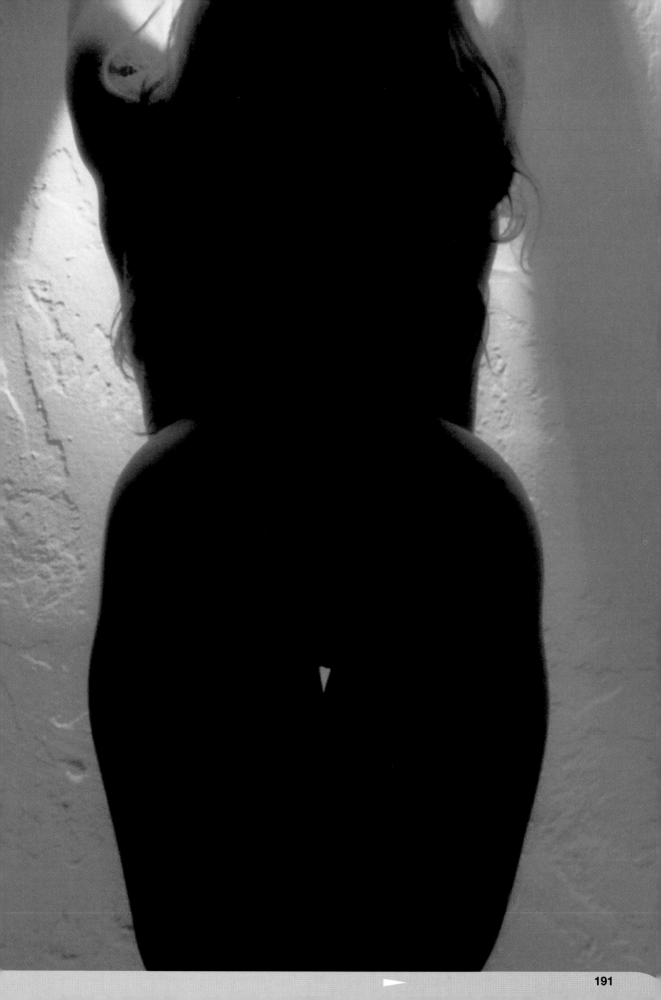

MUSTARD HORIZON

photographer **Craig Scoffone**

camera	35mm
lens	45–125mm
film	Fuji Provia 100
exposure	not recorded
lighting	electronic flash
props and background	hardwood floor, white wall

Craig Scoffone's distinctive colour-wash abstracts take a variety of forms. Here, he has bathed the model's body in the distinctive main colour of the shot, while maintaining a silhouette-style image.

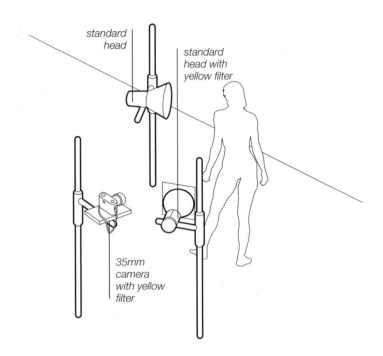

standard head

standard head with yellow filter

35mm camera with yellow filter

plan view

key points

A silhouette does not have to be deep black against white. Experiment for equally stark and interesting results throughout the colour spectrum

Interestingly, it is the presence of the simple horizon that lends the surreal mood to this image, giving it an odd feeling of context but no specific sense of what the context might be. The result is a marked otherworldly look.

The horizon is in fact created by simple wooden floorboards meeting a plain white wall. The colour cast is introduced in two stages. The key light,

a standard head to the right of the camera, is modified by a yellow gel and this is reinforced by a yellow filter on the camera lens. The standard head, which lights the background to the left of and behind the model, is in its natural state, i.e. white light. There is therefore a slight mustard hue to the background because of the lens filtration.

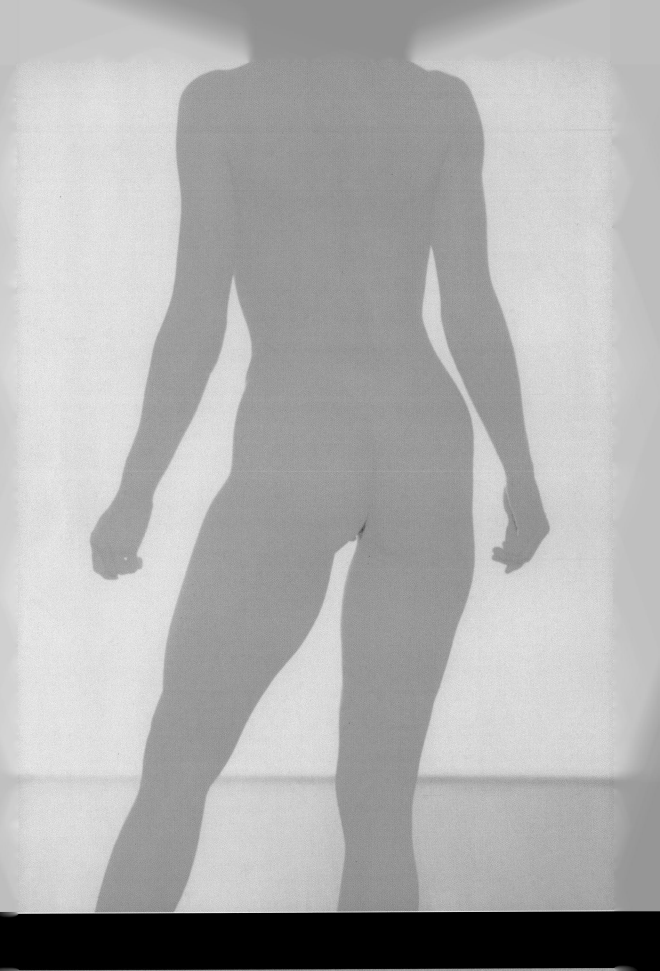

ACCESSORIES and PROPS

10

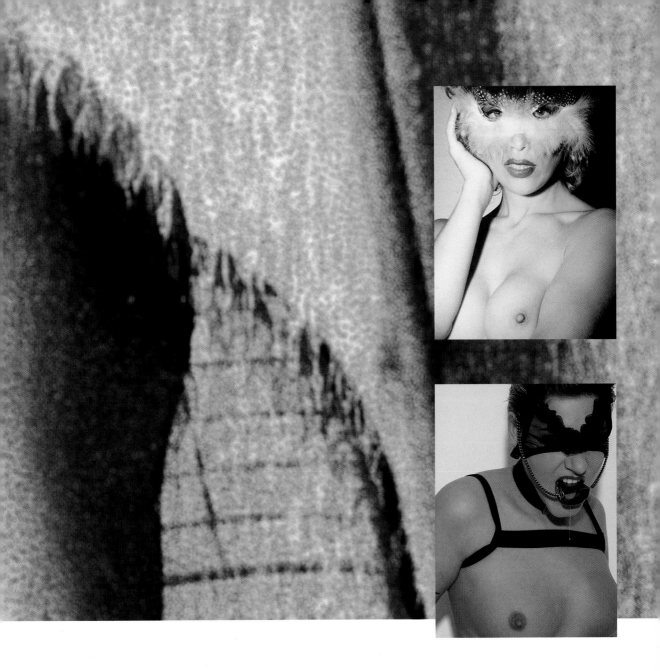

Accessories and props can be used to emphasise and enhance particular features of the erotic shot model, and they can also inspire a whole look or composition on the part of the photographer. While accessories can draw attention to features of the model, often in startling ways (for example, Salvio Parisi's "Unhard rock!"), props can impose a physical framework on the set, within which the photographer must work. Both model and photographer respond and react to the chosen accessories and props, as in Maurizio Polverelli's "Dressing room", for instance. Taking the time for open-minded experimentation with a variety of items can be an exciting undertaking and can stimulate the imagination immensely and lead to a creative and unexpected outcome for both photographer and model — and, of course, for the viewer.

DRESSING ROOM

photographer **Maurizio Polverelli**

use	portfolio
model	Birute
assistant	Emanuela Mazzotti
make-up	Giovanni (Idea 2)
camera	35mm
lens	50mm
film	EPR 64 ISO
exposure	not recorded
lighting	electronic flash
other	elaborated with Photoshop

The choice of the metal mesh chair in this shot demonstrates how a furniture prop can be used to inspire both model and photographer.

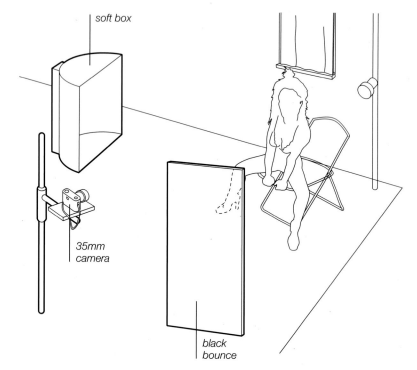

soft box

35mm camera

black bounce

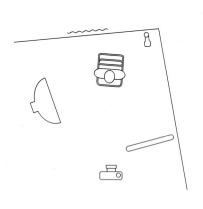

plan view

key points

A soft box used in close proximity can still give a harsh quality and cast strong shadows

Lamps can be used as props as well as light sources

The model here uses it almost as an extension of herself; while from a composition point of view it provides interesting form and texture.

The soft box is close to the model, on her left. On the right of the model is a black bounce, to increase the fall-off on that side. The small lamp visible in the shot is more of a prop than a core lighting element, but nevertheless has some impact on the model's hair, giving a reddish patch of light due to the very low colour temperature of a domestic bulb.

Notice how the shadow cast by the arm across the leg gives the impression of a stocking top, adding to the eroticism and increasing the ambiguity about what the model is wearing – the allure of uncertainties is well known.

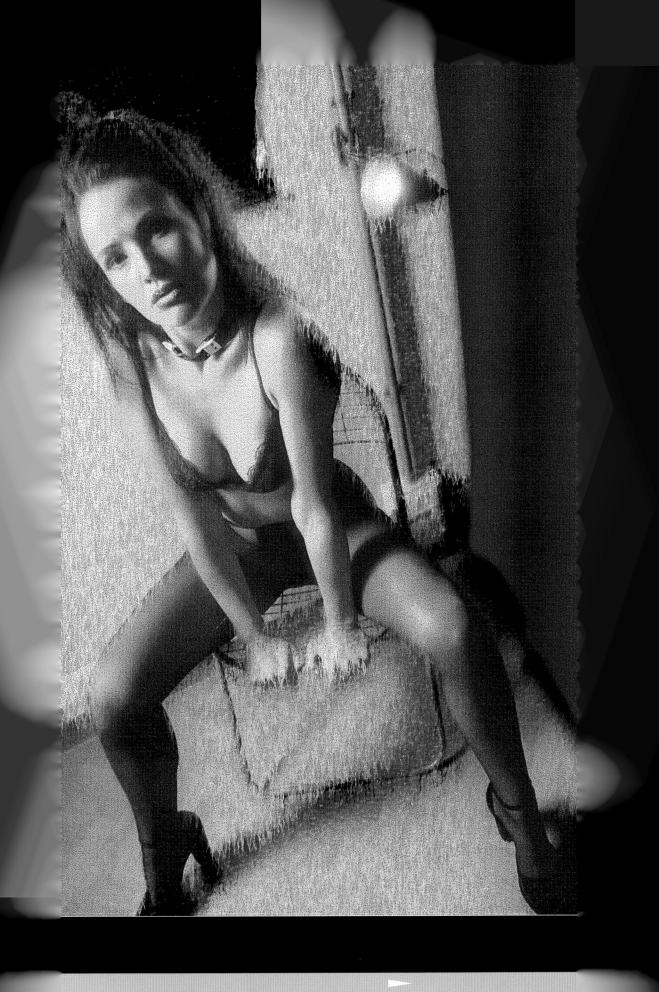

EROTIKA

photographers **Ben Lagunas and Alex Kuri**

client	Private art
use	gallery
model	Viridiana
assistant	Christian Taylor, Paulina, Janice
art director	Ben Lagunas
stylist	Vincent St Angelo
camera	35mm
lens	180mm
film	Kodak Tmax
exposure	1/60 second at f/11
lighting	electronic flash

The eroticism of this shot stems largely from the voyeuristic feel created by the pose and props.

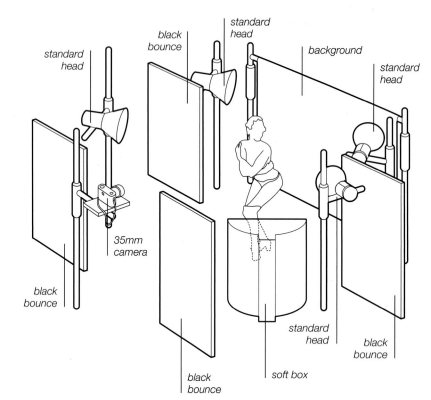

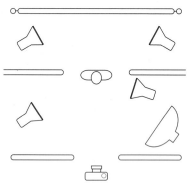

plan view

key points

Tungsten light is better for lighting models, but when working with so many sources the heat can be far too intense and flash heads are therefore the obvious choice

It can be very important to light a background separately from the subject matter

The self-protective position the model has adopted combines with the state of almost complete undress to give an air of vulnerability and the impression of a person caught unawares.

The boots and sunglasses only add to the sense of nakedness and exposure, and the anonymity that the sunglasses provide is another important element in the allure of the shot. The background is lit evenly by two standard heads and any

spill from these lights is flagged off the model by two black panels. The key light is to the left, with a back light opposite this and fill light positioned to the right; basically, a classic three-point lighting set-up, superbly executed.

The two black panels in front of the model create shade at the front of the body, which the model crouches into, and seems to clutch to herself as if for cover.

ACCESSORIES and PROPS

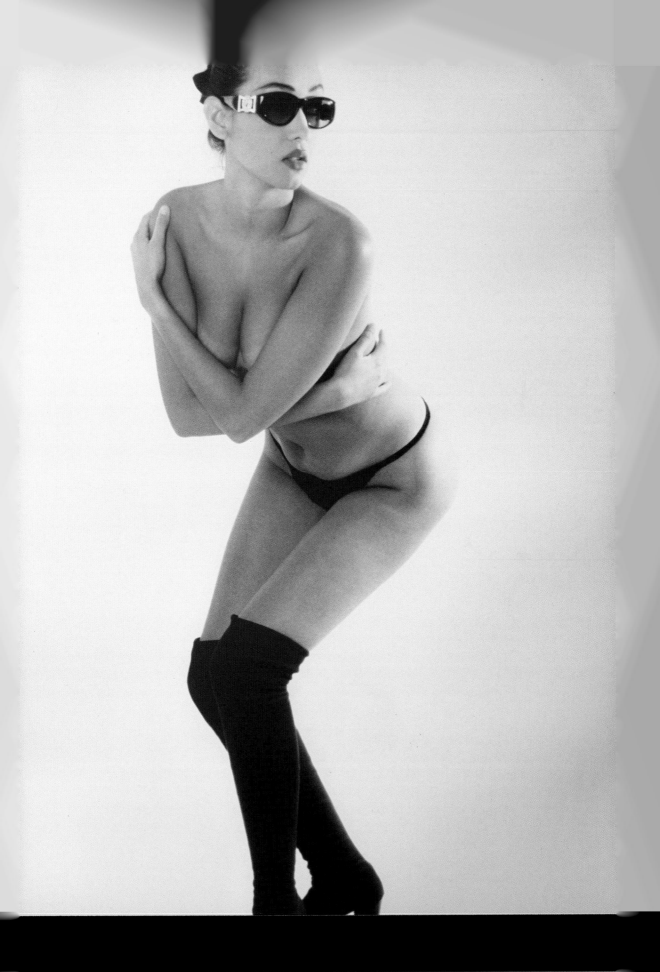

THE PROPOSAL

photographers **Ben Lagunas and Alex Kuri**

client	Private art
use	gallery
assistant	Isak, Christian, Paulina, Janice
art director	Ben Lagunas
stylist	Vincent St Angelo
camera	6x6cm
lens	350mm
film	Kodak Tmax
exposure	1/125 at f/11
lighting	electronic flash

Just a single focusing spot gives the dramatic look to this shot.

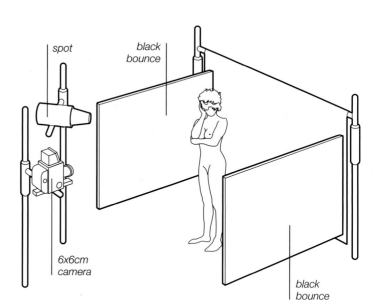

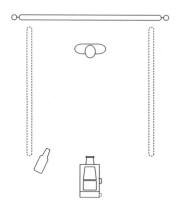

plan view

key points

Props can be used not only in their own right, but also to provide interest and variation to the lighting

Black panels can dramatically reduce the fall-off within an image

The shadows of the arm are strong and clearly defined, the features of the face are clearly delineated with the shadow under the chin giving definite modelling, and the shadow of the model against the backdrop breaks it into two distinct zones of light and dark.

The black panels enhance the fall-off to the sides, adding to the clear-cut modelling and crispness of the final image.

The mask is an arresting prop in itself and works well to emphasise the "proposal" of the title that clearly emanates from the eyes (further emphasised by a catch light). The position of the model's arms is all-important, concealing one breast and framing the other, and thus drawing attention to the exposed nipple, which seems to stare at the viewer just as directly as the eyes do!

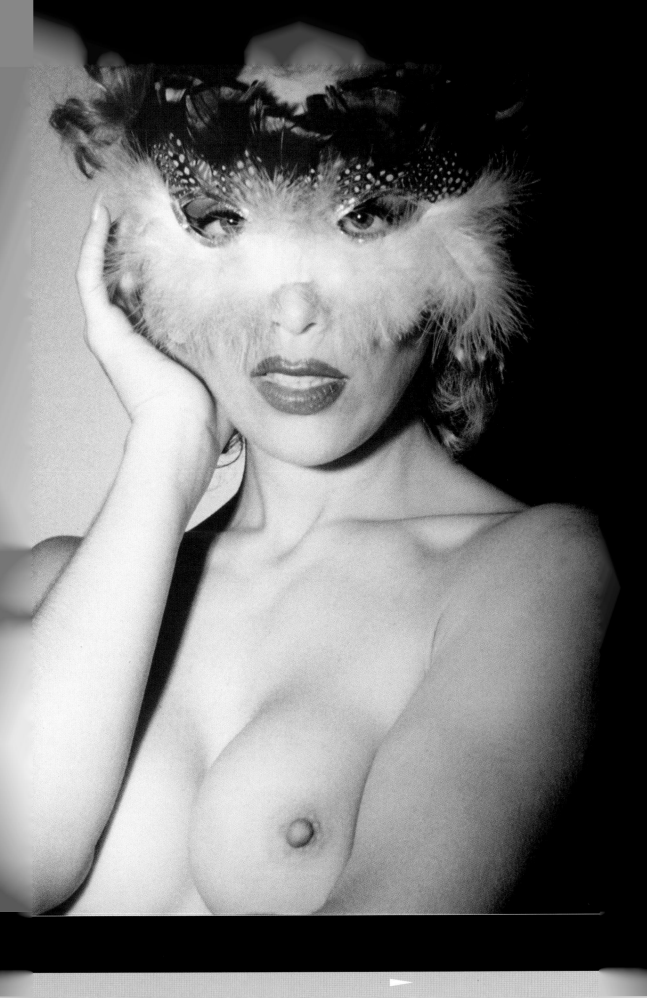

CARVED MASK

photographer **Frank Wartenberg**

use	publicity
camera	6x7cm
lens	90mm
film	Fuji Velvia
exposure	not recorded
lighting	electronic flash
props and background	grey paper background

It is interesting to compare this shot to Frank Wartenberg's "Smiling Face" shot.

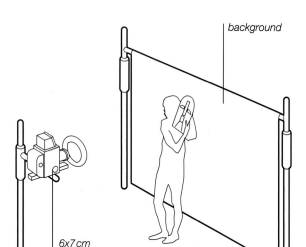

background

6x7cm camera with ring flash

plan view

key points

Experiment with perspective, i.e. changing camera position and focal length to see the effect on a lighting set-up

Inspiration can be drawn from historical sources, in any medium

The lighting set-up is the same: simply a ring flash in front of the lens. But an examination of the detail of the technique shows the differences. In this shot the model is a similar distance from the backdrop, as the model in "Smiling Face", but the camera and ring flash have tracked into a closer proximity relative to the subject. The result is a noticeably wider rim of shadow area surrounding the model and

mask, as well as on the arms, where the outline is also wider. The work is actually very reminiscent of the work of the surrealist photographers, such as Man Ray, working in the earlier part of the twentieth century, who employed strong dark outlines on figure studies. The mask composition is particularly related to his "Noir et Blanche", which uses a very similar prop.

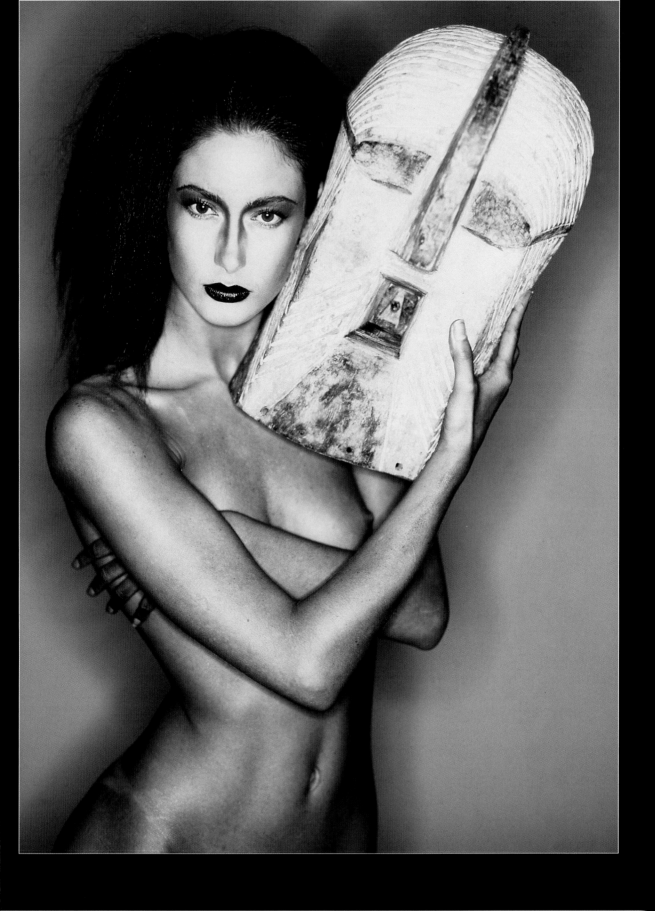

ACCESSORIES and PROPS

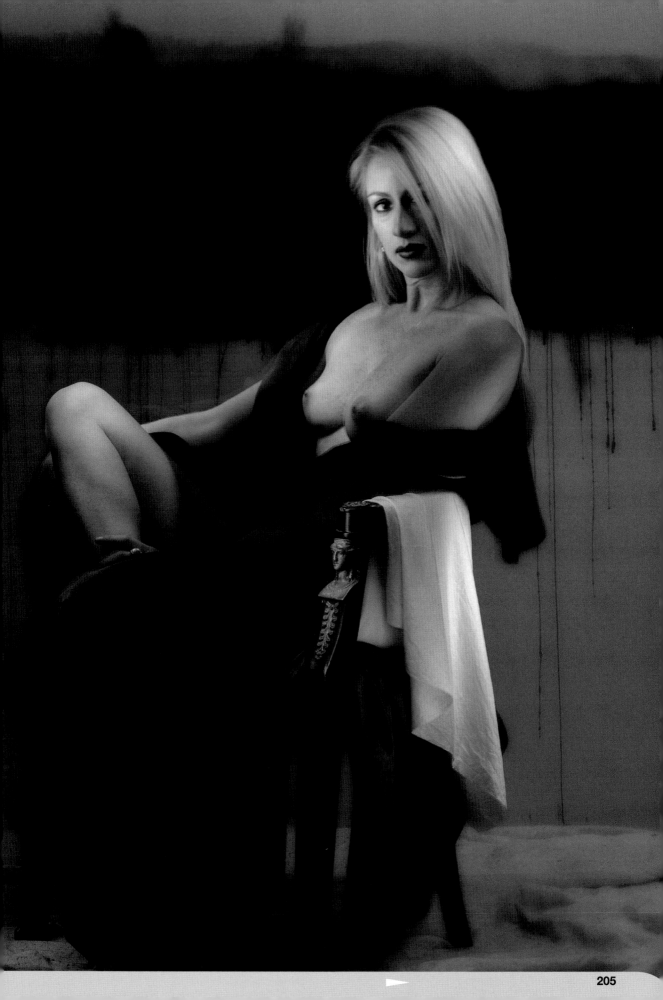

MARIA

photographer **Ricardo de Vicq de Cumptich**

use	exhibition
model	Maria Adelia
assistant	Ednaldo de Sousa Ramos
hair and	
make-up:	Joãozinho
stylist	Debby Gram
camera	4x5 inch
lens	210mm
film	Kodak Tmax 100
exposure	f/22
lighting	electronic flash and light
	brush

The four discrete layers of background imagery which in turn give three strong horizontal lines are visually powerful within themselves, but open to interpretation by the viewer.

plan view

key points

The larger the negative, the more we are able to see into the shadows

This shot is not lit "naturalistically" but for effect, which is an equally valid option depending on the end result required

This gives a sense of mystery to the setting, matched by the gleaming, ethereal quality of this image, which stems from the use of two different types of lighting. The initial exposure is from a large overhead soft box above the model and two standard heads angled either side of the backdrop and modified by diffusers. The shutter stays open for further exposure in the form of a light brush.

Here the photographer has applied the light brush to the hair, breasts and knee, to the scarf draped on the chair and an area on the floor in front of the model, and also to the side of the model's face. This highlighting of both the hair and the face is somewhat unnatural in appearance, but creates interest in the image.

The position of the high-key head is important, being placed against the dark strip of the background for separation. Equally important is the draping of the scarf, which echoes the shape of the hair.

STILETTOS

photographer **Corrado Dalcò**

client	The Saddler SNC
use	editorial
model	Adriana Giotta (Elite Milan)
assistant	Alberto Artesani
art director	Corrado Dalcò
stylist	Manuela Vignali
hair	Jonathan
camera	Polaroid 636CL
lens	38mm
film	Polaroid 600 B/W
exposure	1/15 second at f/11
lighting	electronic flash

This image by Corrado Dalcò demonstrates a very modern approach to composition and lighting. However the more traditional considerations of form, line, tone and texture are still the underlying and key ingredients to make the image work.

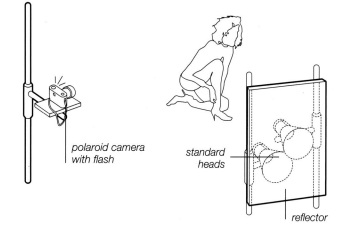

polaroid camera with flash

standard heads

reflector

plan view

key points

It is important to be aware of spatial relationships within a scene and to utilise the positioning of objects to provide shape

A wide-angle lens can offer an added dimension to a shot but can be prone to flare

The costume chosen is very simple with enough movement and interest to appeal to the eye. The choice of stiletto heels is a somewhat more standard fetish, but this is underplayed by the tight cropping. The actual physical setting is also of major importance, the recessed corner providing the potential for shadow, which in turn emphasises the long legs, which are also exaggerated by the wide-angle lens.

There is enough contrast to the image to obviate the necessity for generally hard lighting.

Two standard heads bounce off a white reflector panel to the right of the camera and an on-camera flash provides another blanket of light; just the right lighting to complement, but not over-exaggerate the graphic quality of the picture.

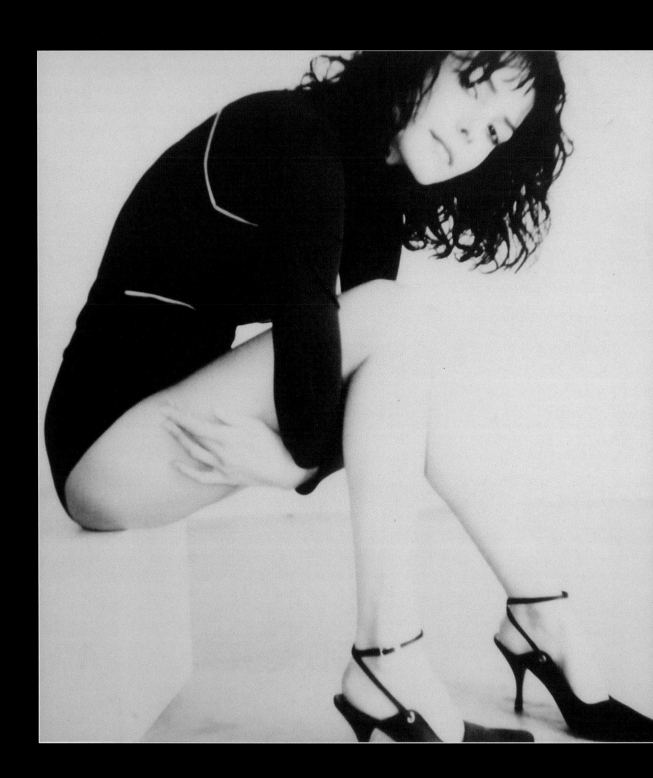

ACCESSORIES and PROPS

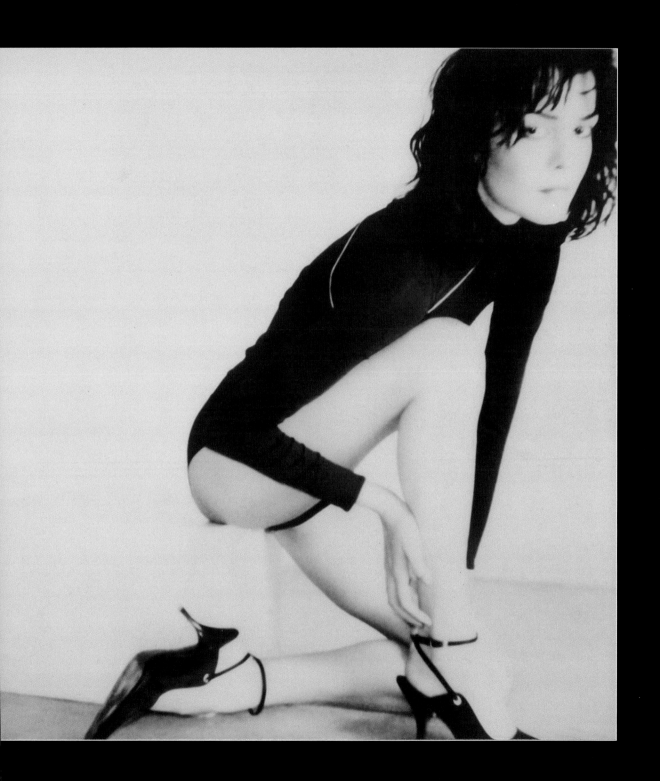

UNHARD ROCK!

photographer **Salvio Parisi**

The imaginative styling of relatively innocuous props gives this shot its powerful impact.

client	Trend magazine
use	editorial
model	Stefania A'Patz
assistant	Chicca Fusco
art director	Salvio and Massi
make-up	
and hair	Clemente Oliva
stylist	Giotto
camera	Canon EOS 1N 35mm
lens	135mm / f/2.8
film	Kodak Ektachrome 100 Plus
exposure	1/125 second at f/8
lighting	electronic flash
props and	
background	white paper background

plan view

standard head with honeycomb and blue gel

black bounce

35mm camera

black bounce

key points

A honeycomb can be used to create a "directional soft light"

Different manufacturers' film stocks render colours with different hues. It is worth experimenting with numerous stocks to establish your preference

"This belongs to a series for a magazine editorial on fashion accessories, with a sexy and ironical mood," explains photographer Salvio Parisi. "That's why it's got a cold light blue dominant and the accessories are worn in an improper way (the model has a metal tie knot in her mouth and a garter belt as a mask!)." The fierce model pose, cool lighting and provocative use of the accessories combine to produce a strong, "in your face" erotic image with a humorous twist. The set-up for this shot is virtually identical to that used for Ben Lagunas and Alex Kuri's "Amore" shot, in terms of the positioning of the source light, reflectors and model. The difference lies in the relative hardness and softness of the sources. Whereas Ben Lagunas and Alex Kuri chose a hard key, producing deep black shadows, Salvio Parisi has modified the standard head with a honeycomb and a blue gel to soften and cool the look. This arrangement produces a less deep, translucent shadow behind the model.

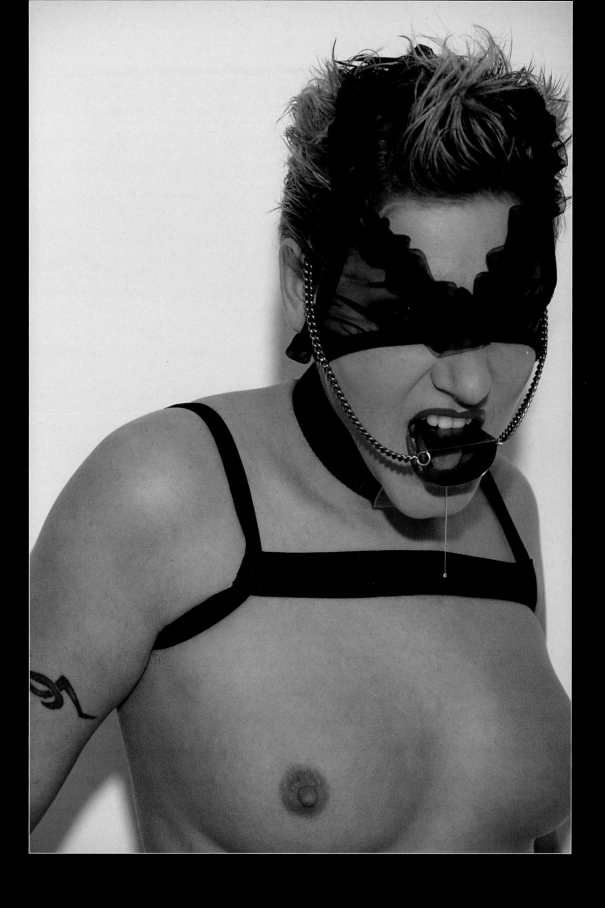

TEXTURES,
11 PATTERNS and
FORMS

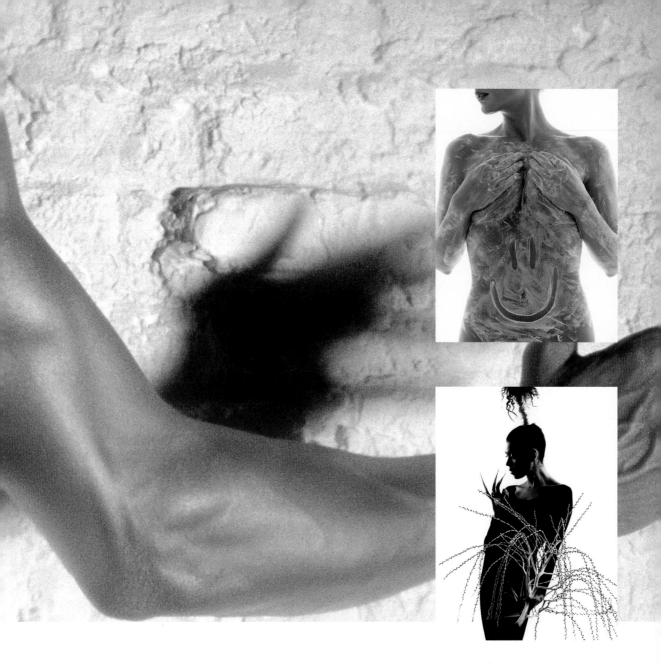

Textures, patterns and forms make a strong impression on the eye and they can come into their own as a major factor in the impact of a shot. Textures and patterning motifs might be part of the background, part of the foreground, a feature of the costume or model styling, or, of course, an aspect of the lighting. Successful composition and model-posing rely hugely on an appreciation of form, and on a thorough understanding of lighting.

Textures and forms can have a quite different impact when shot in colour or black-and-white. Colour can detract from the graphic idea that is being conveyed, while monochrome can emphasise the tones that are an inherent constituent part of the textures. The preponderance of black-and-white shots in this chapter is not just coincidence!

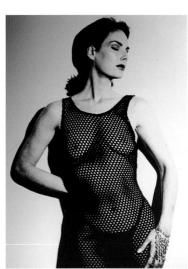

WOMAN WITH BACK ON PUMPKIN

photographer **Benny de Grove**

client	Flanders Expo
use	exhibition
model	Filip
assistant	Ann Temmmenman
art director	Anja Forceville
camera	6x6cm
lens	150mm
film	Kodak Tmax 100 ISO
exposure	not recorded
lighting	electronic flash

"The standard head had to be the strongest source because I only wanted a silhouette rather than the whole figure," says photographer Benny de Grove.

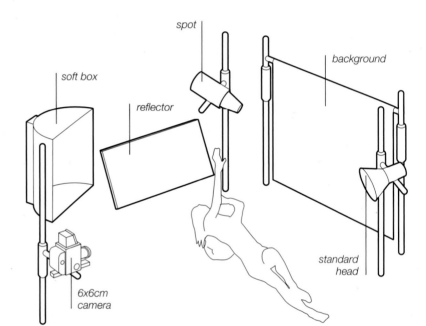

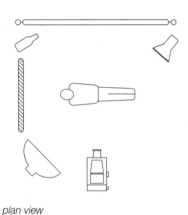

plan view

key points

Notice how a key light can also act as a back light and be effectively dual purpose

Picking up on thematic elements and motifs (such as textures, subject matter, lighting patterns) can make for a strong composition

Benny achieves this very successfully using three flash heads and one white reflector panel. Overall this is a low-key image but with areas of high key, which gives high contrast and a creative "take" on traditional silhouette. A standard head is placed behind the model to the right. Diagonally opposite this is a one-metre square soft box providing fill light and highlighting certain areas of the model. The white reflector bounces light from the key at the back onto the foreground areas of the subject. The third head is a focusing spot aimed at the background, providing a pool of light behind the model. To add interest to the composition the background is painted with similar textures to the pumpkin over which the model is arching. Notice how the positioning of the key head (back and high) allows light to skim over the model and the pumpkin, just defining both the bones of the model's rib cage and the ridges of the pumpkin flesh, to emphasise their textural similarities.

photographer's comment

The picture was developed with a brush.

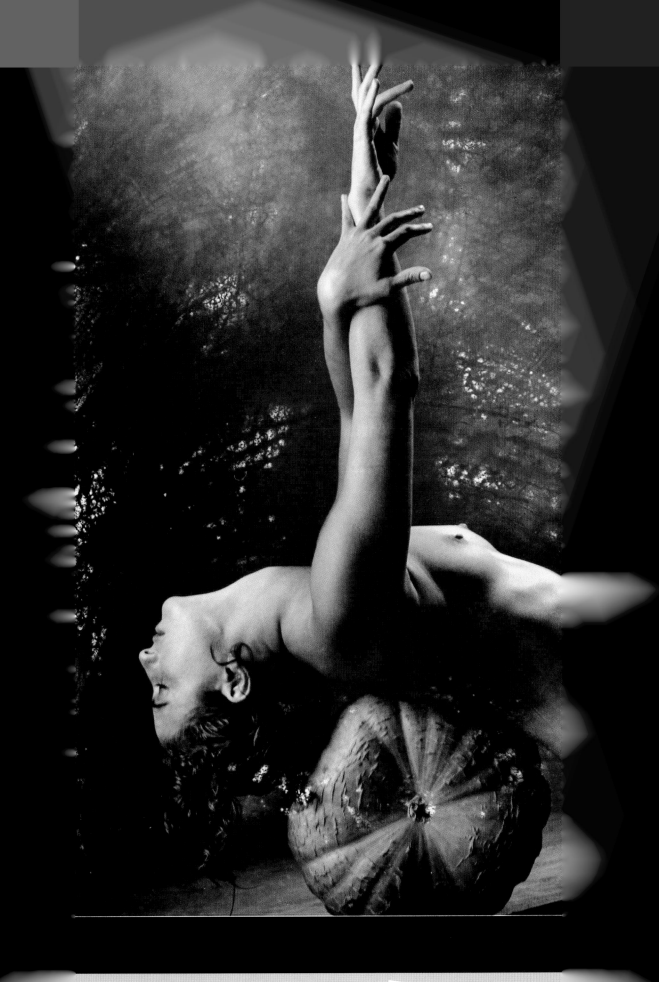

PALM

photographer **Nopphadol Viwatkamolwat**

client	Hasselblad (USA)
use	showcase advertising
model	Alla McKeon
art director	Nopphadol Viwatkamolwat
stylist	Jody Demarcos
camera	6x6cm
lens	80mm
film	Kodak Tmax 100
exposure	1/125 second at f/8
lighting	electronic flash
props and	
background	black nightgown. Palm branch, Thai dancing nails, seamless background

plan view

Compare this shot with Benny de Grove's "Woman with back on pumpkin" as another slant on the use of the silhouette and the compositional technique of using textural motif effectively.

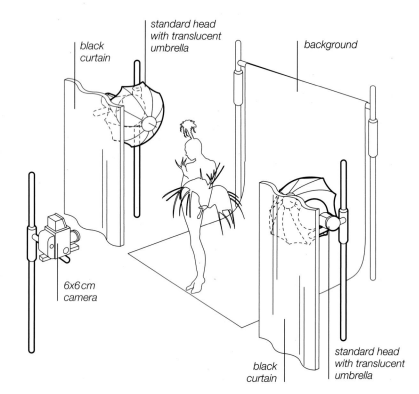

key points

Compositionally, the palm branch, fingernails and hairpiece are carefully selected for their interrelationships and textural qualities

There are degrees of black, but virtually nothing will reflect off an absolutely matt black surface

Whereas Benny de Grove uses a low-key image with areas of highlight on the model, Nopphadol Viwatkamolwat has created a high-key image with a very low-key main subject, which, overall, makes for high contrast. There is no front light for this dramatic shot. The model stands against a white seamless background between two black curtains, which shield her from most of the spill light from symmetrically placed standard heads with translucent umbrellas. Just enough spill is allowed to fall on the forehead, nape of the neck and hairpiece to lift these areas. The palm branch and fingernails are also lit by the carefully judged spill. The choice of dark-skinned and dark-haired model, in a matt black costume, means that without any front light she will be in silhouette, no matter how much spill light there is. The palm branch and all-important fetishistic false fingernails, by contrast, sing out against the dark background of the model.

photographer's comment

A dramatic look can happen from a simple technique but it has a unique style.

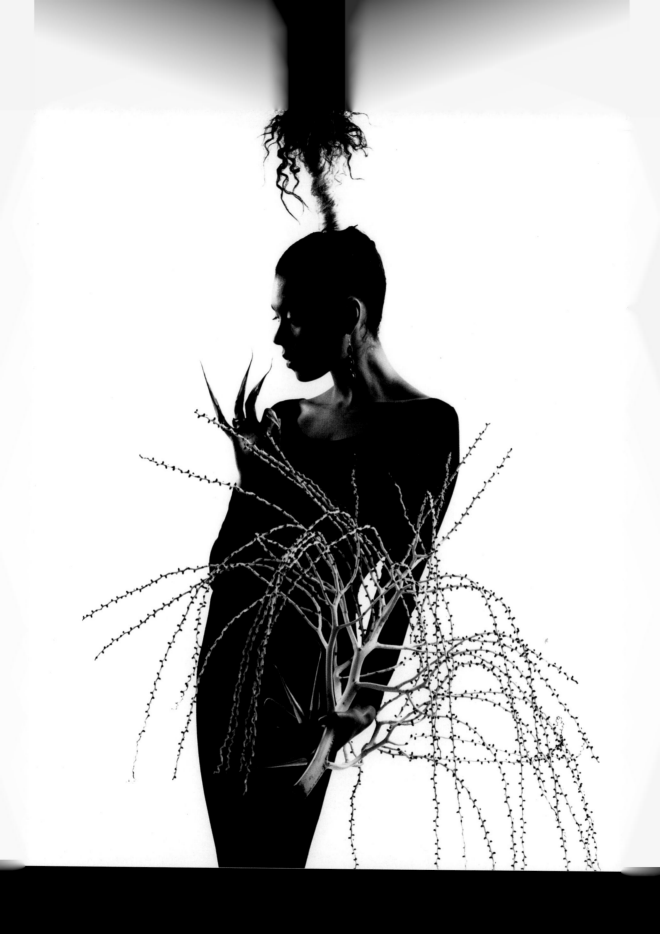

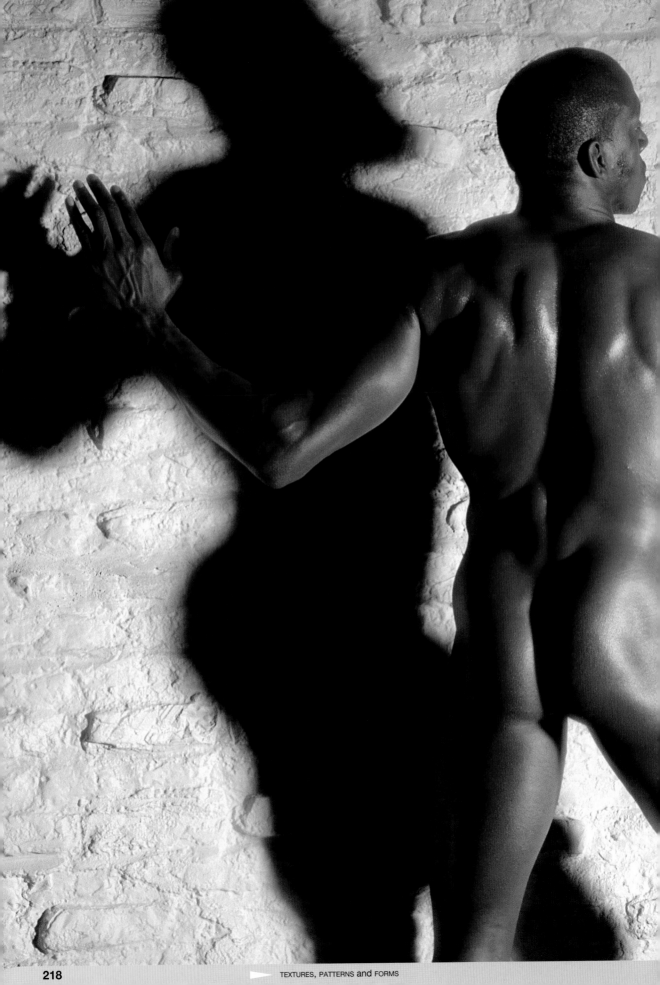

▶ TEXTURES, PATTERNS and FORMS

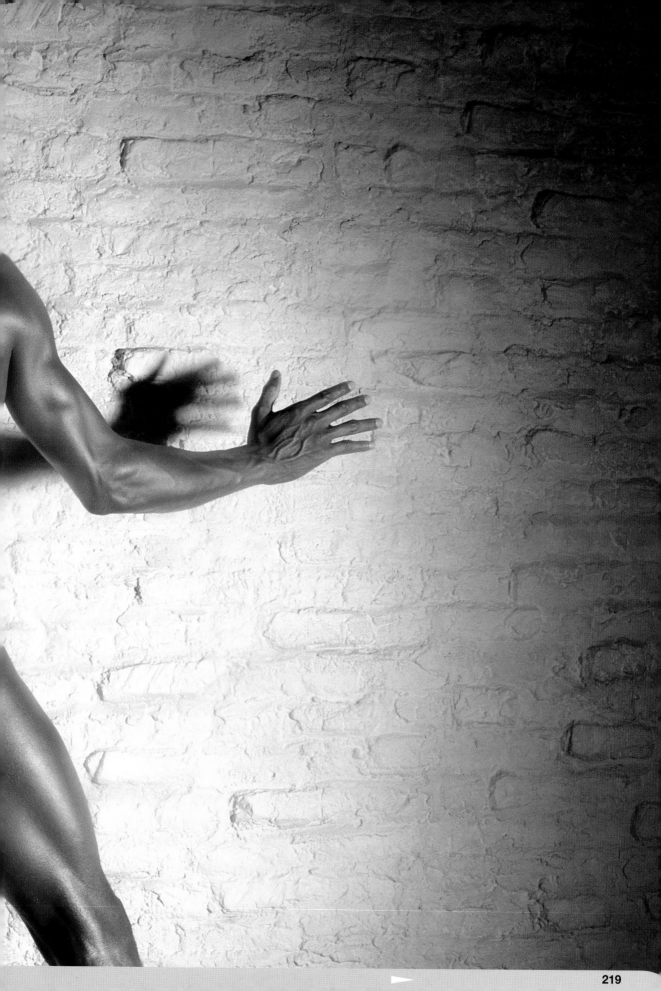

MAN WITH SHADOW

photographer **Patrick Coughlan**

client	Heavenly Desires
use	brochure
model	Ronnie Moore
assistant	Nick Austin
art director	Steve Foster
camera	RB67
lens	130mm
film	Kodak EPP 120
exposure	f/16
lighting	electronic flash
props and background	artificial brick wall painted white

plan view

It is important for the model to be standing close to the wall for two reasons in this example.

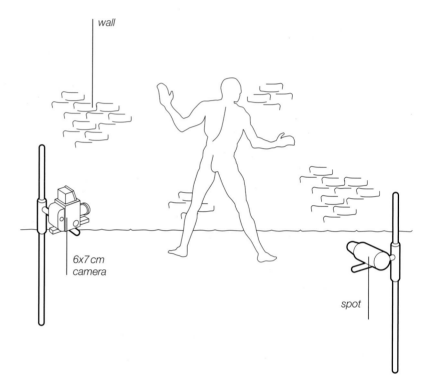

key points

Darker skin tones absorb considerably more light, so incident meter readings should be modified accordingly

First, the shape of the shadow forms part of the composition. Second, the nature of the shadow comes from the positioning and proximity to the wall, but also from the photographer's use of a projector spot with a focusing lens, which can be used to vary the sharpness of the shadow.

The projector spot is also chosen to give a circular type of fall-off light to the right of frame. This is manipulated to be soft fall-off and not hard-edge.

TIFFANY

photographer **Bob Shell**

use	stock
model	Tiffany
camera	35mm
lens	50mm
film	Kodak E100 SW
exposure	not recorded
lighting	electronic flash, slide projector
props and	
background	brown muslin

In this pair of shots, Bob Shell explores the possibilities of two poses using the same model and lighting set-up each time.

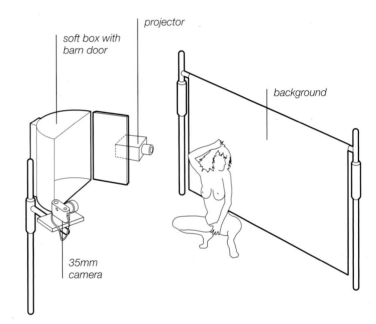

plan view

key points

It is interesting to shoot off a whole series of shots using the same lighting set-up to discover what works well

It is important to establish a good professional working relationship with a model to keep them at ease and so they feel comfortable

There are two light sources: a small soft box with a barn door for the model and a slide projector for the background to give it just a little "lift".

The contrasting poses demonstrate the different effects that can be achieved by positioning the body in different planes in relation to the light source. In the front view, the torso is lit straight-on by the soft box and the arms are angled similarly to give bright lighting on the near surfaces and swift fall-off on the back surfaces. This emphasises the front of the body as the main area of interest and establishes a smooth flattering highlight across this area, with a well-defined black outline at the fall-off edges. In the back view, the main interest is not the central torso (back) area, but the arm, leg, haunches and breast. The model's pose causes these to be side-lit; and the lowlight areas on the off-side from the soft box are also visible. This composition provides mottled shadows on the back, giving a textural interest that contrasts with the stark fall-off look of the first shot.

Photographer's comment

The barn door is to keep spill off the background.

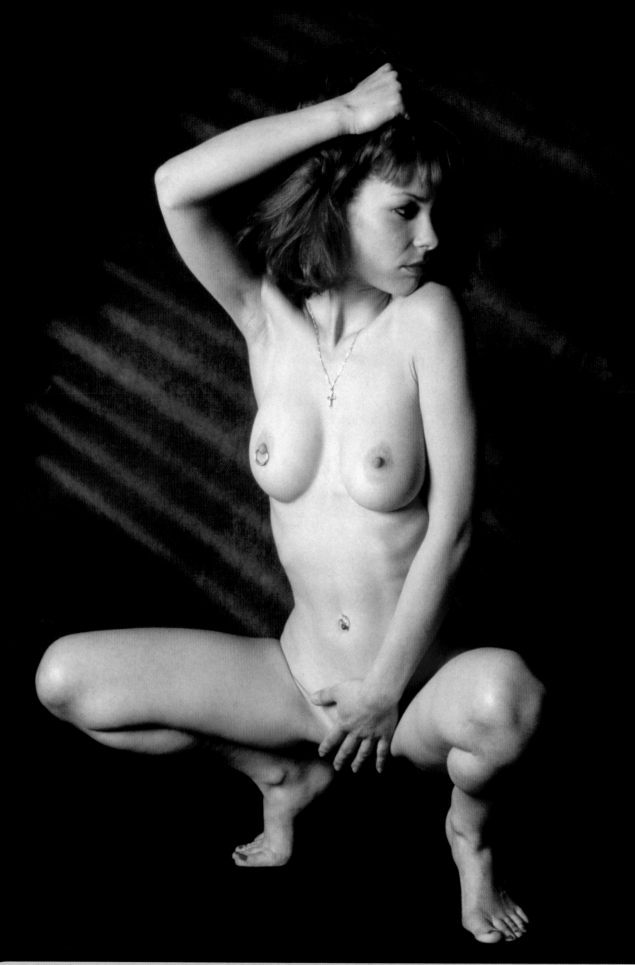

▶ TEXTURES, PATTERNS and FORMS

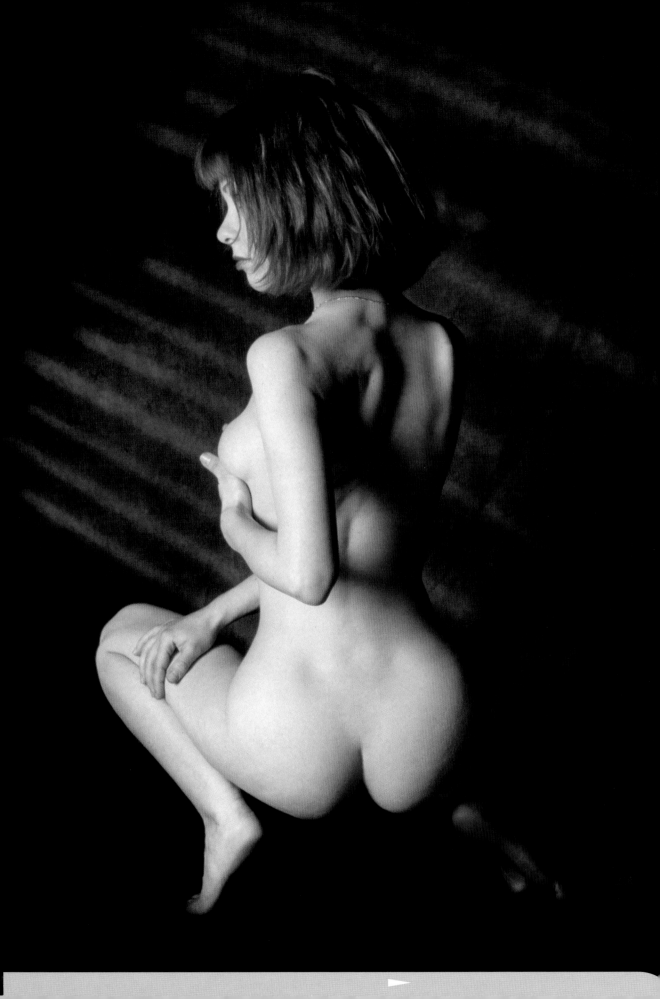

AMORE

photographers **Ben Lagunas and Alex Kuri**

client	Private art
use	gallery
assistants	Isak, Christian, Paulina, Janice
art director	Ben Lagunas
stylist	Fabian Montana
camera	6x6cm
lens	350mm
film	Kodak Tmax
exposure	1/125 second at f/16
lighting	electronic flash

This is a simple, effective image with a simple lighting set-up.

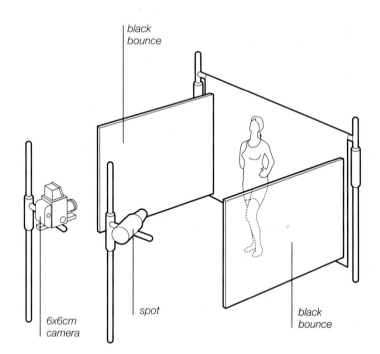

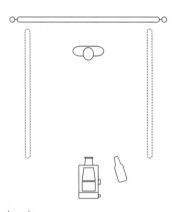

plan view

key points

A carefully chosen single source (used with reflectors and background) is often all that is required

A hard direct source is very versatile: it can be modified to become a soft source, whereas a soft source cannot be made hard so easily

The model is placed with her back almost right up against a white background. A tunnel is made with two black panels, one either side of the model, and perpendicular to the background. The camera is square-on to the model and slightly to the right, and about a foot above of the camera is a focusing spot. This single source shines down the tunnel, illuminating the model and background. The very sharp shadow behind the model on the left of the shot is caused by the use of a focusing spot

and the model's proximity to the background, and this is a very dark black shadow.

The choice of a black fishnet costume is dramatic and gives a feeling of rippling movement within the still image – the nature of this kind of fabric is to "map" the surface it covers, and to provide a sense of the rise and fall of the body it part reveals, part conceals. The fishnet texture of the dress is echoed by the chain-mail hand jewellery.

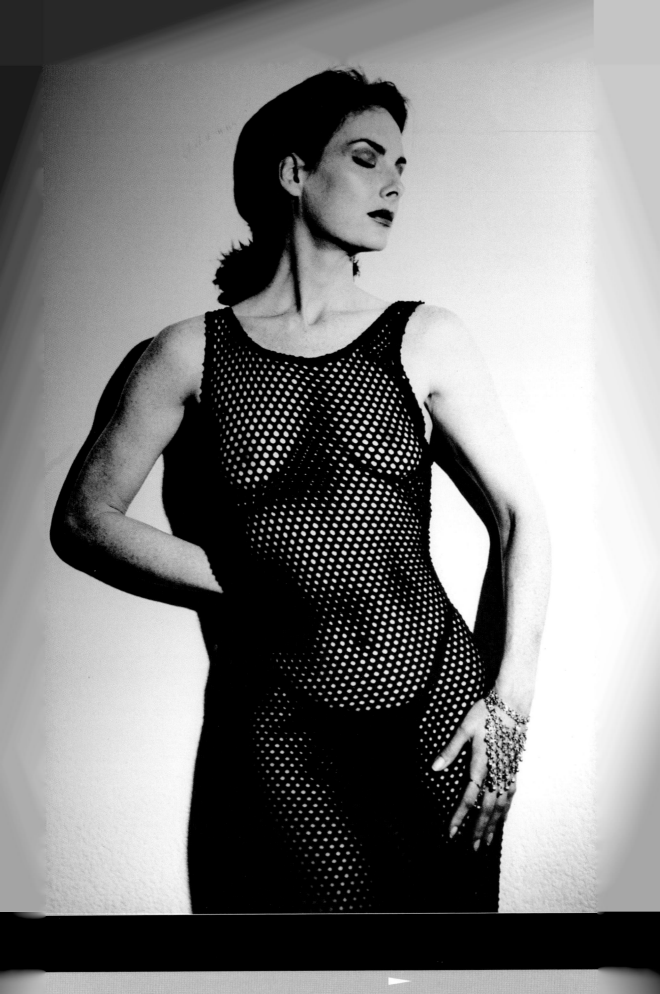

JACKIE

photographer **Jörgen Ahlström**

client	LC
use	editorial
model	Jackie
camera	RZ67
lens	90mm
film	Kodak GPH 100
exposure	not recorded
lighting	electronic flash

The giant Pro-Bouncer soft box itself provides the dazzling white background for this shot.

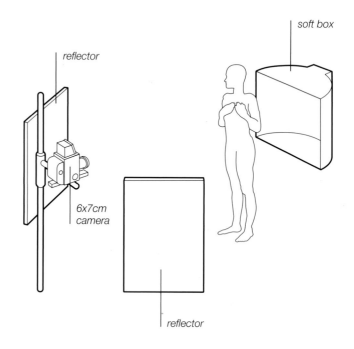

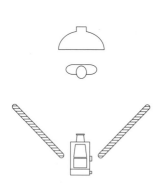

plan view

key points

Colour negative film has much more latitude than colour transparency stock

Flash light is much cooler than tungsten light in terms of actual temperature and so is probably better when working with substances that are liable to be changed by heat

Around the edge of the model is what might be described as a glare light rather than a rim light: notice how the model's outline is edged with a silvery gleam emanating from the far side of her body.

The front of the body is lit by two large white reflectors. These are placed one on each side of the camera and bounce back light from the soft box to give a symmetrical effect: look at the symmetry of the fall-off on both sides of the model's body. This arrangement also makes the most of the form of the soapy froth, catching highlights and lowlights on both sides of every part of the foam. It is not a naturalistic lighting set-up, but if the context does not call for realism there is no need to use a naturalistic arrangement.

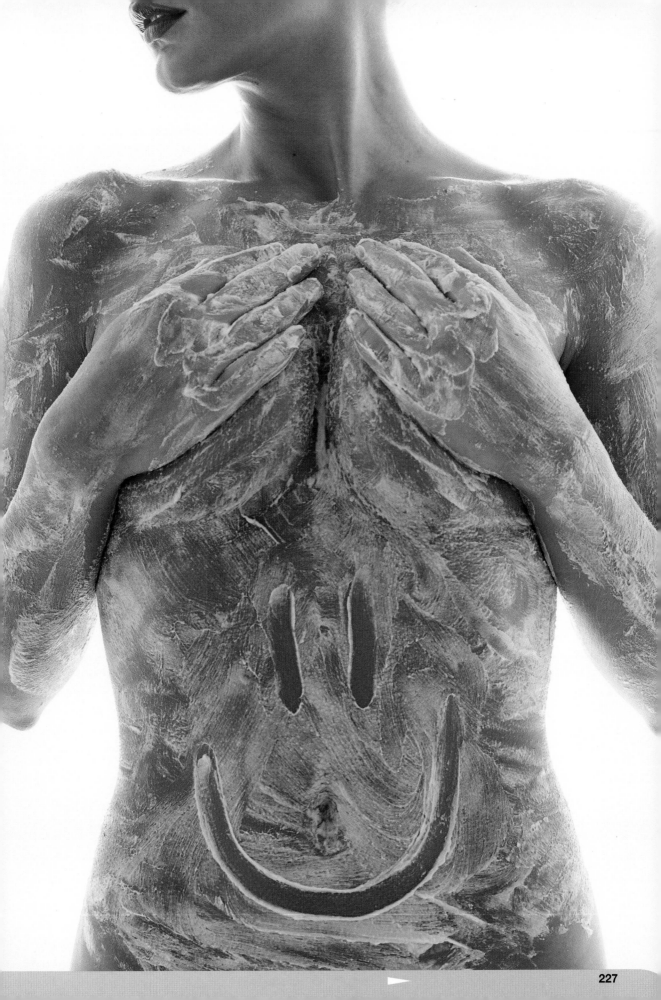

ANNIKA

photographer **Jörgen Ahlström**

client	Sturebadet (SPA)
use	poster
model	Annika
camera	RZ67
lens	105mm
film	Kodak PXP
exposure	not recorded
lighting	electronic flash

Two standard heads shooting into umbrellas provide strong, bright and even illumination on the seamless white background.

plan view

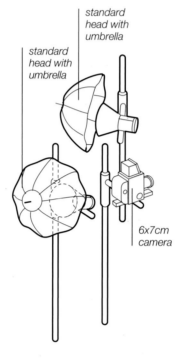

standard head with umbrella

standard head with umbrella

6x7cm camera

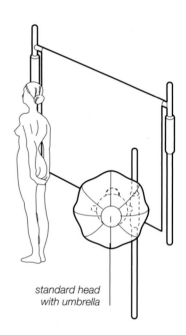

standard head with umbrella

key points

The harmony of the pose is carefully conceived: the upturned features of the face chime perfectly with the natural upturn of the breast and nipple

The model is lit by another standard head, again shooting into an umbrella and positioned immediately behind and above the camera. Separation is provided by the fact that the model is covered in mud-pack mud.

The application of the mud-pack changes the whole texture of the body and skin, and gives the surface a range of different crevices and ridges to catch the light. The shadows in the patterns of the mud give the body an almost sculptural form, reminiscent of the bold textures of a Rodin figure. The mud has been applied and patterned deliberately to emphasise the model's form. For example, the smooth sweeps across the breast provide a series of silvery lines defining its curvature as the light picks up the rippled texture of the mud.

The metallic thread hairnet is the perfect foil to the mud and skin textures, providing an area of intricate meshed design that reflects the light exactly at the position of highlight in the shot.

TEXTURES, PATTERNS and FORMS

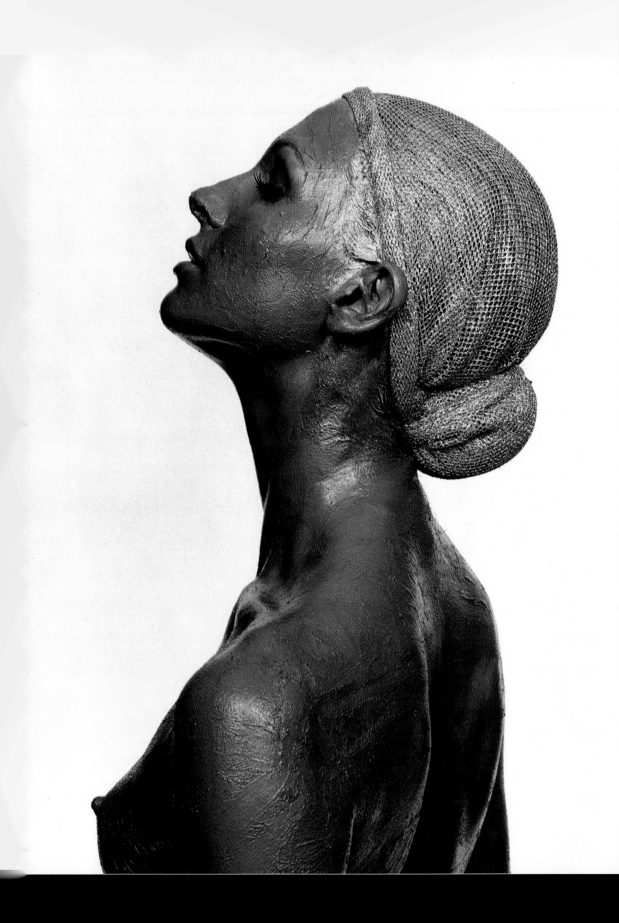

WHITE TRELLIS

photographer **Bob Shell**

use	stock
camera	35mm
lens	35mm
film	Kodak E100 SW
exposure	not recorded
lighting	electronic flash
props and	
background	garden trellis and black velour

The bold graphic form of the background trellis invites a spirited pose and interpretation from the model and photographer.

plan view

gold foil reflector

35mm camera

garden trellis

background

soft box

key points

Simple elements can combine to produce a far more complex image

Choice of film stock is very important if a warmer tone is required

Here the model's nakedness seems doubly vulnerable in this position. The upstretched arms against the rigid framework of the trellis, in conjunction with the straddled leg position and black stiletto heels, combine to suggest classic bondage imagery without explicitly depicting anything so risqué.

The subject is brightly lit by just a single large soft box to the right of the camera, bounced back from the left by a gold reflector which adds warmth to the body and highlights to the Titian hair and hair slide. It is very important that the background should have no texture or movement in order not to detract from the starkness of the foreground composition and subject matter. The black velour is chosen for its well-known light-absorbing and non-reflective qualities.

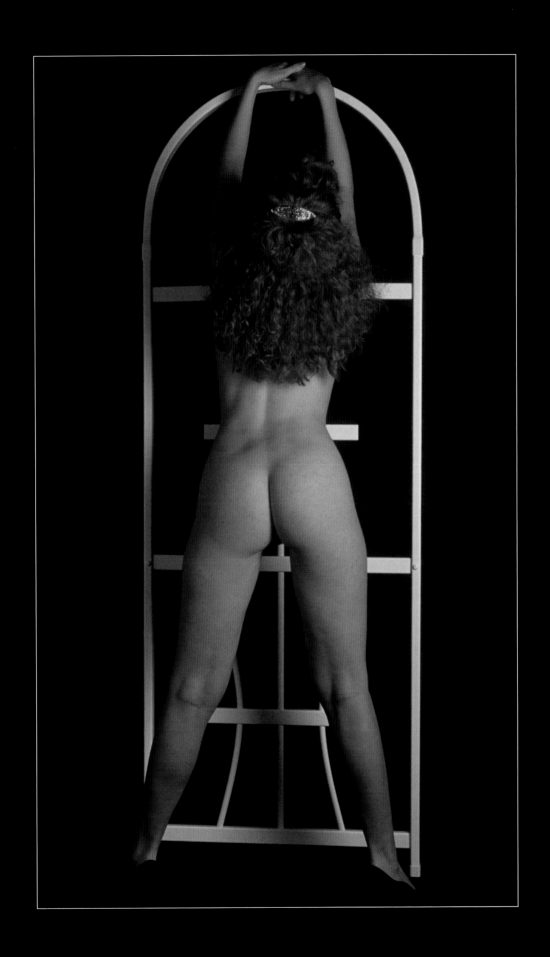

FETISH APPEAL

12

Fetish appeal is at once very narrow and very broad. For some, fetish
appeal lies in an extremely precise set of details, so very specialised and
particular to the individual's taste that it may be difficult for others to
comprehend. This is the sense in which fetish appeal may be narrow. The
other perspective is that almost anything might hold a secret fetish value
for someone, somewhere, so in this sense it is a very broad kind of subject
matter. Every individual responds differently to different things, and the
possibilities of fetish appeal might seem to be endless. However, various
common themes do seem to recur in erotic imagery. This chapter
concentrates on some of the subjects that are widely regarded as having
that indefinable fetish appeal.

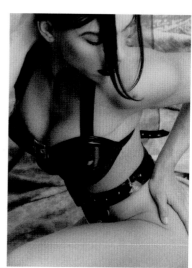

MARCI

photographer **Bob Shell**

Bright sunlight outside indicates the position of the sun as being slightly to the left, obviously on the far side of the building.

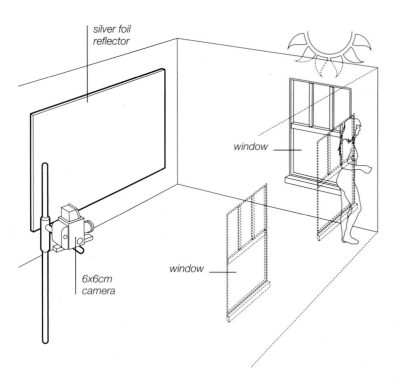

silver foil reflector

window

window

6x6cm camera

Available light from outside falls on the model's back to give the rim definition highlights, and a silver reflector, positioned to camera left, is used to bounce back some light as fill onto the rest of the model to lift the shadows slightly. This bounce also creates the pool of light on the floor in front of the model, as the shadows on the far side of her feet indicate.

The unevenness of the old glass in the windows adds to the soft effect of the look of the foliage outside. The highlights along the window ledges and linear structure of the window frames all draw the eye to the model at the centre of the composition.

use	stock
camera	6x6 cm
lens	50mm
film	Kodak E100 SW
exposure	not recorded
lighting	available light and reflector
props and	
background	location

key points

Be aware that the dense foliage outside also acts as a reflector and can add a greenish tinge to the shot, something that can be used to good effect

plan view

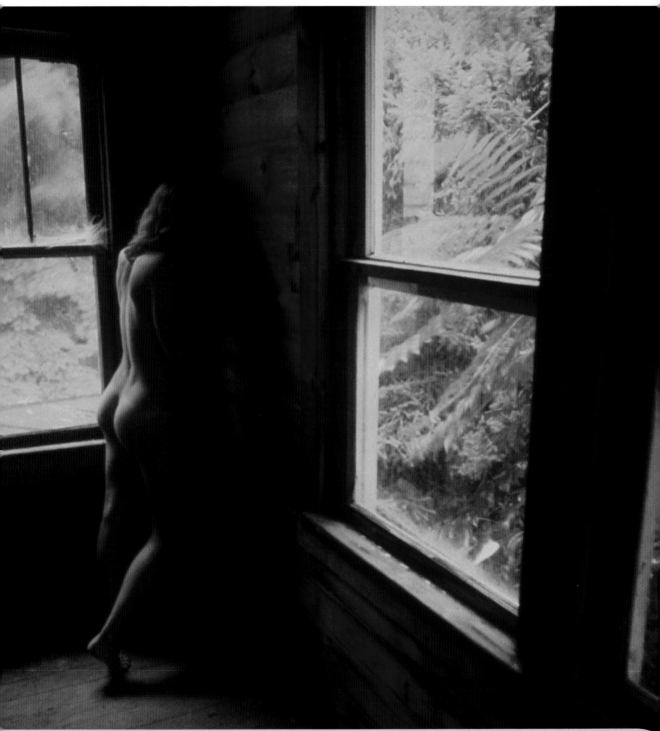

ANDROMEDA

photographer **Patrick Coughlan**

use	fine art personal work
model	Vicky Lee
assistant	Nick Austin
stylist	Alchemy
camera	RB67
lens	135mm
film	Kodak EPP 100
exposure	1/30 second at f/16 (flash) plus 1/4 second at f/16 (tungsten)
lighting	flash: Strobex
props and background	Colorama grey with white plinth

plan view

According to Greek mythology, Andromeda's mother boasted that she and her daughter were more beautiful than Aphrodite, the goddess of love, and thus incurred the wrath of Poseidon, who sent a sea monster to ravage the lands.

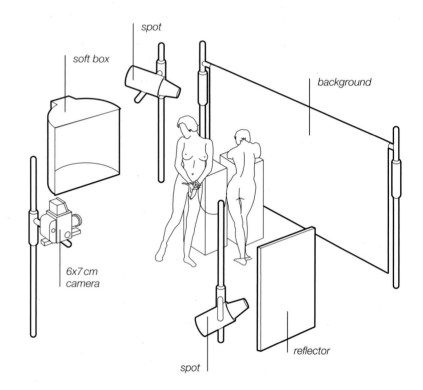

key points

Colour film shots can be duped onto black-and-white or sepia stocks later, if a different look is required

It is better to shoot an image "clean", i.e. without filtration or diffusion as these effects can be added later

The only remedy was for Andromeda to be delivered to the monster by being tethered to a rock on the coast. She was spared this unhappy fate by Perseus, who came along just in time, fell in love with her, killed the monster and rescued and married her.

Patrick Coughlan reinterpreted the crux of this legend – the idea of the tethered beauty – as an inspiration for a modern figure study. The image is the product of two separate exposures later assembled electronically into this 'front and back view' study. The lighting set-up was the same in both exposures and basically is a full-length soft box to the camera left of the model, with fill light provided by a 500-watt tungsten lamp at ground level, reflected off a white panel. The pool of light on the background is from a third 1000-watt tungsten spot, adding interest and providing separation.

photographer's comment

Two separate shots of Ms Vicky Lee, one full-frontal, then one rear view. Carefully grafted together via image manipulation.

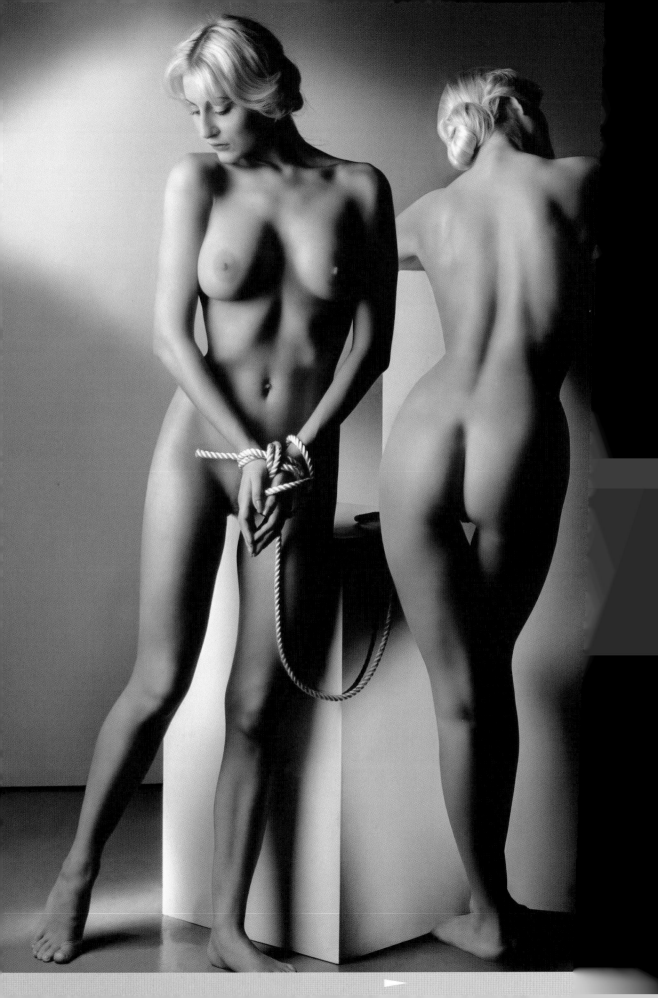

BITING GLASS

Photographer **Frank Wartenberg**

use	publicity
camera	6x7cm
lens	180mm
film	Fuji Velvia
exposure	not recorded
lighting	electronic flash
props and background	black velvet, glass

This image is a classic example of the notion of "theatre of cruelty". The drama and element of danger are extremely striking and this is supplemented by harsh, appropriate lighting.

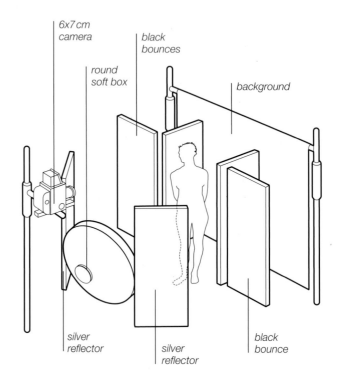

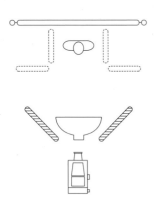

plan view

key points

In effect the glass shard is backlit because the soft box is in such a low position

The silver reflectors concentrate the light from the soft box, making it a very hard form of soft light

The restrained lighting set-up consists of only a circular soft box and a handful of silver reflectors. Equally important are what might be termed the "anti-light" items of equipment: black panels, black velvet, and dark make-up. The soft box is at a low position and in close proximity to the model, reducing modelling below the chin to give a flat, almost abstract expanse of skin against which the made-up facial features and all-important glass stand out starkly.

WHITE BOX RED BACKGROUND

photographer **Gary Darrar**

use	personal work
model	Evelyn
camera	35mm
lens	35–105mm
film	Kodak 100
exposure	1/60 second at f/8
lighting	electronic flash
props and	
background	white box, red background

This shot is a stunning example of the use of symmetry to create a formidable composition combined with soft lighting which is well controlled.

soft box

35mm camera

soft box

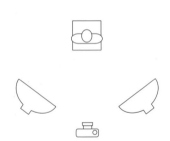

plan view

key points

Simplicity is the key to a superb image

Choosing the colour of items within a shot is very important when it comes to controlling the contrast ratio

The lighting is also based around the central axis of the shot with two large soft boxes relatively close to the model, one to the left and one to the right. The exposure is closely controlled so that good detail is clearly visible in the beautiful flowing long hair. The white box, which the model sits astride, is allowed to begin to burn out. This separates the model from the box and the box from the background. Finally the background is well saturated and has a devilishly warm, or in fact very hot, rich colour.

photographers comment

I wanted to try another shot, but the model couldn't bend that far.

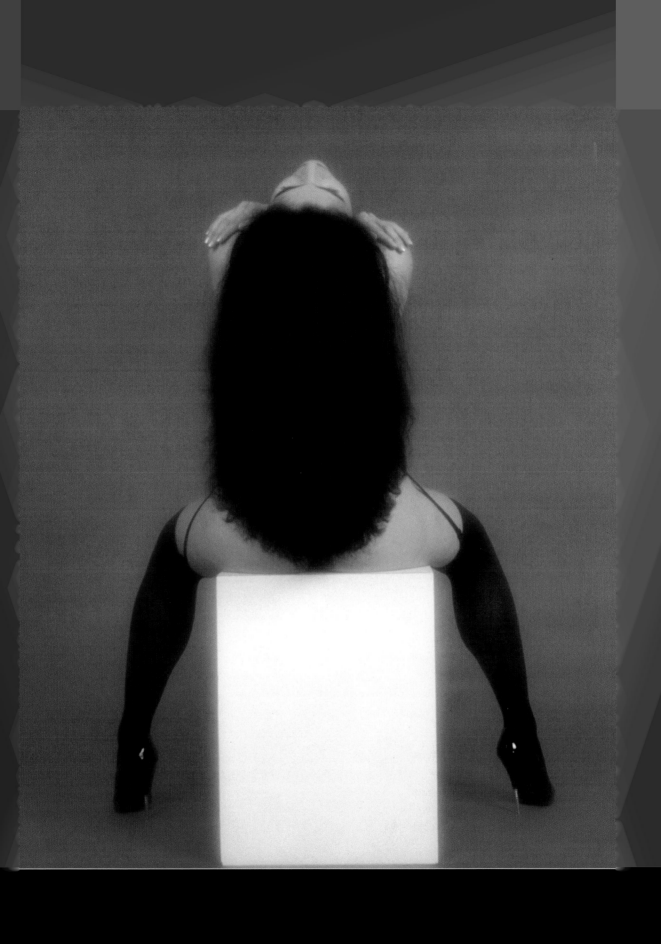

LYN

photographer **Bob Shell**

It is interesting to compare this shot with Bob Shell's "Liz". The lighting set-up is very similar, but not exactly the same.

Although both shots involve a large overhead soft box illuminating the full length of the model's body, in this case it is angled slightly more towards the near side of the model, giving highlights to the areas of skin facing the camera, rather than the outermost edges as in the "Liz" shot.

It is also positioned more to the feet end of the model, as the position of the shadows show behind the foot on the floor, the head and beneath the arched back. The emphasis from the lighting is on the torso and on the area framed by the stocking tops and suspender belt. Graphically, the pose of the legs and choice of deep black stockings and shoes draws attention to the classic fetish icons of the stiletto heels, clearly silhouetted against the painted background.

use	stock
camera	35mm
lens	35mm
film	Kodak Tri-X
exposure	not recorded
lighting	electronic flash
props and	
background	painted backdrop

key points

A painted backdrop can add interest to shadow areas and complement lighting generally

It is possible to use silhouette for selected areas of an image in order to emphasise particular features

plan view

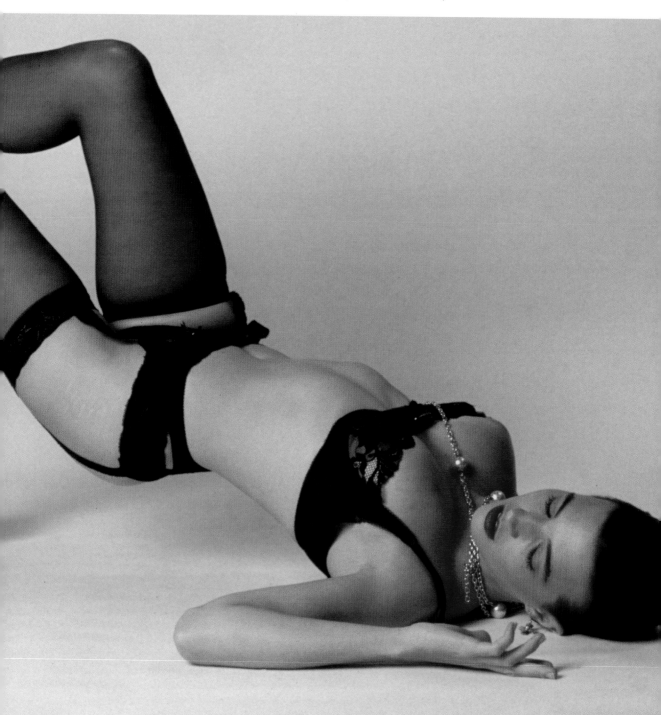

NICK

photographer **Bob Shell**

use	stock
camera	35mm
lens	85mm
film	Kodak E100 SW
exposure	not recorded
lighting	electronic flash
props and	
background	inflatable wading pool and shower

The model's costume has a good reflective sheen on the left-hand side of the camera, deriving from a combination of its wetness from the overhead shower and the not totally light-absorbent blackness of the material from which it is made.

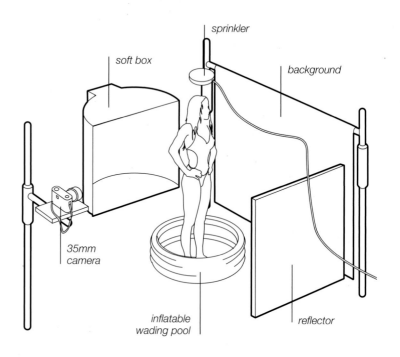

plan view

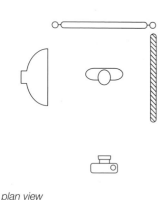

key points

The shutter speed is important when working with moving water: it needs to be at the most 1/250 second in order to freeze the water movement

Safety considerations are paramount when working with water and electricity

The single large soft box to camera left is sufficient to give warm, even lighting along the length of the model's body, and her position ensures reflective highlights at just the right point on the costume.

The near arm demonstrates well the use of a white reflector opposite a soft box source. The back half of the arm is very high-key in contrast with the dark,

yet just visibly defined side nearer the reflector. Similarly, notice the difference between the high-key reflective area on the bottom of the swimming costume (soft box side) and the dark, unreflective top (reflector side). It is important that the background is black to keep the overall rich warmth and intimacy of the shot.

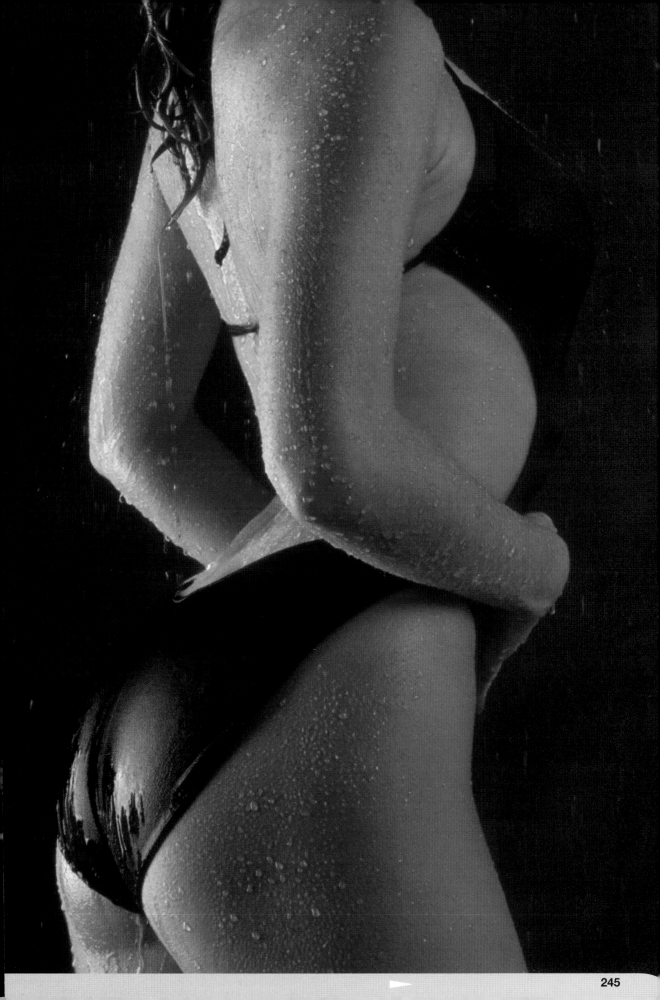

TIFFANY AND COLLAR

Photographer **Bob Shell**

camera	35mm
lens	35mm
film	Fuji Provia 100
exposure	not recorded
lighting	electronic flash
props and	
background	dog collar and chain

The key light is a large full-length soft box to the right of camera.

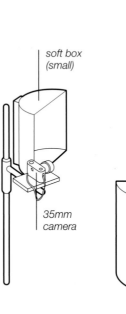

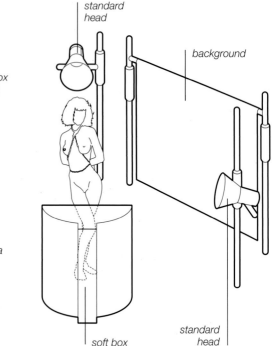

standard head

soft box (small)

background

35mm camera

soft box

standard head

plan view

key points

Props can change the whole mood of a shot, as can the lighting

Work to the strengths of the model

Fill-light is supplied from a smaller soft box further away and to the left of camera. To the back right there is a standard head which is a rim light. In this instance it is not actually opposite the key light because of the angle of the model's body: she is twisting slightly so the position of the rim light is adjusted accordingly in relation to her. Finally, to the back left there is a standard head accentuating the hair and providing the highlight.

The props for dressing the model are important: the chains, collar, nipple ring and bellybutton ring. The position of the key light ensures that these stand out against the skin. The colour tone of the skin is also important as a backdrop to these items. The necessary rich warm colour (rather than, say, an over-bright, slightly overexposed paleness that might have been chosen in other circumstances) is achieved by careful attention to exposure.

FETISH APPEAL

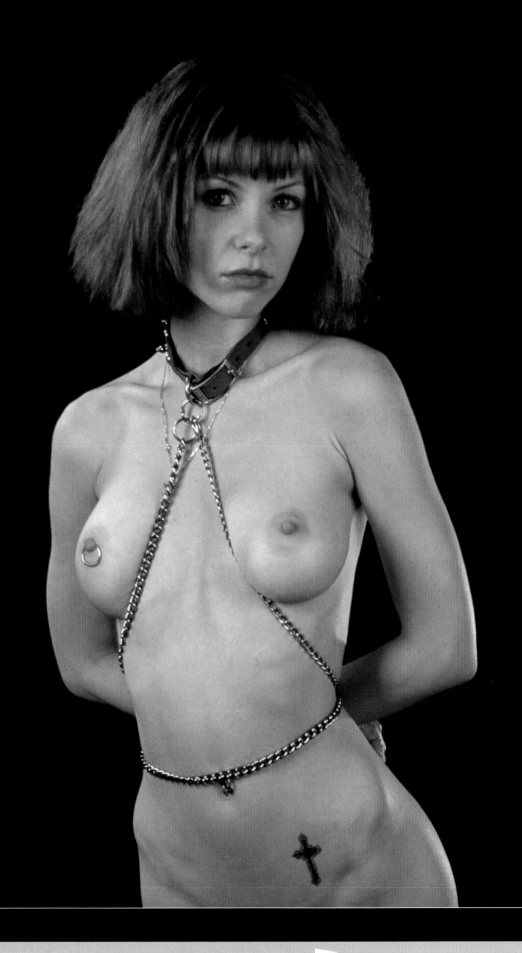

BLACK BRA

photographer **Craig Scoffone**

client	Fad Magazine
use	editorial
model	Tina Joe
camera	35mm
lens	45-125mm
film	Kodak Tri-X
exposure	not recorded
lighting	available light
props and	
background	leather lingerie

Using available light does not mean simply taking whatever nature happens to give you at any particular moment, as Craig Scoffone demonstrates here.

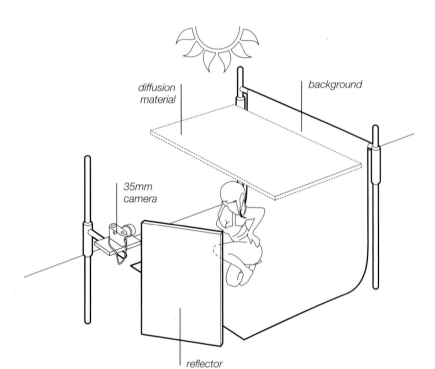

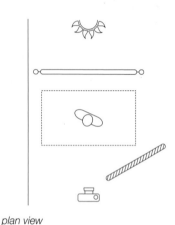

plan view

key points

Working outdoors is a perfectly viable option, but the variability of the sun and clouds can delay shooting

When working in a studio, the photographer has complete control over the lighting

Sunlight can be modified as required. In this case the direct overhead sunlight needed to be diffused, so Craig suspended a silk screen over the area of the shoot to act as a diffuser (just as the silk behaves on the front of a studio soft box). He placed the model against a white wall, which acts as a reflector on the left, and supplemented this with a white reflector to the right of the camera. The tight crop emphasises the lingerie and the model's limbs are positioned to frame the shot and the centrally important clothing.

The carefully positioned strands of hair hide the model's face and add to the eroticism as well as reinforcing the lines within the picture.

photographer's comment

In the patio of my studio I used the subject posed against a white wall under a suspended diffuser to create this photo for an editorial on erotic leather clothing.

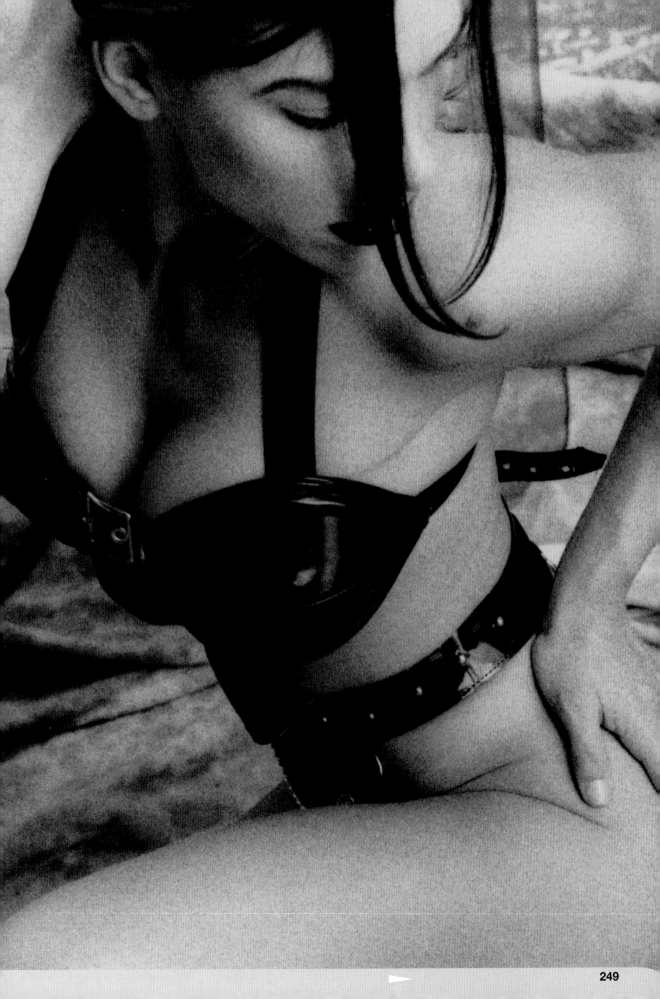

THE ROMANTIC
LOOK

13

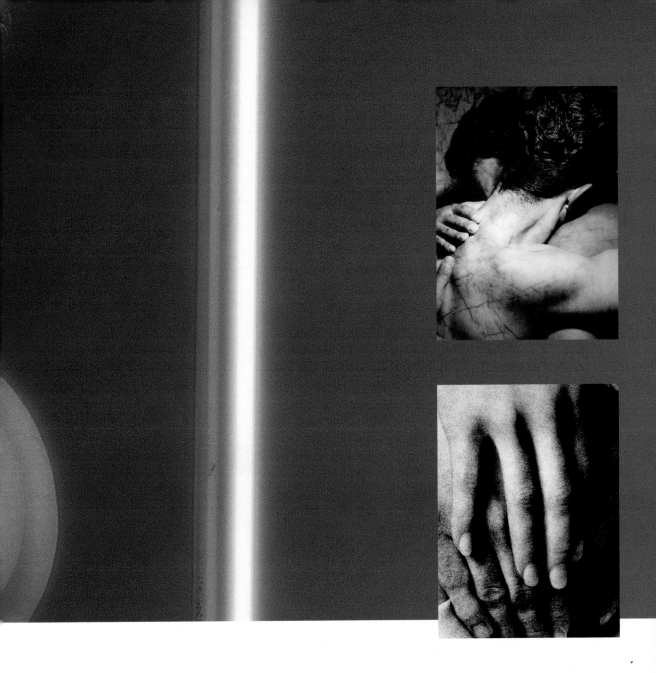

It is no accident that it is only in this chapter that we come to photographs of couples. In most forms of erotic imagery, the viewer is the second party in an erotic scenario, however it is portrayed, and often plays a somewhat voyeuristic role. For a romantic shot, however, the relationship needs to be modified in order to convey emotion and mutual intimacy rather than one-sided voyeurism.

This is not to say that a shot of a single model cannot convey romanticism, as many other images in this chapter will demonstrate. The essence of the romantic shot is the mood, and careful choice of styling, pose, expression and setting can all contribute to a romantic look that involves the viewer in a more emotional and not solely erotic scenario. Generally, romantic lighting is low-key, soft and easy on the eye, the candlelit meal being the classic example of a romantic setting.

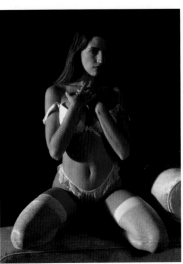

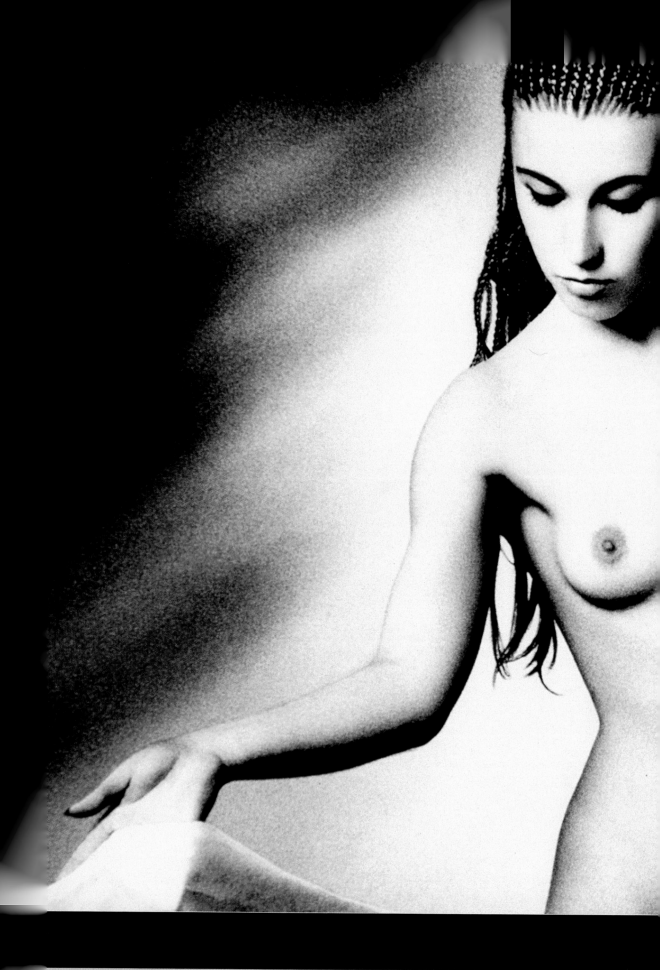

THE ROMANTIC LOOK

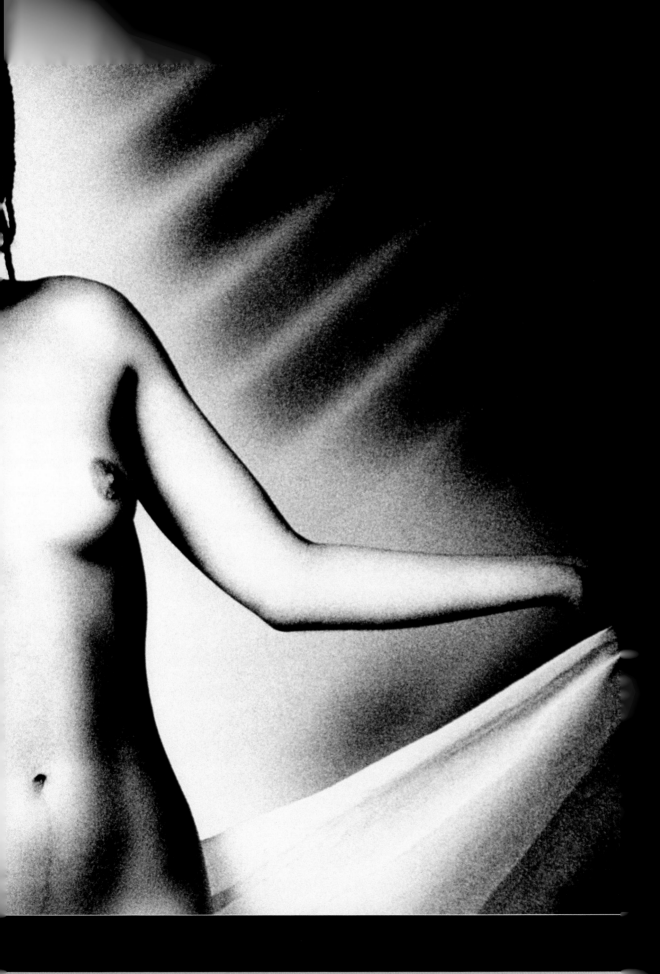

UNTITLED

photographer **Gérard de Saint-Maxent**

use	editorial
camera	Mamiya 645
lens	55–110mm
film	Tmax 400
exposure	1/60 second at f/11
lighting	electronic flash

The pool of light creating the aura-like effect behind the model comes from a projector standard head directed at the background and modified with a gobo to produce the bar pattern.

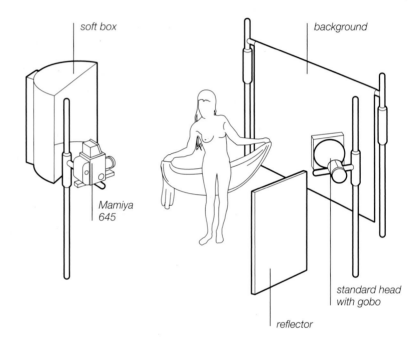

soft box

Mamiya 645

background

standard head with gobo

reflector

plan view

key points

It is very important to be aware of the great range of film stocks that are available and choose the right one to achieve the end result

Tmax is a very versatile film. It can be manipulated to be totally grainless or, by judicious lighting and processing, the grain structure can be made to appear.

The model herself is lit by a two-metre square soft box placed at a distance of about three metres from the subject and to the left of the camera. This is complemented by a white reflector one metre to the right of the subject.

For this shot, Gerard de Saint-Maxent has used Tmax 400, a fast film stock which allows him to achieve this high-contrast image. The granularity of the film itself becomes a distinctive feature here, and is a key element of the graphic nature of the image.

Adding to the graphic impact is the styling and pose of the model herself, with the clear-cut straight lines of her hair braids, and the crescent-like form of the drape that she holds reflecting the form and position of her arms and body.

HANDS

photographer **Gérard de Saint-Maxent**

use	editorial
camera	Mamiya 645
lens	55–110mm
film	Tmax 400
exposure	1/60 second at f/11
lighting	electronic flash

As with so many erotic compositions, what is not quite seen arouses even more interest than what is seen clearly.

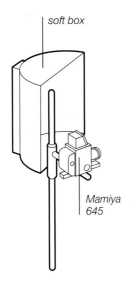
soft box

Mamiya 645

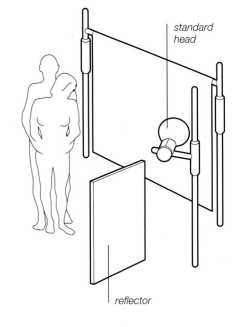
standard head

reflector

plan view

key points

The shadow area in a shot can be just as important as the midtones and highlights, and are often more important for a romantic moody shot

A more abstract image requires more attention to lighting detail

it is important for the composition and for the intimate mood of this shot that the crucial point of convergence, where hands meet body, should remain swathed in darkness and mystery.

Fall-off to camera right is therefore all-important, and the models are angled slightly away from the key light to camera left in order to achieve darkness at just the right point in the composition. The key light is at about

45 degrees to the camera, but straight-on to the central area of thigh so that fall-off also occurs on the outer edge of the leg, giving good definition against the background. A certain amount of light is bounced back from the right, but not too much: again, expert positioning of models and bounce ensure just enough "lift", without making too much totally visible.

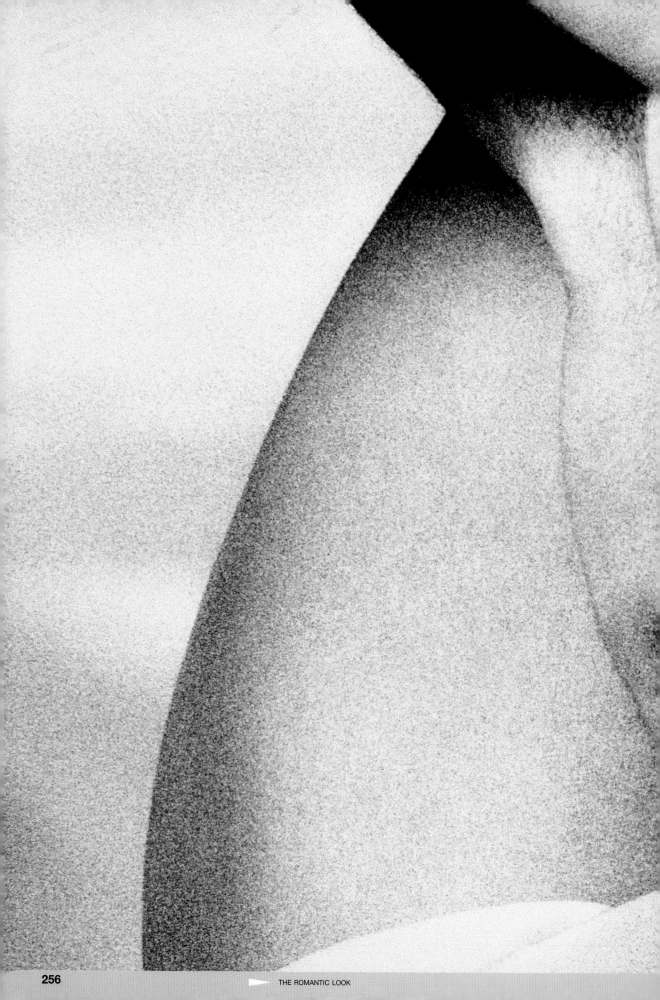

▶ THE ROMANTIC LOOK

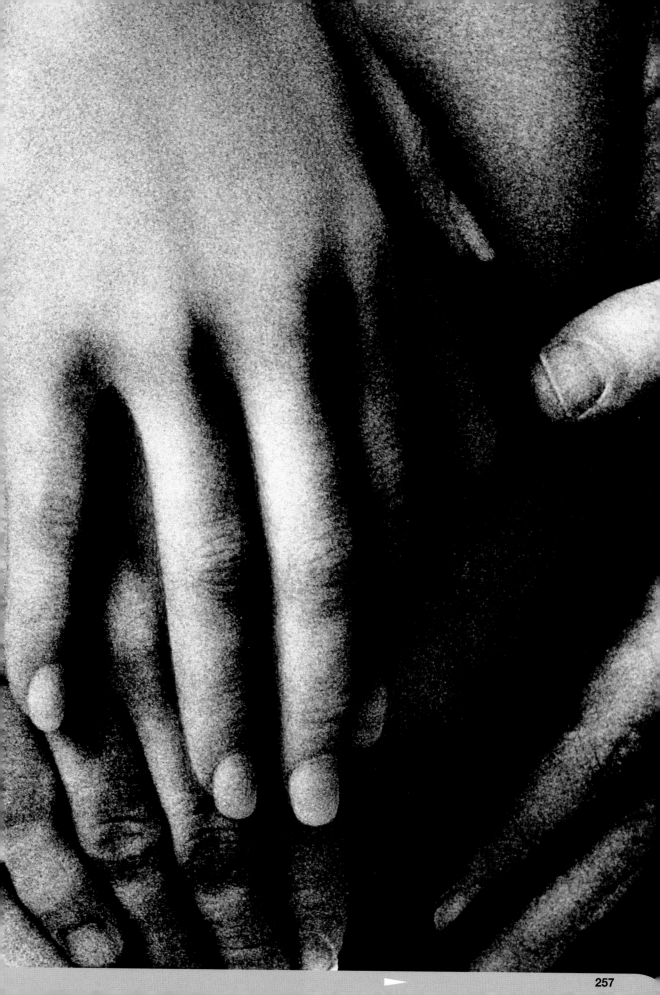

LOVERS

Photographer **Ben Lagunas and Alex Kuri**

client	Private art
use	gallery
model	Marlou and John
assistant	Isak, Christian, Paulina, Janice
art director	Ben Lagunas
stylist	Fabian Montana
camera	6x6cm
lens	350mm
film	Kodak Tmax CN
exposure	1/125 second at f/16
lighting	electronic flash

Ben Lagunas and Alex Kuri again demonstrate their mastery of the simple yet effective approach to lighting.

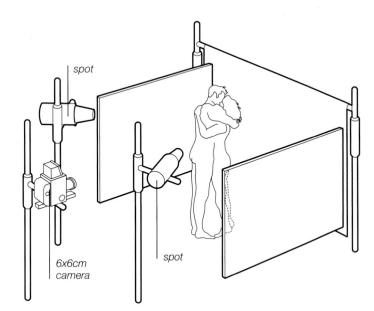

plan view

key points

For establishing a romantic mood, a low-key lighting approach is often the most appropriate

The multiplicity of shadows adds substantially to the mood. Naturalistic consistency of lighting is unimportant in this kind of context

A white panel is placed to the left, a black panel to the right, and two symmetrically positioned focusing spots, higher and further forward than the camera, cross each other and aim at the models. This crossing of the two spots results in shadows both to the left of the far model as well as to the right of the head in the foreground.

The tightness of the focus of the spots means that a relatively restricted area of the models is high-key – just across the shoulders and heads – while the upper and lower parts of the image remain quite dark, yet adequately illuminated to convey the detail required. The mystique of the shot is the perfect style for the ambiguous nature of the subject matter: the sex of the models is not clear, adding to the risqué eroticism.

photographer's comment

We used a toner on the paper and a texture to give more drama and force to the concept.

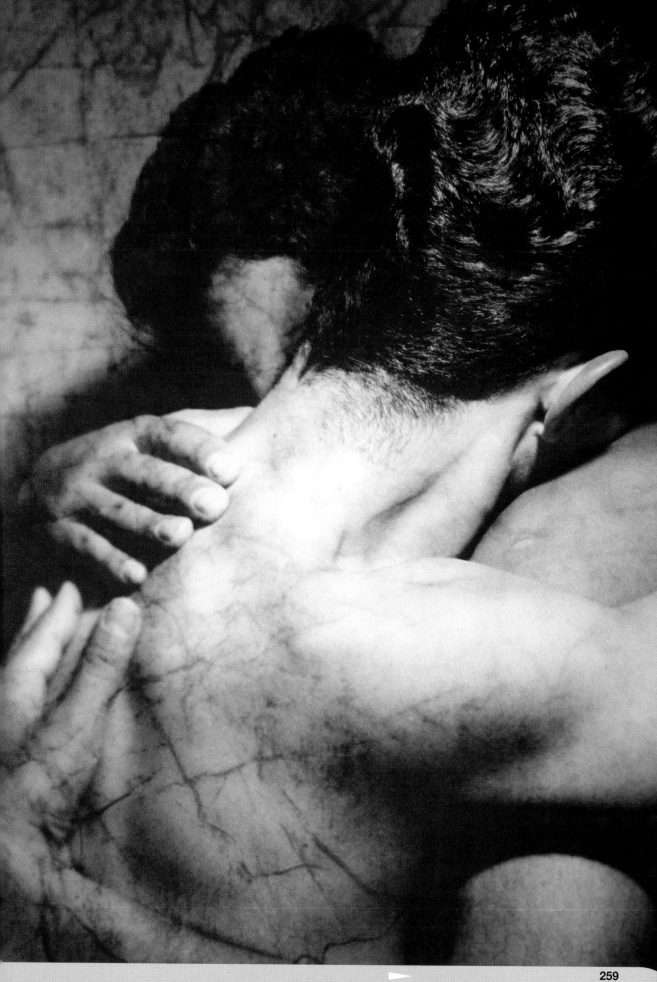

FARMYARD

photographer **Frank Wartenberg**

use	publicity
camera	6x7cm
lens	105mm
film	Kodak Tmax 100
exposure	not recorded
lighting	available light

This erotic shot combines the excitement of outdoor nudity with witty symbolism. The man is holding a long hard staff, and a multi-pronged one at that!

6x7cm camera with gel

black sheet with stones

plan view

key points

When on location, it is possible to use the surroundings as lighting tools

A combination of high and low key can provide a means to good separation

The ground is no accident. It is important that the far ground should be light and higher key for the form of the silhouetted lower body to stand out. This is supplemented and enhanced by the use of a black panel in between the camera and the model, just out of shot and flat on the ground. This black sheet was weighed down with stones on what Frank Wartenberg describes as a very windy day. It was also very cloudy with no direct sun, but an overcast sky can act like a giant soft box, in this case giving strong highlights on the upper torso.

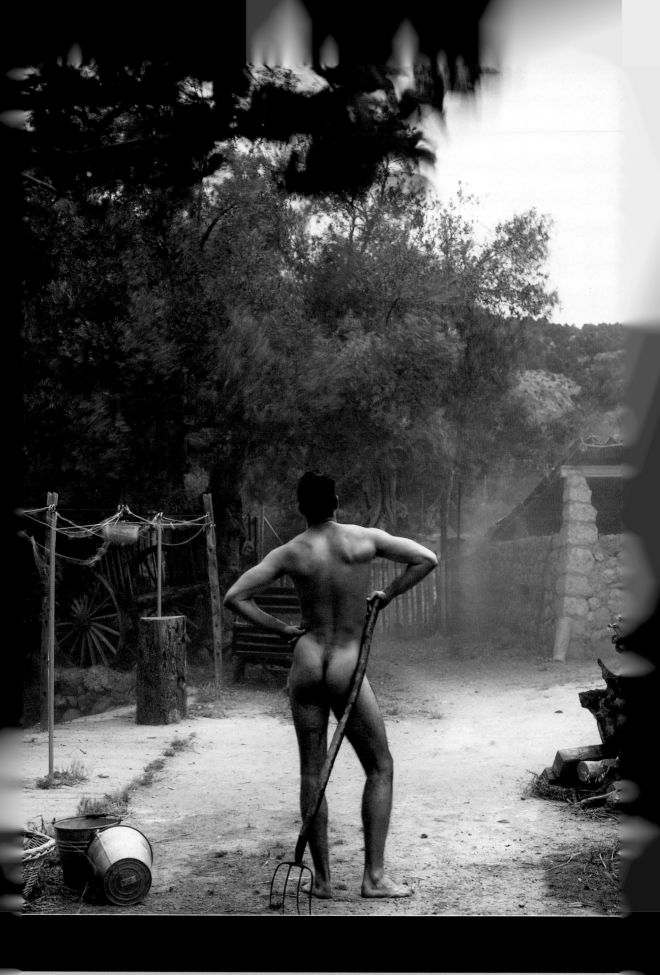

THE ROMANTIC LOOK

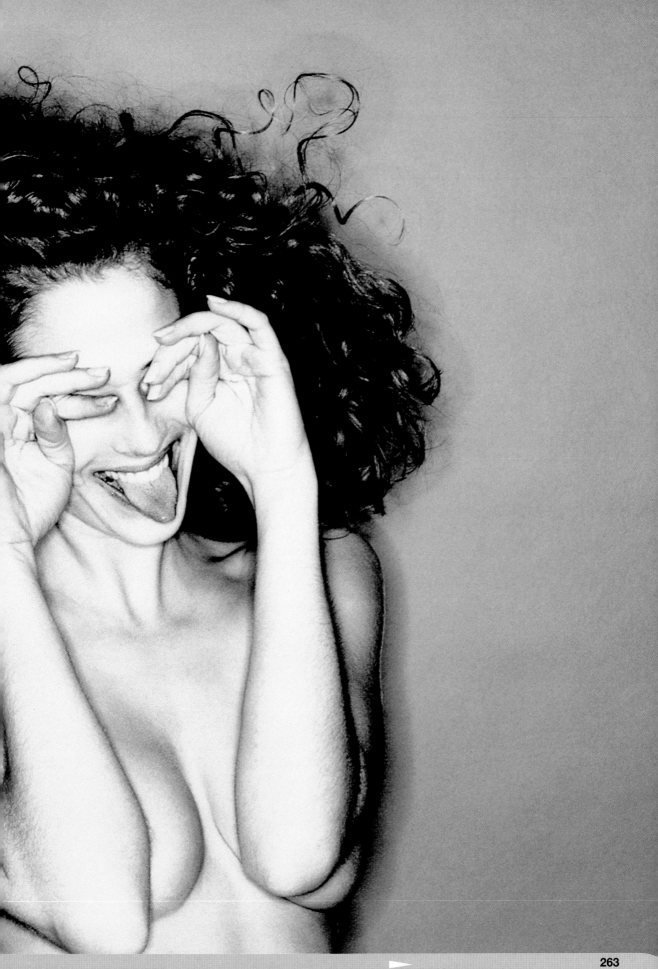

SMILING FACE

photographer **Frank Wartenberg**

Here we see how a master photographer can break all the rules and capture a moment than normally would be written off as a mistake.

use	publicity
camera	6x7cm
lens	105mm
film	Kodak Tmax 100
exposure	not recorded
lighting	electronic flash
props and	
background	blue paper

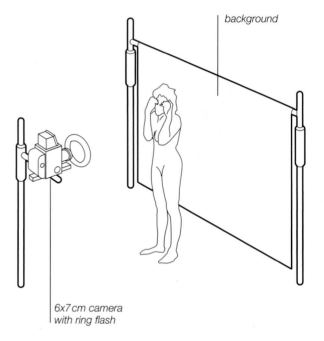

background

*6x7cm camera
with ring flash*

plan view

key points

A good rapport is needed with a model to extract the best performance

The effect of a ring flash can look like that of a whole array of lights from several direction

Frank Wartenberg places the model right up against the light blue Colorama backdrop, and goes on to point a hard flash source directly at the subject. However the source light is a ring flash and the model's proximity to the background introduces the soft aura type shadow around her whole figure.

The direct light also emphasizes and picks out every single digit on the hands and highlights wonderfully the frizzy hair. It is interesting to notice how the arms are separated from the body areas behind with lowlights, a fine but strong black outline, the opposite of a rim light.

LIZ

use	stock
camera	35mm
lens	50mm
film	Kodak Tri-X
exposure	not recorded
lighting	electronic flash
props and	
background	white muslin, pillow

photographer **Bob Shell**

The large overhead soft box is angled so as to be in line with the model's body.

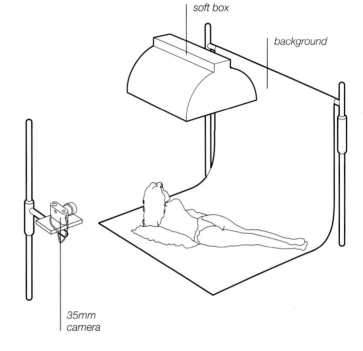

soft box

background

35mm camera

plan view

key points

A hard source can be modified to become a soft source

Muslin, like gauze, will look different if lit from behind rather than from the front

This gives a brightness to the upper edges of the body and good separation from the white muslin background. On the lower edge of the body, meanwhile, is a clearly defined separation provided by the black outline to the body from the shadow area where it rests against the pillow. The shadow line defining separation between the legs is, of course, significant as the focal point of interest.

The model's face is upturned towards the light to give a good profile, and the hair receives highlights from the same source.

This shot is all about softness: the soft flowing hair, soft, voluptuous pillows, ruffled lacy lingerie and soft, smooth skin are shown to very romantic effect by the soft lighting that this set-up produces.

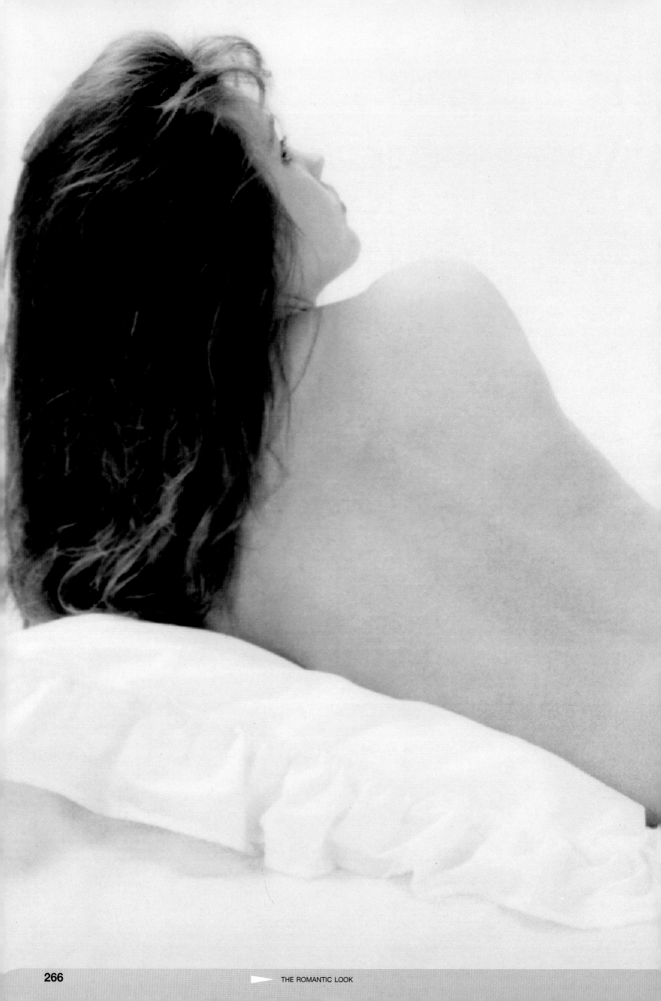

▶ THE ROMANTIC LOOK

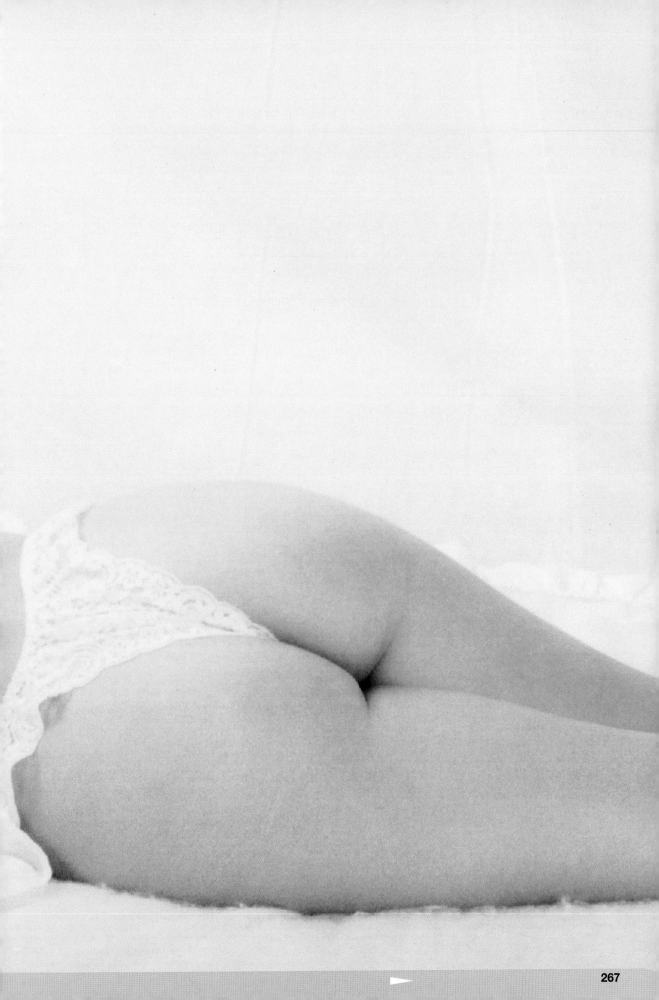

FUR RUG

photographer **Gary Darrar**

client	Sable Club
use	Internet Site
model	Bridget
camera	645
lens	75mm
film	Ektachrome 100
exposure	1/60 second at f/8
lighting	electronic flash
props and	
background	bed and rug

The natural feel and look to this shot was produced very simply and easily in a studio setting.

plan view

645
camera

soft box

key points

All sorts of common items can be used a gobos

A window frame effect can also be achieved by a square wooden frame with the addition of strips of black masking tape to create the cross pieces

The evening light that seems to come in through a window to the right of camera is actually literally coming in through a window. A window frame placed several feet in front of a large soft box which makes the appearance of semi hard shadows which resemble the uprights and cross pieces.

The image was slightly underexposed to give a lower key effect, the feel of an evening set but without being too dark. Finally, again with the use of the right props to establish the context and mood a bedroom scene is created full of romance and a certain je ne sais quoi.

photographer's comment

We were all pleasantly surprised at how well the image turned out.

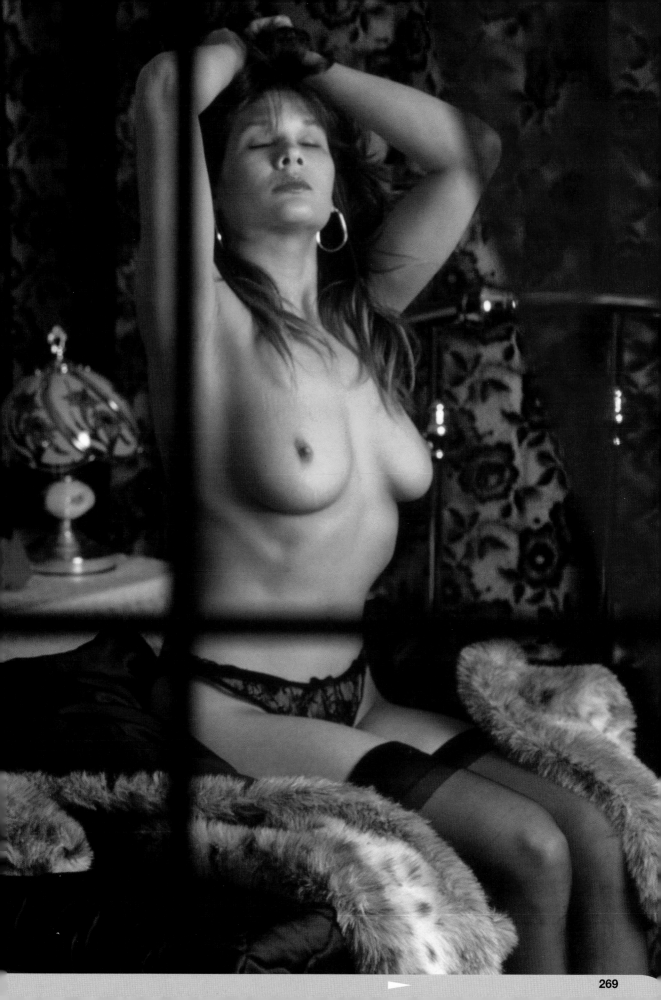

LYNNET

photographer **Bob Shell**

use	stock
camera	35mm
lens	50mm
film	Fuji Provia 100
exposure	not recorded
lighting	electronic flash
props and	
background	chaise longue

The camera is square-on to the model. Directly side-on to the model is a standard head. The lighting is straightforward but the effect is very strong.

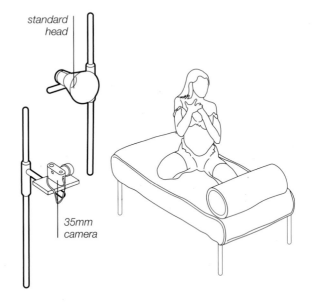

standard
head

35mm
camera

plan view

key points

Lighting can be used selectively to conceal as much as reveal a subject

It is, of course, this bold lighting look in conjunction with the styling that establishes the romantic mood of this shot. The chaise longue is a classic romantic prop, and the choice of erotic lingerie is important, as are the alluring pose and expression. Details such as the carelessly slipping shoulder strap add immensely to the powerful erotic charge of the image. Stockings and lace lingerie could be all too clichéd as the standard fare of the erotic shot, yet here Bob Shell has brought a freshness to a familiar subject. The frank full-frontal pose is one element of the shot's success; the high-contrast look also adds to its integrity (compared with a brightly lit, purely voyeuristic approach), and the less-is-more technique pays off handsomely in relation to the crucial areas of shade, stimulating the imagination. The model's unabashed steady gaze is arresting and engaging. The result is far from being a clichéd erotic shot: it is instead a classic of its type.

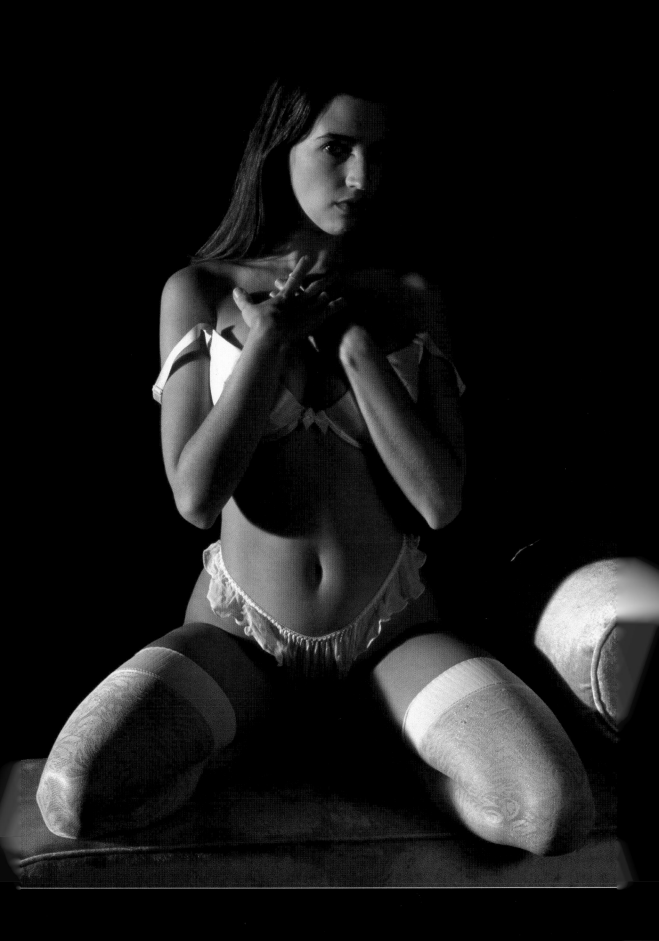

LONG BOOTS

photographer **Chris Rout**

client	model
use	portfolio and stock
model	Lesley-Ann
camera	6x7cm
lens	180mm
film	Kodak E100SW
exposure	1/60 second at f/11
lighting	electronic flash
props and	
background	grey colourama and
	colourama poles

When Chris Rout was looking for inspiration for props for this shot he turned to his large supply of lighting equipment as a source.

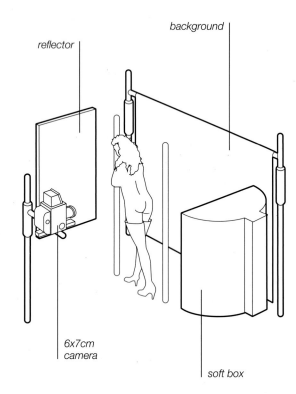

reflector

background

6x7cm
camera

soft box

plan view

key points

Long vertical props in a shot will emphasize length and can even give the impression of elongating a body

Be aware of reflections in shiny objects, control them and work with them, they may add to the composition

The model was looking for a promotional shot that was sexy but not too common, and as we can see the choice of long stiletto black patent leather boots was a real winner for the costume. The photographer chose to use poles usually used to suspend background material, as the keys props in the shot.

The poles are actually made by Manfrotto, which luckily have a very good sheen to them, but are actually finished in silky satin rather than highly reflective chrome, which might have caused problems with reflections of the lighting. The lighting set-up is relatively simple, an Elinchrome soft box to the right of the camera with a large 8 x 4 foot white full length reflector panel to the right of the camera. There is just enough detail and highlights in the boots to show of their shape perfectly.

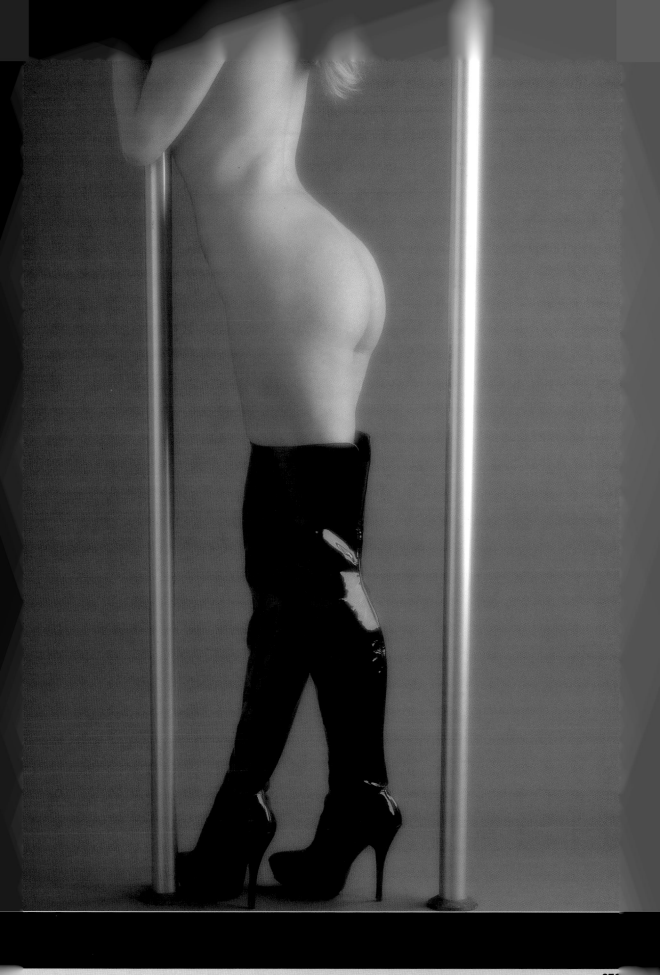

PUSHING the 14 BOUNDARIES

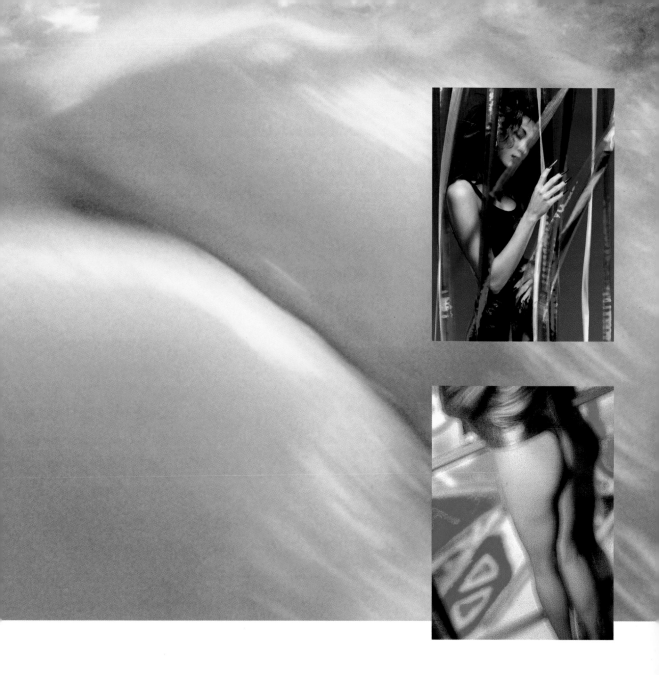

The word "ostentatious" springs to mind with the selection of shots in this chapter. They use bright colours, abstract ideas and a quirky, unusual and, some might say, over-the-top approach. Whether experimenting with manipulation, composition or the very definition of eroticism, the photographers in this chapter are not afraid to explore the unexpected in a variety of ways, using juxtapositions, props and techniques that do not fit easily into the mainstream of erotic photography. This work could be used in a variety of contexts, from fashion advertising to personal fine art work; the erotic element is undeniable, but it is never predictable.

It is important to develop ideas and to keep pushing an idea to its limit, or even beyond, in order to realise exactly what the end result should be. Self-editing is a hugely important skill in this respect. It is also important to keep notes of experimental settings, exposures and lighting set-ups.

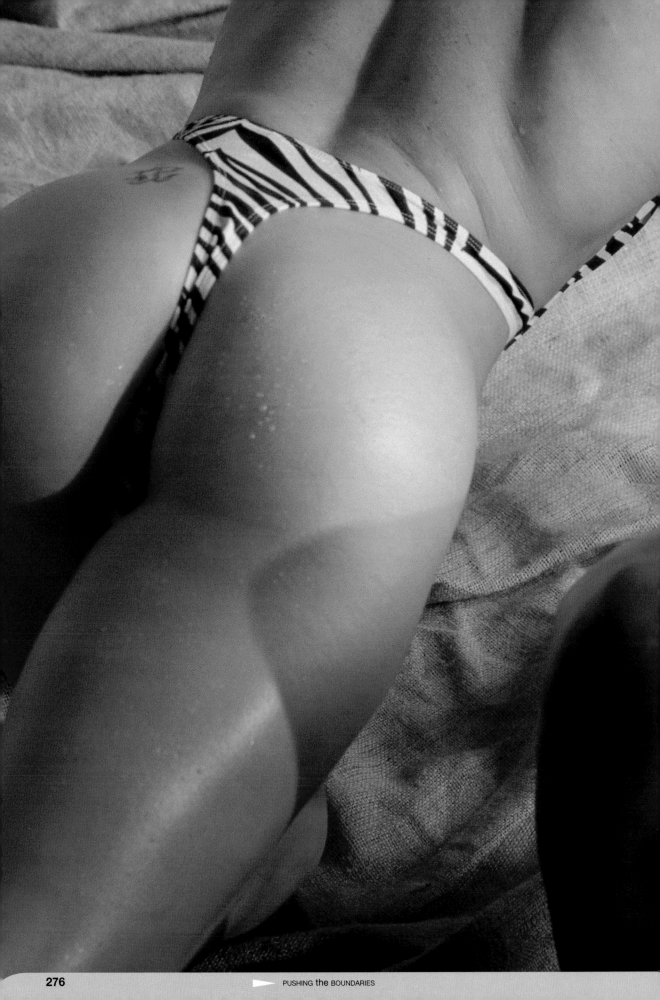

▶ PUSHING the BOUNDARIES

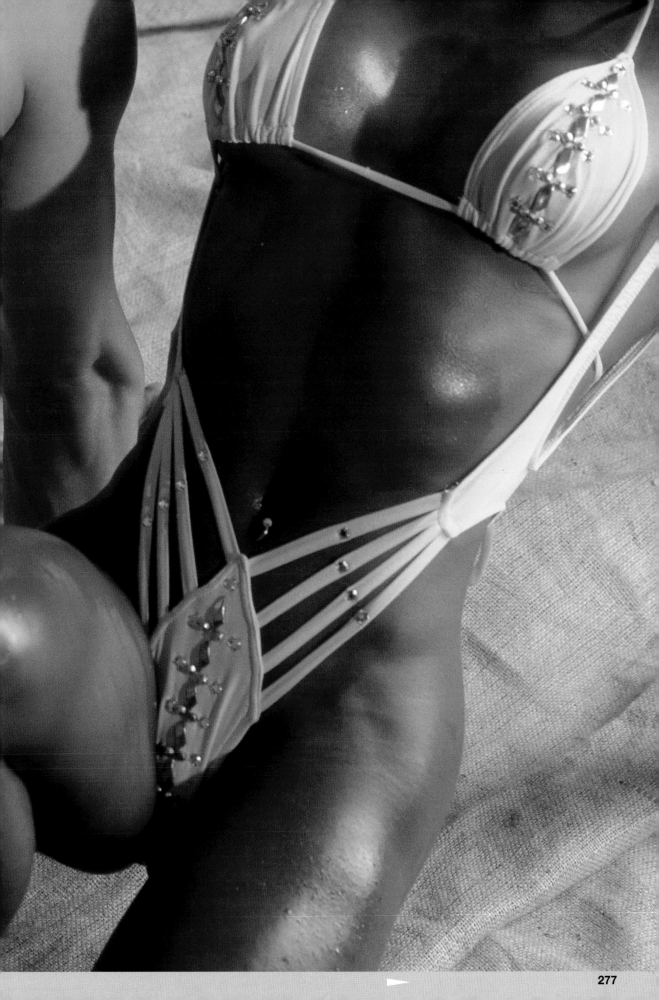

DIFFERENT BEAUTY

photographer **Maurizio Polverelli**

client	Multipower/Haleko
use	advertising
model	Pamela and Marzia
stylist	Emanuela Mazzotti
camera	35mm
lens	70-210mm at 100mm
film	EPR 64
exposure	not recorded
lighting	electronic flash

This is a studio set-up emulating the look of bright sun on an idyllic beach, so a single powerful source is required to give a strongly directional effect.

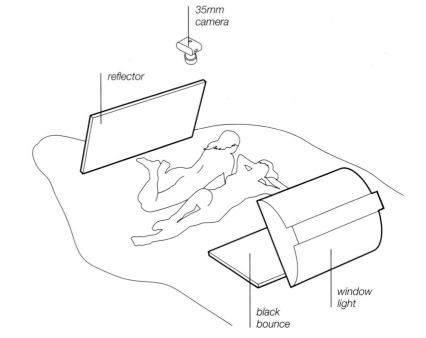

plan view

key points

It is not just coincidence that the black-skinned model is on the right of the composition. If she had been further away from the light source than the white-skinned model, she would have been under-illuminated

Polaroid test pictures can be invaluable for instant visual checks on exposure. However, colour rendition needs to be monitored judiciously

A large window light (1 x 1.5 metres) is to the right of the camera, only slightly above the height of the models, angled down into a black panel. This means that the key light is spill rather than a directly aimed source. A white panel on the opposite side provides a certain amount of fill on the left of the models' bodies. The photographer has used the light to give different effects in relation to the two very different types of skin tone. The black skin, enhanced by oil, gives a greater degree of reflectivity, while the white skin gives a more matt effect. The natural difference of the skins has been deliberately contrasted further to emphasise the title's theme of "different beauty".

photographer's comment

Only one light point is important to model the beauty of the models' bodies!

INGY & ANNA

photographer **Jörgen Ahlström**

client	Garbergs
use	editorial
Models:	Ingy and Anna
camera	RZ67
lens	90mm
film	Kodak VHC 100
exposure	not recorded
lighting	available light
props and	
background	pool

In a fairly fast-moving action shot of this kind, the easiest way for the photographer to proceed is to get himself and the camera into position, direct the action into frame and shoot plenty of film in order to catch just the right moment.

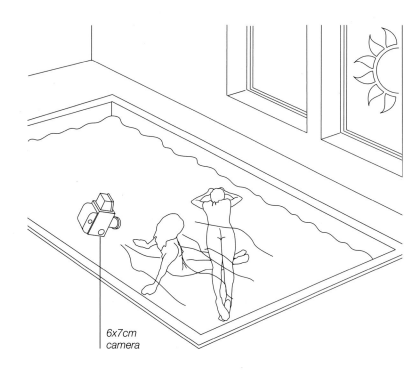

6x7cm
camera

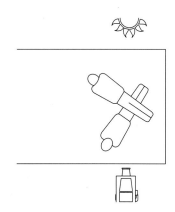

plan view

key points

If assistants are available they should constantly monitor the light level and adjust the aperture/shutter speed appropriately

An assistant must be briefed about the parameters of the shot, i.e. if a blurring of movement is required the aperture must be adjusted or neutral density filters added

The available light here is not open-air daylight, as the context might suggest. This is an indoor pool and the light comes from large windows opposite the camera. The photographer is thus positioned at a point where there will be plenty of light catching the splashing water and no problems with shadows off the camera or photographer. By using a tripod it is not necessary for the

photographer to be suspended in gymnastic fashion over the centre of the pool, whatever the composition and camera view may suggest. This shot was achievable from dry land at the very edge of the water, with the models in place at a corner of the pool, one holding a relatively stationary position while the other dives over her.

SEXY REAR

photographer **Maurizio Polverelli**

client	personal
use	portfolio
model	Birute
stylist	Emanuela Mazzotti
camera	35mm
lens	80mm
film	Fuji Velvia
exposure	not recorded
lighting	electronic flash
props and	
background	murals
other	elaborated with Photoshop; the filter was "Squint" by Eye Candy

The overall illumination of the shot comes from the soft box, which, in turn, is bounced off the white reflector panel facing it on the opposite side.

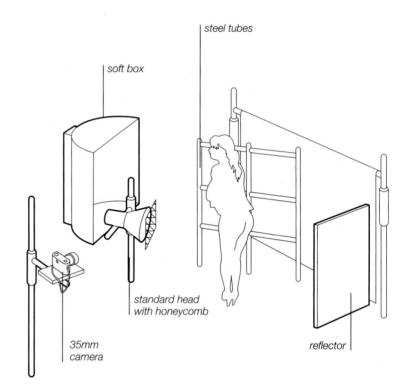

plan view

key points

Computer software facilitates all kinds of possibilities but it is important to use it creatively for the effect you want to achieve, and not to be led passively by the pre-set ideas available

It is usually best to shoot an image "clean" as it can be manipulated afterwards

To make the erotic point, directional soft light in the form of a standard head modified by a honeycomb adds a hot spot to the (already hot!) "sexy rear" of the title.

The shot is very highly side-lit and the surreal element of the composition is extended by the deep shadow area to the right of the legs, following their contours closely, and appearing like a ghostly third limb. The choice of leather clothing gives a very reflective area of interest above the flesh zones and the main highlight of the shot is shared between the jacket and the buttocks: careful juxtaposition of two extremely erotic elements.

photographer's comment

Sometimes it is better to imagine than to see. The spot point softened with a honeycomb was necessary to create a little hard impact.

AU DESSUS

photographer **Jeff Manzetti**

When thinking of an erotic shot composition, a table top set-up might not be the obvious choice - but this is a table top shot with a difference!

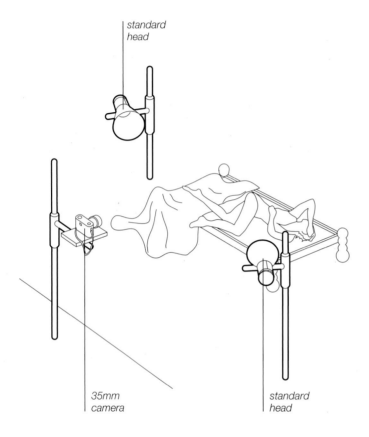

standard head

35mm camera

standard head

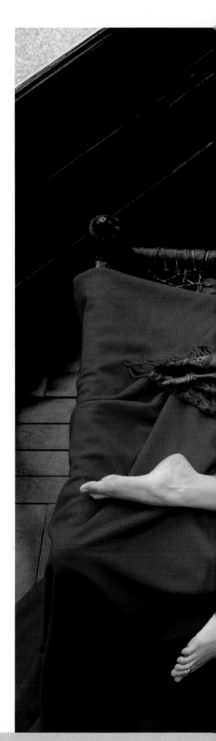

Far from being a typical pack-shot or product shot associated with the 'table top' label, this is a large flat thatch bed used as the table top surface, and a long-limbed model in langourous pose takes the place of the product. The analogy may seem frivolous at first glance, but in fact the principles in lighting a table top shot of any scale and subject are similar. The surface table top background will require certain lighting considerations while the product needs to be highlighted against it. Here a standard head to side left, combined with windows just out of shot, give the even light and reflections on the floor and table surface, as well as acting as the key light on the model (notice shadows to the near side and below the model). The standard head to camera right provides some frontal light and overall fill. The result is an imposing but delicate composition.

use	editorial
client	Grazia
camera	Pentax
lens	90mm
film	GRY 400
exposure	f/5,6.5
lighting	HMI
props and	
background	apartment

key points

This stark contrast of a dark landscape and bright subject achieves a certain classic elegance and warmth

Location, location, location, as they say – this corner shot shows a unique approach to what could otherwise be a staid subject

plan view

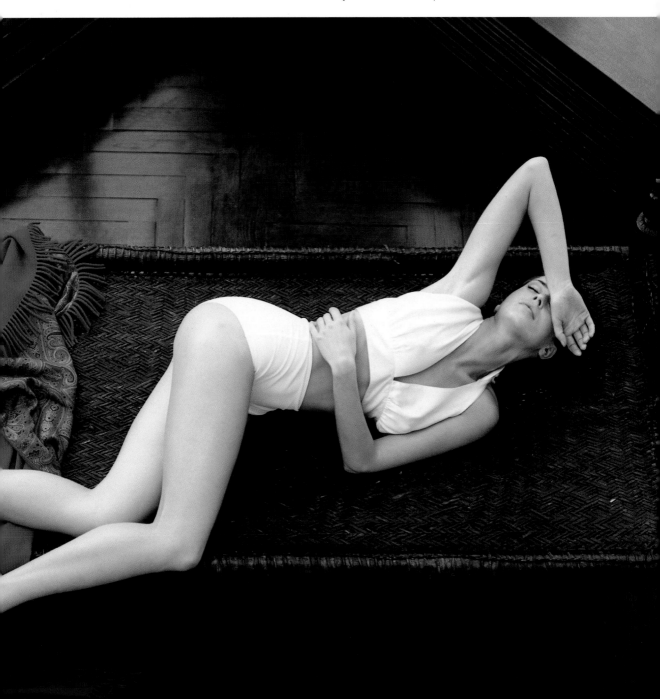

SOUZAPHONE

photographer **Frank Wartenberg**

use	publicity
camera	6x7cm
lens	80mm
film	Fuji Velvia
exposure	not recorded
lighting	electronic flash
props and	
background	sousaphone, and cigar, golden backdrop

There is real emphasis on the gold within this composition. The model is wearing an unusual instrument, which is carefully chosen for its shape and colour.

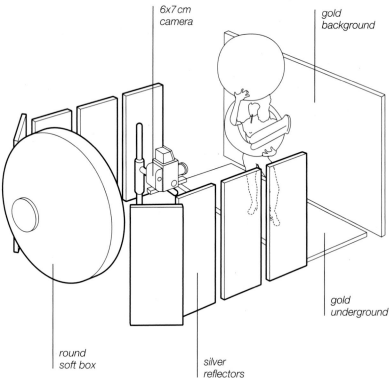

6x7cm camera

gold background

gold underground

round soft box

silver reflectors

plan view

key points

The shape or form of a prop can be the inspiration for the lighting

Careful attention to detail can bring huge rewards

Not only is the background golden, but so is the floor. The light source is a very large circular soft box, which is directly behind the photographer. The round soft box is used because it complements the form of the sousaphone and highlights the multiplicity of brass tubes, showing off the curvature to best effect.

To alleviate any chance of unwanted reflections, such as studio walls or crew, the soft box is shot through an enclosure of silver reflectors. Gold bounces could have been used, but this would have diluted the effect in the highlight areas.

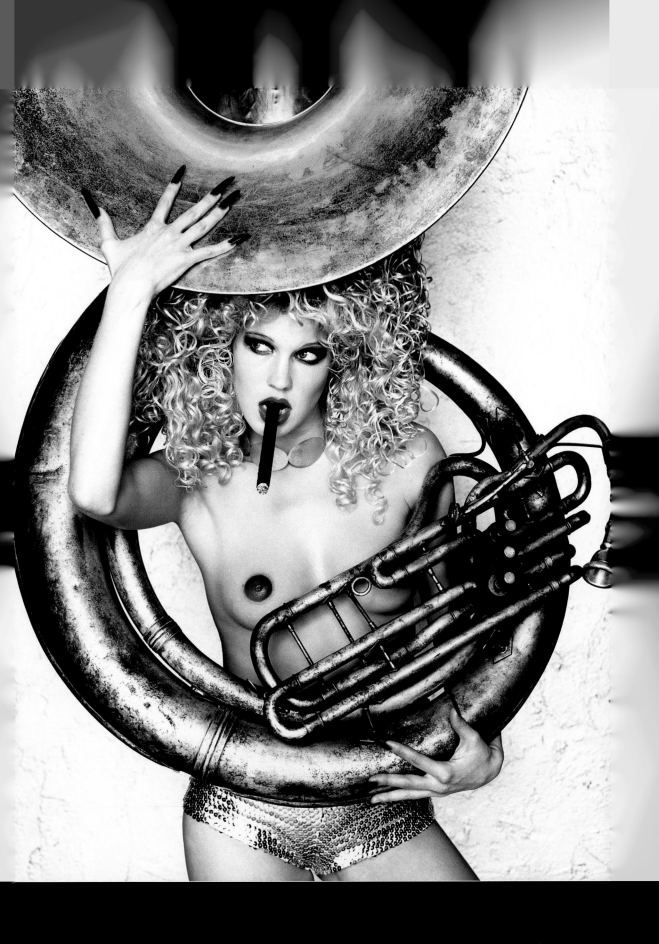

LIPS ON TV

photographer **Frank Wartenberg**

use	publicity
camera	6x7cm
lens	180mm
film	Fuji Velvia
exposure	1 second at f/22
lighting	electronic flash
props and	
background	wall of TVs

A long exposure was needed in order to capture the full image of the mouth on every TV screen.

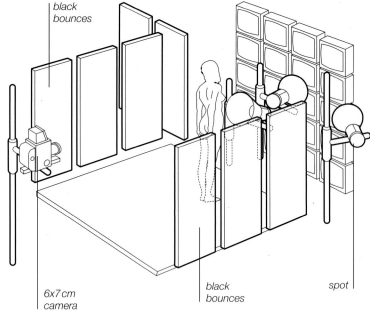

black bounces

6x7cm camera

black bounces

spot

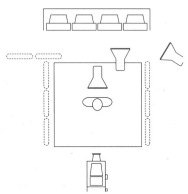

plan view

key points

Remember to check the colour temperature of any monitor that may appear in a shot

An exposure time of longer than 1/30 second will be required to alleviate frame bars

The illumination on the model comes from an overhead snooted standard head. The remainder of the lighting set-up is concentrated on the wall of television screens that form the background. Of course, the televisions also radiate their own illumination. It is essential that there is no light spilling onto the TV screens in a way that would produce large blocks of light, detracting from the visibility of the images. Black panels form a tunnel along the raised black floor. This keeps the overall look of the image very low key, seductively revealing the shape and form of the model.

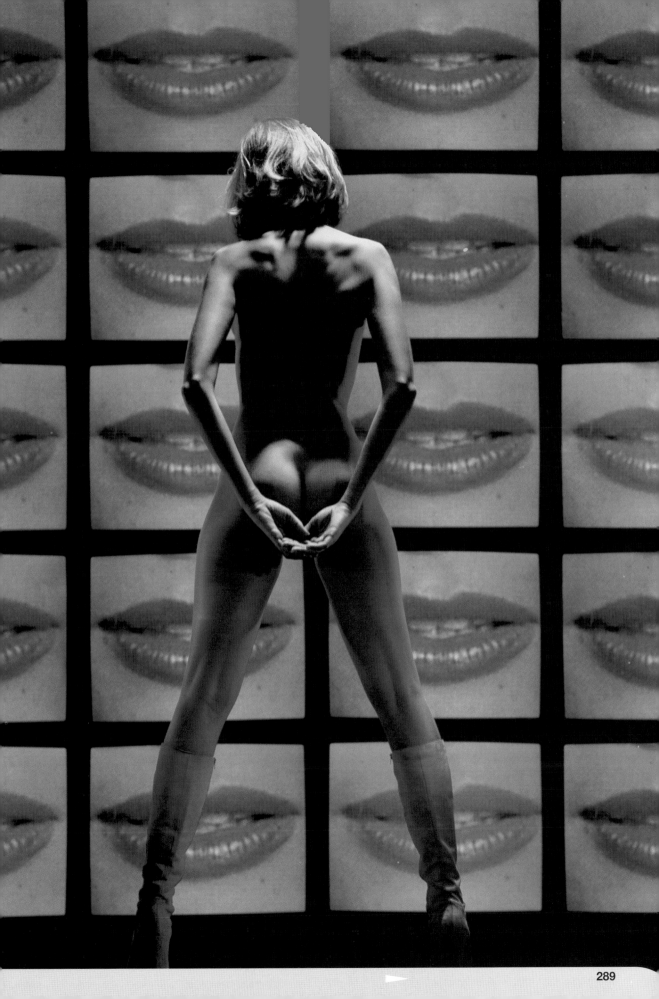

CICI

photographer **Jörgen Ahlström**

client	LC
use	editorial
model	Cici
camera	RZ67
lens	90mm
film	Kodak GPY400
exposure	not recorded
lighting	UV, tungsten and daylight
	fluorescent tubes
props and	
background	grey background, wind
	machine

This interesting assortment of light sources creates an unusual look.

plan view

key points

Black (UV) light is wavelengths shorter than about 400nm. Shots in the near ultra violet are possible with most standard lenses down to about 320 nm and most films are sensitive to this. They will record it as a very deep violet.

It is worth testing with UV light to establish how different materials record on film.

The model is standing within a plastic curtain containing many strands, blown by a wind machine, as is her hair. The hand reaching forward through the curtain displays fearsome long black talons. Directly above the curtain and the model is a Kinoflo daylight-balanced fluorescent tube. Skimming along the curtain tails from the left is a tungsten light modified by red gel. Slightly closer to the camera on the same side is a UV black light.

On the opposite side is a roughly mirror-image set-up, except that the UV is slightly more behind on the right and the tungsten with red gel is further round towards the camera. Both the UVC and red tungstens pick up the strands of the plastic curtain to give the interesting look here. The slow shutter speed captures visual echoes of the strands, each with a different colour hue, as they blow in the breeze from the wind machine.

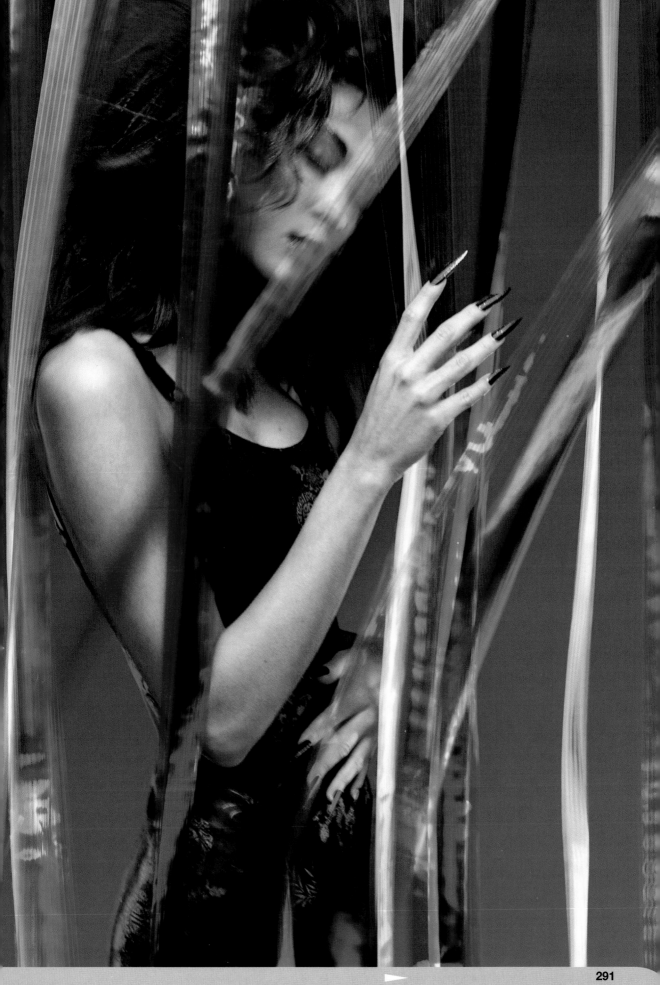

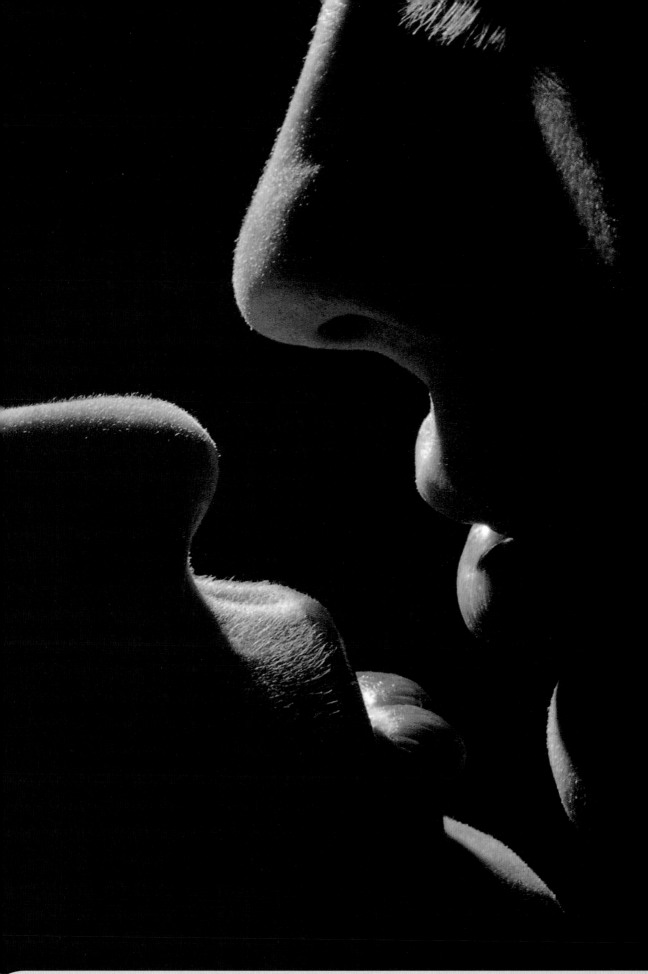

PROVOCATIVE SHOTS

PROVOCATIVE SHOTS

The provocative image is nothing if not imaginative. People are not interested in or excited by tame, predictable imagery, and the shots in this book present a wide range of innovative approaches to the subject area from all over the world. This field is intrinsically super-imaginative, and so displays the cutting edge of experimental work, offering an even more unexpected view, an extraordinarily innovative take on the world of the erotic image, or a broadening of the definition of what counts as provocative. Provocative is one step beyond the erotic.

The erotic frisson has to be there, but there also has to be an element of pushing the boundaries – of the viewer's expectations, as well as the boundaries of the genre.

An interesting way of looking at the genre is to consider the word 'provocative' itself – what exactly is the photographer trying to 'provoke'? A reaction, obviously, but more than this: the provocative shot should be provoking a reaction that the image has triggered – something unanticipated and fresh that exceeds familiar boundaries of content, composition, or even taste. A provocative shot may be a controversial shot, but it is not necessarily so. It is not so much provocation that the photographer is aiming at, in the sense of incitement to irritation or anger, but something more akin to stimulation of the senses – an emotive and emotional reaction to a visually impactful image.

The commercial world

Erotic imagery is used in so many contexts that it seems almost pointless to begin to identify and examine them. However, different applications bring different subtle requirements and the commercial photographer needs to be aware of the boundaries of the context in order to judge their challenge of

those boundaries, and to 'provoke' to just the right degree. What is acceptable imagery in high-street advertising will not be the same as that which is acceptable in the glossy fashion and lifestyle magazines. Different again are the 'norms' for fine art imagery, postcards and posters, and at the other extreme, calendar and traditional glamour contexts. In order to push the boundary the photographer needs to know exactly what the boundary is. The cutting edge should not be so far removed from the usual reference point that it becomes unacceptably out of place; rather it should just add an edge of excitement to a relatively well-established area.

The contexts into which the photographer of provocative shots may place his or her work are many and varied. There is an ever-increasing demand for mass-produced fine art work. Stock libraries need fresh images for a variety of editorial contexts, and particular commissions for magazine and advertising work will bring their own requirements. Photographs of men, women, groups and couples all have their place, although images of a single model perhaps allow for the greatest versatility of application, since a shot of an individual can either invite the

viewer to identify with the model (essential for some forms of advertising and commercial work) or can allow the viewer to project a virtual relationship and intimacy with the subject of the image.

Health and beauty editorial work often has an overtly sexual element and the impulse of the provocative genre may be just what the campaign needs to grab the attention of the potential consumer.

Personal work for exhibition, private commission or simply as personal development and experimental work, is well represented amongst the shots featured in this work. This is hardly surprising, since provocative shots are by their very nature an experiment with the boundaries and extremes of the imagination, and photographers need to invest time in themselves in order to develop their visual imagination and enter new areas. Some of the most challenging images in the book tend to be those where the photographer is not bound by anyone else's vision, and is not working to commission, but is truly exploring all the creative possibilities.

Film, cameras, and lenses

Not only are provocative shots likely to be experimental in many cases, but

they are also likely to feature models in a variety of unusual and interesting poses, sporting unusual and interesting make-up and clothing, and revealing a considerable amount of bare skin. The appropriate choice of film stock has to take account of these elements of subject matter and composition.

A good awareness of skin tone is an essential prerequisite for any photographer working seriously in this area. There are many film stocks available and it is important for the photographer to have a good feel for how each stock will render the endless variety of human skin tones and colours. For example, some film stocks offer a warm tone preventing the need for endless warm-up filters to enrich the colour of the skin.

Cross-processing is an option that many photographers are currently exploring. It offers an interesting look with increased contrast, heightened colour intensity, and an often cyan tinge in the low-lights, amongst other characteristics, although the results can be somewhat unpredictable. Tones and tints offer a further range of visual possibilities. Films such as Ilford's XP2 black and white stock, which is normally processed in C41 chemistry, can be put through a pushed or pulled E6 process, to give instead a blue or green tinted black and white transparency. The end result required and the nature of the commission will determine the choice of camera format and lens. If enlargement on a large scale is planned (for example for an advertising campaign poster), then as large a format as possible at the shooting stage will bring better quality (i.e. a less grainy image) later. In many situations a 35mm camera will be the most convenient choice, especially if the work is experimental and the shoot involves active and spontaneous movement on the part of the model and speedy reactions and mobility on the part of the photographer. In other situations, a shot may be carefully planned to the last detail and a tripod-mounted medium-format camera will be more appropriate.

The same is true when it comes to the choice of lens. If a tightly cropped, close-in and intimate look is wanted, a long lens will serve the photographer well, filling the frame and reducing depth of field while allowing the photographer to work from a convenient distance. For a provocative shot, this physical distance between photographer and model may help with the general ease of the model in the studio situation, and can be a significant factor in attaining the right mood of relaxation that will make the shoot a success. It is also easier to light the subject when there is a little more space available to play with.

When working with models, it is useful to know what effects different lens types will produce, in order to accentuate a model's individual features. A wide-angle lens gives the effect of elongating and slimming, and few models will object to this illusion! However, it is also essential to be aware of how to capture a naturalistic representation of the subject using a more standard lens, and how to allow for any unwanted fore-shortening effects by adjusting the camera position.

Clothes, props and make-up

Clothing has an important part to play in many provocative shots; it can be arranged so as to reveal just the right amount, to accentuate the body form beneath, and to add interest with framing and enhancement of selected body areas. Make-up and hair-styling are equally important; make-up can be used playfully to give a surreal look to the model, or more subtly for an innocent look, or somewhere in between to add a touch of glamour. Both must be carefully considered and executed by artists who are able to maintain the photographer's desired look throughout what might be a long and hot shoot. Styling of the whole composition establishes an effective harmony (or dissonance, if that is what is required) for the whole of the scenario.

The choice of props is another crucial factor. Not only must the right item be selected for the shot, but it must be exploited in the most effective way. Graphic and textural form are primary considerations when selecting props. They can also provide something for the model to respond to and interact with, and can stimulate the progress of a shoot and introduce a spontaneity to the exploration of the possibilities. An interesting chair or table, or even a wooden block, can encourage both model and photographer to try out new positions and effects in unplanned ways; for

example, see Mark Joye's "Geneviève". On the other hand, an inspirational prop may be the impetus for imagining and planning a shot to every last detail. Look at Mark Riedel's "Mud Girl with Bone" as an example of this kind of image.

Lighting equipment and mood

However much thought has gone into styling, content and composition, it is inevitable that ultimately it is the lighting that will define the mood of a shot, and atmosphere is all when it comes to creating a successful provocative image. To create this, the photographer should be fully aware of the potential of a variety of lighting equipment.

In many cases, the hard source is the more versatile starting point as it can be adapted to become a soft source whereas to do the opposite is not so easy. At the most basic level, standard heads with soft box attachments are a good place to begin assembling a set-up, along with a range of modifying items such as gels, gobos, barn doors, and so on, whether professionally made or improvised by the imaginative photographer. Many everyday household items can easily be adapted to become modifiers of various kinds: stockings over the lens, home-made cut-out paper gobos; and coloured fabric, coloured paper and any number of reflective items can be used as reflectors. (Always remember, however, that safety must always be at the forefront of the mind where improvised lighting props are concerned. Lights get extremely hot and great care must be taken not to place any possibly flammable materials anywhere where they might constitute a fire hazard.)

The shooting session

It cannot be emphasised too strongly that it is essential for both the photographer and the model to establish from the outset a completely professional method of working. Although the nature of the final image that must be produced is essentially of an intimate nature, this is best achieved by establishing a professional yet relaxed atmosphere where all parties know what to expect of each other and have agreed on a way of working towards the desired result.

Clear briefing of the model (and any crew) beforehand will make explicit what is wanted, and the model can then be prepared for the session and will not feel that anything has been 'sprung' on her or him which might be a problem if they are not at ease with what is requested. Full involvement with the planning process will minimise any such unwanted and time-wasting problems.

A balance needs to be struck between keeping a professional difference and striking up a favourable working relationship and rapport between photographer and model. The best work will emerge where there is mutual understanding and respect, and if a opportune knowledge of each other's working style can be arrived at too, there will be dividends in terms of useful anticipation of each other's probable moves and requirements. The photographer needs to develop a clear understanding of the strengths and capabilities of the model and to develop a strong relationship whereby the best performance can be elicited for the shoot. However, the model needs to feel at ease with and be able to trust the photographer's judgement, and time spent on model test shoots are never wasted if they help to build up a working relationship that will come to fruition when it really matters on a commissioned shoot.

An ongoing relationship is not always possible, of course, and if working from cold with a model for a specific shoot, a good manner is essential to establish the right mood and atmosphere. Each photographer has his or her own style of directing the shoot, and this is a particular kind of skill in itself, and an invaluable one to develop. Music, light conversation, refreshments and space for the model to change and relax may all play a part, just as much as time spent briefing the model and crew.

It is important always to remember that a great deal of vulnerability is inevitably never far from the surface in a nude or almost-nude shoot, and this has to be allowed for with sensitivity and professionalism at all times. The presence or absence of other crew may or may not help to establish the correct balance between the necessary professional approach and the all-important intimate atmosphere that will surely show through on the film. Again, consultation with the model is important and a mutually agreeable arrangement must be arrived at.

SIMPLY
NAKED
15

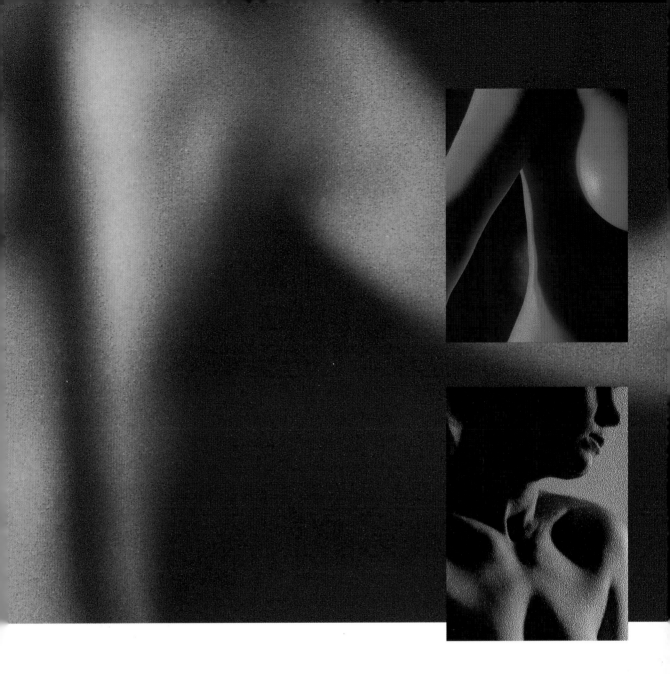

With nothing more than a purely naked subject, the photographer of provocative shots is reliant entirely on the body, the posing and the lighting for creating impact, since there is no clothing or other extraneous components to add interest and play with visually. Composition and lighting are the crucial creative elements of the shot, to establish the required erotic mood.

There is a marked difference between the classical artistic concept of the 'nude', as compared with the deliberately erotically-oriented 'naked' subject. The nude in fine art historically is portrayed and composed for its aesthetic qualities of form, tone and texture, generally divorced from explicit sexuality, whereas the point of the naked shot is to dwell on that nakedness as such. Of course, form, tone and texture are major considerations for successful composition in this context too, but the subject matter has a deliberate emphasis on the naked body as a sexual entity, whether in a romantic, blatantly provocative or subtle seductive mood. The lighting has to be employed effectively to establish the exact timbre of the work.

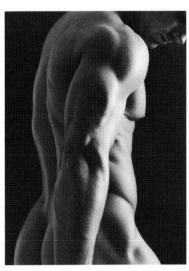

KATE

photographer **Gianni Russo**

use	Portfolio
model	Katerina
camera	35mm
lens	85mm
film	Tmax 400
exposure	1/125 second at f/4
lighting	Tungsten

This shot has a cool elegance and simplicity to it. Although the lighting set-up used to achieve it may at first glance seem rather busy and perhaps complicated, it is in fact quite a straightforward arrangement.

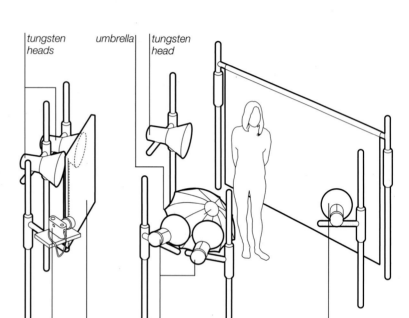

plan view

key points

If diffusion filters are used in conjunction with other filters, it is important that the diffusion filter is at the back of the array to prevent internal refraction

Filtration can also be applied to the rear element of the lens in the form of a low-denier stocking

The background is lit by a symmetrically placed pair of 500-watt heads.

To camera right are two more 500-watt heads, this time placed closely together and shooting through an umbrella. To camera left is another pair of 500-watt heads, this time shooting through a diffuser panel. The net effect is very high key, with only the merest hint of modelling to the model's body.

The hair frames the face and provides just enough separation for the chin line on the right, and the eyes, lips and throat register as the only dark details of the whole composition. A diffuser filter was used over the lens to soften the look.

The photograph was elaborated in the darkroom to emphasise the high-key look required.

photographer's comment

I like a simple recipe for my photographs: 1. a pretty model; 2. essential lights; 3. charm.

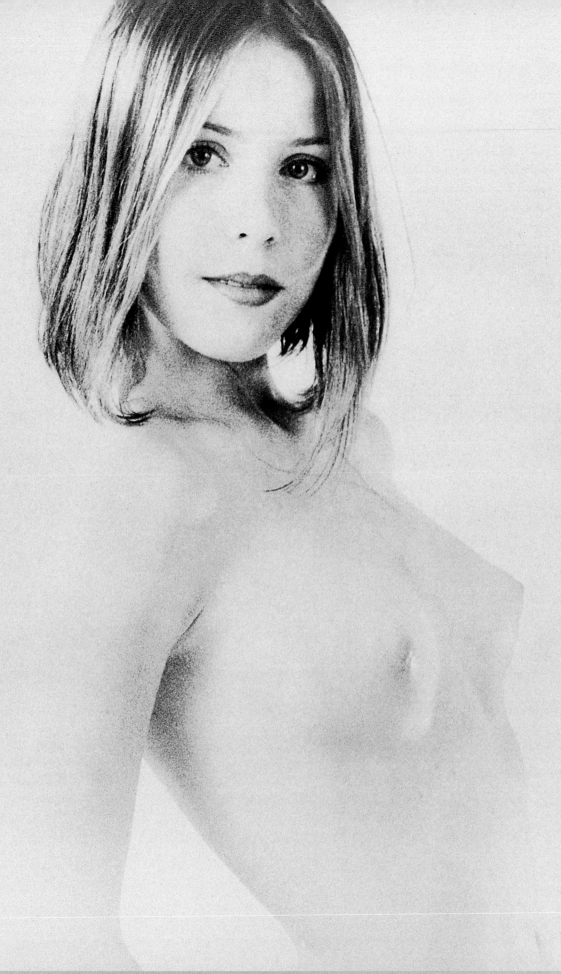

BACK GIRL

photographer **Ben Lagunas**

use	Gallery
assistants	Pauline and Christian
stylist	Vincent St Angelo
camera	35mm
lens	180mm
film	EPT
exposure	1/60 second at f/8
lighting	Tungsten
filtration	Blue filter over lens

The crucial point of interest here is the bright triangle of light defined by the model's right arm and body.

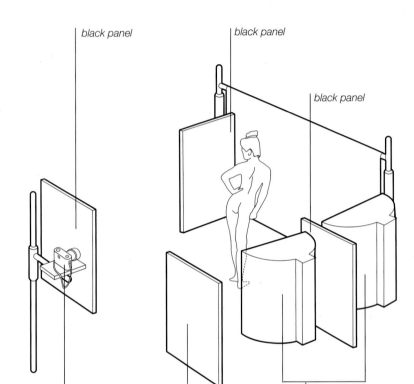

black panel

black panel

black panel

35mm camera

black panel

soft boxes

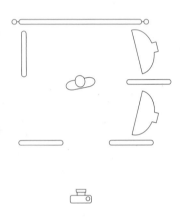

plan view

key points

A slight amount of rotation or 'Dutching' of the camera can just slightly exaggerate and emphasise the angle of a pose without being particularly noticeable or obtrusive

Using electronic flash with tungsten-balanced film would give a blue cast on the film

Its position redefines the hour-glass contour of the model's figure to give the appearance of a waist that is even more slender than the reality. This illusion is the result of a strong highlight on the edge of the body at the waist point, which creeps round on to part of the back. A close examination of the detail at this point reveals a sliver of the background visible along the inner edge of the arm, and this gives the clue as to the real outline of the model's figure.

The all-important highlight is managed by the extremely side-lit set-up. A soft box directly side-on gives highlights on the right edges of all the visible bodily contours. A second soft box merely skims the background, and is flagged so that no light spills on to the model.

Only the modelling lights have been used on the soft boxes.

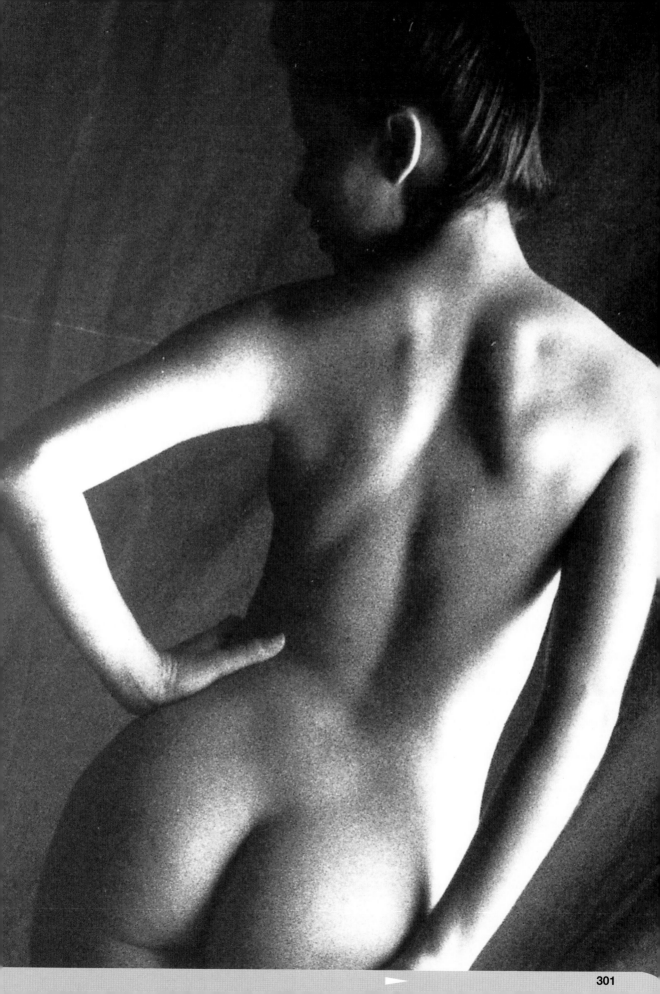

BARON

photographer **Art Minds**

use	Fine art limited edition prints
model	Baron Rogers
camera	6x7cm
lens	90mm
film	Kodak Plus X
exposure	1/60 second at f/11
lighting	Electronic flash

The camera view is relatively low down, positioned at mid-torso height to emphasise the muscular physique by framing it right at the centre of the image.

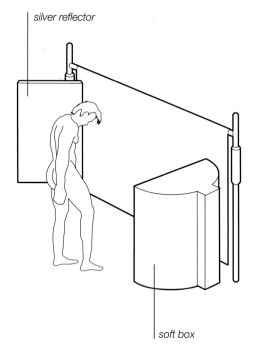

silver reflector

soft box

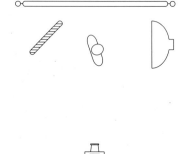

plan view

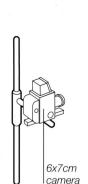

6x7cm
camera

key points

Adjusting the camera height and therefore viewpoint will emphasise different aspects of the subject

Applying oil or gel to strands of hair introduces highly reflective qualities, as well as controlling its style and positioning

A single soft box to camera right is at a similar height, so the full heat of the light falls on the chest and stomach areas, with good fall-off on the far surfaces of the body.

The strands of hair and the very edges of the facial profile are picked up by this side light while the majority of the face remains relatively shaded.

A silver reflector opposite the soft box and angled forwards a little, reflects some light back to give a gentle rim of highlight along the extremes of the body on the left of the frame, and picks up the ripples of the muscle tone across the back.

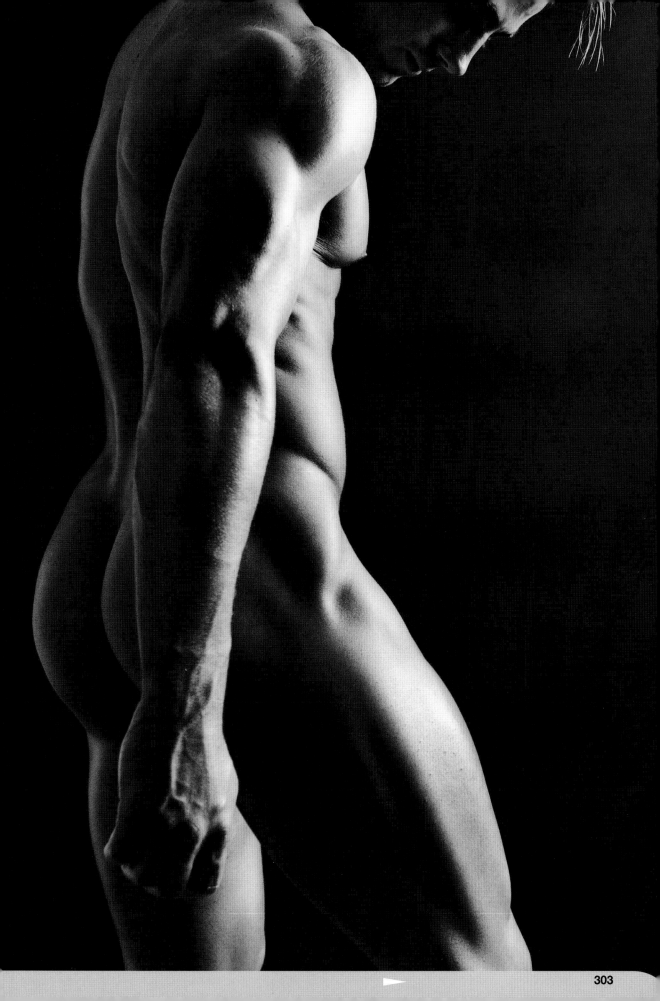

THE DARK AND THE LIGHT

photographer **Michael Engman**

use	Personal work
camera	6x6cm
lens	110mm
film	Kodak T400 CN
exposure	1/15 second at f/4
lighting	Tungsten

The title of this picture sums up the interest of the shot succinctly, both in terms of its visual impact and in terms of the technical elements that combine to achieve the look.

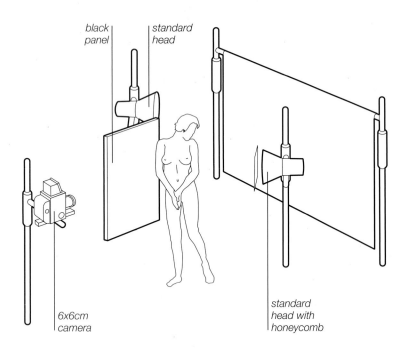

black panel

standard head

6x6cm camera

standard head with honeycomb

plan view

key points

Texture can also be introduced through gobos when lighting, or in printing using a number of media such as tissue paper, mesh, or even freezing the negative

Reticulation is a method of introducing texture although it is unpredictable and leaves the negative permanently affected

In terms of the 'light' of the title, only the modelling light from two electronic flash heads were used. The first standard head has a honeycomb, and is positioned to camera right, aimed at the model from behind. The second head is to camera left, and lights the background to a similar level as the main areas of the body. Separation is provided along the upper arm by the long highlight and on the face profile by the backlighting.

With regard to the 'dark side', the slight backlighting combined with the posing of the model achieves the areas of deep shade. By ensuring that particular areas of the body are oriented away from the front light deep, interesting graphic shadows are created. The photographer used a black flag between the model and the light on the left to avoid unwanted light falling into these areas and to prevent any fill.

Finally, the chromogenic film was printed on to colour paper, and the unusual grain was achieved by placing a plastic sheet on the paper during printing.

photographer's comment

The important thing about this picture is the contrast between the softness of the body and the hardness of the light.

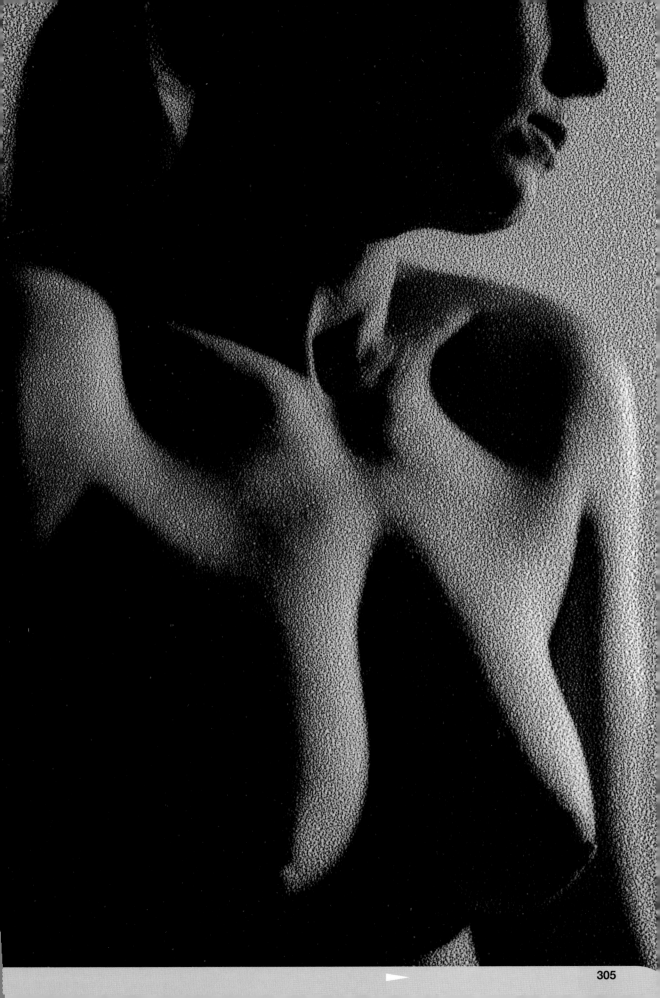

EMMARED

photographer **René De Carufel**

use	Personal
camera	6x6cm
lens	150mm
film	Fuji Velvia
exposure	1/60 second at f/11
lighting	Electronic flash
props and	
background	Black seamless backdrop

The colouring of this shot derives purely from the use of coloured gels on the lights, and not from any post-production manipulation.

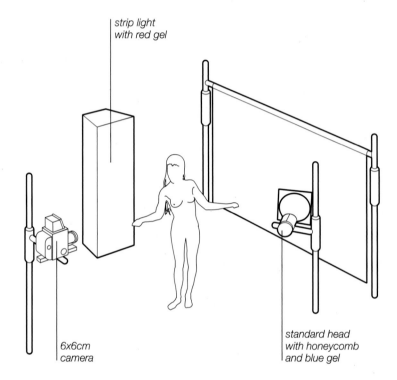

strip light
with red gel

6x6cm
camera

standard head
with honeycomb
and blue gel

plan view

key points

Working with a restricted colour range can give a graphic, abstract quality even to the most familiar of subjects

Coloured gels will provide discrete areas of colour if aimed specifically at separate parts of the composition, or can be blended to give a different kind of effect

To the left of the model is a 25x100cm strip light with a red gel, giving strong directional light across the arm and unshaded areas of the torso. The arm shields a large part of the body from this light and a deep black shadow results in this area. Notice particularly how the red light spills onto the underside of the arm to give an almost luminous edge-defining rim.

The background is lit by a standard head with a 10° honeycomb grid and a blue gel. The honeycomb increases directionality of the head to give the relatively well-defined blue circular hot spot on the background, which also serves to provide an area of colour contrast against which the model's body appears.

photographer's comment

The graphic quality of the lighting resides in the way the red light slips along the front and back of the arm. This image is part of a series.

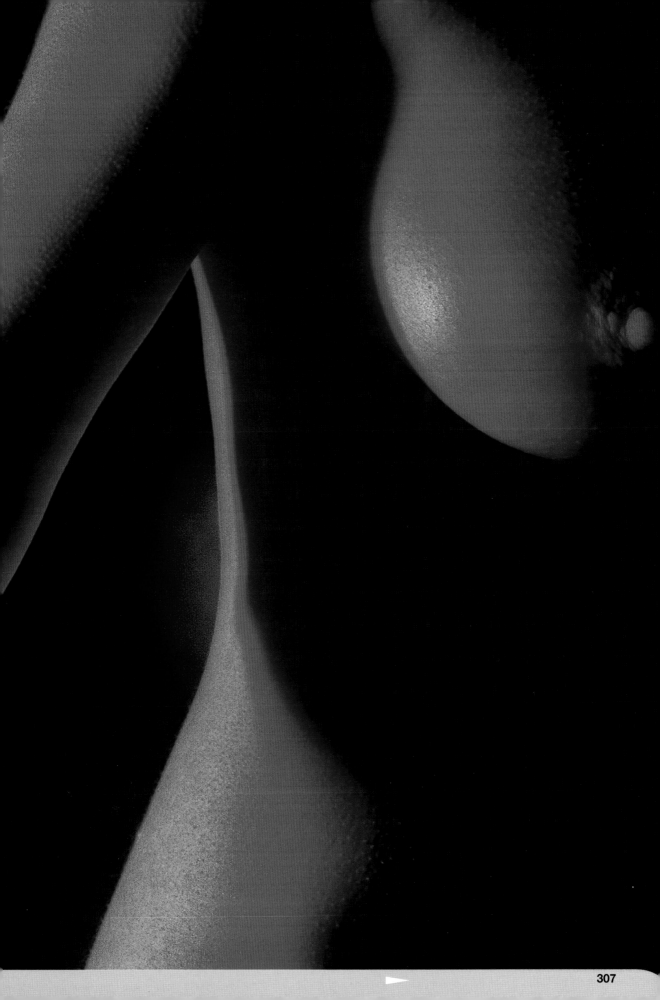

MARIA

photographer **René De Carufel**

use	Personal
camera	6x6cm
lens	150mm
film	Tmax 100
exposure	1/60 second at f/11
lighting	Electronic flash
props and	
background	Hand-painted backdrop

The extremely directional lighting gives an element of drama that is appropriate for this interesting pose.

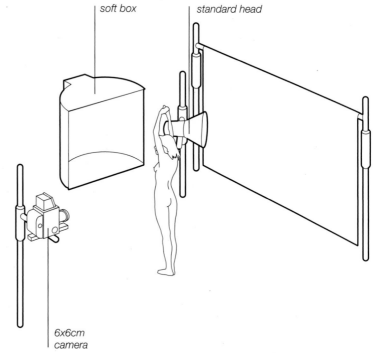

soft box standard head

6x6cm camera

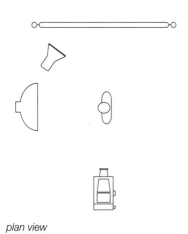

plan view

key points

Less is more. If a simple set-up is all that you need, then use a simple set-up and don't feel compelled to complicate things just for the sake of it

Playing with framing can bring interesting results

The pose in itself is straightforward enough, once we have had a moment to work out what we are seeing, yet its effect is disproportionately unnerving. René De Carufel has discovered an unexpected view of the arm and shoulder in profile, and an unexpected way of framing the model's eye. He has lit the whole to emphasise lines and contours with which we are strangely unfamiliar. The rotating of the camera to frame the shot 45° round from reality is the final masterly touch.

A 50x100cm soft box to the left of the model provides simple and effective sidelighting and the pose provides the interesting areas of shadow on the arm and breast. A single standard head on the same side lights the hand-painted background.

photographer's comment

Extremely directional lighting, low-key effect. Naturally the camera is turned about 45° and not the model.

SAMANTHA

photographer **Ron McMillan**

use	Calendar
model	Samantha
camera	6x6cm
lens	120mm
film	Ektachrome ISO 100
exposure	Not recorded
lighting	Electronic flash

Ron McMillan explains the thinking behind this archetypal calendar shot:

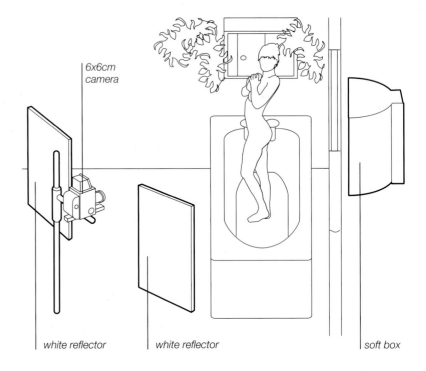

6x6cm camera

white reflector | white reflector | soft box

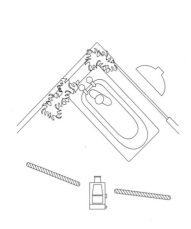

plan view

key points

With so much electricity and cabling in the studio extra care has to be taken with shots featuring water

With a naturalistic setting, it is sensible to emulate natural daylight

"This shot was one of a series taken for a glamour calendar in which each shot had also to incorporate one of the company's products, in this case the bathroom cabinet. The company logo also discreetly appears on the flower container.

"The shot needed to be provocative but not too overt. Because the cabinet had to feature, it was necessary to build a partial bathroom set in the studio. The bath needed water in it to keep the model wet and create the foam. It also needed to be warm enough to keep the model comfortable but not so hot as to create steam.

"The lighting was from a large swimming pool light behind the blind with large reflector boards either side of the camera. The blind helped to diffuse the light and the effect was increased by the use of a soft-focus filter with diffused edges and a clear centre spot."

SIMPLY NAKED

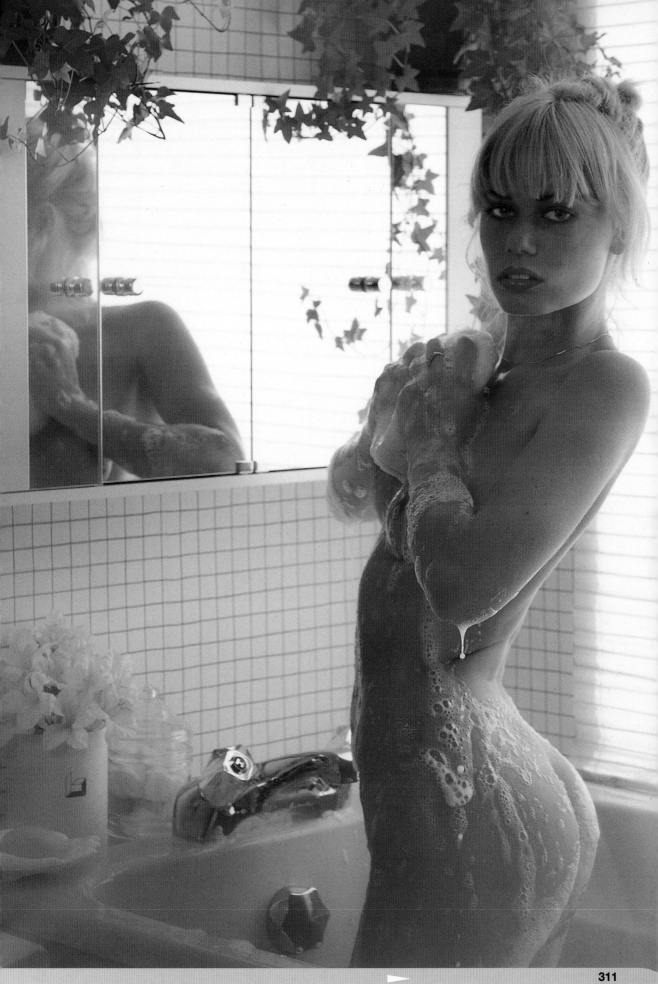

UNTITLED

photographer **Dima Smelyantsev**

The spot-on framing of this de-focused subject, especially at the top corners of this image, is a case-study in how to bring off this tricky task successfully.

use	Edition of Photogravure
client	Behz-Thyssen Ltd., New York
assistant	Julius Glickstein
camera	6x6cm
lens	180mm
film	Kodak Plus X
exposure	1/60 second at f/4
lighting	Electronic flash

standard head with honeycomb

6x6cm camera

plan view

key points

Sometimes with de-focusing things can become invisible through the viewfinder. It is important to keep a close eye on exactly what is going to register, and to compose accordingly

De-focusing can be a good way to salvage a shoot if skin texture is marked or flawed in any unanticipated way

Perhaps the best way to execute a shot with this kind of de-focused look is to work with the lens set to the maximum relative aperture available so that the depth of field as seen through the viewfinder will match the end result.

In this instance, Dima Smelyantsev used a neutral density filter over the lens to allow the use of a wider opening of the aperture, in order to reduce depth of field. He comments that "this way it was easier to control out-of-focus blur and see what you get with a fully open setting."

The model stood against a plain black background and was lit by a single standard head with 10° honeycomb, positioned behind and to the left of the camera. The angling of the body was directed to give the seductive and shape-defining shadows along the full length of the spine.

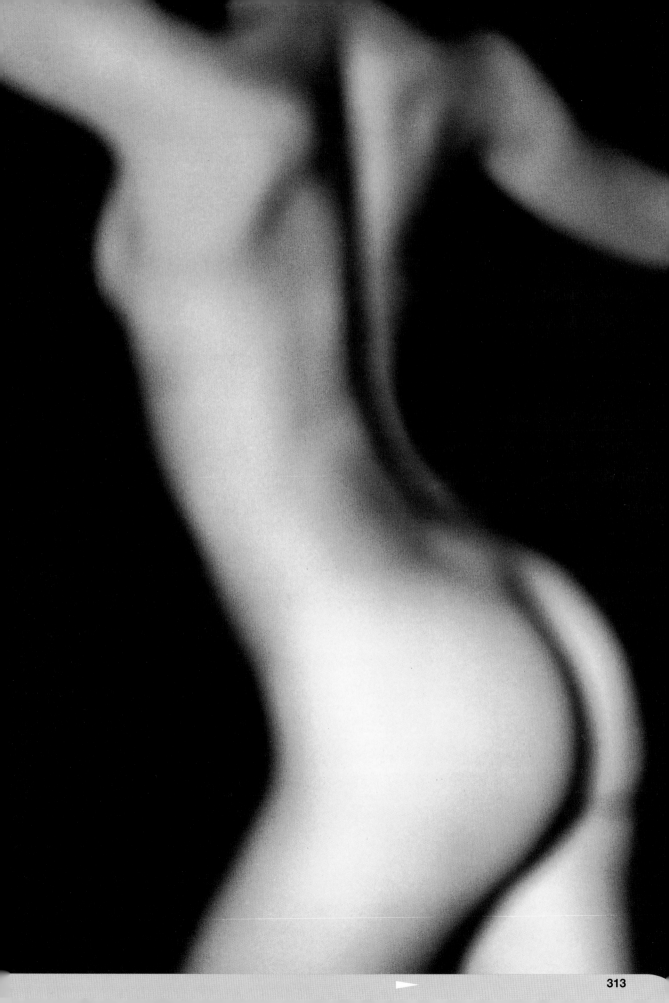

HAIR and

16 MAKE-UP

Hair and make-up styling both become part of the model subject, like any other physical characteristics, and yet their malleability and changeability makes them function more like props than like other unchangeable aspects of the model's appearance. Imaginative styling of both or either can add a very unexpected aspect to the model's look, verging on the surreal in some cases, or it can be more naturalistic in style and be used to emphasise unique qualities of an individual's appearance. In either case, the lighting has to work with the look, and not against it. It is important to decide how the playful, experimental hair or make-up styling is best captured: in stark, bold lighting, or in shadowy, subtle lighting, for example.

Make-up introduces texture and reflective or matt qualities to the subject, and it is important to be aware of this and to light appropriately. Be aware, too, that make-up can melt and run under hot tungsten studio lights, and a stylist will need to keep a close eye on things and be ready to retouch as necessary during the shoot.

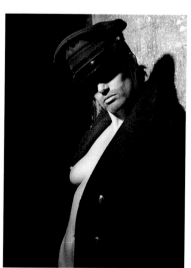

BODY

photographer **Saulo Kainuma**

use	Personal
model	Daniela Fritas
art director	Tércia Marques
assistant	Raimundo Costa
camera	6x7cm
lens	135cm
film	RDP 100
exposure	f/11¹/₂
lighting	Electronic flash
props and	
background	Black velvet

Jackson Pollock woz 'ere! The brush strokes smear stripes of paint across the three-dimensional canvas of the body surface to give a distinctly Modernist look: a mixture of Pollock's boldness, Mondrian's colour and lines, and Picasso's distorted figures.

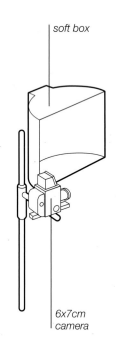

soft box

6x7cm
camera

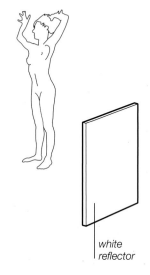

white
reflector

plan view

key points

Thick paint has form as well as colour and can be sculpted three-dimensionally to allow a play of light as required

Be sure the model isn't allergic to the paint before you start

It is the lighting of this angular pose that gives the Picasso-like distortion to the body shape. The sidelong one metre square soft box is all that is required to illuminate the near side of the model, while the far back and side of the torso are in shadow. The brightly-lit area defines the outline of an impossibly slender, asymmetric and angular torso,

reminiscent of Miro's dancing figures. The shadier parts of the body, just lifted by the white reflector panel, appear more as a visual echo of the main body area than as part of the whole human form. The black background is essential to give the crisp cut-out definition to the body outline.

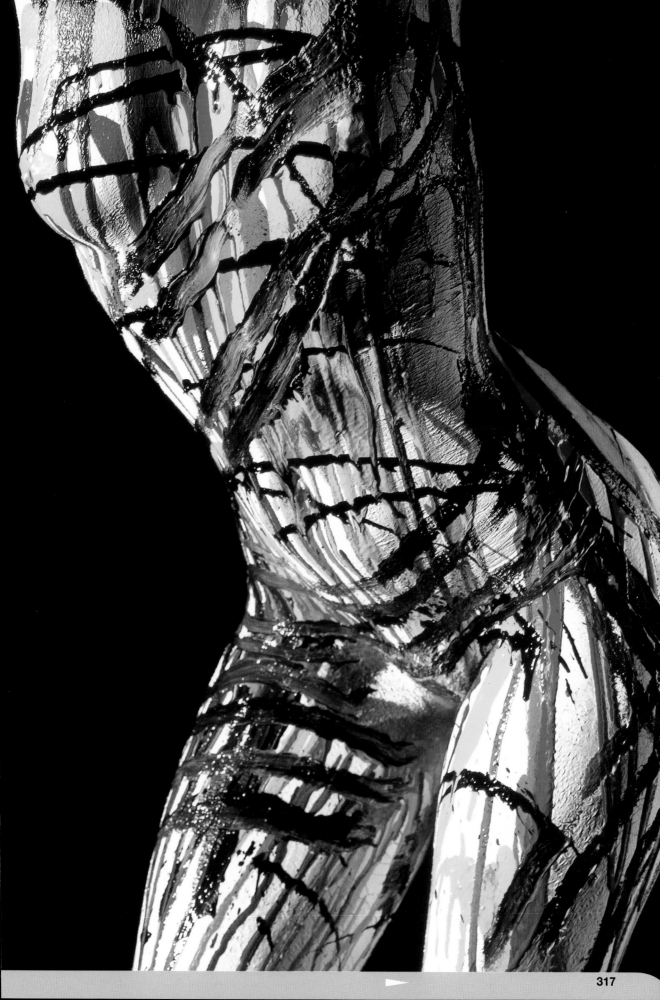

THE NIGHT PORTER

photographer **Clint Adam Smyth**

use	Exhibition
model	Christina
camera	6x6cm
lens	80mm
film	Tmax 100
exposure	1/125 second at f/11
lighting	Electronic flash

In an unusual take on the use and application of make-up as a central feature of a shot, the model here has been made up to give the impression of wearing a decidedly masculine five o'clock shadow – an incipient beard growth on the chin.

spot with honeycomb

6x6cm camera

plan view

key points

Props, such as the hat in this example, can be used to shade or flag areas from light

It may be necessary to test for contrast when applying make-up in this kind of situation, to be sure that it will record appropriately

It is not every model's idea of glamourous make-up for the camera, but in this instance it is an important part of the visual illusion and the paradoxical, androgynous and ambiguous nature of the final fine art image. The posing, styling and background are equally important in pulling off the idea so successfully.

The lighting used for this shot is very simple. There is just one spot with a 15° grid honeycomb attached to it, to emulate the look of a street light shining down on the model. The high angle of the source allows the cap to shade the eyes to add to the mystery.

photographer's comment

This photograph was shot for one of my gallery exhibitions. In this image I wanted to throw in a little bit of a gender twist. I kept the light very directional and harsh to give it the feeling of a night streetlight. This also added definition to the model's face and made it more masculine in appearance.

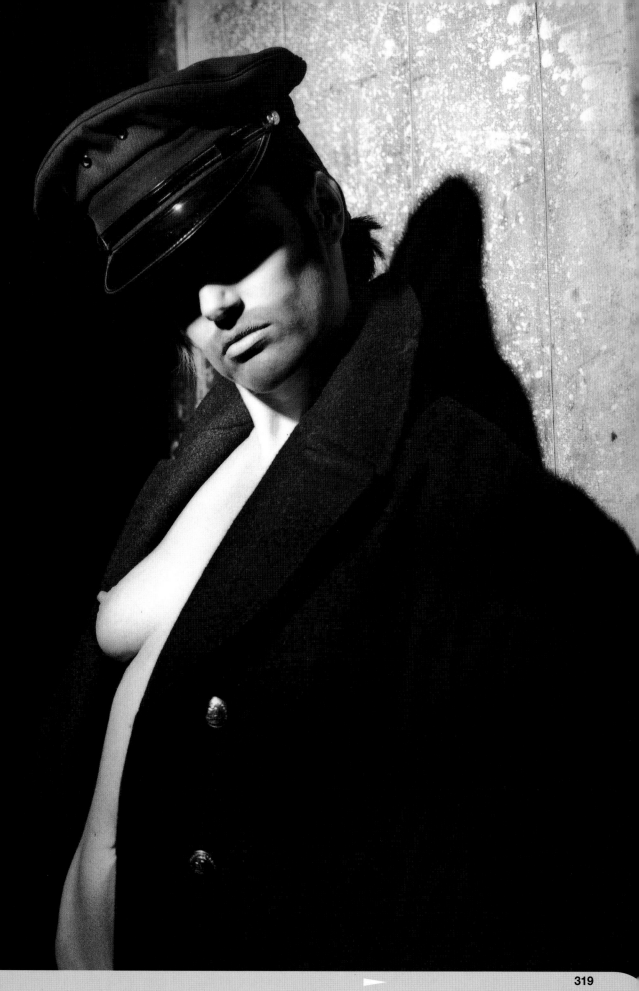

THREE OF CLUBS

photographer **Robert Anderson**

use	Calendar
model	Nikki
assistant	Jodi Herlich
stylist	Mary Fennello
camera	35mm
lens	200mm
film	Fuji RDP
exposure	1/60 second at f/16
lighting	Electronic flash
props and	
background	White seamless
	background

The all-important body painting was achieved by means of a stencil cut-out placed over the model's skin, and the paint, which had been mixed with glycerin, was then applied with an automotive spray gun.

plan view

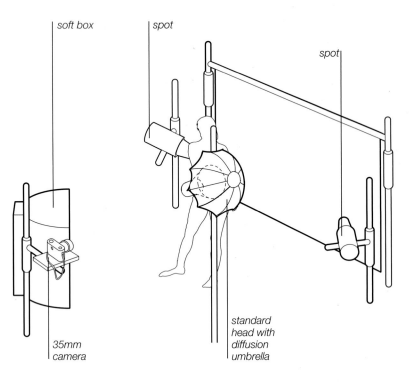

soft box

spot

spot

35mm camera

standard head with diffusion umbrella

key points

When working with paint directly on skin, it is important to make sure there are no allergy problems

A test film may be required to find the exact settings for the required level of burn-out

The overall aim in this shot was to achieve a fair degree of burn-out on the model's skin, but not so far as to allow the subject to merge completely with the background. Accordingly, the lights on the background were set at plus two stops while the key light, a standard head shooting into an umbrella, was set at one stop over. This head was placed above the camera some ten feet from the model, and angled downwards.

Finally, fill light is provided by a soft box to bring up the shadows slightly. This light was set at minus one stop, so that the shadows are not lifted too much, but remain to give some separation and definition.

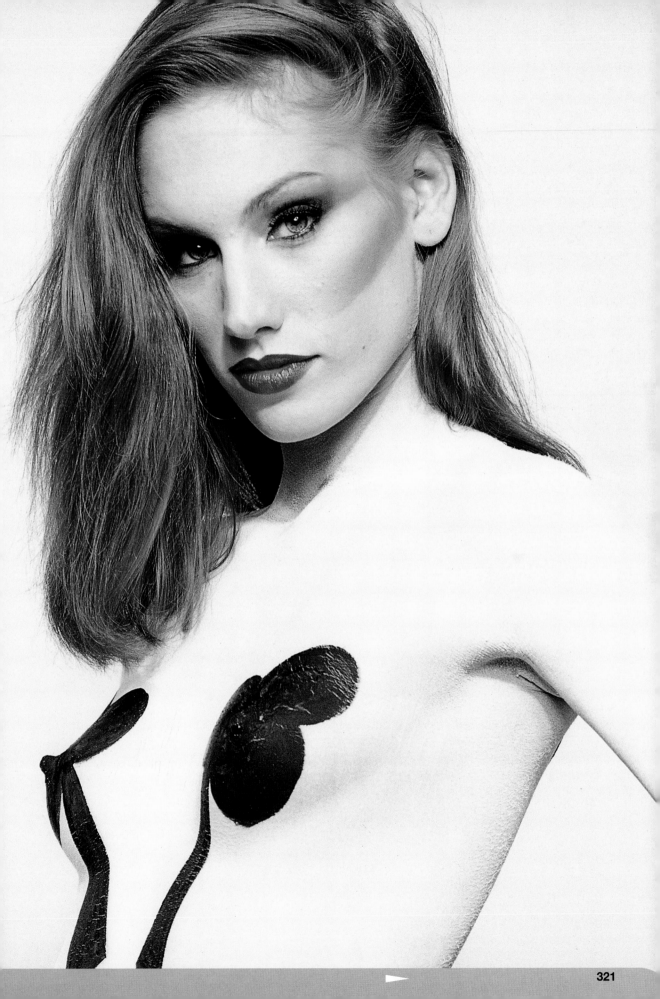

KATIA

photographer **René De Carufel**

camera	6x6cm
lens	150mm
film	Fuji Provia
exposure	f/11
lighting	Electronic flash
props and background	Hand-painted backdrop

The background, lit by a focusing spot with red gel, complements the colour on the lips. This red sets off the alarming blueness of the model all the more.

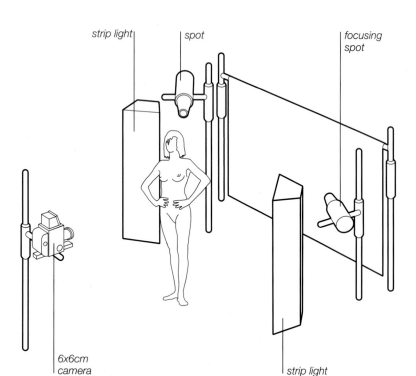

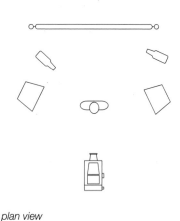

plan view

key points

Geometric composition is very forceful. Notice the near-perfect parallelogram formed by the arms akimbo, the strong corner-to-corner diagonal, and the way the lines of the bikini area echo the corner of frame

Focusing spots are useful for placing hot spots on the background of portraits with a good degree of precision

The dazzling crown of hair is brightly back-lit by a spot at very close proximity, above and slightly to the left, and suspended on a boom. By contrast, the body is relatively low key, with roughly symmetrical rim lighting coming from a pair of 25x100cm strip lights, one on either side and angled towards the model from a position slightly behind, to give sidelong light skimming the skin surfaces, rather than fiercely straight-on side lighting. The exact positioning of the arms accounts for the difference in shadow on either side of the body trunk area, and for the different way the light falls on each arm.

The head is deliberately angled to keep light from reaching most of the face, but just allowing the lips and chin to come through.

photographer's comment

This image forms part of a series on body painting. Each model was specially selected to represent a particular colour of the spectrum.

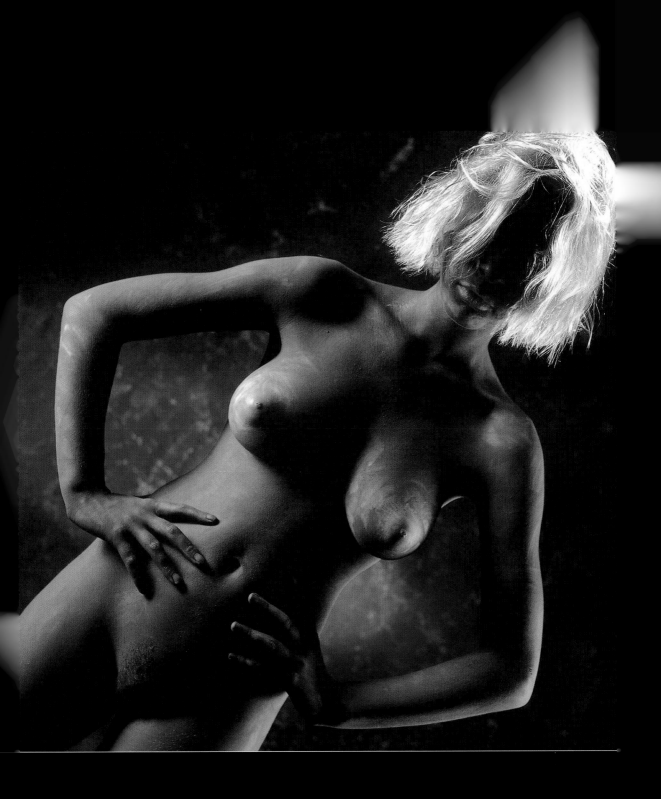

MUD GIRL WITH BONE

photographer **Michael Riedel**

use	Personal work
art director	The model
hair	Brent Levet
camera	35mm
lens	90mm
film	Kodak Kodachrome 25
exposure	f/5.6
lighting	Electronic flash

"It was very cold, the day we shot this," remembers photographer Michael Riedel. "At least, cold at 65°F when all you're wearing is clay!"

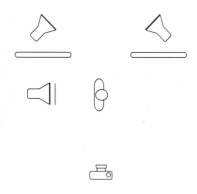

plan view

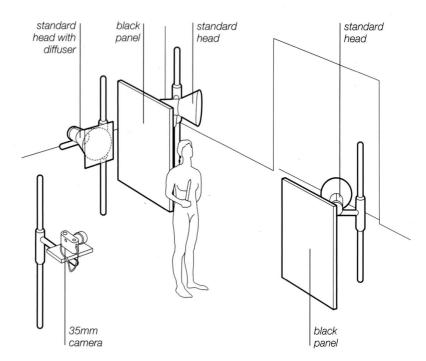

standard head with diffuser

black panel

standard head

standard head

35mm camera

black panel

key points

Substances such as wet clay will dry out and change in appearance, texture, and reflectivity as well as temperature as time goes by during the shoot

Watch out for the risk of unwanted flare and flag accordingly

In order to overcome the problem of the coldness, the clay was warmed through before application, which was initially a help, but of course it cooled considerably as the water in the paste began to evaporate under the studio lights.

"We had to warm her up with hair dryers to keep her from shivering and having an overall bad day!" recalls Michael.

The subject was lit by a standard head with an 11½-inch reflector, slightly up from and to the left of the model, with a small piece of diffusion material in front of it.

The white painted cove background was lit with two standard heads with wide-angle reflectors. The background was lit to have two stops more light on it than was on the subject in order to keep it an absolutely pure white. Two black panels prevented flare from the background in the camera.

photographer's comment

The object the model is holding is an old jaw bone. The 'mud' is actually clay mixed with water and tempera paint.

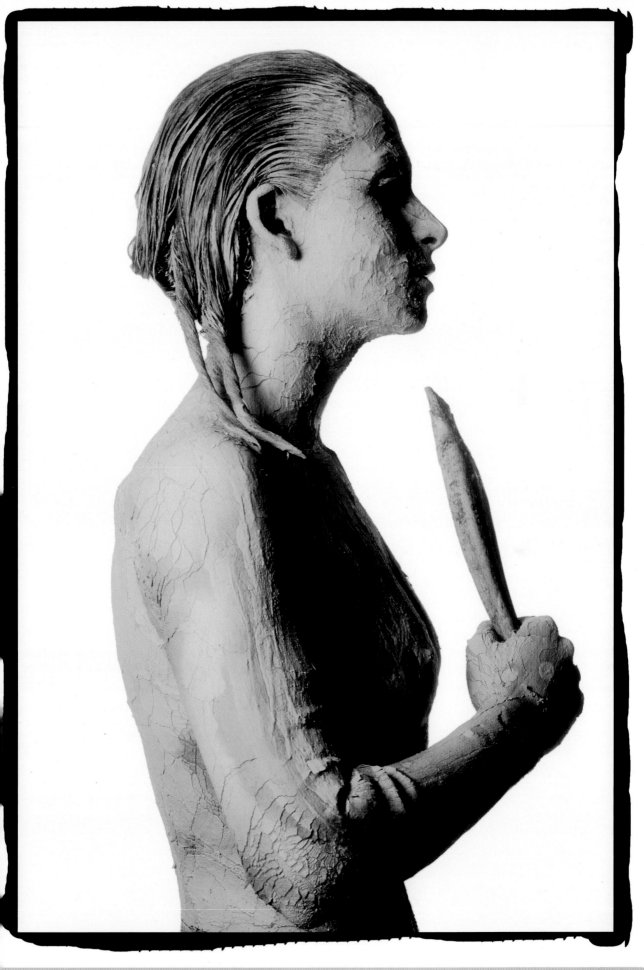

NICOLE

photographer **Kingdome 19**

client	Private
use	Private collection
model	Nicole
camera	35mm
lens	85mm
film	Kodak 400 (colour)
exposure	Not recorded
lighting	Electronic flash

The initial lighting set-up is very important here, but it is the finishing in the darkroom that really makes the final image.

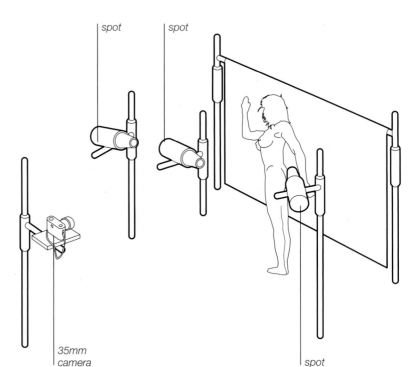

plan view

key points

Classical and ancient art forms and conventions can inform and inspire interesting contemporary work

The model is lit from camera left by two spots, to give the highlights on the upper surfaces of the body and, just as importantly, to give the large shadows on the background behind. A third light high on the right adds a hot spot to the hair and chest area.

The shadow on the model's back gives the illusion of an impossibly narrow waistline, and the model's pose accentuates the visibility of the rib cage to emphasise the slenderness of the figure.

The ancient Egyptian-style pose has a graphic simplicity that works well in this sepia tone. The added textures such as the scratching at the top of the image and the gouge across the image at hip level were introduced at the darkroom stage.

photographer's comment
From the 'Unique' series. Sepia toned. Six exposures on the photo in the lab.

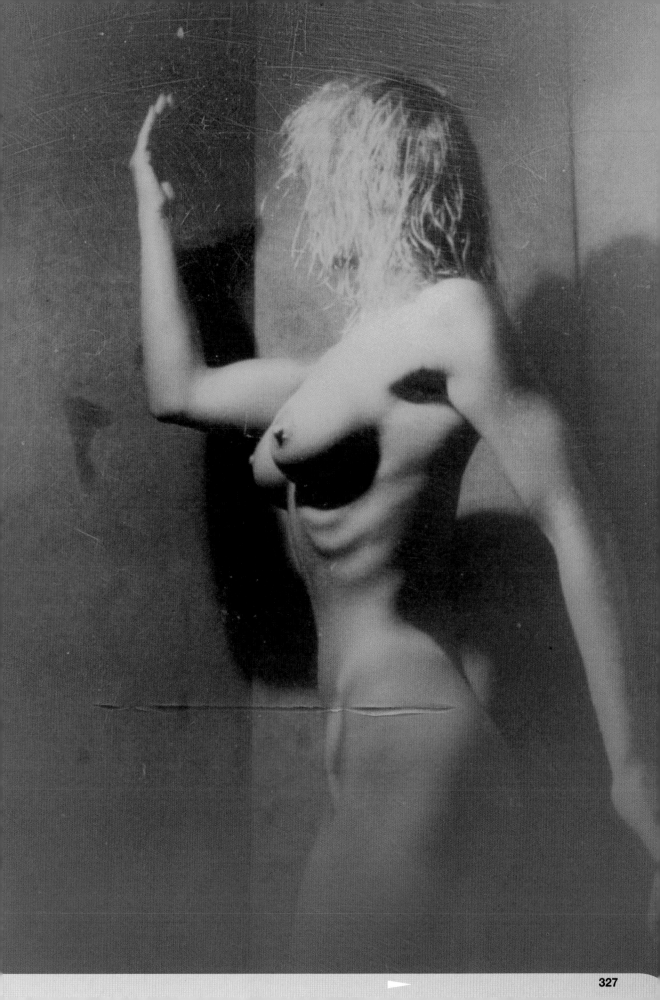

ALIEN

photographer **Marc Joye**

use	Personal work
model	Geneviève
assistant	Mike
stylist	Jenny
camera	35mm
lens	35mm
film	Ekta 100
exposure	1/60 second at f/16
lighting	Electronic flash

With the intention of capturing strange body forms and perspectives, Marc Joye photographed from very close proximity while the model danced to music.

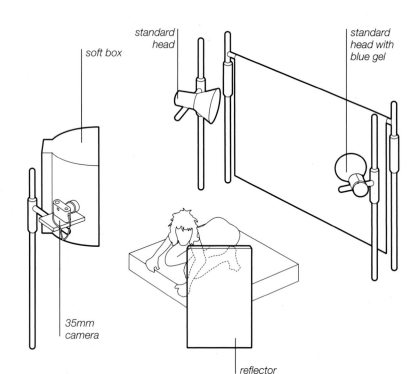

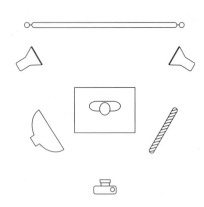

plan view

key points

Alarming distortions can be achieved purely by composition and posing. Special effects are not necessarily needed

The blueness on the background is somewhat diluted by the fact that the second background light is without a gel

The spontaneity of this kind of shoot can produce unexpected and interesting compositions. Here, the pose and framing create the look of a somewhat alien-like being, in that she seems to consist of only a head, breasts and arms, no body, and no legs.

The straightforward lighting set-up consisted of a one metre-square soft box to camera left, just forward of fully side-on to the model and angled towards her, and reflected back by a symmetrically-positioned panel to camera right.

The icy chill to the background, picking up the blue make-up on the model, emanates from a strobe head with a blue gel directed at the background from the right. A second flash without gel is on the left.

photographer's comment

While Geneviève, who is a dancer, was moving to music, she knelt on her hands and knees. This offered me this strange view through the wide-angled lens.

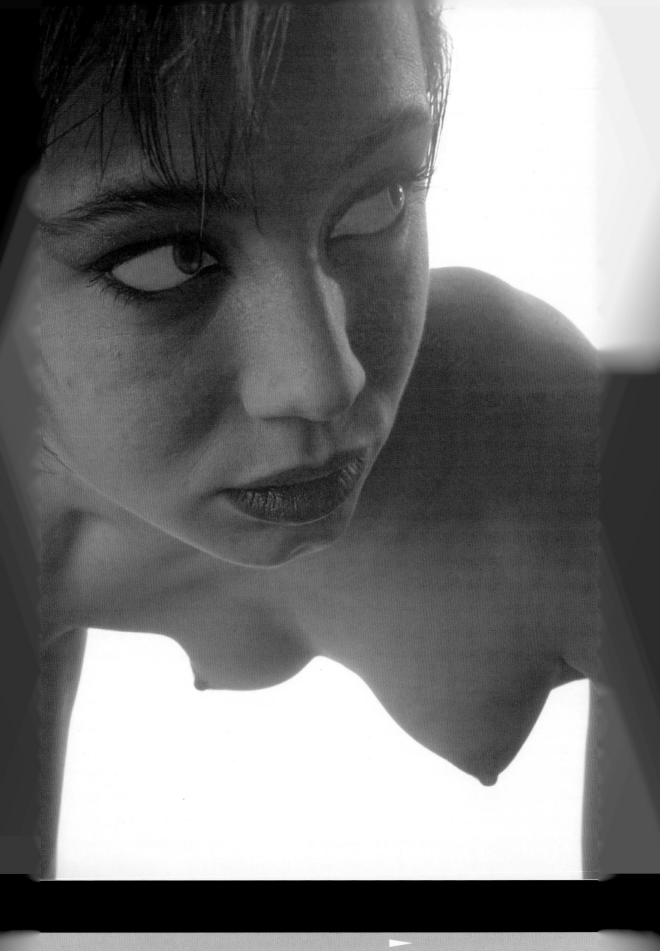

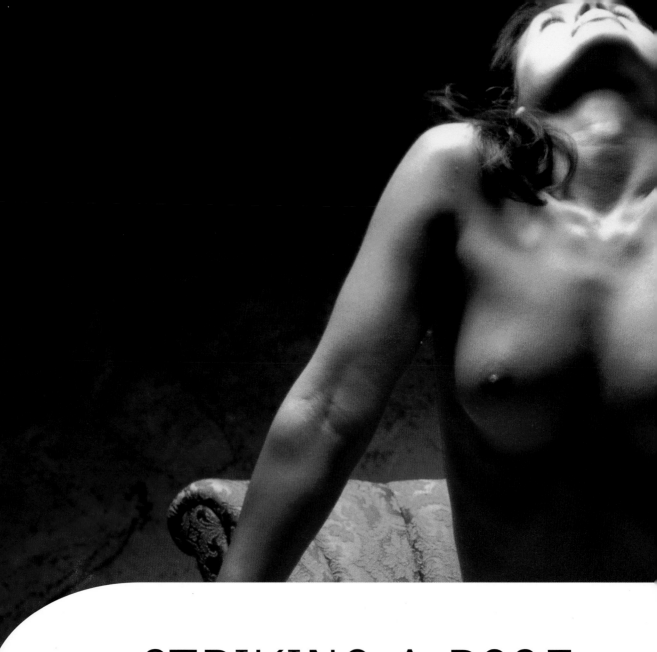

STRIKING A POSE

17

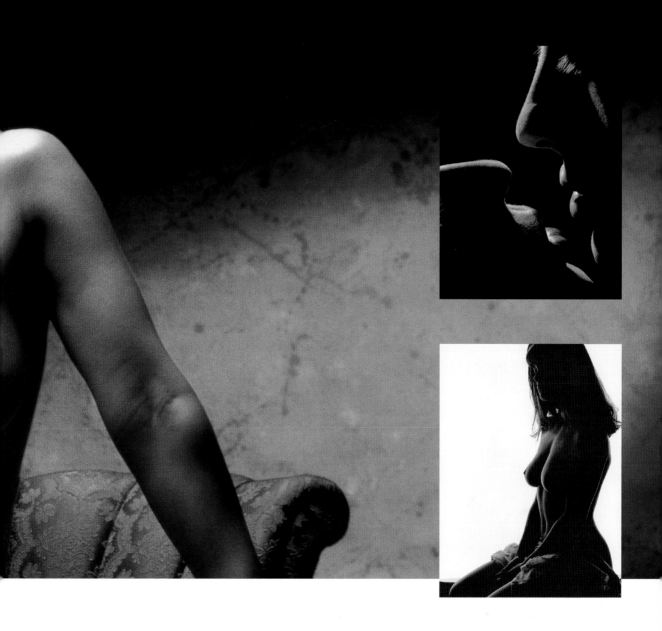

There is more to posing than strutting and pouting on the part of the model. While the model has to be well in control of his or her body, and to understand their own assets to the nth degree, the photographer also has to be ready to direct clearly, and the model must be able to respond and deliver the movement, position and expression that the photographer is looking for. It is a partnership that must work in both directions.

Posing has everything to do with composition, and the lighting must be in sympathy with the overall final look required. If strong graphic forms are wanted and an appropriately graphically-formed pose is planned, then the lighting will be instrumental in capturing that pose to the best possible advantage, whether to increase or reduce modelling, add or eliminate shadows, introduce or suppress separation. The exact positioning of the pose will be as much a part of the lighting set-up as any number of lights and panels in achieving the exact detail of the look required.

KISS

photographer **René De Carufel**

use	Personal
camera	6x6cm
lens	150mm
film	Tmax 100
exposure	1/60 second at f/16
lighting	Electronic flash
props and background	Black velvet curtain

The romantic intimacy of this pose, reminiscent of many a Hollywood 'final clinch' scene, requires precise and sympathetic treatment from the lighting set-up if the mood is not to be broken. With such a shot, the balance between details that are revealed and shadowy areas can make all the difference.

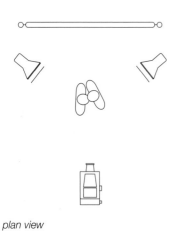

plan view

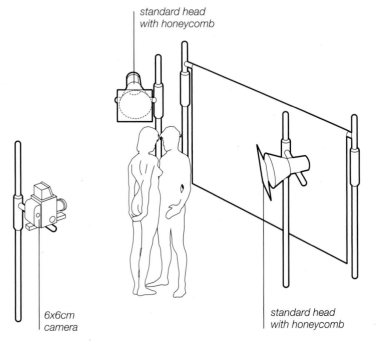

standard head with honeycomb

6x6cm camera

standard head with honeycomb

key points

Lighting and exact posing have to be worked out and controlled to the nth degree when every detail of what is lit in the composition, counts

Cross backlighting gives the best control for rim-lighting two closely positioned models

René De Carufel has here restricted the lighting to pick out only eyelashes, lips and profiles. Two standard heads with 10° honeycomb grids are positioned, one over the far shoulder of each of the models. Careful directing produces the composition that is required with the eyelashes and lips just in the line of the light sources, but no more than that.

The background is provided by a black velvet curtain that gives a deep, smooth blackness that is matched by the darkest areas of shadow on the foreground of the faces.

photographer's comment
The key to this simple lighting is the precise positioning of the delicate light rays on each face.

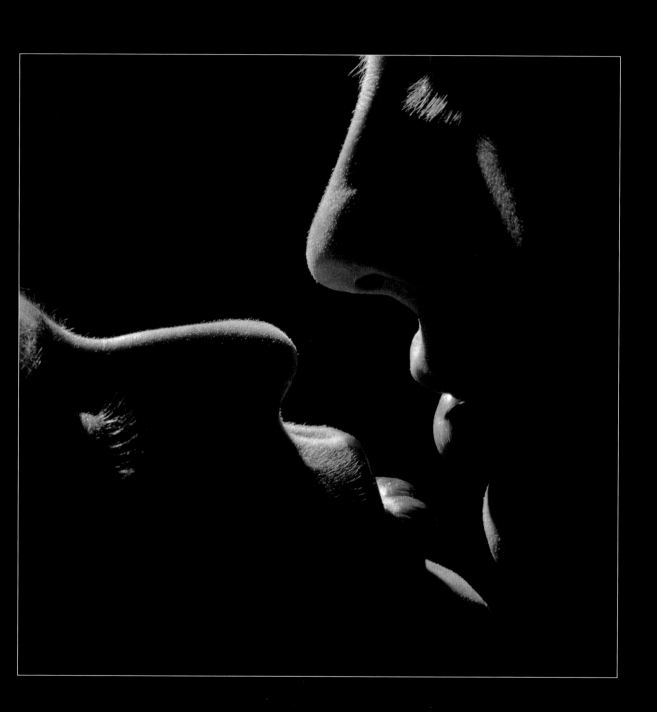

MAN

photographer **John Knill**

use	Stock
client	Digitalvision
assistant	Jonathan
model	Matthew Barrett
camera	6x6cm
lens	110mm
film	Kodak Tri-X
exposure	Not recorded
lighting	Tungsten

This is a good example of the technique of taking a light and dark subject and setting it against a contrasting dark and light background for separation.

plan view

tungsten head

tungsten head

black panel

6x6cm camera

key points

Counter-balanced posing is helpful when a balance of light and dark is the underlying structure for an image

Note how the penumbra area where shade gives way to light on the background is almost completely blocked from view by the position of the model in relation to the camera

The key light on the model is to camera left, as is the light on the background. However, the background light is flagged so that the area behind the highlighted side of the model remains dark, and thus the light falls only on the right side of the background. In other words, the area behind the dark side of the model is in light.

The rippling muscle tone of the model allows considerable textural interest and play of light across the subject surface, while again by way of contrast the background is utterly plain and flat. The result is a strikingly well-composed graphic image.

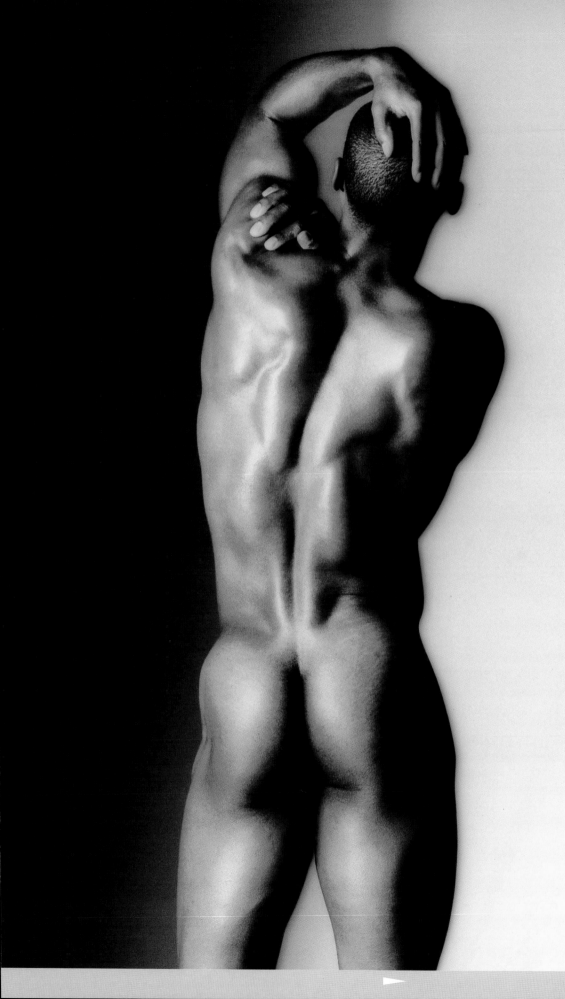

CHAIR

photographer **René De Carufel**

use	Personal
camera	6x6cm
lens	80mm
film	Fuji Velvia
exposure	1/8 second at f/8
lighting	Electronic flash and tungsten
props and background	Hand-painted backdrop

For this dramatic image, René De Carufel contrived direct overhead lighting, which provides both the 'bathed in light' effect on the upturned face and the discreetly 'plunged into shadows' effect on the lower body.

plan view

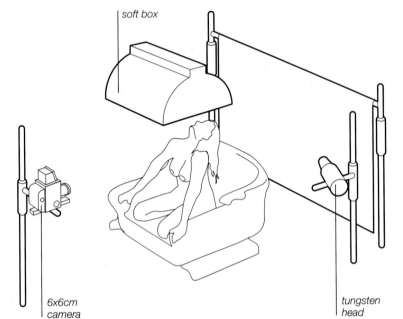

soft box

6x6cm camera

tungsten head

key points

Booms can get lights into the most awkward of positions, but make sure that they are counterbalanced adequately

The unseen has a compelling appeal and mystique that the candidly revealed cannot compete with

The soft box directly above the model has a warm gel to make the most of the tanned skin tones of the model. Gleaming highlights are allowed on the curves of the knees and shoulders for dramatic effect, and the upper torso shades the lower body to play up the well-known allure of the unseen.

The hotspot on the background is created by a 1 kw tungsten head with a Fresnel lens to the right of the model. Colour is an important factor in the success of this shot. The chair and background are chosen for their warm, golden colours, which complement the skin tones perfectly.

photographer's comment

To achieve this effect I used simple, dramatic lighting, warm colour, and a spotlight on the backdrop to create depth.

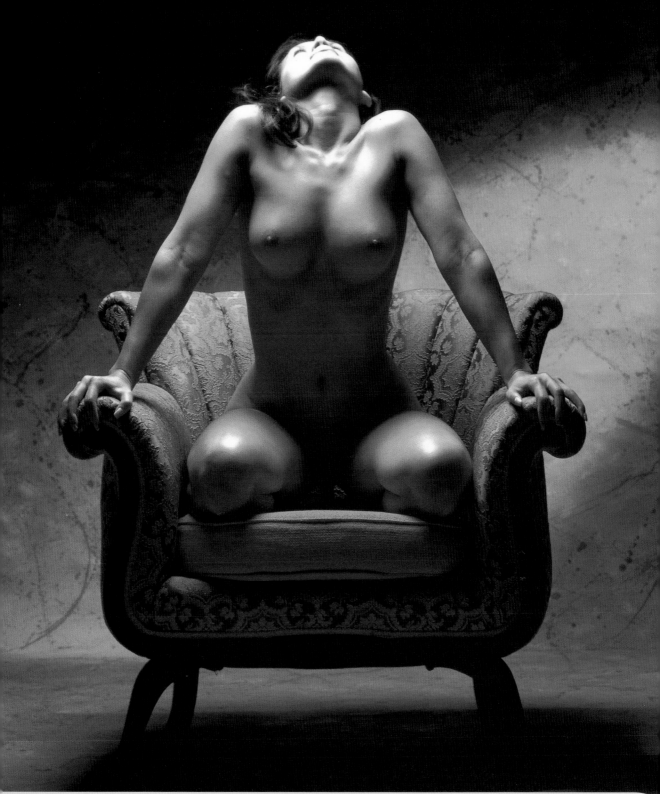

UNDRESSING

photographer **Pascal Baetens**

use	'The Fragile Touch' book
client	Foto Art
model	Geraldine
camera	35mm
lens	28–85mm
film	Kodak Tmax 400
exposure	1/60 second at f/11
lighting	Available light

The model is placed simply on a low platform with just a large window to camera left.

plan view

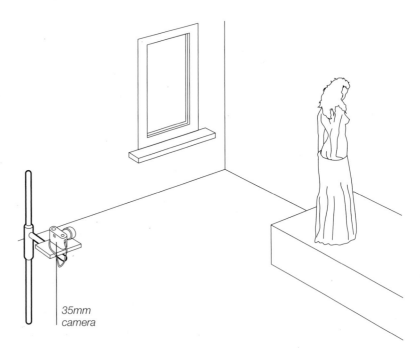

35mm
camera

key points

With a series of this kind, choosing the moment for each stage is important, and careful editing of the available selection of shots is a consideration

Subtle adjustment of camera position and zoom can make a good deal of difference to the impact of the series

The window supplies indirect northern light, which performs much like a large soft box, although the overall look to this series of images is quite hard and contrasting, with strong, well-defined shadows.

Light and shade are provided by the location. The black beam at floor level separates the block from the model and the wall, and the paint peeling on the walls behind makes the picture still harder.

The series here looks very fluid and continuous, yet close examination of each shot shows that each picture is perfectly composed and controlled, indicating a high degree of deliberation. The model is in good control of her posing and the photographer is consistently directing the composition.

photographer's comment

This natural window light is perfectly comparable to an 80x120cm soft box.

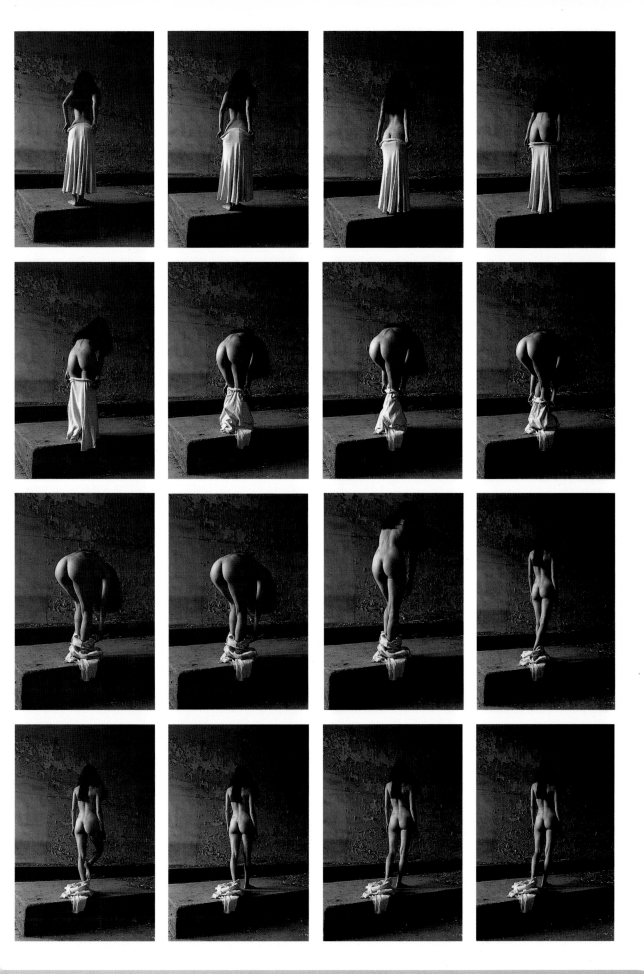

NUDE

photographer **Michèle Francken**

use	Exhibition
model	Sofie Weiss
camera	4x5 inch
lens	300mm
film	Polaroid 59
exposure	1/125 second at f/11
lighting	Electronic flash
props and	
background	Hand-painted background

The inspiration for this shot is clearly classical sculpture. The draped nude adopts a statue-like pose, the hair is sculpted to the head, while the style and colour of the draped material and the colour and shading of the hand-painted backdrop are highly reminiscent of stone.

plan view

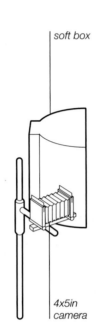

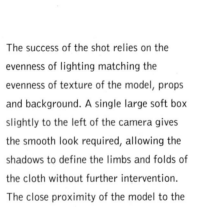

soft box

4x5in
camera

key points

To get shadows for separation and good modelling, it is important to place the light source slightly to the side rather than directly face-on to the model

Re-shoot the results of Polaroid shoots swiftly as insurance against accidents or damage to the original

The success of the shot relies on the evenness of lighting matching the evenness of texture of the model, props and background. A single large soft box slightly to the left of the camera gives the smooth look required, allowing the shadows to define the limbs and folds of the cloth without further intervention. The close proximity of the model to the background (as well as the angle of the light source) is evident from the shadow that falls on it. This shadow provides just enough separation from the backdrop – so close in tone to the model's skin – while natural fall-off serves the same purpose on the left. This is a shot of classical beauty, executed with classic simplicity.

photographer's comment

It is very interesting to work with Polaroid material because you see the results immediately. When you have achieved the picture you want, you can stop and make another image. However, concentration is very important in this case.

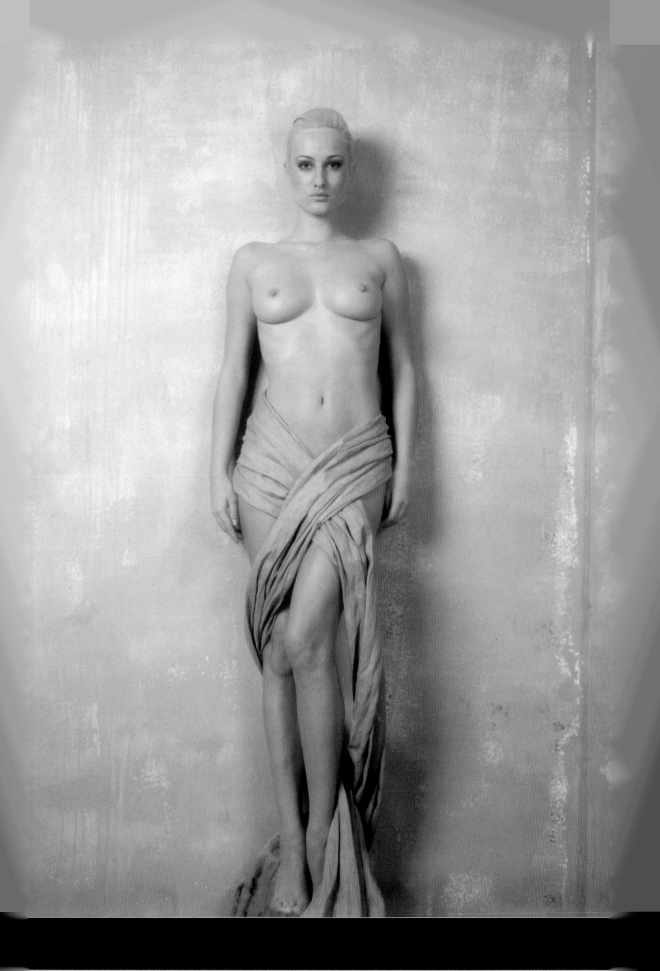

CATHY

photographer **Robert A. F. van de Voort**

use	Self-promotion
model	Cathy
camera	6x7cm
lens	110mm
film	Agfa APX 100
exposure	1/125 second at f/22
lighting	Electronic flash

Robert van de Voort used an innovative arrangement to get the smooth back-lit look that he wanted for this shot.

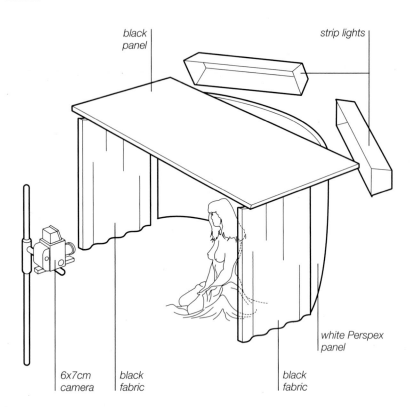

black panel

strip lights

white Perspex panel

6x7cm camera

black fabric

black fabric

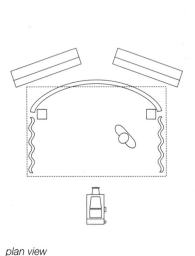

plan view

key points

Whereas a large swimming-pool light as a background would be just a flat source of light, this construction curves around the model to partially sidelight simultaneously (for example on the near arm edges)

Spot-metering is essential on a shot like this

What is not obvious from the final image is that the model is placed inside a 'box' constructed of lighting equipment. Behind her is a large (2400x1200mm) frosted white Perspex panel which has been forced into a curve by means of weights at each side. Overhead, the top of the box is formed by a black polystyrene panel. The side walls and floor of the box are black fabric.

The Perspex panel is trans-illuminated by two 1250mm strip lights, some 60cm above the ground. They provide an even sheen of light through the back wall of the 'box' which results in the merest sliver of light picking out the edges of the body.

photographer's comment

The curved lighting technique lifted the delicate lines and shapes into a showpiece.

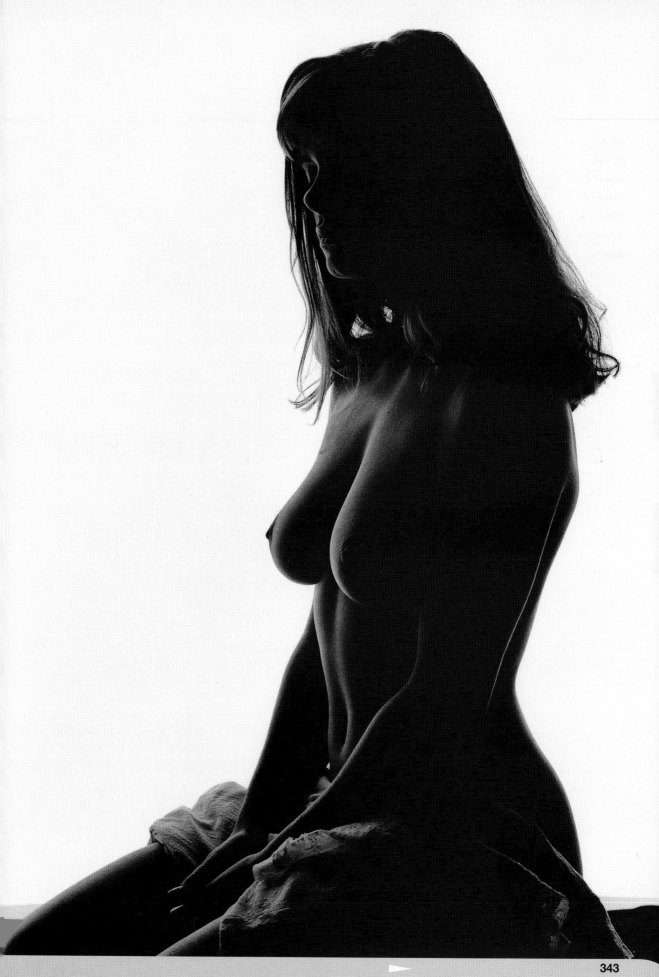

TOP HAT

photographer **Robert Anderson**

client	Glance Magazine
use	Editorial
stylist	Abbie Ribes
hair and	
make-up	Caroline O'Neil
camera	6x7cm
lens	180mm
film	Fuji Provia rated at 80ISO pushed 1/3 in processing
exposure	1/60 second at f/16
lighting	Electronic flash
props	Top hat, blue feather boa, thigh-high leather boots

The boldness of the clothing, pose and styling are made all the more stark and striking by the way the colourful subject is set against a cool white background. The subject stands out as crisply as a cut-out.

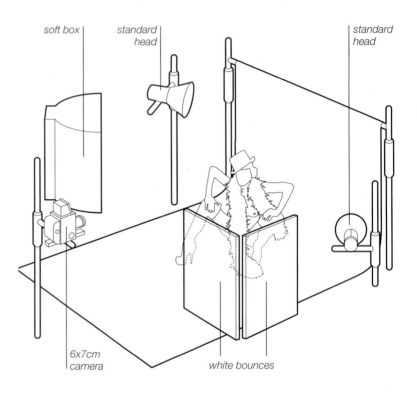

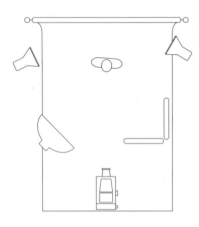

plan view

key points

Post-production cut-outs can be fiddly and unsatisfactory in the detail. Lighting and exposing for the same effect in the first place may be a better solution

Mixing areas of flat black and white with highly detailed and modelled textures (such as the hat and background as compared with the feathers in this example) can make for a very strong visual impact

The lights on the background are standard heads, one light on either side of the model and slightly behind her. Both are set to half stop over-exposed to ensure the bright whiteness of the background. The light from these heads is allowed to spill over onto the back of the model, essentially to act as a rim light.

The main light is a large soft box on a boom, placed to the left of the camera. Fill is provided by a 4x8-foot foam core 'bookend' or poly-wedge placed to the right of the camera, giving a good sense of modelling to the limbs.

photographer's comment

This shot was inspired by the movie 'A Clockwork Orange'. My creative team came up with this stylised '90s take-off.

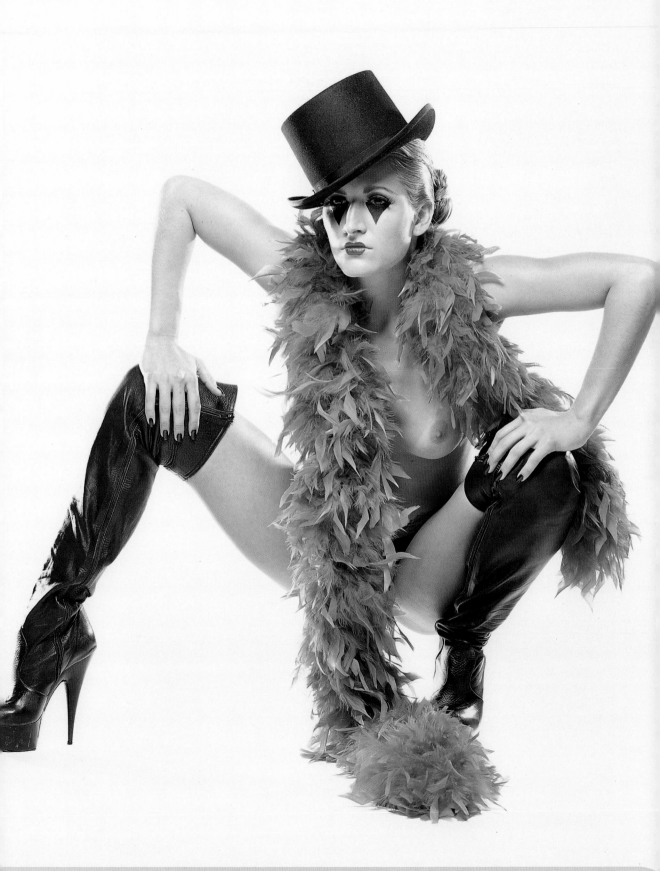

VEIL

photographer **Ray Spence**

use	Personal work
model	Josephine
camera	6x7cm
lens	90mm
film	Ilford FP4
exposure	1/15 second at f/8
lighting	Tungsten

Many artists have experimented with coverings and drapes, from sculpted robes dressing classical statues, to contemporary artists wrapping buildings and cliffs as headline-grabbing modern art works. A simple veil is as straightforward a covering as you can get, but its effect is anything but dull and commonplace here.

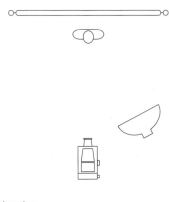

plan view

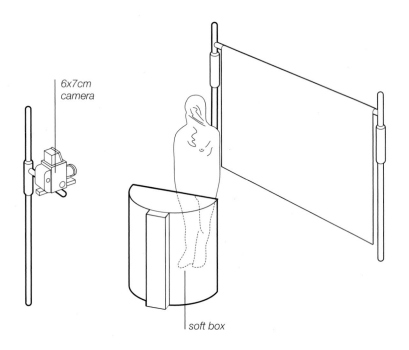

6x7cm camera

soft box

key points

It can be interesting to print an image flipped as it can have a different kind of impact each way round. Ray Spence likes to print this shot flipped sometimes, as it is presented opposite. Compare this with the thumbnail below.

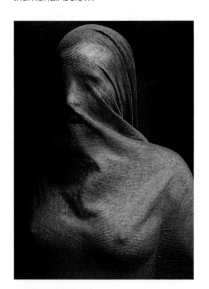

The cloth is draped to give folds of fabric that cradle the shadows, and it is arranged so as to cling to give just enough sense of the figure underneath. The modelling light of a single soft box penetrates the gauzy material to reveal a certain amount of detail of the body, and the model is oriented to keep the far side of the head and torso in shade.

The beauty of the image lies in the way the various elements come together with exquisite and precise execution. Notice the perfect draping of the material to get the folds to ripple just so, revealing just enough of the facial expression and also ensuring that the textured grain of the fabric lies in a pleasing orientation. The styling is superb.

photographer's comment

I like to print this image flipped sometimes.

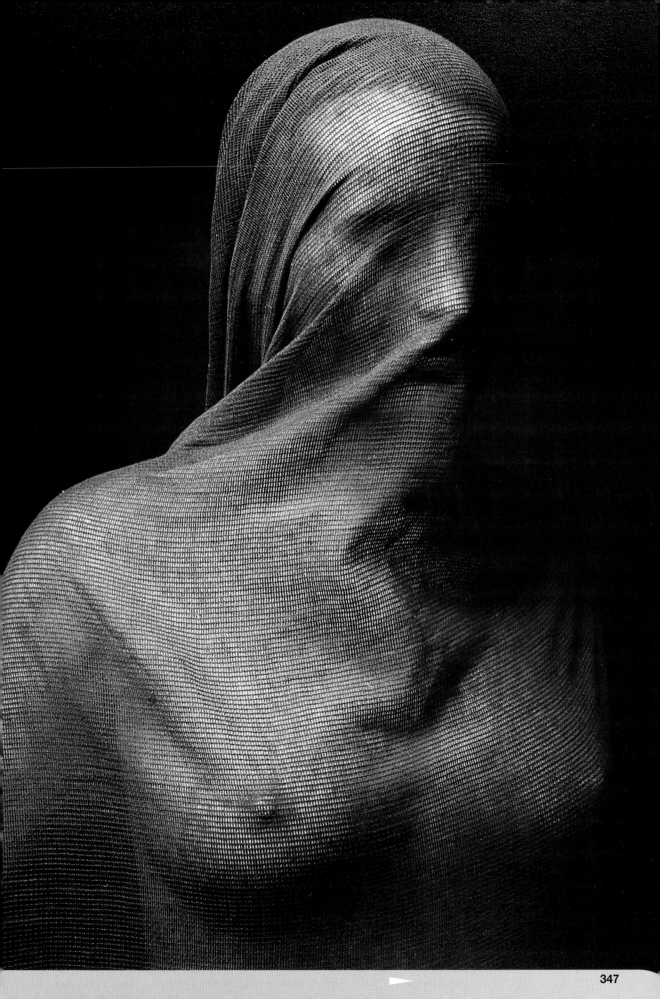

CHEEKY

photographer **Suza Scalora**

use	Editorial
art director	Suza Scalora
model	Lisa Whiting
make-up	Susan McCarthy
camera	4x5 inch
lens	Home-made
film	Polaroid type 55
exposure	1/125 second at f/2.8
lighting	Electronic flash

The superb composition really makes this shot. As with Renata Ratajczyk's "Corset", which makes an interesting comparison, the close-in crop makes for an intense image, placing the accent firmly on the fantasy element of the subject.

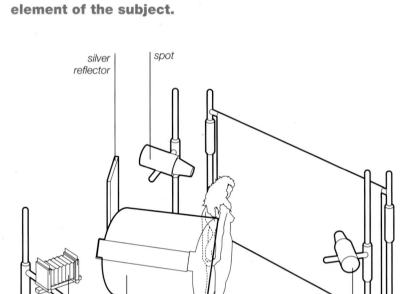

plan view

key points

With a pale subject on a pale background, the shadows assume a great deal of importance for providing subtle (or not so subtle) definition

The overhead direction of the light provides the required impact and drama

One soft box overhead positioned as close to the model as possible is the main light on the subject. This results in the sculptural modelling on the body and the deep shadow behind the hands and on the lower edges of the curves of the subject. A silver fill card is below and in front of the model at a 45° angle and is again as close to her as possible,

to reflect light into the shadow areas.

The 12-foot white seamless background is illuminated by two heads with tight grid spots to focus the light.

To produce this image the photographer has adapted a lens to be compatible with the large-format camera used.

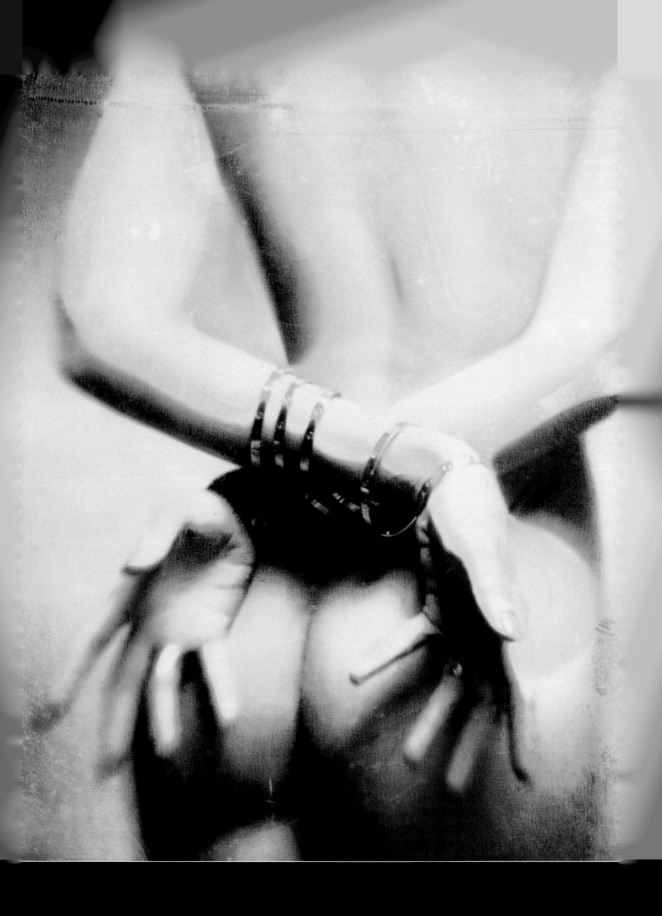

EXPOSITION DÉPOSÉ

photographer **Kingdome 19**

use	Private collection
models	Lars and Bianca
camera	35mm
lens	85mm
film	Ilford FP4
exposure	Not recorded
lighting	Electronic flash

It took twelve separate exposures in the darkroom to create this final image. The framing and title captions account for some of those exposures, but the details of finishing and textural control account for the others.

plan view

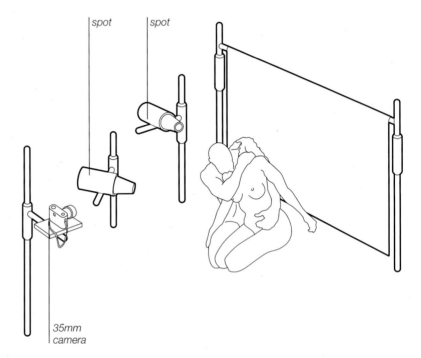

key points

When a multiple exposure in the darkroom is planned, it is important to get the lighting right on the original image in order to avoid too many complications later on

When multiple images are printed onto one piece of photographic paper, the order in which the components are printed is a consideration and time adjustments will be required to achieve a balanced final print

The original exposure in the studio was lit by just two heads to camera left, one slightly higher than the other, to give the generous lighting on the models' bodies. As with many shots in this book, sidelighting is the photographer's preferred choice for a dramatic look, and gives the strongly contrasting shadowy areas on the off-side of the subject.

The precise positioning of the lights is crucial. The upper light is high enough to illuminate the woman's upturned face, and the lower light is high enough to allow some modelling to occur beneath the curve of the breasts.

photographer's comment

From the 'Unique' series. Sepia toned. Twelve exposures in the lab.

KINGDOME 19

-EXPOSITION-
DÉPOSÉ

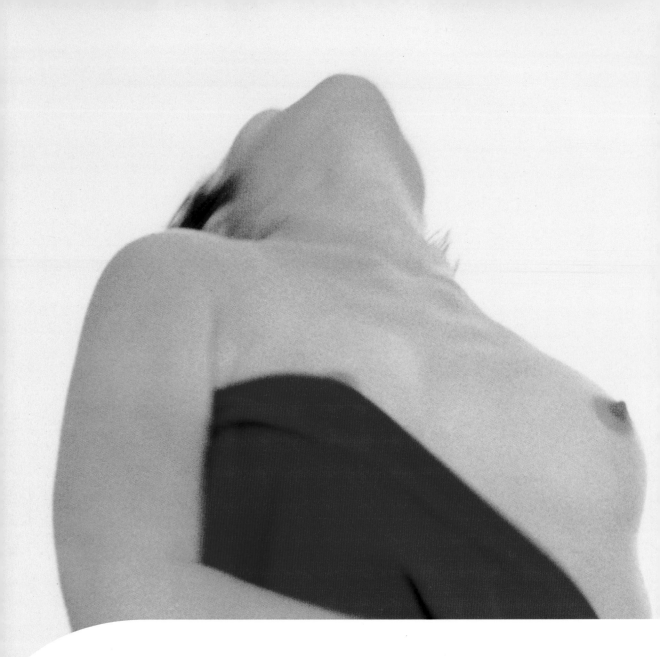

PROPS

18

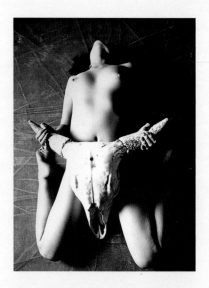

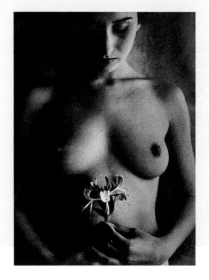

What are props for? Indeed, what are props? They might be defined as any object included in a shot, other than the model. They usually are considered of secondary importance to the model in terms of subject matter interest, but this is to undervalue their importance in a composition. While a shot may not primarily be 'about' the props that feature in it, the props will certainly contribute – perhaps tacitly or unobviously – to the success of the overall composition. Clothing, furniture, fruit, flowers, jewellery, objets d'art and objets trouvés can all serve a useful purpose in this respect.

The photographer has to plan the shot using the props to strengthen and enhance the composition, and needs to light appropriately to bring out the aspects required. The versatility of props is that they come in all shapes and sizes, and can be for countless purposes, even as lighting props that flag, add shadow or reflectivity as required. The only rule is that a prop has to earn its keep in a composition: if it is not contributing something, it should not be there.

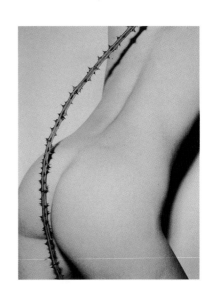

SCAR

photographer **Ray Spence**

use	Personal work
model	Josephine
camera	6x7cm
lens	90mm
film	Ilford FP4
exposure	1/60 second at f/11
lighting	Electronic flash

The curves and smooth softness of the model's body are in sharp contrast with the spiky thorns of the bramble, although the graceful arc shape of the stem does, of course, echo the curvature of the model.

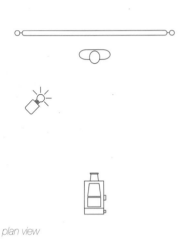

plan view

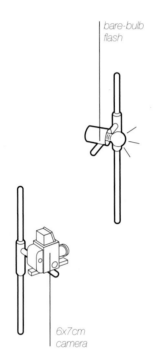

bare-bulb flash

6x7cm camera

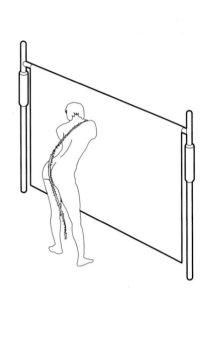

key points

Bare-bulb flash, i.e. a standard head without a reflector, is undirected and unchannelled. It therefore spreads out over a wider span from the source, giving a more even hard effect

'Hard' light and 'soft' light are difficult to define, but are always recognisable. The important thing is to understand how to get the result you want

Ray Spence used a single bare standard head to camera left which was angled down on to the subject at about 45°. The model is positioned so as to give an important yet minimal amount of gentle modelling to define the spine and body curves.

The shadows from the two elements of the subject again emphasise associations of hardness with the

vicious thorns and softness with the body. The thorns, in close proximity to the skin, cast a well-defined hard shadow across the model's back to make the scar of the title; contrast this shadow with the almost parallel soft shadow along the spine. The model casts her own soft shadow on the more distant background, continuing the thematic juxtaposition of hard and soft.

photographer's comment

Slightly harsh light was used to emphasise the difference between the thorns and the skin.

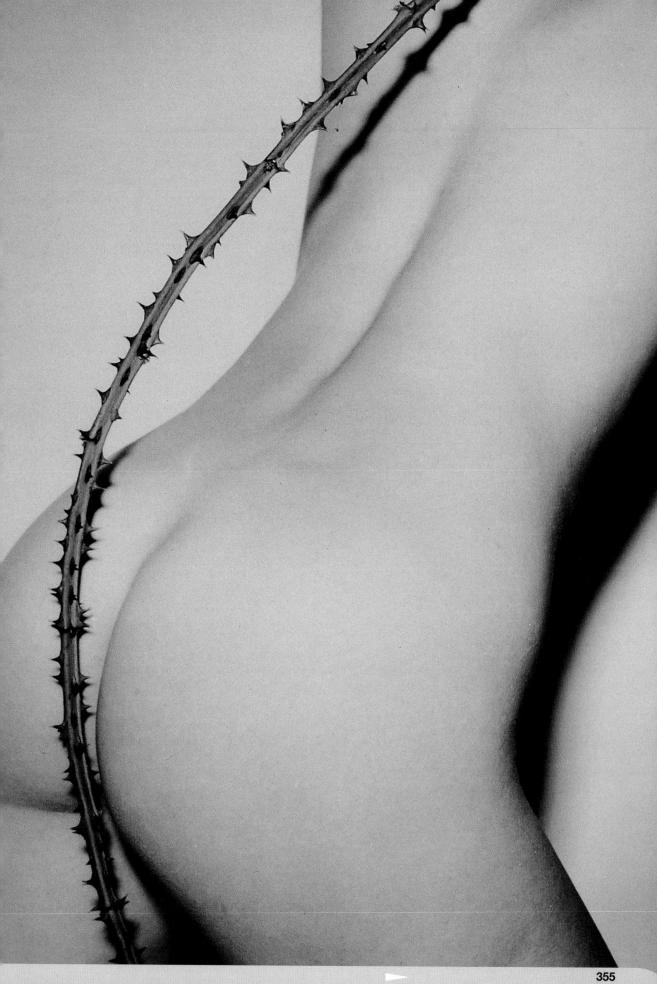

MASK

photographer **Michèle Francken**

use	Personal work
model	Thierry
camera	6x6cm
lens	120mm
film	Kodak VHL
exposure	1/60 second at f/11
lighting	Electronic flash

The background is hand-painted with golden brown paint to give a mottled look that sets off the subject to good effect.

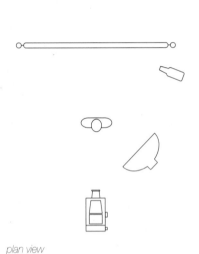

plan view

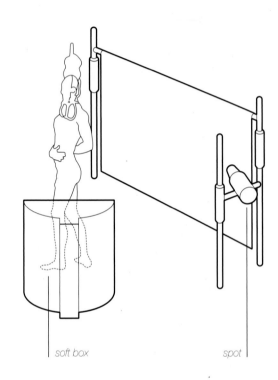

6x6cm camera

soft box

spot

key points

Colour and tone as well as texture play an important role when it comes to selecting backdrops

If you can't find the ideal backdrop for your shot, create your own

Michèle Francken used a spot light to skim across the background and bring out the textured painted effect. On the model, she used a single light to camera right.

The directionality is clear in the picture, and the gleaming highlights down the length of the body were achieved by first applying body oil to the model's skin. The overall contrast balance is closely controlled by choice of background and model, positioning of lights and posing of the model. When printing the image, Michèle Francken says that she was aiming to bring out the most interesting colour and contrast possible.

The metallic details of the mask and of the bangle on the upper arm show good catchlights, as a finishing touch.

photographer's comment

This image forms part of my experimental work on nudes.

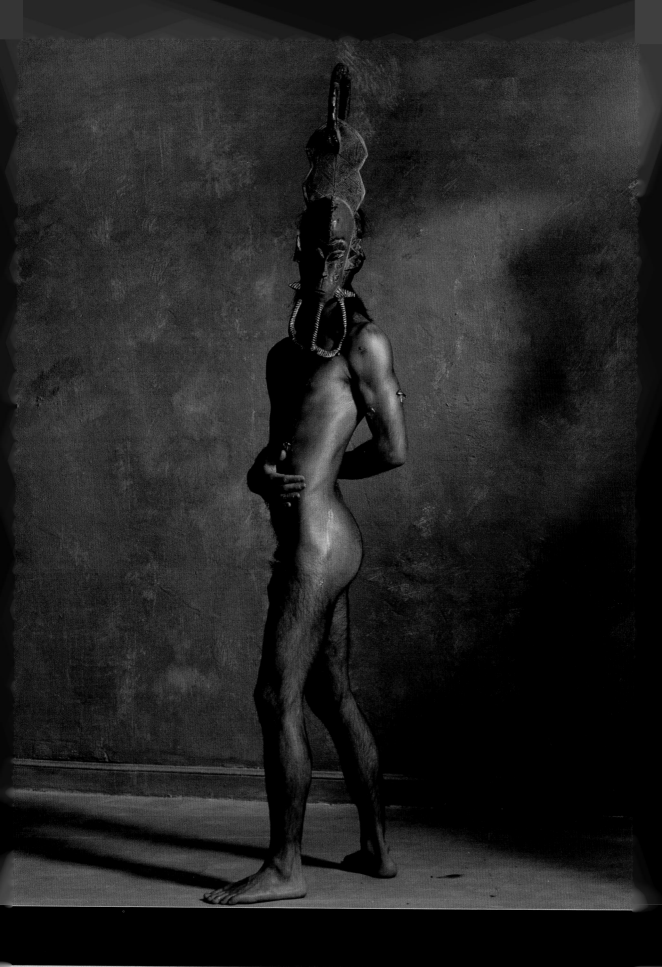

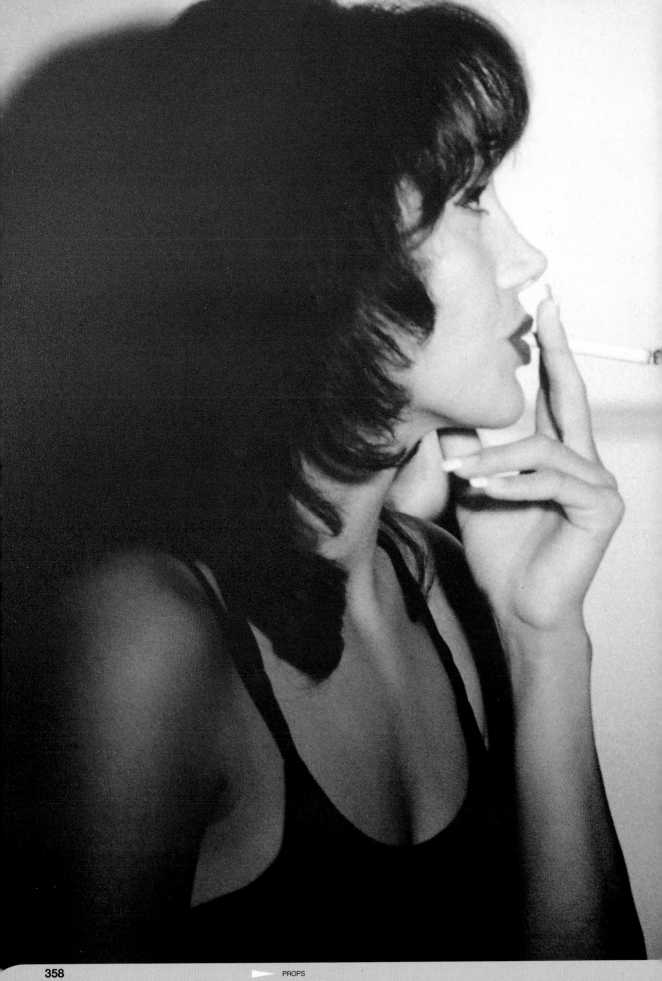

▶ PROPS

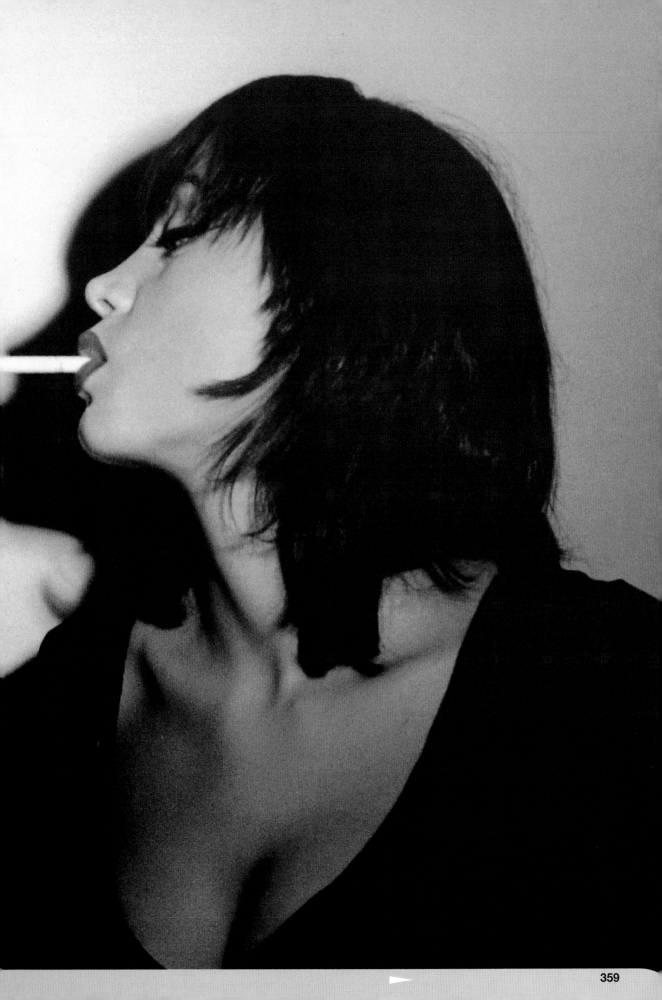

INSINUATION

photographer **Ben Lagunas**

The models are, in essence, standing inside a box with three black walls and one white.

use	Gallery
assistants	Pauline and Isak
stylist	Fabian Montana
camera	6x6cm
lens	210mm
film	Tmax 100
exposure	1/60 second at f/11
lighting	Electronic flash

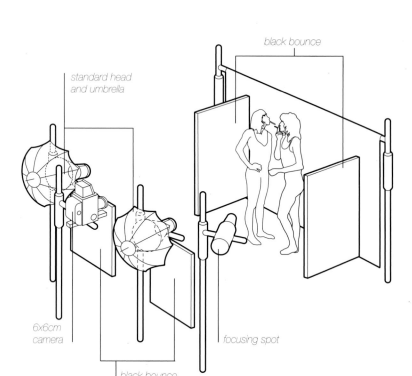

black bounce

standard head and umbrella

6x6cm camera

focusing spot

black bounce

plan view

key points

By placing the subject in effect inside a black box, all stray light is eliminated leaving the photographer free to place the desired light exactly where he wants it to fall

The angle of the spot will determine how much the shadow shape is distorted in comparison with the face profile

The black walls on three sides are formed by an array of black bounces which leave just enough of a gap for the camera to look through and for the light from two standard heads shooting into umbrellas and a single spot to enter the scene.

The standard heads, one on either side of the camera, give the diffused and relatively low level of overall even light, and lift the seamless background to a mid grey (see the top right corner of the shot).

The focusing spot to camera right is used to good effect to give a pool of light only on the faces of the models and to throw a strong shadow on to the backdrop behind them. The faces and the cigarettes are thus picked out brightly in contrast with the neutral background, the dark hair and clothing, and relatively dark body skin tones.

DANCE OF FURY and CROSSING SANITY

photographer **Elena von Kraskowski**

These two images from the same shoot demonstrate some aspects of the difference that variations in posing and use of clothing props can make.

use	Exhibition
model	Dea
camera	6x6cm
lens	120mm
film	Kodak EPT, cross-processed
exposure	1/30 second at f/4
lighting	Tungsten

tungsten heads and umbrella

white panel

tungsten heads

black panels

white panel

6x6cm camera

tungsten heads

plan view

In "Dance of Fury" the red fabric swathes and conceals the body of the model. The sense of dynamic movement is tangible as the fabric swirls around her, and the head and shoulders record with the softness of rapid movement. In "Crossing Sanity", the model leans back and the fabric is loosely held so as to reveal the upper torso, which records quite sharply as it is static, while the hand and fabric again show an amount of movement.

Two pairs of 800-watt tungsten heads light the background and the far floor area. Another pair of similar heads shoot through umbrellas from camera left on to the model. The black panels screen the model from the background lights and control light on the floor, and the white panels bounce in light to control front light on the model.

key points

Make sure that the lab is aware that it really is your intention to cross-process a film

It may be necessary to modify exposures when a film is to be cross-processed so tests are strongly recommended

photographer's comment

The expression of strong feelings – movement and beauty.

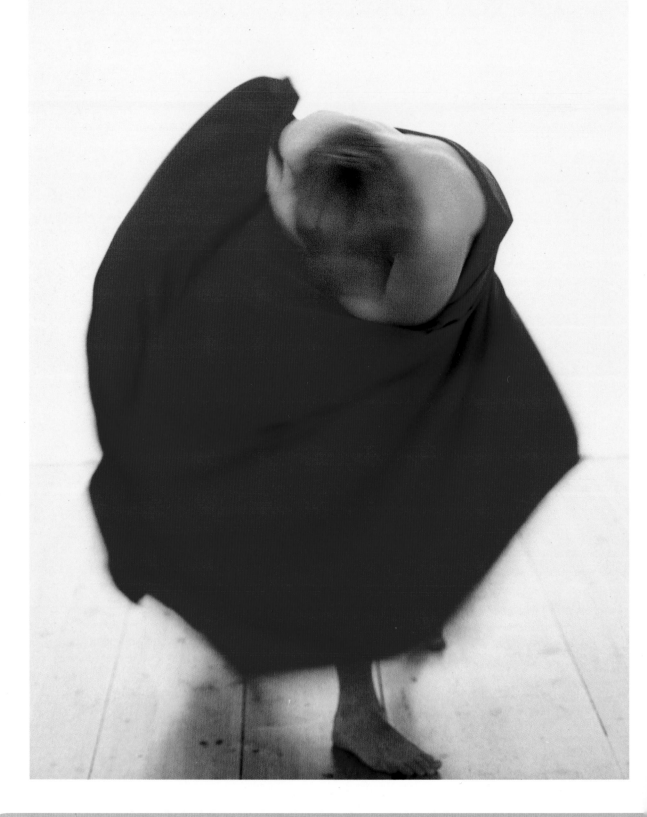

▶ PROPS

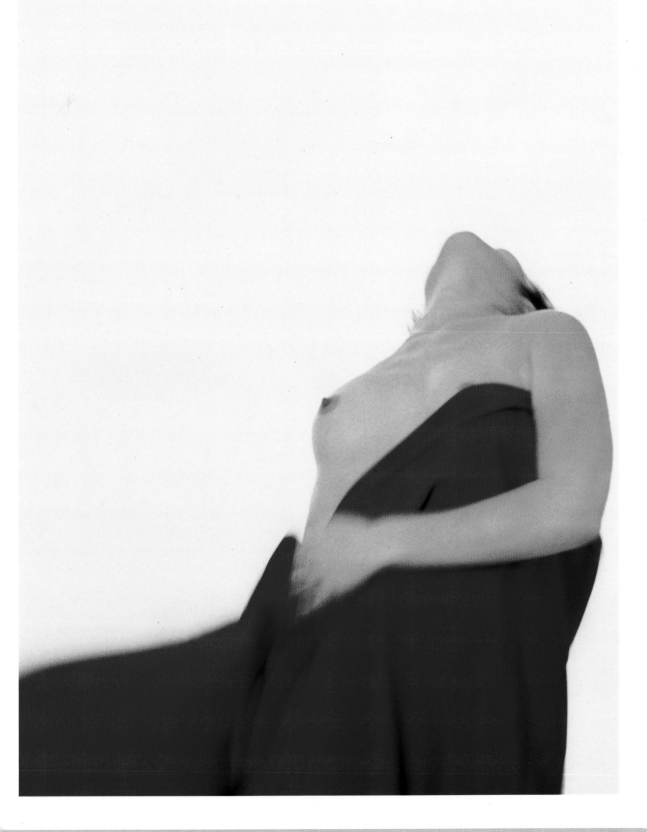

HONEYSUCKLE

photographer **Ray Spence**

use	Personal work
model	Josephine
camera	6x7cm
lens	90mm
film	Ilford FP4
exposure	1/15 second at f/8
lighting	Available light

The shot was taken in the studio, and the available light in question emanates from a window to camera right.

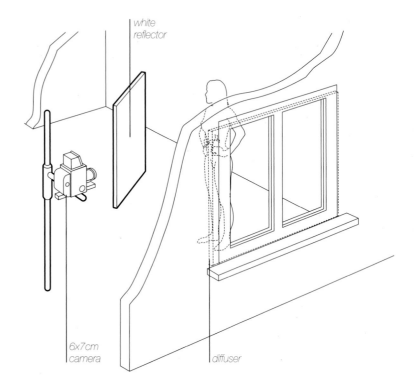

white reflector

plan view

6x7cm camera

diffuser

key points

Particular areas of a shot can be emphasised in the darkroom instead of or as well as by the lighting in the studio. However, it is usually better to balance the light initially to achieve the tonal range you want

Black and white film stocks of different speeds will give varying qualities in their granularity. It is good to become familiar with the stocks and choose the right one for the look you want

A diffuser was placed across the window, resulting in a soft-quality ambient light. Since the window is approximately at head level, in effect the light is angled downwards slightly. It is also directly side-on to the model and the highly directional source thus allows the far side of the model to remain in darkness with only the camera right side of the subject in clear light.

"I work with this model a lot," says Ray Spence, and the resulting rapport between photographer and model can only help when precise posing and positioning of props is required for such a shot.

Notice how the skin tones and the flower register with quite distinct textural and tonal qualities. The reflector to camera left helps to pick out the honeysuckle bloom particularly.

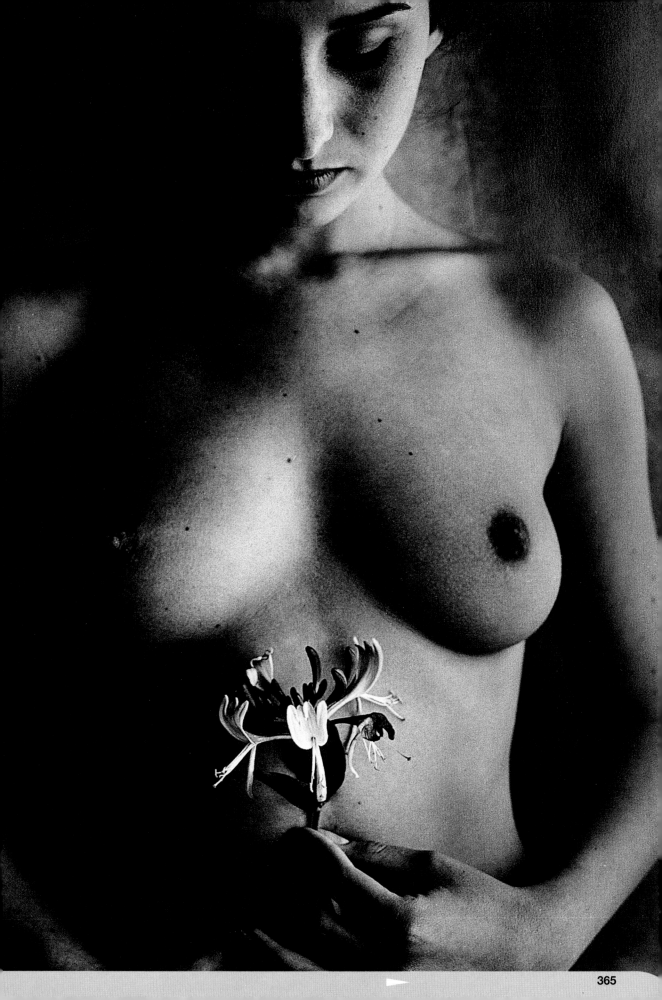

ARTIST'S PALETTE

photographer **Michael Stanley**

use	Personal work
model	Debbie Bunch
camera	35mm
lens	70mm
film	Kodak Tmax 100
exposure	1/250 second at f/8
lighting	Electronic flash

Shape and texture were the most important aspects of this work: accentuating the hour-glass female shape was the aim.

plan view

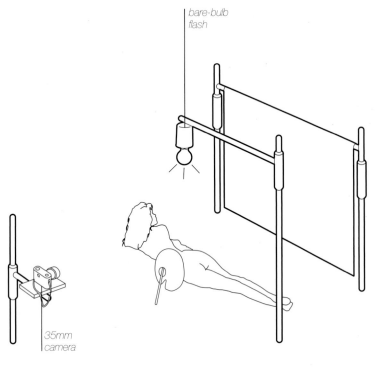

bare-bulb flash

35mm camera

key points

The model's skin was dry to give a natural satin sheen

Props can be used to emphasise form and shape within a composition

The pose combined with a hard light accomplished this goal. A simple but effective single light set-up was used. The light was a bare-bulb flash, positioned directly above the subject for a 'high noon' look, providing strong highlights on the upturned surfaces of the figure, and swift fall-off lower down. This gives a good sense of modelling to emphasise the rounded form.

The composition is carefully arranged. Notice how the indent of the palette's shape echoes the indent of the waistline. Both subject elements have a smooth curvature of outline to emphasise the hour-glass notion further.

The black and white print was finally hand coloured using Marshall's photo-oils and pencils.

photographer's comment
The floor consists of two sheets of wall panelling.

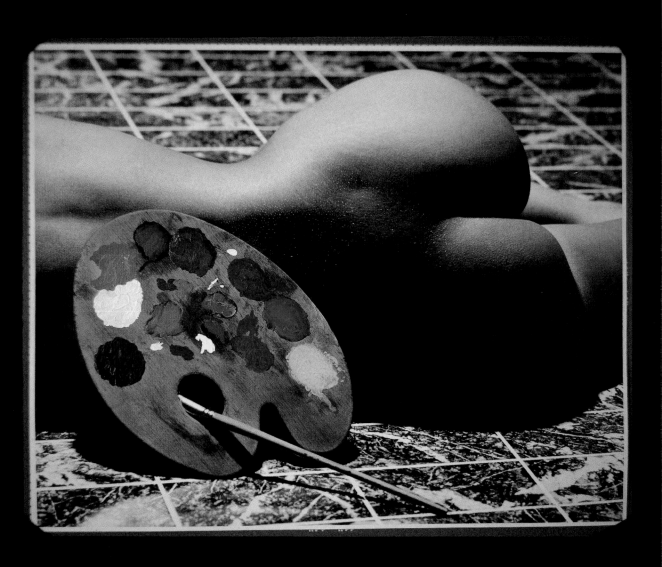

SKULL

photographer **Ben Lagunas**

use	Gallery
assistants	Pauline and Janice
stylist	Fabian Montana
camera	6x6cm
lens	210mm
film	Tmax 400 CN
exposure	1/15 second at f/16
lighting	Tungsten
filtration	Red filter

It is often said that a picture is more than the sum of its parts, and here that is certainly true. This image seems much more provocative than its component parts would suggest.

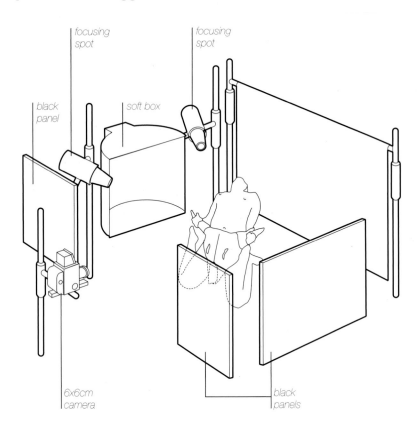

plan view

key points

Don't confuse Tmax 400 black and white film with Tmax 400 CN chromogenic film

It is worth collecting unlikely props and exploring their potential whenever you have the opportunity

Just an animal skull and a model are featured, but the way they are posed produces a considerable shock value. It is the gaping hole of the mouth of the skull, positioned where it is in relation to the model, which is the most impactful aspect of the composition.

The model is reclining on the floor and in order to light the full length of the subject, Ben Lagunas has used the modelling light of a soft box as well as two focusing spots to camera left, arranged in a row.

The strong side lighting and use of black panels leave the right of the model in shade. The focusing spots are aimed at the head and knees of the model, and the soft box between them lights the central area and floor.

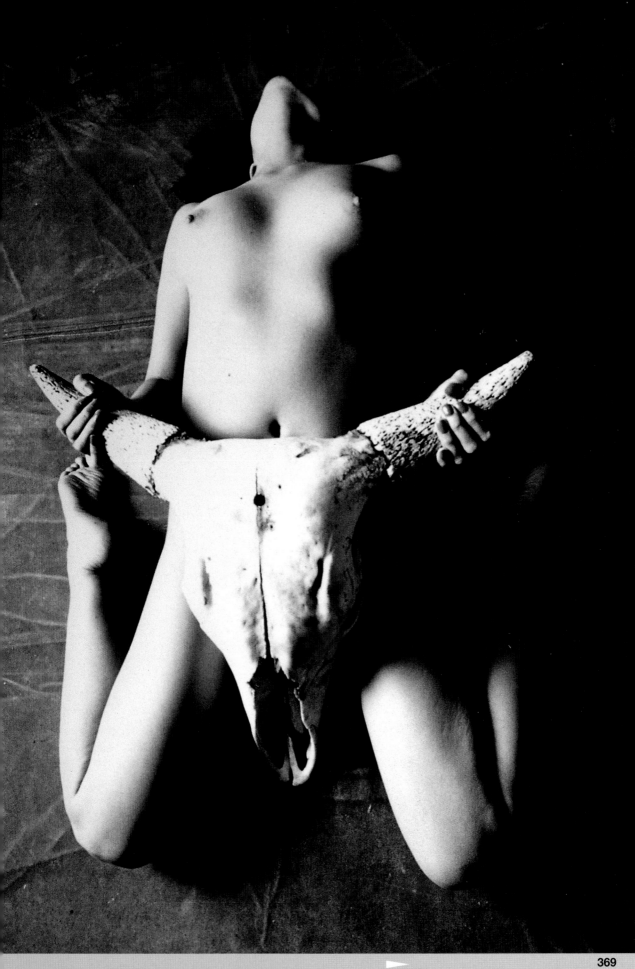

PEAR

photographer **René De Carufel**

use	Personal
camera	6x6cm
lens	150mm
film	Agfachrome 1000
exposure	1/60 second at f/22
lighting	Electronic flash
props and	
background	Red velvet curtain

Fruit, flesh and chocolate. The initial ingredients make a mouth-watering combination, and René De Carufel has built on the fantasy quality of the subject matter by creating a glistening, warm look that emphasises the delicious appeal of all the elements.

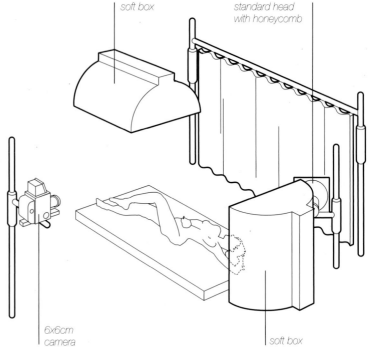

soft box

standard head with honeycomb

6x6cm camera

soft box

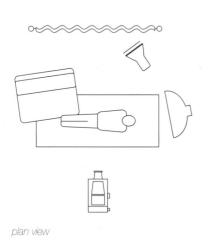

plan view

key points

Melting chocolate can be difficult to work with. If possible, use it only on replaceable elements of the shot. Wiping it off a model repeatedly will soon mar the freshness of the skin tone

Viscous and semi-liquid props are constantly on the move and it is important to know exactly what you want, style accordingly, and shoot swiftly as soon as you have what you need

There is a 50x50cm soft box directly over the model, giving gentle modelling to the body's contours and ensuring a velvety shadowiness at the navel, which is oriented so as to be just beyond the direct reach of the light.

A 50x75cm soft box to camera right adds a second highlight to the pear and introduces the shadow of the fruit across the skin. Finally a standard head with a 30° honeycomb grid illuminates the background.

All the lights have a half 85 filter, acting in this instance as a warming gel rather than as a colour correction filter.

photographer's comment

Basic lighting aimed at getting some nice reflections on the pear and the chocolate. Part of a series on the theme food and flesh.

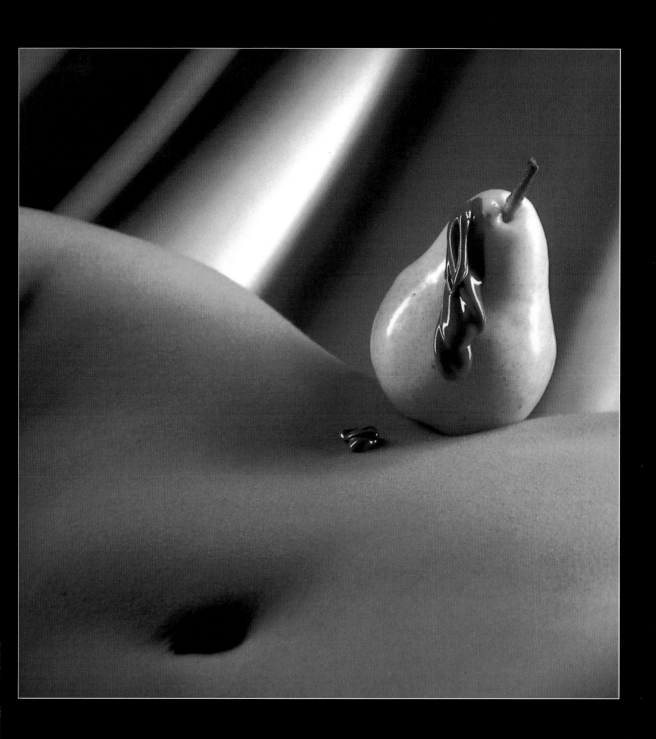

EFFECTS and
19 FINISHING

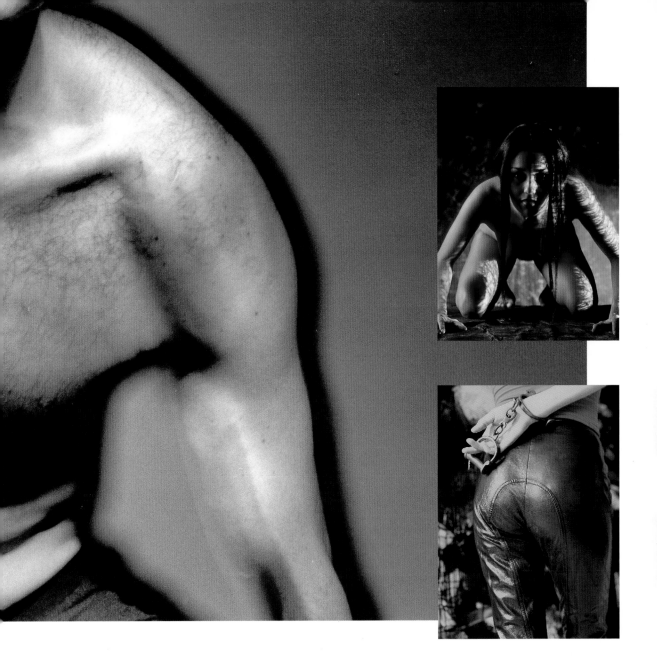

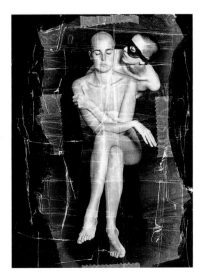

Effects can be introduced to an image at any stage of the process: in the original lighting, by using a special light or a gobo or gel over a light, or using light-painting; in the camera by introducing an effects or coloured filter over the lens or by taking multiple exposures; in the processing, by using non-standard processing chemistry. Effects can be introduced in the darkroom, by using solarization, texture screens during printing, multiple exposures, defacing or working on the negative; and at the final print stage, by working on the printed image to add tinting, texture, defacing, collage techniques and so on.

The photographs featured in this chapter explore a range of methods for adding effects and using finishing techniques to introduce a certain special look to the final image. But what they have in common is close attention to the initial lighting to ensure that they have the initial exposure they need to work well in tandem with the effects and finishing techniques applied.

SERPENT

photographer **Dima Smelyantsev**

use	Personal work
models	Maria and Karina
camera	4x5 inch
lens	210mm
film	Kodak Plus X
exposure	1/60 second at f/16
lighting	Electronic flash

The complexity of the final image belies the simplicity of the original exposure.

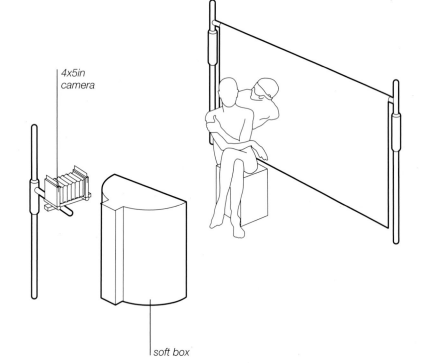

4x5in camera

soft box

plan view

key points

Bear in mind that when altering a negative directly severe changes are difficult to undo and the original can be ruined altogether. If in doubt, keep a dupe

A 4x5 inch negative is quite sizeable compared with a 35mm negative and is easier to handle for this kind of manipulation

Just a 2x3-foot soft box to the right of camera provided all that was needed to get a clean initial shot. While the imagery is startling, the lighting is perhaps surprisingly undramatic and soft, with an even sheen across most of the skin areas and just enough modelling and separation to define limbs and contours.

The finished image, though, is highly theatrical, in terms of content and finishing, and a representation of realism is not of particularly high importance.

The finishing consists of severe defacing of the negative. The edges were ripped away and the remaining central area was taped to a piece of glass with multiple layers of translucent tape. This glass-mounted collage then served in effect as the new negative.

The final print was bleached and multiple-toned after printing.

photographer's comment

The name is inspired by the tempting of the serpent in the Garden of Eden.

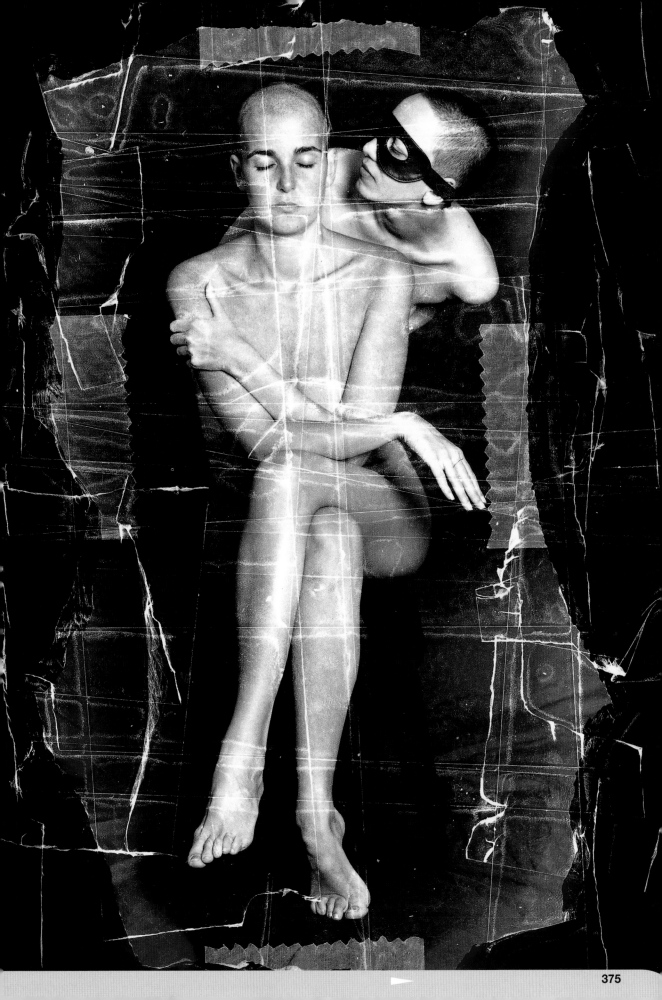

GENEVIÈVE

photographer **Marc Joye**

use	Personal work
model	Geneviève
assistant	Mike
stylist	Jenny
camera	6x6cm
lens	100mm
film	Ilford Delta 100
exposure	1/60 second at f/16
lighting	Electronic flash

After a day's shooting with Marc Joye, the model was keen to show the photographer a pose that she had come up with and which she herself liked very much.

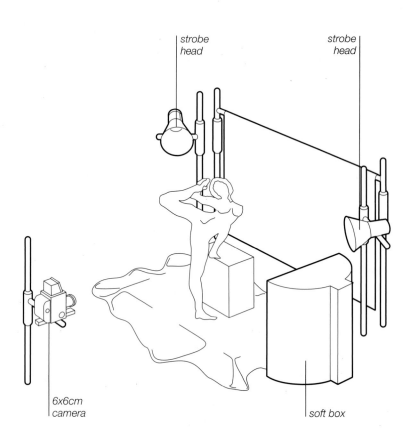

plan view

strobe head

strobe head

6x6cm camera

soft box

key points

Solarization is far more controllable when using digital manipulation but the pleasure of the darkroom method is in the very uncertainty of the result

A good range of grey tones is a useful starting-point for an image that is to be digitally manipulated

Standing on a low block, she leaned with one hand on a higher block to demonstrate, and Marc Joye decided to go ahead and shoot the pose as an experiment.

Two strobe heads were positioned behind the model, one on either side, and a soft box was placed directly side-on to her, to camera right. The original photograph was shot in black and white, and this lighting set-up gave gentle modelling and a good range of greys which were interesting to enhance digitally on the computer.

The photographer partially solarized the image using Adobe Photoshop, and then selected certain shades of grey and painted those areas in different shades of blue to add to the abstract nature of the pose.

photographer's comment

Geneviève, who is a dancer, created this pose while moving to music.

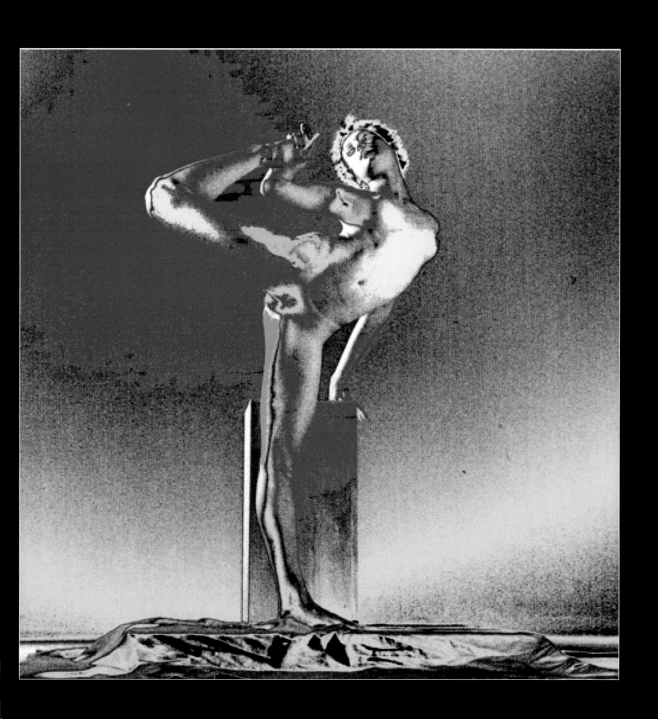

UNTITLED

photographer **John Knill**

use	Stock
client	DigitalVision
model	Rhydian Lewis
camera	6x6cm
assistant	Jonathan Stokes
lens	80mm
film	Kodak Tri-X
exposure	Not recorded
lighting	Tungsten

This is an example of an apparent special effect which is actually nothing of the sort. It may at first glance look like a manipulated image but is in fact a combination of a silhouette, a reflection and a translucent reflective surface.

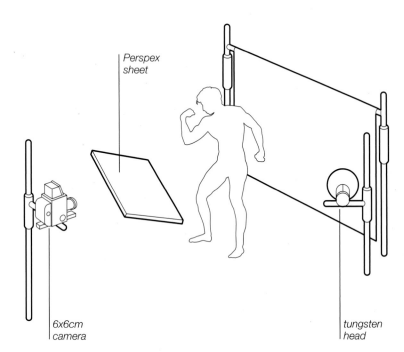

Perspex sheet

6x6cm camera

tungsten head

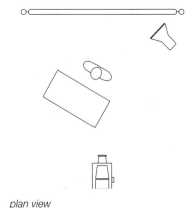

plan view

key points

A special effects look can be achieved by nothing more 'special' than imaginative posing and use of props

The image is split-toned sepia and blue

Once the eye has had a moment to work out how these various aspects combine, it becomes apparent how the end result was achieved.

The background is lit and the model is silhouetted by a tungsten flood. The model is standing by a large sheet of translucent opal Perspex which gives a good reflection of the silhouetted figure, but also provides the unexpected cut-off where the model's thighs meet the Perspex 'tabletop' edge.

The floor and the ceiling of the studio are all painted white so as to avoid any unwanted reflections or visibility of what lies above or below.

The strong posing is the finishing touch.

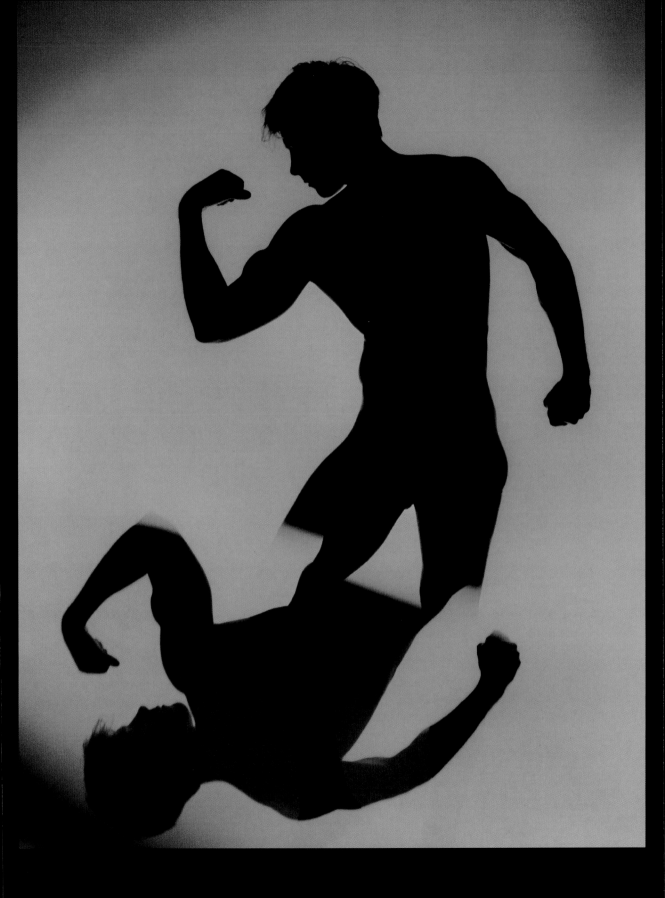

SARAI

photographer **René De Carufel**

camera	6x6cm
lens	150mm
film	Fuji Velvia
exposure	1/4 second at f/5.6
lighting	Electronic flash and slide projector
props and	
background	Hand-painted backdrop

The interesting effect on the model's body comes from a slide of a textured pattern projected from camera right.

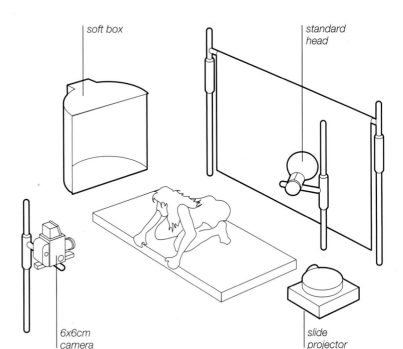

plan view

soft box

standard head

6x6cm camera

slide projector

key points

Slide projector bulbs are tungsten-balanced and therefore produce a warm tone of light on daylight-balanced film

Fuji Velvia is renowned for its rich rendering of the colour palette

The relatively long exposure of 1/4 second is required to allow the pattern to register. Unsurprisingly, a certain amount of model shake also records – 1/4 second is a long time to hold such a pose perfectly still – but the ghosting that this movement gives along the edge of the arm on the right only adds to the mood.

To camera left is a 50x75cm soft box with warming gel, which enhances the skin tone. Set against the jewel-like blues of the background (achieved by means of a blue gel over a standard head), the deep gold of the skin positively glows.

Finally, notice the catchlights in the eyes – one from either side, and therefore not symmetrically placed or similar in shape and detail. They add an unnerving penetrating quality to the gaze.

photographer's comment

This is part of a series using slide projections on the body.

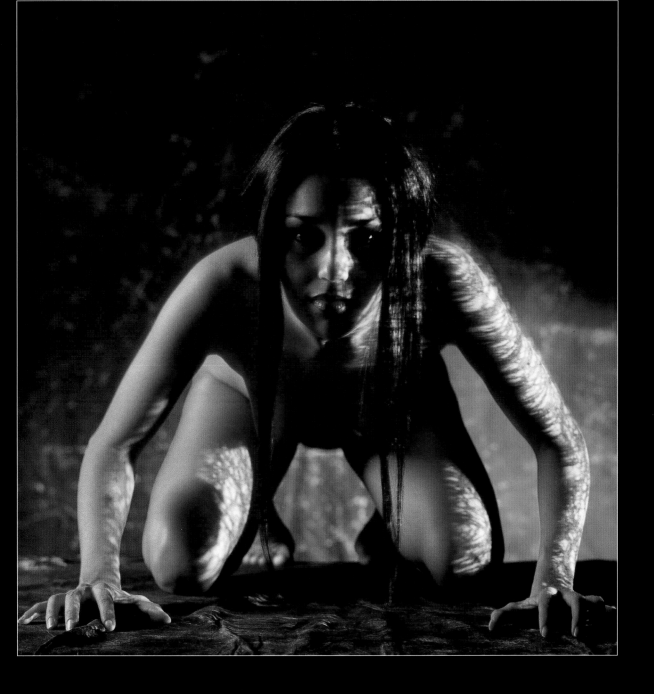

MEN'S HEALTH

photographer **Stephen Speller**

use	Magazine cover
client	Nursing Times
art director	Marion Francis
model	David Milnersmith
camera	6x6cm
lens	150mm
film	Fuji neopan 400
exposure	40 seconds at f/4 + f/22
lighting	Tungsten and electronic flash

This shot consists of two exposures, and two types of lighting.

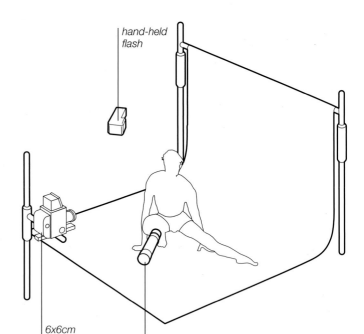

hand-held flash

6x6cm camera

torch

plan view

key points

Don't move the camera when physically handling it to change apertures on a single shot

Changing aperture between exposures may introduce a slight rack of focus because the circles of confusion are different sizes (differently focused) at each setting

In the initial part of the exposure, light comes from a hand-held flash above the subject, accounting for the f/22 element of the exposure recorded. This first flash showers light both in front of and behind the model. It thus creates the shadows of the head and muscles on the chest, lights the shorts to give the sharpness and hard shadows on the fabric, while also casting the shadows on the ground below the extended leg as well as the hard rim shadow around the arm to the right. Finally, it also illuminates the background.

In the second part of the exposure, Stephen Speller carried out free-style light-painting using a focusing torch, for a duration of about 40 seconds. The rest of the studio space was entirely blacked out throughout the exposure. The inevitable amount of model movement that records is a calculated and desired aspect of the resulting shot.

photographer's comment

The lighting for this subject is built up over long exposure using a torch to paint the light. The subject has to remain as static as possible for a long period, but the overall feeling is one of movement and action.

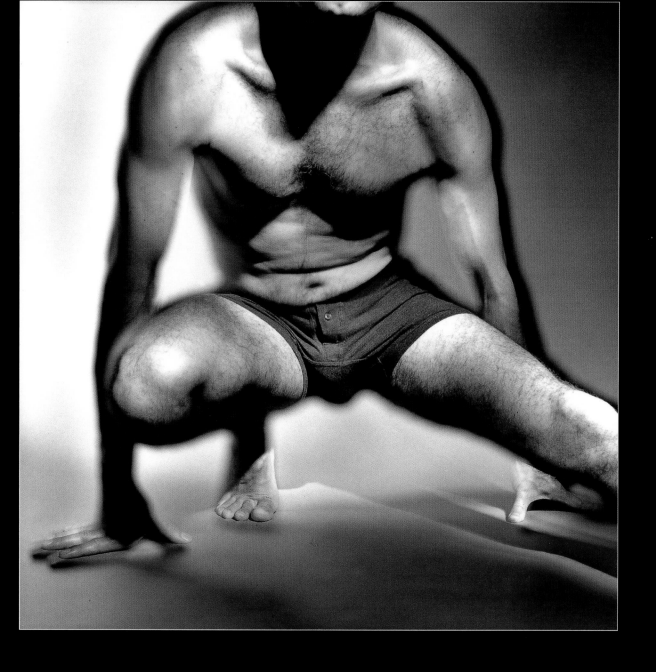

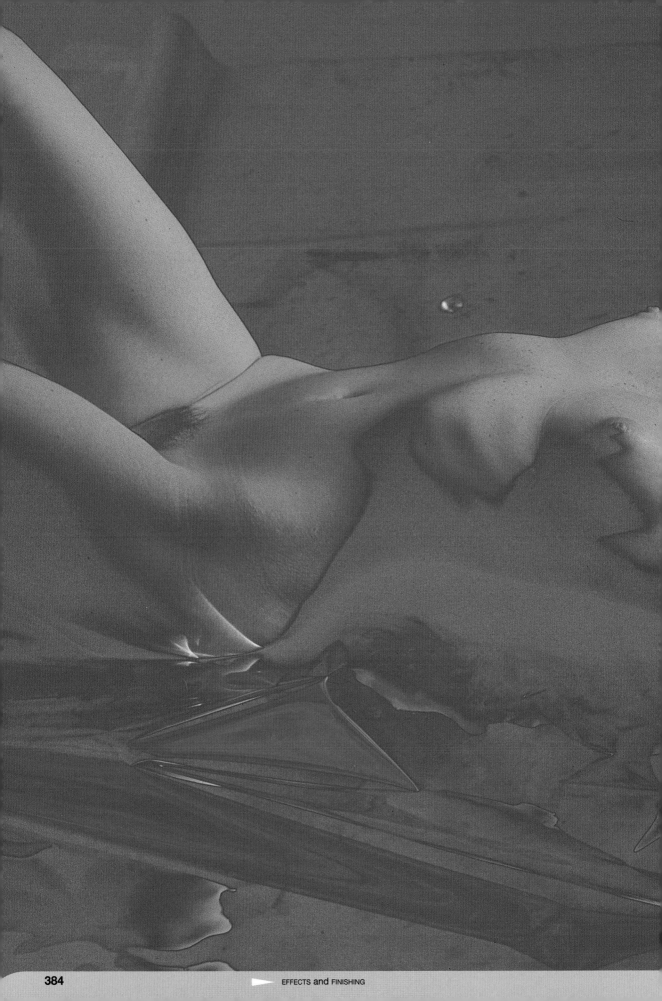

EFFECTS and FINISHING

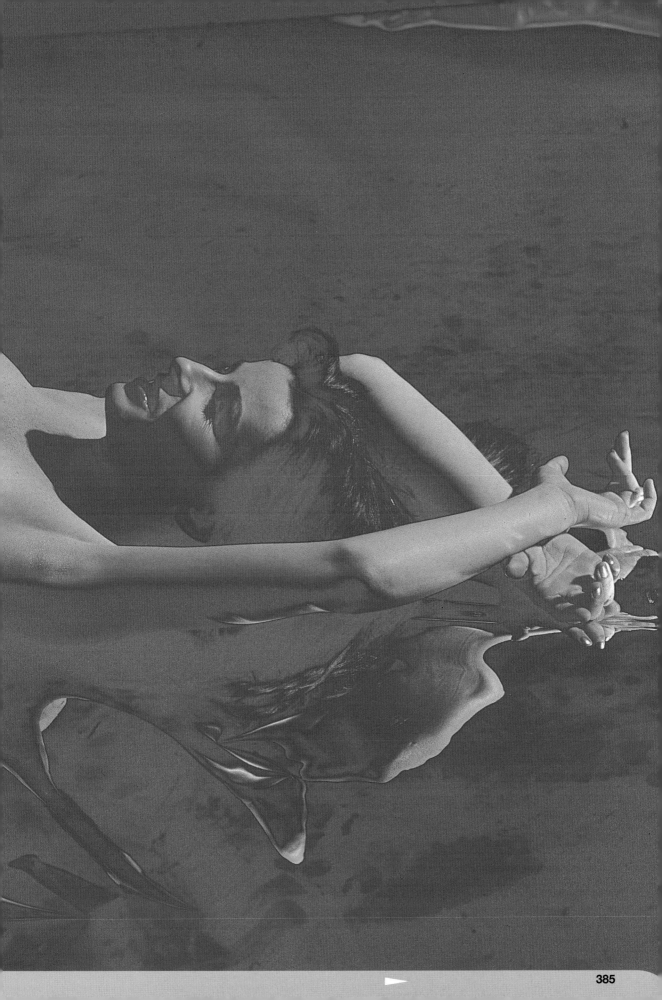

SOLARIZED NUDE

photographer **Ron P. Jaffe**

use	Editorial
camera	6x6cm
lens	80mm
film	Ektachrome 100
exposure	1/125 second at f/8
lighting	Electronic flash

The lighting is what Ron P. Jaffe describes as 'traditional portrait'. In other words, main and front fill.

standard head

standard head

6x6cm camera

plan view

key points

Solarization can be carried out either on the film or on the print

A coloured light source could give a different coloured result

The lighting was provided by two standard heads, each with an umbrella. The key light was to camera right and the fill to camera left.

The ratio of key to fill light is approximately $1\frac{1}{2}$–2:1, which is tight and low-contrast. Slight under-exposure of the image in the camera is necessary as the 'light strike' during the solarization part of the processing in effect increases the speed of the film. In this case the solarization was done to the transparency film. It is the solarization that is responsible for the red-tinted uniform fogging of the image.

The reflective surface that the model is on is Mylar, a shiny foil-like material. It provides interesting reflections to the composition.

photographer's comment

Shadow detail was not necessary but was mostly experimental.

LUCY

photographer **Björn Thomassen**

The location was quite a shallow pond, and both Björn Thomassen, the photographer, and the model were in the water.

use	Model portfolio
camera	645
lens	150mm
film	Tmax 400
exposure	1/125 second at f/5.6
lighting	Available light

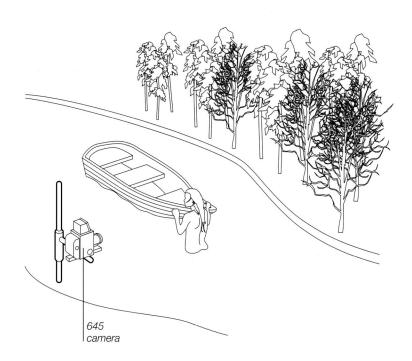

645
camera

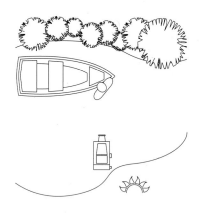

plan view

They had rehearsed the pose in the dry, before going in to the water just before sunset. The picture was taken just after the sun went down, and the photographer knew that there was very little time to achieve the shot with the quality of light that he wanted.

The photographer reports that he had previously tried the same shot with a dark-haired model but the result was simply not as successful because of the difficulty of achieving the required degree of separation.

key points
Research a location thoroughly before taking any plunges into the unknown!

It is worth having someone else standing by in case unexpected situations arise

EFFECTS and FINISHING

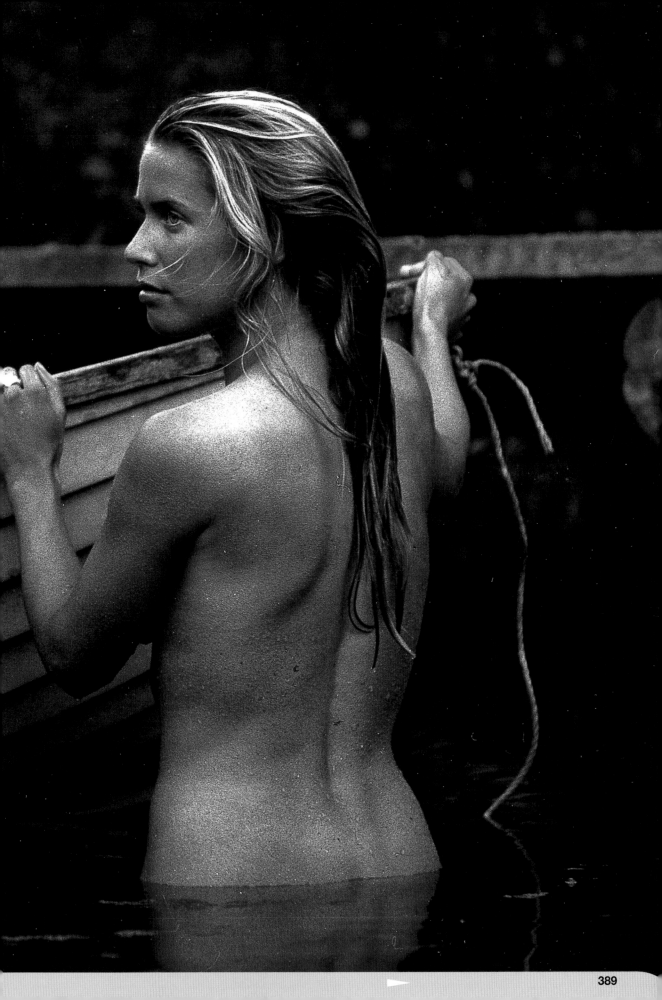

THE SIXTH SENSE: POWER

photographer **Laura Hodgson**

use	Editorial
model	Chloë
camera	6x7cm
lens	80mm
film	Kodak GPM
	(cross-processed)
exposure	1/15 second at f/8
lighting	Available light
background	Abstract painting
props	Handcuffs – model's own

This image was shot for a book entitled 'Aphrodisiac', and the subject incorporates two icons of erotic imagery: leatherwear and bondage. The appropriateness of the picture title is self-evident.

6x7cm camera

white reflector

plan view

key points

Mild contrast negative films produce subtler skin tones when cross-processed

A similar cross-processed effect can be achieved by putting a C41 tungsten film through E6

The model stands about 2 metres from a window to camera left, and about 1.75 metres in front of an abstract painting which serves as a background. A white reflector to camera right bounces back some of the available light to provide fill.

The highlights on the leather trousers are important for conveying their textural quality; an all-important feature to those with a specialist interest in leather. The cold metal handcuffs are positioned so as to contrast strongly with the pale, soft skin, and the shadow they cast across the hand is carefully contrived to add to the impact.

The overall blue tone comes from the cross-processing used.

SWIRL

photographer **Marc Jaffe**

use	Personal work
model	Leslie Hall
camera	645
lens	80mm
film	Agfa APX 100
exposure	3 minutes at f/11
lighting	Light brush

This photograph was lit in two separate steps. The first stage involved the main lighting on the model's body, and the second stage was for the swirl.

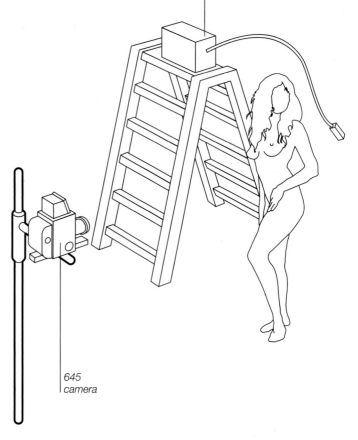

light brush

645
camera

plan view

key points

Choosing the exposure when light brushing is something to learn from experience

It is important to have a very clear idea of where the edges of the frame are when freely swinging the light

The entire subject was first lit with a single light in the photographer's hand – a light brush 300. All the surfaces were smoothly painted with the light, a process taking about three minutes to ensure the precise coverage wanted.

In order to give the swirl effect around the model, the photographer then mounted a ladder to one side of the model and swung the light brush through the air around her in the spiral pattern visible in the final image.

Keeping the model perfectly still was not an issue for this shot, as when using this kind of light brush work only a very small amount of the subject is illuminated at any one time; the photographer wanted a slightly softened look anyway. A nylon stocking over the lens contributed to the softness.

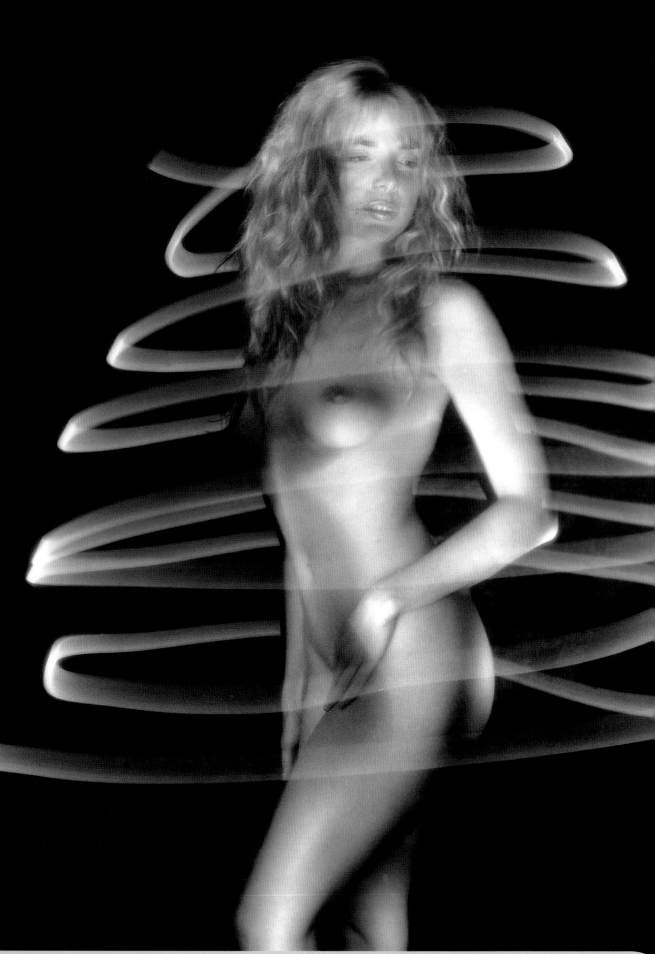

DRESSING UP

20

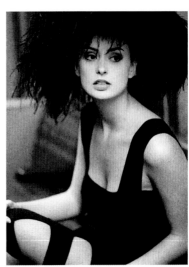

From the photographer's point of view, clothing serves as a prop to add elements of texture, colour and form to a composition. From the point of view of the provocative shots photographer, clothing also carries a strong potential for erotic charge, since the trappings of the traditionally sexual subject consist of such items of clothing as lingerie, stockings, leatherwear, and so on.

The lighting of the varied textures of different fabrics is a major consideration. The photographer may want to emphasise tight, shiny clothing, with strong highlights at the curviest points, and a high-key set-up may be required to make the most of the high-gloss finish of the clothing. A softer, more seductive feel may be more appropriate for lacy or gauzy clothing, with suggestive shadows in place of revealing highlights. It is worth keeping in mind the fact that the items of clothing can themselves be used as lighting modifiers, as gobos and flags, or to introduce shadows as required.

FEMME FATALE

photographer **Michael Miller**

use	Personal work
camera	35mm
lens	85mm
film	Kodak Tmax 3200
exposure	1/2000 second at f/1.4
lighting	Fluorescent tube

The film choice, location and styling all blend to create a timeless modern classic in this shot. The lighting could hardly be simpler.

plan view

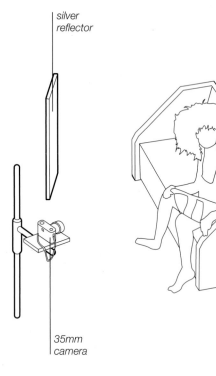

silver reflector

fluorescent tube

35mm camera

key points

The grain structure of a film can really 'make' a picture

It may be necessary to obtain the permission of public transport companies to shoot for commercial purposes on their property

The model was sitting on an underground train and the location was illuminated by the available fluorescent lighting. These fluorescent lights were above the model, in the ceiling of the train, and were modified with just a single silver reflector to give even illumination across the subject area, while still allowing the overhead position of the available lights to play

its part. It allows the shading beneath the chin to distinguish the jaw line from the throat, and provides an amount of modelling to the body curves.

The film was rated plus one stop to accentuate the grain. As the film was pushed to 6400 ISO, it was important not to burn out the highlight detail in the finished negative.

photographer's comment

This photograph was taken on a London Underground tube train at Kennington Station.

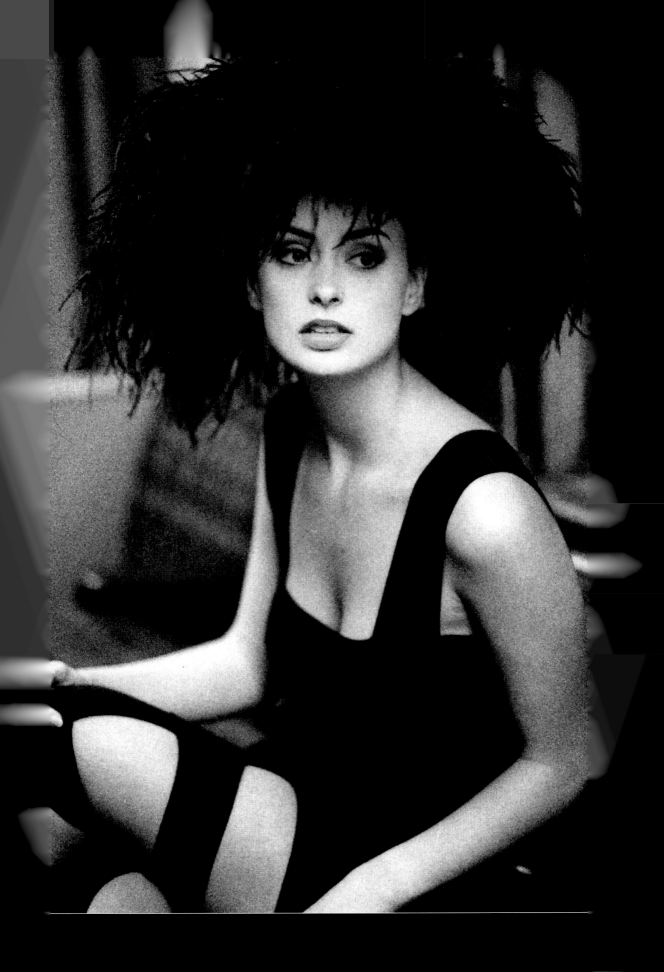

SO OUT OF TOUCH

photographer **Kingdome 19**

client	Private
use	Private collection
model	Jens I
camera	35mm
lens	85mm
film	Ilford FP4
exposure	Not recorded
lighting	Electronic flash
set	Shower room in the 'Kickboxing Temple I'

Multiple exposure in the darkroom is something of a signature technique for Kingdome 19.

spot

35mm camera

spot

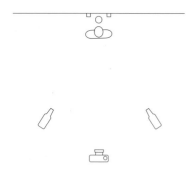

plan view

key points

Water and electricity do not mix. Take great care on shoots involving water

Steam produced by hot water can be used as a diffuser

Compare this shot with "Nicole" and "Exposition Déposé" by the same photographer: although the lighting changes each time, the finishing technique marks out a personal style that is very clear to see.

The lighting set-up in this instance consists of a spot on either side of the camera, two metres high in both cases and well back from the shower location – an important point, since the shower is turned on.

The classical influences that Kingdome 19 cites is evident from the strong pose and choice of model with powerful, athletic physique. Notice the care taken with the composition: the T-shape formed by the plumbing is placed just so in the gap between arm and body, and the same shape is echoed in the layout of the typography so that a crescent of Ts can be traced across the image.

photographer's comment

From the 'Unique' series. Sepia toned. Ten exposures in the lab.

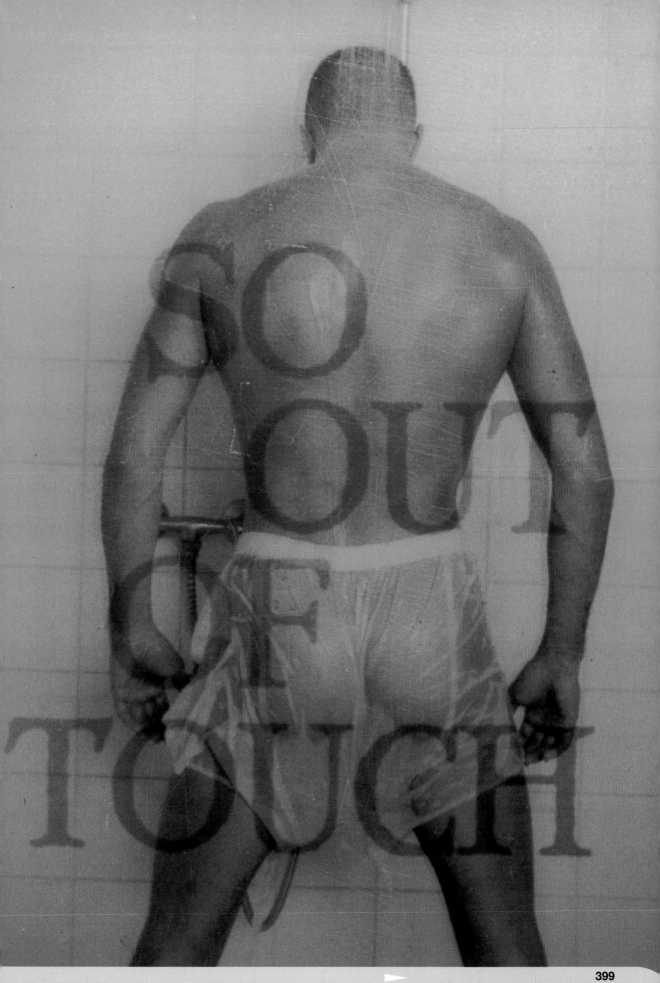

LAST DRAPE

photographer **Gianni Russo**

use	Portfolio
model	Katerina
camera	35mm
lens	50mm
film	Tmax 400
exposure	1/125 second at f/4
lighting	Tungsten

It is interesting to compare this shot with another photograph by the same photographer: "Kate", on pages 18–19. Exactly the same lighting set-up has been used for both shots, and in both cases the result is the distinctive high-key black and white look that Gianni Russo favours.

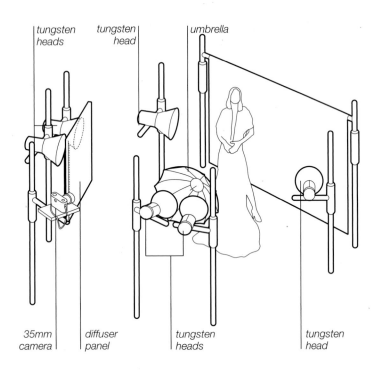

plan view

key points

Working under tungsten lights can get very hot for the model. Keep the model refreshed and rested and pay attention to make-up

Composition is important. All lines of light and dark, whether body parts or drape, converge at the centre of the composition, which is of course also the central point of interest; not least because it is obscured from direct view

Yet notice the difference that a single, simple prop can make. The length of dark drape contributes to composition, visual interest and contrast, and adds to the sense of drama. It also works as a lighting modifier, in that it shades the inner thighs from the array of frontal tungsten heads, and adds shadowy allure. Where the "Kate" shot had an effect of naked innocence, the minimal clothing element of this shot changes the mood to seduction.

The drape hanging down between the model's legs is backlit by light reflected from the background and casts a shadow on the floor. The remainder of the drape trails towards the camera giving the illusion of a further textured shadow, though of course the texture is in fact the rippling of the fabric.

photographer's comment

In black and white photography I prefer to use tungsten photofloods. I make every photo in my own darkroom. Often I like to change the traditional process and destroy the black and white prints for the purpose of obtaining original effects.

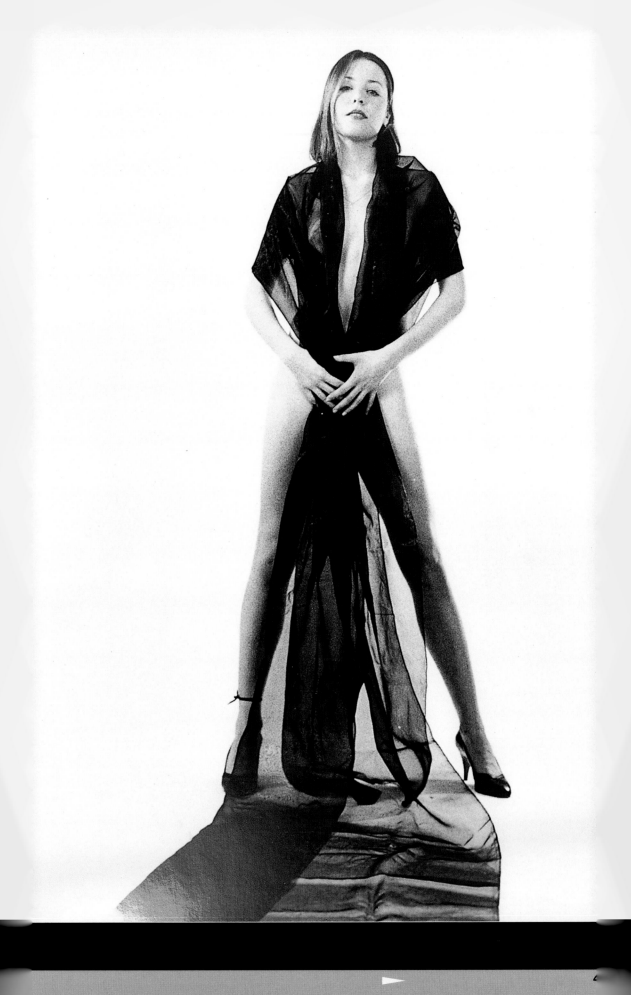

UNTITLED

photographer **Gérard de Saint-Maxent**

The textures and patterns of the fashion accessories provide the perfect subjects for Gérard de Saint-Maxent to demonstrate his mastery of the art of using available light to stunning effect.

645 camera

white reflector

The model is positioned so that she is half in the natural sunlight flooding in from camera right, leaving the left part of the shot in boldly graphical chiaroscuro contrast. The relative darkness of the model's skin provides a foil against which to set the lace textures, and the stocking-top to the right of the shot shows up particularly well against the inner thigh, which is of course, as a curved surface, out of the direct line of the sunlight.

The 1/8 second exposure allows a slight amount of camera movement, in order to obtain what the photographer describes as the 'fluidity' of the final image.

		key points	
use	Exhibition		
camera	645		
lens	105–210mm		
film	Tmax 400		
exposure	1/8 second at f/8		
lighting	Available light and reflector		

key points

Long exposure allows some movement to be recorded to give a softer look – but it's worth taking several frames to allow for the unpredictability of the fine detail in the result

Concentration on patterns and textures with figurative subjects can make for very interesting semi-abstract composition

plan view

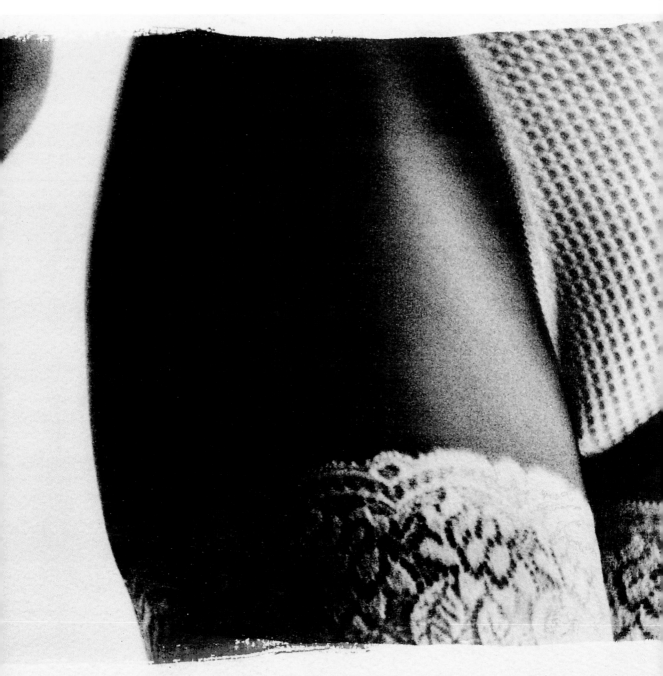

CATALINA

photographer **Antony Nettle**

use	Portfolio
model	Catalina
camera	35mm
lens	135mm
film	Fuji Reala
exposure	1/125 second at f/2.8½
lighting	Available light
setting	Leicester Square, London, with the Empire cinema behind

plan view

This shot was taken in London on a fairly bright but overcast day.

35mm camera

key points

Directionality of available light may be only slight on an overcast day but it is important to recognise it and to use it to the best possible effect

Negative film has a far greater latitude than transparency film but it is still the best policy to expose to a good level than have to bring out detail in the darkroom

With buildings rising high on all sides in the famous central landmark, Leicester Square, the main light source was overhead daylight in light cloud conditions, which gave a diffuse quality to the light.

Diffuse is not to say totally even. Antony Nettle reports that there was still some degree of directionality of the light, with the sun behind the camera, which is evident in the final image. The left side of the image is oriented towards the sun so the face on that side is lifted slightly more than the right

side. The pearls have catchlights on the upper left-most surfaces, and the separation of the lapel against its own shadow on the body of the jacket confirms the direction of the light, albeit a gentle and diffuse light.

Most importantly, the amount of directionality of the light allows the texture of the black fishnet top to remain defined against the black fabric beneath, especially on the uppermost surface, which emphasises the curvature of the body.

photographer's comment

This shot comes from a short rapid-fire sequence taken from different angles whilst the model was seated. The styling of the clothes and accessories, by the model herself, gives a strong fashion feel and the de-focused background concentrates the attention on this.

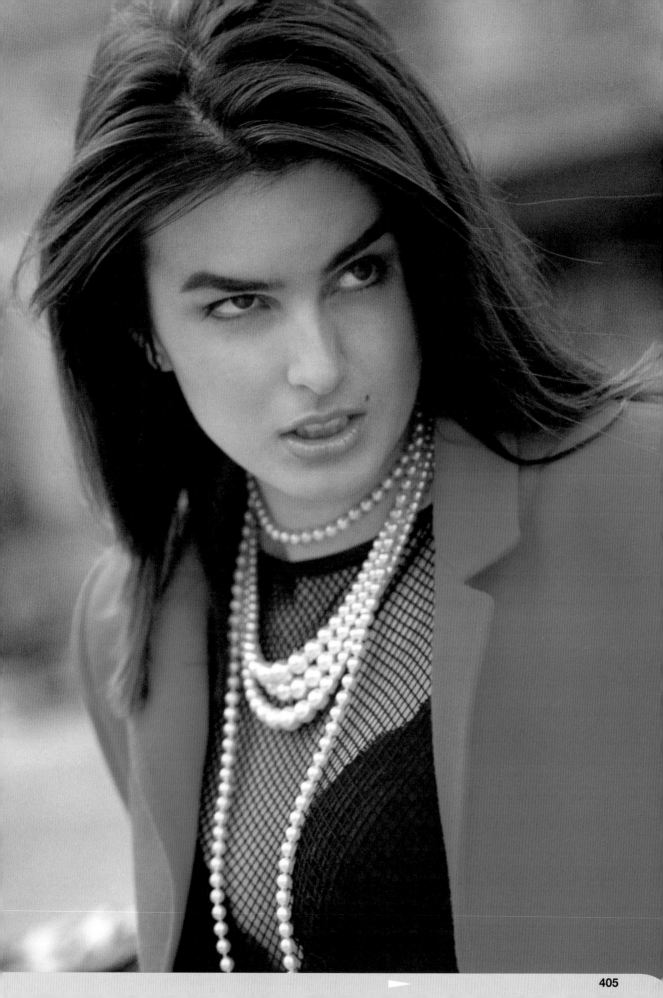

GRACIELA

photographer **Juan delGado**

use	Self-promotion
model	Graciela
assistant	Moncho Aldamiz
art director	Juan delGado
camera	645 camera
lens	105mm
film	Agfapan 25
exposure	1/60 second at f/8
lighting	Electronic flash
props and	
background	Cyclorama (medium tone)

Confidence and power almost tangibly emanate from this shot. "By slightly framing Graciela from below," Juan delGado explains, "I accentuated her powerful sense of self-confidence."

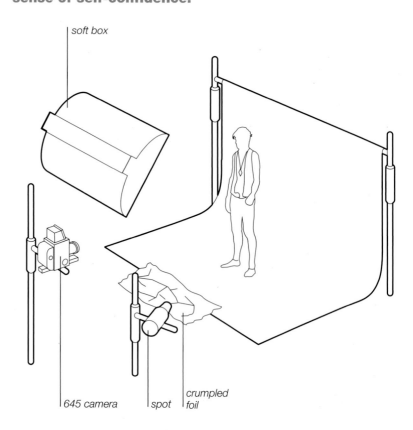

soft box

plan view

645 camera *spot* *crumpled foil*

key points

Lighting a face from overhead can accentuate shadows below the brow on the eyes, and below the nose, and can give modelling below the chin, for a dramatic look

Combining different forms of lighting on discrete parts of the subject can give an interesting effect

The main light – a 50cm-square soft box overhead on the camera's axis – was combined with a focusing spot reflected in crumpled foil to light the hands from below, highlighting the gesture and also increasing the skin texture.

This lighting set-up complements perfectly the arresting pose and expression adopted. The face and hair have a cool, graphic feel, with the main features of eyes, nose and lips defined, as it were, by the simple, bold strokes of shade across areas of light. The strong highlight on the torso flattens the figure to add to the androgynous mystique of the shot. The spot light reflected on crumpled foil bounces light in from below just onto the hands, giving them a distinctly different warm glow all of their own.

DRESSING UP

photographer **Laura Hodgson**

client	Kyle Cathie Limited
use	Editorial
model	Chloë
camera	35mm
lens	80mm
film	Kodak GPM
	(cross-processed)
exposure	4 seconds at f/5.6
lighting	Available light

This shot was used for a book on aphrodisiacs, and its relevance to that subject is quite clear. It is a discreetly composed shot with a very real erotic frisson.

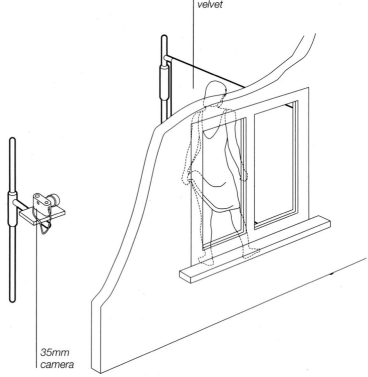

black velvet

35mm camera

plan view

key points

As well as affecting the final colour rendition, cross-processing affects the grain structure and pushing increases the grainy texture of an image

The power of suggestion is immense. A highly successful provocative or erotic shot need not be an explicit one

The shot was simply lit with available light from a window to camera right.

The directional light is evident in the highlights on the fabric of the dress and along the legs and arm, while the other side of the subject shows rapid fall-off into considerable shade.

The treatment other than lighting produces a considerable amount of interest in the final image. The C41 film was processed in E6 chemistry, shot at 2 stops over and processed at 3 stops over, to give an eventual grand total of a 5-stop push.

The slow shutter speed was chosen to give movement, which combines with the cross-processing and the pushing to give an overall dreamy, soft look.

photographer's comment
Used in a book, Aphrodisiac, by Marion McGilvary.

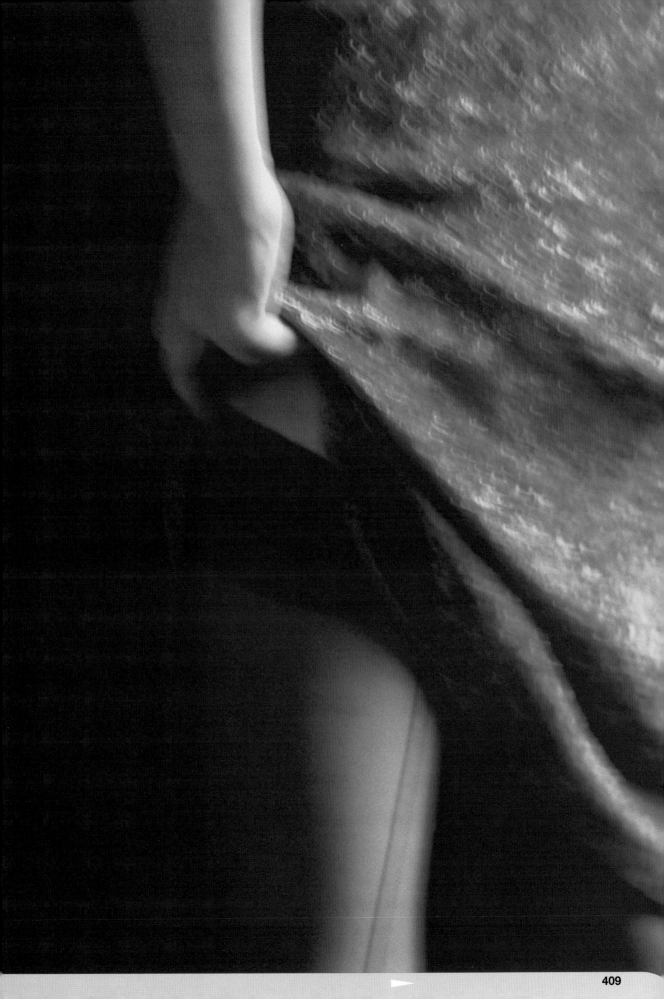

CORSET

photographer **Renata Ratajczyk**

camera	35mm
lens	85mm
film	Kodak Plus X Pan
exposure	1/125 second at f/11
lighting	Electronic flash

The tight crop on the tightly laced corset gives a strong visual impact to this simple but effective shot by Renata Ratajczyk.

plan view

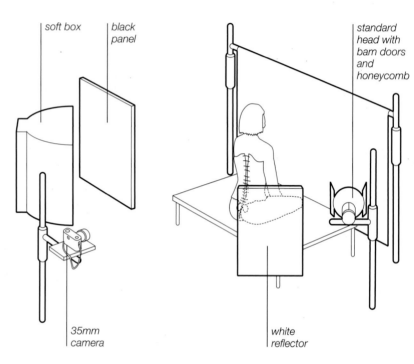

soft box black panel standard head with barn doors and honeycomb

35mm camera white reflector

key points

Pay attention to the temperature in the room so the model feels comfortable, not too hot or too cold

Keep your camera extra steady by using a tripod and a cable release

Simplicity is sometimes only contrived by considerable preparation and input. A soft box to the left of camera is the main light. This is flagged from hitting the background using a black flag. To the right of the model there is a white reflector providing fill. Also on the right is a standard head with barn doors and honeycomb grid which lights the background.

photographer's comment

Make-up is important. Also the details of the clothing have to be perfect, especially when photographing small details.

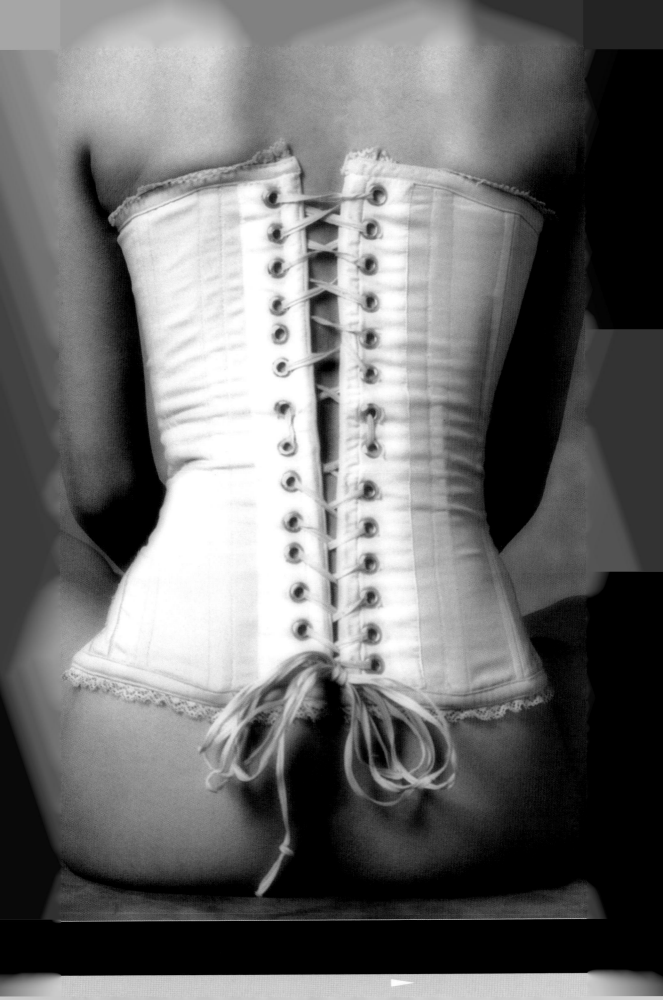

VOYEURISTIC
SHOTS

21

The provocative shot is made to be looked at. It seems an obvious thing to say, but it is interesting to stop and consider the differences between shots that seem to be open to view and inviting to the audience's gaze, and those which somehow convey a sense that we are looking in on a secret, surreptitiously viewing something that we really shouldn't be looking at. The voyeuristic element carries a powerful charge. The private, the intimate and the blatant behind-closed-doors are all represented here.

Juxtaposition of props, settings and posing of the models are all important. And as always, the lighting plays a crucial part in achieving the look required. There are plenty of surprises in store...

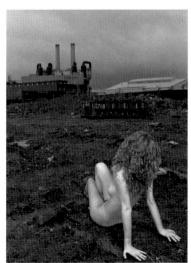

NKI S/M

photographer **Salvio Parisi**

In an unlit, underground cement-built chamber, Salvio Parisi had only a ring flash to light this striking image.

client	NKI Bags and Backpacks
use	Collection campaign
assistants	Chicca Fusco and Ezio Manciucca
art director	Stefano Scialla
stylist	Cristina Casini
hair and make-up	Peko at Coppola Agency
model	Isabel at Pepea Models
camera	35mm
lens	35mm
film	Fuji 64 Tungsten
exposure	1/125 second at f/8
lighting	Electronic flash
background	Cement all round!

plan view

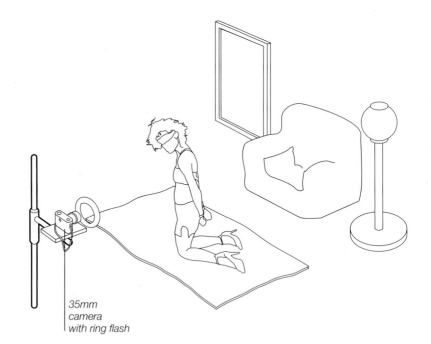

35mm
camera
with ring flash

key points

A single light source may be all that is required to achieve the desired effect

It may be easier to use a room with no ambient illumination than it is to black out a well-lit studio

He chose this combination of ring flash, wide-angle lens and a cold dominant film stock in this particular location to give the idea of a strange and sado-masochistic portrait. The ring flash gives the bright illumination on the model and a soft all-round shadow. The wide-angle lens gives the disconcerting skewed view of the subject, and the choice of tungsten film stock in conjunction with the electronic flash contributes the cold blue tinge.

The model was some 4–5 metres from the back wall and the furniture props were allowed to remain in the gloom of the background without any additional lighting of their own. The impression is of a torchlight picking out the figure in a darkened space, an impression that adds to the sense of drama and immediacy.

photographer's comment

The picture was shot in an underground garage with some designer furniture (chair, mirror, lamp) to emphasise the idea of 'sado-maso', helped by the type of dress, too!

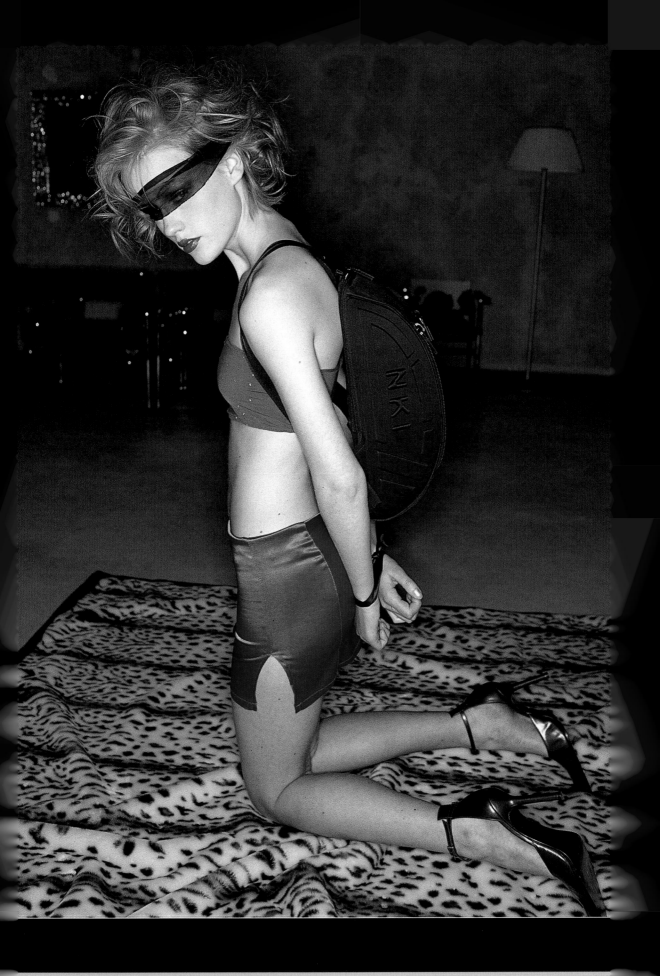

PARADOXICAL

photographer **Andrew John Sherriff**

use	Portfolio
camera	35mm
lens	50mm
film	Tmax 100
exposure	Not recorded
lighting	Electronic flash

The prominence of the crucifix is essential to the raison d'être of the picture. Andrew John Sherriff used a soft box on the right and a standard head with honeycomb on the left, which is the key light.

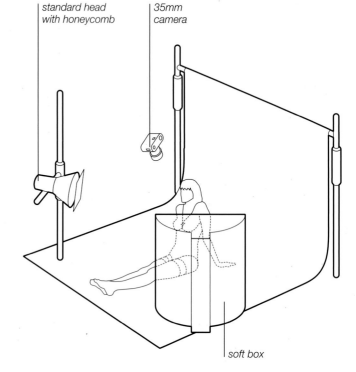

standard head with honeycomb

35mm camera

soft box

plan view

key points

It is usually more convenient to have the model sitting on a raised table or plinth rather than on the floor, for ease of lighting

Hand-tinting is an excellent method emphasising an element within an image

The standard head ensures that the crucifix is well picked out, and then it is hand-tinted by the photographer on the print. The soft box reduces the harshness and lightens the shadow cast by the pendant.

The composition is contrived to set up the juxtaposition of religious element and sexual element. Although at first appearance it may seem that the model is leaning forward into the camera, in fact this is an aerial view looking down on the seated model. This is important in order to bring all the elements of the subject close together in a tight and well-composed crop.

photographer's comment

I wanted this photograph to express the conflict and contradiction between sex and religion.

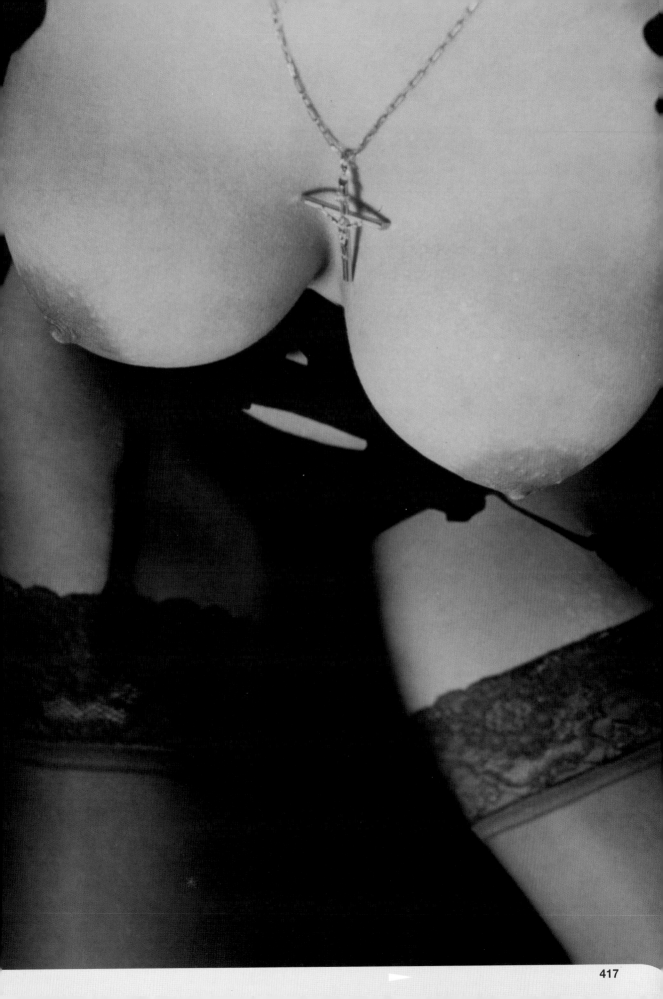

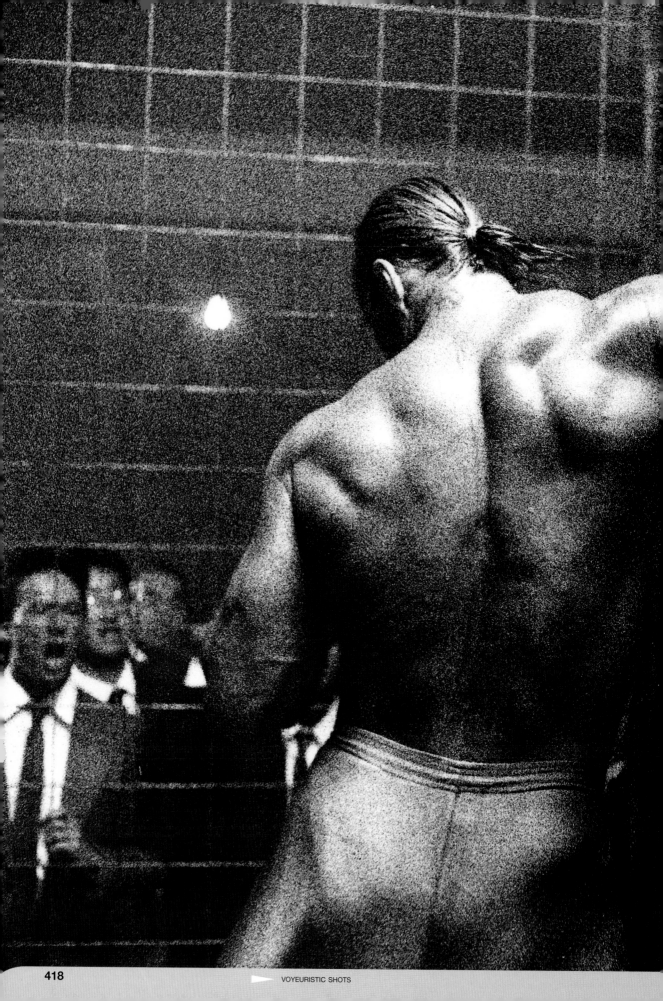

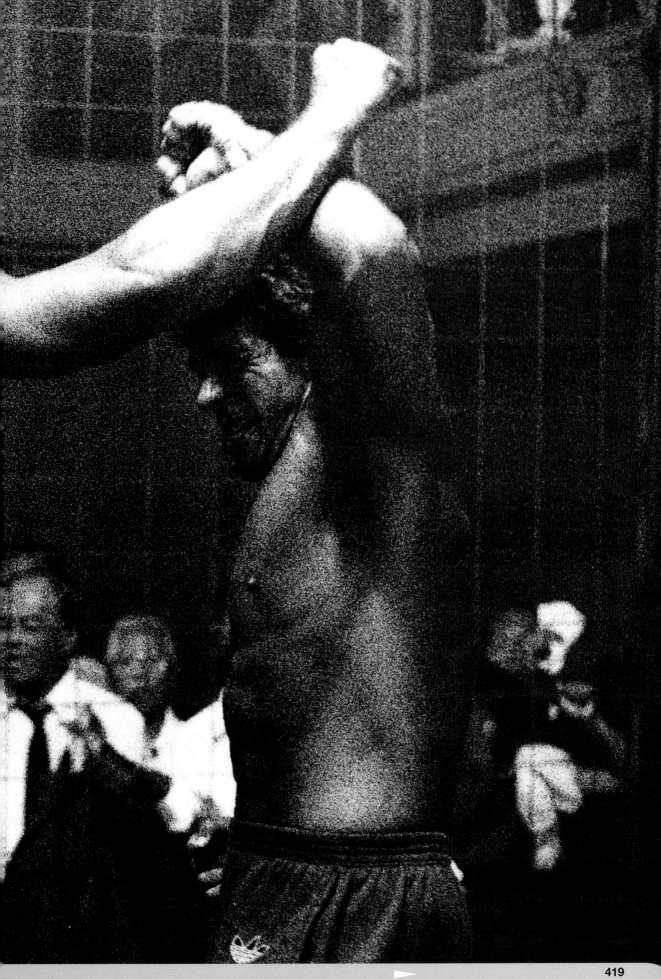

CAGE

photographer **Ron P. Jaffe**

client	Lang Elliott Entertainment
use	Publicity pictures for movie advertising
models	Lou Ferrigno and Matias Hues
camera	35mm
lens	35mm
film	Colour negative 400 ISO printed in black and white
exposure	1/250 second at f/5.6
lighting	Tungsten

This movie fight scene was lit for stark effect. The film set lighting consisted of a bank of tungsten lights with soft box diffusion, directly overhead, which produced hot spots on the actors. However, this lighting was too harsh for the publicity stills.

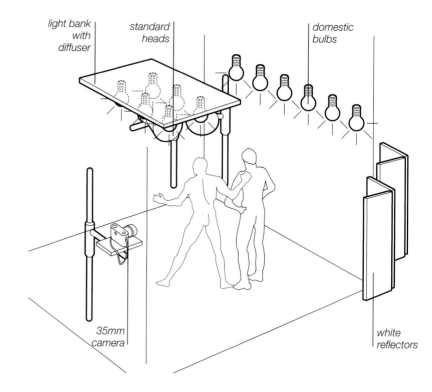

light bank with diffuser standard heads domestic bulbs

35mm camera

white reflectors

plan view

key points

Cinematographic lighting is quite different from lighting for stills. A film set may not supply the best arrangement for the stills photographer and time needs to be allowed to adjust the set-up to get the shot that is wanted. Also movie film is generally tungsten-balanced negative

Remember never to use flash photography during a take

Blimps are available for stills cameras to reduce noise

With the permission of the director, Lang Elliott, photographer Ron P. Jaffe moved the actors from centre ring closer to the cage wire and the background actors, and from under the full glare of the overhead lights. This gave less harsh shadows and a more compatible exposure for the background scene.

Six bare bulbs provided soft fill on the background and the wire screens of the boxing cage added to the diffusion of the overhead lights on the rear audience.

Kick lights (not shown) to camera left and polywedge reflectors to camera right completed the set-up.

photographer's comment

The frozen action of the actors portraying violence to one another and the violence of the audience viewing the fight lends a secondary tone to the silent still picture of the fighters' balletic motion.

FACTORY

photographer **Igor Aronov**

Although this may look like a purely location shot, it is, in fact, an exceptionally well-executed digital collage. The model and the landscape were shot separately, then scanned and digitally combined.

use	Personal
camera	35mm
lens	28–110mm
film	Ilford Delta 400
exposure	1/125 second at f/16
lighting	Electronic flash and available light

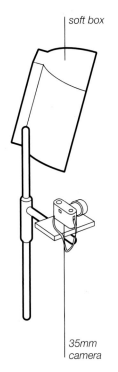

soft box

35mm camera

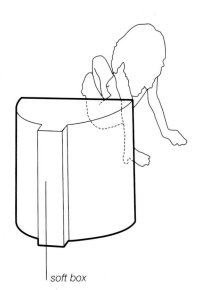

soft box

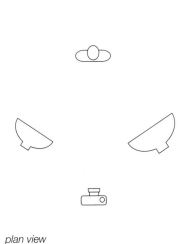

plan view

Natural light was used for the landscape, which was shot during a cloudy day. The cloudy conditions provide a low-contrast look with no hard shadows, which is essential to allow for the digital manipulation planned. The model was shot in the studio, using two soft boxes, one either side of the camera. These heads were angled at about 45° and slightly above the model.

After scanning the images and assembling them into a single image, the required shadows were added digitally. The completed file was then output onto film and finally printed as a conventional black and white silver gelatin print.

key points

It is easier to add required shadows electronically than it is to remove unwanted ones

Planning ahead to every last detail is essential for first-rate convincing digital collage work

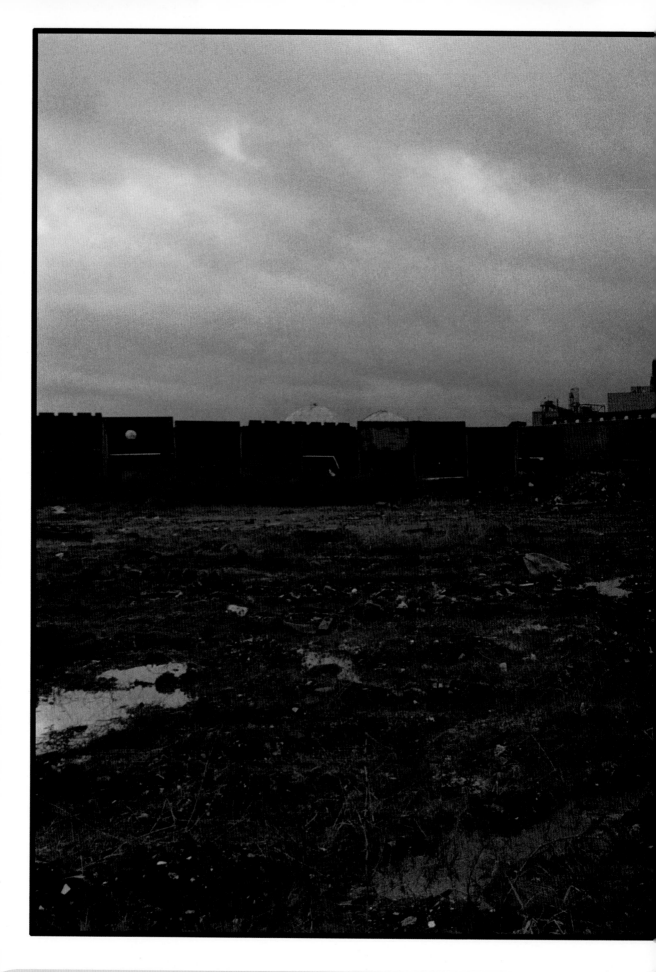

VOYEURISTIC SHOTS

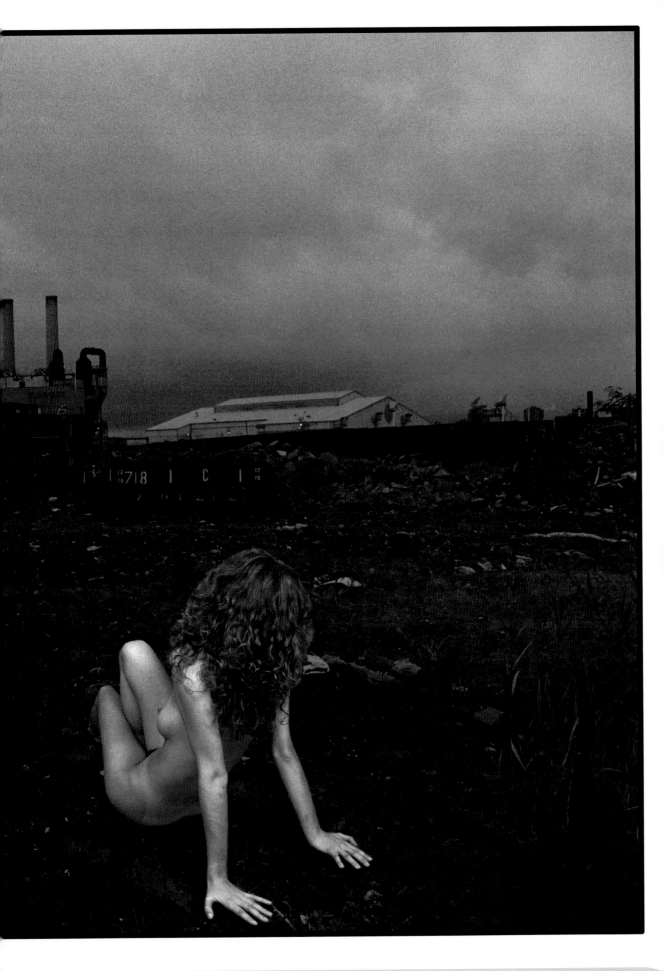

STEPHANIE AND PATRICE

photographer **Frank Wartenberg**

client	Select
use	Amica
models	Stephanie and Patrice
art director	Frank Wartenberg
hair and	
make-up	Ingrid Novratil
camera	6x7cm
lens	110mm
film	EPR
exposure	Not recorded
lighting	Electronic flash

Wartenberg sets the scene with an unusual pose which is strong and sexy. The models are smeared all over with baby oil to emphasise the highlights and to add to the eroticism and the feeling of strength and power.

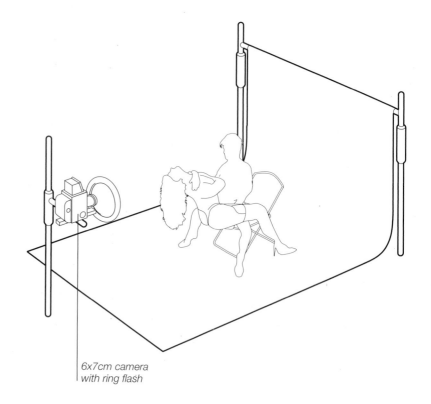

6x7cm camera
with ring flash

plan view

key points

The purple backdrop and surround introduce an overall cast to the image

This shot has the characteristic all-round shadow that is often the result of using a ring flash

The models are placed very close to the background and the photographer has chosen a tight composition, again for emphasis. The ring flash around the lens is the only light used.

The difference in skin tone and the difference in distance from the camera flash affects how both models register in the final image. The three limbs in a row on the left of the image show this particularly well. The tonal gradient ranges from palest on the pale arm closest to the flash to the deepest shade on the dark skin of the man's leg further from the flash, with an intermediate tone on the woman's leg which is lighter in colour but furthest of all from the light source.

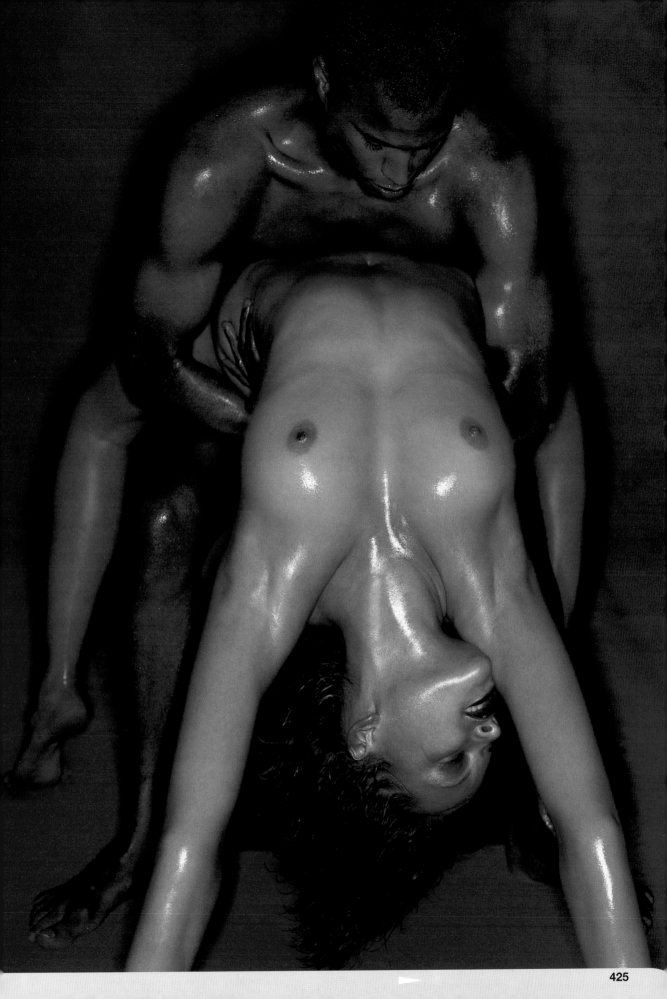

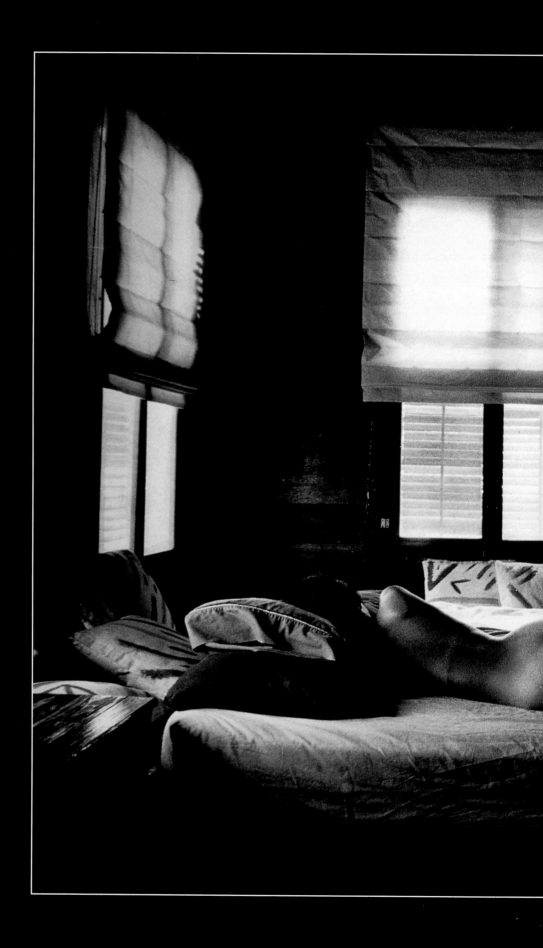

VOYEURISTIC SHOTS

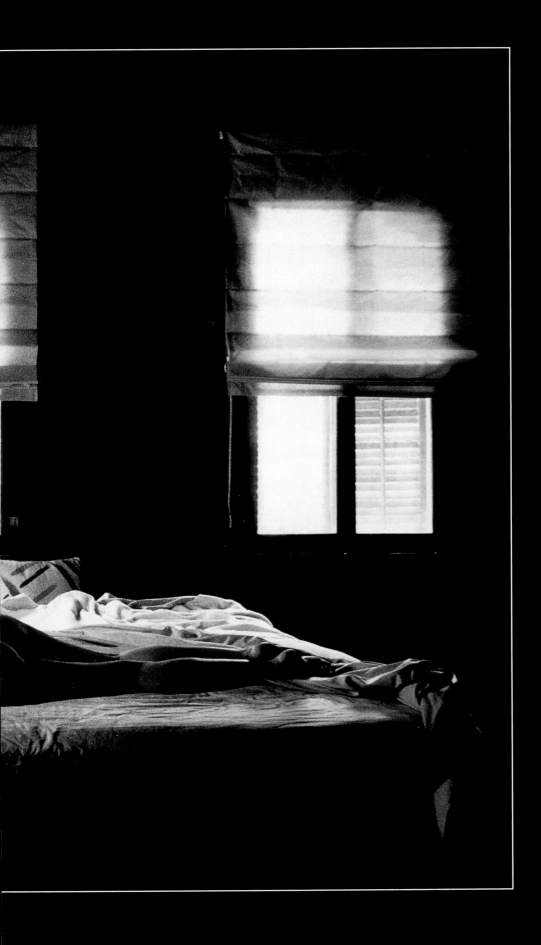

RECLINING

photographer **Stock Library**

client	Stock library
use	Library stock
camera	6x7cm
lens	65mm
film	Ilford HP5
exposure	1/8 second at f/11
lighting	Tungsten

The windows are screened by two sets of blinds. These coverings serve to diffuse the light sources in the form of a series of tungsten heads, one behind each window.

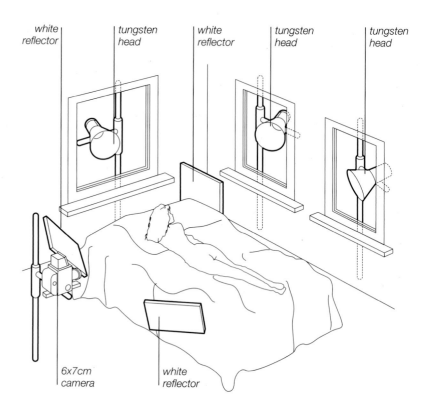

plan view

key points

Stock library shots need to be versatile and open to interpretation for a variety of uses

Subtle variations of light and shade can be introduced by folds of fabric

The lights are positioned at the height of the upper panes, and are angled down to simulate sunlight. It is possible to make out the hotspots of the lights in the upper parts of the two windows facing the camera.

Two narrow reflectors in front and to either side of the camera bounce back just enough light to pick out the rim of the bed along the edges nearest to the camera. A further small reflector in the far back corner picks out the detail of the wooden wall to add interest and provide some separation for the model's head.

Finally the image is sepia-toned.

BIKE

photographer **Marc Jaffe**

This cult status Harley Davidson motorbike, draped with a beautiful nude model, provides a complex subject.

use	Personal work
model	Leslie Hall
camera	645
lens	80mm
film	Polaroid type 55
exposure	7 minutes at f/11
lighting	Light brush

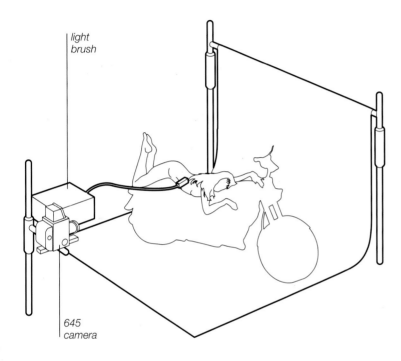

light brush

645 camera

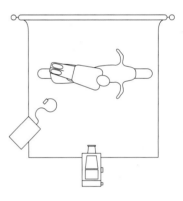

plan view

The choice of light brushing for the illumination offers the photographer absolute control over every part of the image: over which exact areas to bring forward and pick out and highlight, and which to leave in relative darkness.

This level of control allowed Marc Jaffe to painstakingly apply highlights to the precise points he wanted to emphasise on the motorbike, to make it seem to sing out from the dark background, and to introduce the kind of modelling and separation he wanted for the model, emphasising her sinuous clinging form. This complicated operation with the light brush took a full seven minutes to perform.

Finally, the image was hand-tinted to give the rosy glow to the model and the amusing touch of the coloured indicators on the bike itself.

key points

It is best to concentrate on the model first so that she doesn't have to hold the pose for too long

Hand-tinting can capture the attention and make the viewer look twice when small details are unexpectedly picked out

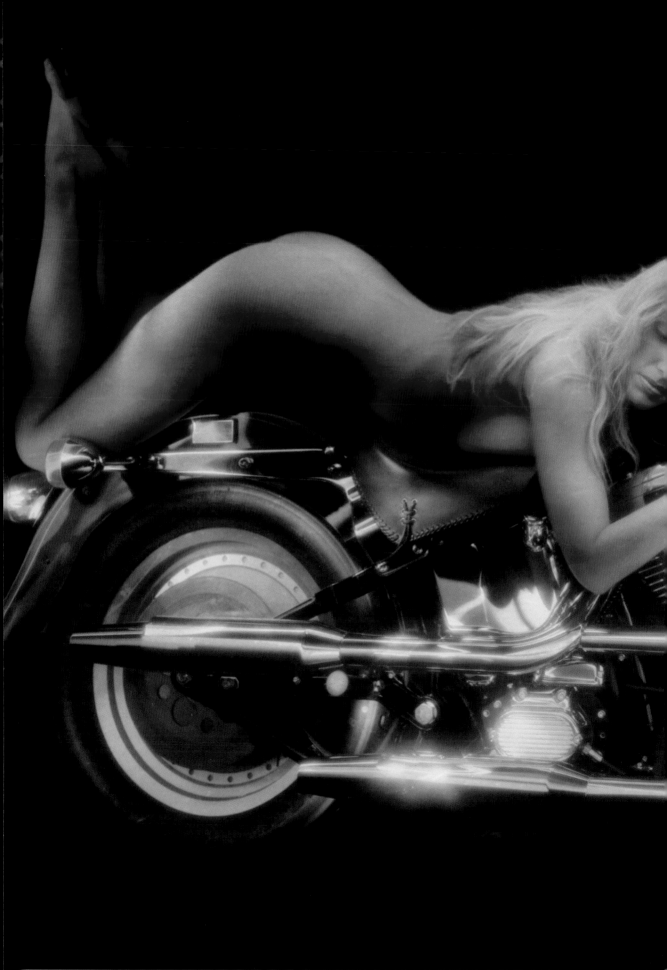

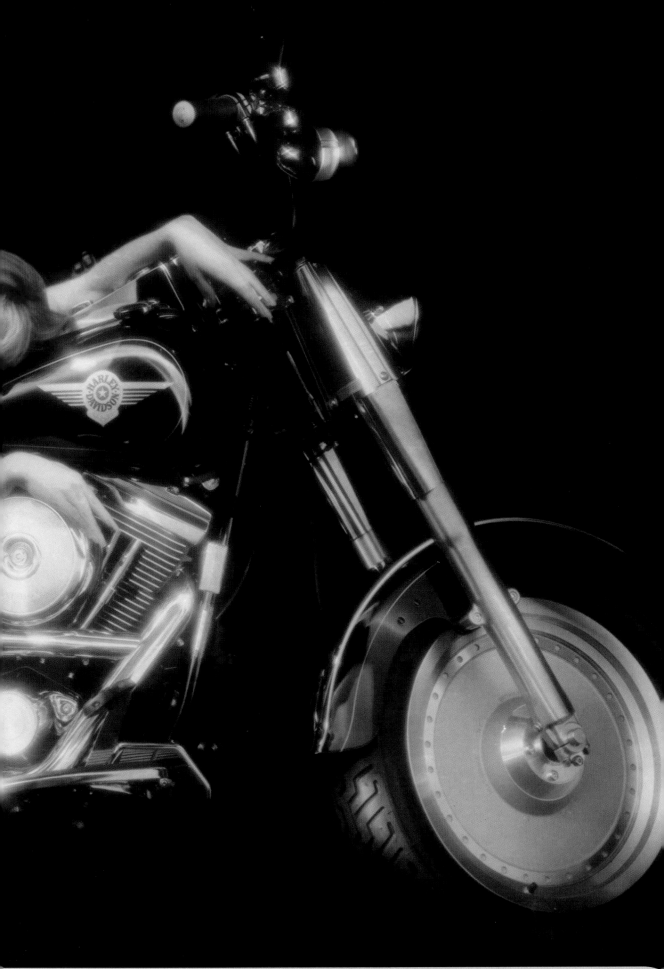

ASA DELTA

photographer **Fernando Bergamaschi**

The photographer, Fernando Bergamaschi, is the person best placed to explain how this extraordinary – and terrifying – shot was achieved.

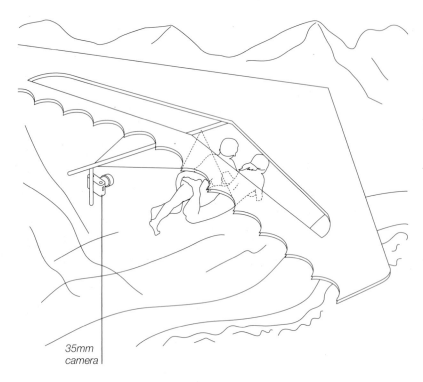

35mm
camera

"The camera was mounted on the back of a hang-glider, and an electronic wire cable was used to trip the shutter. This kind of shot requires a very good and experienced pilot. He has to carry an inexperienced and usually scared model, and as the camera is attached to the very rear of the glider, it is a very dangerous landing – for the camera and the people!

"The shoot was scheduled for very early in the morning in order to get a low angle of light. This would have meant that both models would be clearly lit. Unfortunately, because of the wind conditions, it was almost three hours later that the shoot actually took place and the sun was high, casting strong shadows."

The light may not have been exactly where Fernando originally intended, but the result is nevertheless one of those once-seen-never-forgotten images, perhaps all the more striking for the relatively hard light that was eventually available.

photographer's comment

Taken over São Conrado beach, in Rio de Janeiro city, Brazil.

use	Portfolio
model	Claudia
camera	35mm
lens	15mm fisheye
film	Fujichrome
exposure	Not recorded
lighting	Available light

key points

It is strongly advised to put new batteries into a camera when the set-up is difficult or impossible to repeat

Don't try this at home!

plan view

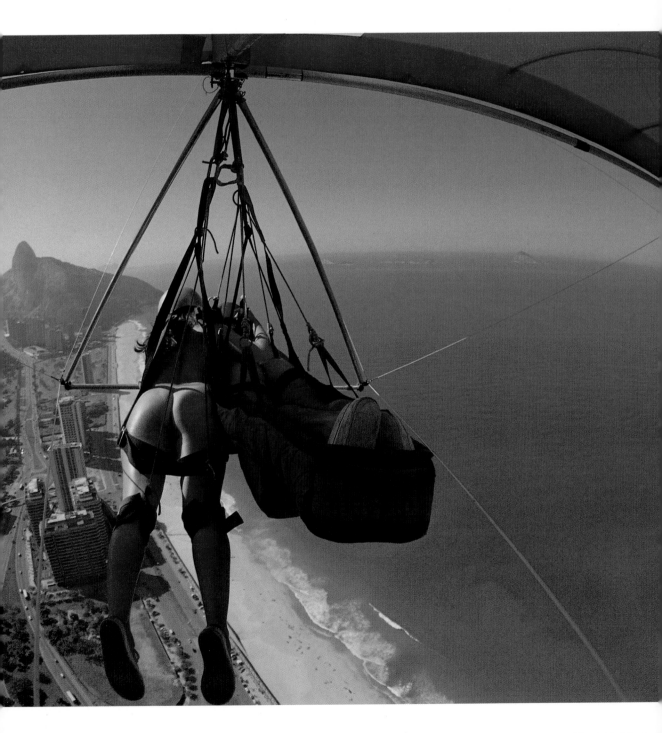

DIRECTORY of PHOTOGRAPHERS

22

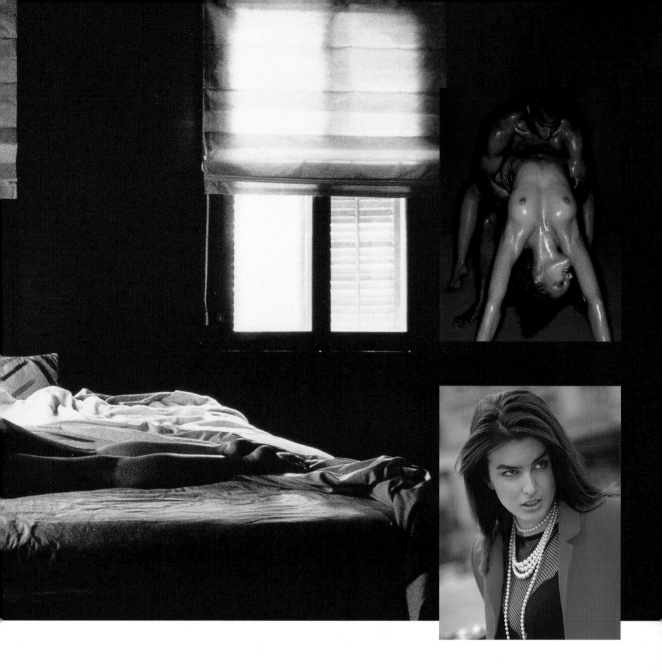
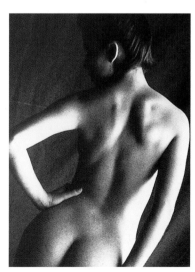

photographer	**Jörgen Ahlström**
address	Norr Mälarstrand 12
	112 20 Stockholm
	Sweden
telephone	+46 (8) 650 5180
fax	+46 (8) 650 5182
agent	The Purdy Company Ltd
(England)	7 Perseverance Works
	38 Kingsland Road
	London E2 8DD
	England
telephone	+44 (0)171 739 3585
fax	+44 (0)171 739 4345

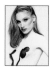

photographer	**Robert Anderson**
address	RAP Productions
	1230-A East Jackson Street
	Phoenix
	Arizona 85034
	USA
telephone	+1 602 254 8178
fax	+1 602 256 2796
email	randerson@uswest.net
biography	Robert Anderson is widely known for his provocative fashion and advertising imagery. Primarily self-taught, his unique style reflects strong vision and a personal pursuit of technical mastery.

photographer	**Igor Aronov**
address	900 Lydig Avenue No.5L
	Bronx
	New York NY10462
	USA
telephone	+1 718 409 5660
fax	+1 718 409 5660
biography	Igor Aronov was born in 1972 in Kharkov, Ukraine. He went to America in 1989 and, after spending some time studying medicine, decided to switch to photography. Although currently working as a web designer, Igor has vowed never to abandon his camera.

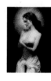

photographer:	**Rod Ashford**
address:	Unit 10
	Arundel Mews, Arundel Place
	Kemptown
	Brighton BN2 1GD
	England
telephone:	+ 44 (0) 1273 670 076
mobile Phone:	+ 44 (378) 036 287
biography:	Rod runs a commercial photographic studio and a busy stock library. His personal work consists mainly of black and white and hand-coloured images which have been widely published as fine art posters and postcards. His work is in great demand for both hardback and paperback book covers in the UK, Europe and the United States. Commercial clients have included American Express, Elizabeth Arden, Revlon, Lloyds, South Eastern Electricity Board and Iceland Frozen Foods.

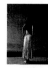

photographer	**Pascal Baetens**
address	Daylight Studio
	Salve Mater Monastery
	Groot Park 1
	3360 Lovenjoel
	Belgium
telephone	+32 (0) 475 390244
mobile	+32 75 390244
email	pascal@pascalbaetens.com
biography	Pascal Baetens specialises in fashion, reportage, portrait and glamour photography. He has exhibited widely throughout Europe in galleries and at photo festivals and his book 'The Fragile Touch', published by EPS, can be viewed at www.eps.org.uk.

Photographer:	**Peter Barry**
Address:	57 Farringdon Road
	London EC4M 3JB
	England
Telephone:	+ 44 (0) 171 430 0966
Fax:	+ 44 (0) 171 430 0903
Biography:	Peter Barry's work is extremely varied – fashion, advertising, girls, still life and food – so every day is different, exciting and stimulating. Constantly learning and experimenting with new techniques, his two main passions are people and food. He has travelled all over the world and met many fascinating people and as a result feels that photography is not so much work as a way of life for him.

photographer	**Fernando Bergamaschi**
telephone	+55 51 4802499
fax	+55 51 2410051
email	berga@photoindustrial.com
website	www.photoindustrial.com
biography	A professional photographer for thirty years, Fernando Bergamaschi is able to take on a wide range of commissions. He enjoys technically difficult, challenging assignments using long or wide lenses.

photographer	**Ben Lagunas and Alex Kuri**
studio	BLAK PRODUCTIONS
address	Galeana 214 Suite 103
	Toluca, Mexico
	C.P. 50000
telephone	+52 (72) 15 90 93
	+52 (72) 17 06 57
fax	+52 (72) 15 90 93
biography	Ben and Alex studied in the USA and are now based in Mexico. Their photographic company, BLAK PRODUC-TIONS also provides full pro-duction services such as cast-ing, scouting, models, etc. They are master photography instructors at Kodak Educational Excellence Center. Their editorial work has appeared in international and national magazines, and they also work in fine art, with exhi-bitions and work in galleries. Their commercial and fine art photo work can also be seen in the Art Director's Index (Rotovision); Greatest Advertising Photographers of Mexico (KODAK); the ProLighting Series (Nudes, Protraits, Still Life, Night Shots, Intimate Shots, Beauty Shots, Fashion Shots, Erotica and New Product Shots); and other publications. They work around the world with a client base that includes advertising agencies, record companies, direct clients, magazines, artists and celebrities.

photographer	**René De Carufel**
address	René De Carufel Photography
	2551 de Chateauguay Street
	No.302
	Montreal
	Quebec
	H3K 3K4
telephone	+1 514 935 6808 / 781 0520
fax	+1 514 932 8693
biography	A successful freelancer with over twenty years experience, René De Carufel specialises in a wide range of photographic areas including corporate, advertising, digital, celebrity, travel, artistic nude and por-trait. His recent clients include Uniglobal, Bacardi and Praxair.

photographer:	**Guido Paternò Castello**
Address:	Av. Henrique Dodsworth
	83/1005
	Rio de Janeiro 22061-030
	Brazil
Telephone:	+ 55 (0) 21 5218064
Fax:	+ 55 (0) 21 2870789
Biography:	Born in New York City March 19, 1958. Associate Arts degree at the American College in Paris: June 1979. Bachelor of Arts degree in Industrial and Scientific Photographic Technology at Brooks Institute of Photographic Arts and Science: June 1984. Presently working in Brazil as a commer-cial photographer. His clients are all major agencies based in Rio de Janeiro. He has won various awards including silver medal in 1992 and gold medal in 1993 at the Prêmio Produçao from ABRACOMP (Brazilian Association of Marketing and Advertising).

photographer	**Patrick Coughlin**
studio	Patrick Coughlin Studio
	14A Hesper Mews
	London SW5 0HH
	England
telephone	+44 (0)171 373 7859
fax	+44 (0)171 373 9313
biography	My tutelage was thorough and extensive at Vogue Studios (Condé Nast Publications) under the editorship of Beatrix Miller, assisting both the great and the good Helmut Newton, Frank Hovat and Henry Clarke. Past commissions include Harper's Bazaar, Tatler and Vanity Fair, vital experience which primed me for the Design and Advertising industry, where I am still happily ensconced. I am a member of the (formerly) Fashion and Editorial Photographer's Association (AFAEP) now known as the Association of Photographers . I have also enjoyed numerous exhibitions of my work.

photographer	**Corrado Dalcò**
address	via Sciascia 4-43100
	Parma, Italy
telephone	+39 521 272 944
fax	+39 521 778 8434
email	imadv@mbox.vol.it
biography	Corrado Dalcò was born in 1965 in Parma. He studied for five years at the P. Toschi Institute of Art in Parma, specializing in graphic design. He is a self-taught photographer, working as a freelance photographer abroad before founding his own photographic studio in 1991. He won an international competition in 1993 ("5ième Biennale") for young Italian photographers and his photos were published in the Photo Salon Catalogue. At present, Corrado works mainly with agencies in Milan, concentrating on fashion.

photographer	**Gary Darrar**
studio	The Glamour Studio
address	433 N. Wood Ave.
	Linden, New Jersey
	USA 07036
telephone	(908) 486 1120
fax	(908) 486 4884
email	glamourstudio@msn.com
URL	www.theglamourstudio.com

photographer	**Ricardo de Vicq de Cumptich**
studio	RVC Produções e Studio de Fotografia Ltda.
address 1	Rua Pedro Teixeira, 91
	04550-010
	São Paulo SP
	Brasil
address 2	Rua Irauna, 202
	04518-060
	São Paulo SP
	Brasil
telephone 1	+55 (11) 866 0549
telephone 2	+55 (11) 828 0085
fax 1	+55 (11) 866 4018
fax 2	+55 (11) 866 1107
email	rvicq@macbbs.com.br
biography	Ricardo de Vicq de Cumptich, 47, was born in Rio de Janeiro and has lived in São Paulo since 1985. His editorial work has appeared in Vogue, Elle and Marie Claire, but the majority of his work has been in advertising. His portfolio includes personal work on nudes, landscapes and a large work from Roberto Burle Marx Gardens. His specialities include food, beverage, portrait, still life and nudes. Almap/BBDO, DPZ, J.W. Thompson, Leo Brunett, McCann-Erickson, Salles DMB&B, Young & Rubican, F. Nazca and Saatchi & Saatchi are among his clients. He has received awards from the Cannes Festival, International Advertising Festival of NY, Clio Awards, London International Advertising Awards and The Art Directors Club Inc., among others.

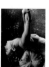

photographer	**Benny de Grove**
studio	Fotostudio De Grove Buba
	Zwynaardse Steenweg 79
	9820 Merelbeke
	Belgium
telephone	+32 (9) 231 96 16
fax	+32 (0) 231 95 94
biography	A photographer since 1983, I work mainly as a publicity photographer and in illustration photography. In 1997, I had exhibitions in the Utrecht Headquarters of Kodak Benelux, Italy (Incontri professionali).

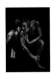

photographer: **Mike Dmochowski**
Studio: Stills-in-the-Sticks
Address: Phoenix Flaundon Lane
Feldon
Herts HP3 0PA
England
Telephone: + 44 (0) 831 321 202,
(0) 1923 211 077
Fax: + 44 (0) 1923 228 702
Biography: Mike specializes in people and
still lifes, often with complex
built sets, working for major
international clients. He used to
do a good deal of "trick" and
special effects photography,
but increasingly supplies what
he calls "jigsaw pieces" to be
assembled electronically. He is
well known for his glamour
photography and has pro-
duced a video on lighting for
glamour called CAPTURED
SECRETS, which is available
from the above address.

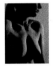

photographer **Michael Engman**
address Fotograf Michael Engman
Box 177
88124 Solleftea
Sweden
telephone +46 620 160 20 or
+46 620 68 38 38
fax +46 620 68 38 38
website www.engmanbilb.nu
biography A self-taught photographer,
Michael Engman primarily
works for advertisers and
magazines. He enjoys
experimenting in the dark room
and studio, and likes
photographing single-object
still life because shape and
colour are most important.

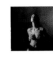

photographer: **Michèle Francken**
Studio: N.V. Francken
Address: Vlaanderenstraat 51
9000 Gent
Belgium
Telephone: + 32 (0) 9 225 4308
Fax: + 32 (0) 9 224 2132
Biography: Michèle is equally at home
shooting fashion or publicity
shots. She seeks to create a
sense of atmosphere using
light and composition, and
often works on location, which
she feels conveys a greater
sense of intimacy.

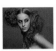

photographer **Wolfgang Freithof**
studio W. Freithof Studio
address 342 West 89th Street 3
New York, New York
USA 10024
telephone +1 (212) 724 1790
fax +1 (212) 580 2498
biography New York-based freelance
photographer with international
clientele spanning a wide range
of assignments from fashion,
advertising, editorial, record
covers to portraits, as well as
fine art gallery shows.

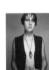

photographer **Juan del Gado**
address 38, Fifth Avenue
London, W10 4DN
UK
telephone +44 (0)181 968 6334
fax +44 (0)181 968 6334
email postmaster@delgado.
u-net.com
biography Born in Cartagena in 1965,
Juan del Gado studied photog-
raphy at the Escola D'Arts I
Oficis de Valencia. He was
involved in the experimental
films, 'Toccata et Fugue'(1997),
'The Passion of Teresa'(1998)
and the documentary
'Breaking Mirrors'(1999), and in
1997 was selected for the
John Kobal Photographic
Portrait Award.

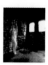

photographer: **Peter Goodrum**
Address: 2 Hillend Cottages
Kewstoke Road
Worle
Weston-super-Mare
Avon
England
Telephone: + 44 (01) 1934 516 178
Biography: Peter Goodrum has turned his hobby of the early 1980s into a career for the 1990s and beyond. As a book illustrator, he was hit hard by the recession: clients, art directors and advertising agencies vanished overnight, so in 1993 he decided to do a degree in photography at Cheltenham. He now looks upon this as the best thing ever to happen to him, both for exploring new ideas and techniques and for his personal development. He now specializes in photographing people – he particularly likes to photograph artists – and works for editorial, advertising and corporate clients as well as establishing a growing reputation as a photographic printer.

photographer **Laura Hodgson**
address Laura Hodgson Photographs
14 Collingwood House
130 Great Titchfield Street
London W1
UK
telephone +44 (0)1523 124146
fax +44 (0)171 384 3725
biography Laura Hodgson specialises in still life and interiors. From her London studio she works mainly on illustrative and editorial pieces. 'Aphrodisiac', a collaborative project with writer Marion McGilvary, was published lin 1998.

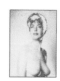

photographer: **Kay Hurst**
Studio: K Studios
Address: 9 Hampton Road
Great Lever
Bolton
Lancashire BL3 3DX
England
Telephone: + 44 (0) 1204 366 072
Biography: K's work is concerned with the positive representations of women: women seen as assertive without being viewed as aggressive, women seen as natural without being viewed as uncultural, women seen as feminine without being viewed as passive. Her images have been exhibited in a number of leading galleries and have received major awards as well as being published as a range of very personal greetings cards. K specializes in people, black and white and hand colouring and her work is applicable to editorial, advertising and fashion as well as being bought as fine art.

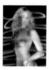

photographer **Marc Jaffe**
address Marc Jaffe Studios
12 Spruce Road
South Salem NY 10590
USA
telephone +1 914 715 6969
email marc@marcjaffe.com
website www.marcjaffe.com
biography Marc Jaffe attended the Art Centre College of Design in Pasadena, and spent eight years as a freelance artist. He now runs a studio in South Salem, offering web and graphic design services as well as photography.

photographer **Ron. P. Jaffe**
address Ron P. Jaffe Photography
6200 Vista del Mar ste. 205
Playa del Ray
CA 90293
USA
telephone +1 310 822 0386
fax +1 310 822 0386
email RPJphotog@aol.com
biography In twenty-three years Ron P. Jaffe has travelled to over thirty countries and worked with the likes of Ronald Reagan and Henry Kissinger. Able to set up and establish photo shoots at minimum notice, Ron's quick intuition allows him to capture mood and emotion.

photographer	**Marc Joye**
address	Photography Joye
	Brusselbaan 262
	1790 Affligem
	Belgium
telephone	+32 53 66 29 45
fax	+32 53 66 29 52
agent (Japan)	Mitsuo Nagamitsu
telephone	+33 1 44 89 64 64
biography	Marc Joye prefers arranged set-ups both in the studio and on location. Recently he discovered the possibilities of digital photography and is mixing both studio and digital techniques.

photographer	**Kingdome 19**
address	Photographics
	PO Box 870104
	13167 Berlin
	Germany
fax	+49 4036 03 34 54 33
email	kingdome19@aol.com
website	www.kingdome19.de
biography	Kingdome 19 works on the borderline between photography and graphics. Inspiration comes from early photos, classical sculptures, and poses of sexual freedom.

photographer	**John Knill**
address	John Knill Studio
	6 Hesper Mews
	London SW5 OHH
	UK
telephone	+44 (0)171 373 4896
fax	+44 (0)171 244 6091
biography	John Knill has worked in advertising and design for thirty years, working in almost all areas of photography. Aside from commissioned work, John really enjoys shooting and experimenting with his own projects.

photographer	**Elena Von Kraskowski**
address	Hagagatan 48
	1347 Stockholm
	Sweden
telephone	+46 8 313149
fax	+46 8 314120
email	elena@kraskowski.a.se
biography	Elena Kraskowski has been a self-taught photographer since 1995. She mixes portrait, lifestyle and commercial commissions with her own projects and exhibitions.

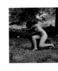

photographer:	**Harry Lomax**
Address:	The Annexe
	Norman House
	Henley-in-Arden B95 5AA
	England
Telephone:	+ 44 (0) 1564 794 001
Fax:	+ 44 (0) 1564 794 752
Mobile Phone:	+ 44 (0802) 282 765
Biography:	Well known as an architectural photographer and best recognized for his interior work; buildings don't move or answer back, or at least they shouldn't! Harry, like most professionals, looks at photography as a way of life rather than as a business and so relaxes with a camera (plus a gin and tonic). He has – and who in this business has not – shot glamour work for calendars and magazines but likes to concentrate on figure work, especially using complex multi-images such as the girl and the dragon. He much prefers to work on his 5x5 monorail, which is his favourite tool because of ease of composition and the discipline needed in any situation, but he has sometimes been known to use smaller formats for speed and portability.

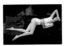

photographer	**Jeff Manzetti**
studio	Studio Thérèse
address	13 rue Thérèse
	Paris 75001
telephone 1	+33 (1) 42 96 24 22
telephone 2	+33 (1) 42 96 26 06
fax	+33 (1) 42 96 24 11
biography	Jeff Manzetti has been a photographer for the past 12 years. His work took off rapidly, beginning with campaigns for international clients such as Swatch (worldwide), Renault, Lissac, Dior and L'Oreal, as well as many editorials for ELLE magazine. Jeff's work has always focused on beauty and personalities. His work has appeared as covers and spreads in Figaro Madame, DS, Biba, and 20 ans. He has had the opportunity to photograph well-known celebrities such as Isabelle Adjani, Isabelle Huppert and Sandrine Bonnaire. His energy and humour extend to his work, as reflected in his advertising campaigns for Cinécinema and Momo's restaurant in London. He has also directed numerous videos and commercials in France, to great acclaim.

photographer: **Julia Martinez**
Address: Flat 2
37 Lansdown Crescent
Cheltenham
Gloucestershire GL50 2NG
England
Telephone: + 44 (0) 1242 255 094,
(0) 1341 421 029
Mobile Phone: + 44 (589) 722 973
Biography: After completing a degree in photography in 1995, Julia finds that her passion for the subject continues to grow. Her forte is beauty photography, in particular her ability to bend the light in such a way that the bad points disappear and a beautiful person emerges. She agrees this may be deceiving, but who says the camera never lies? Her reputation and client list is rapidly growing, by word of mouth recommendation alone, and she spends several months a year shooting abroad. If she does not respond promptly to messages on her answering machine, please call the 1341 421 029 number above.

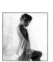

photographer: **Ron McMillan**
Address: The Old Barn
Black Robins Farm
Grants Lane, Edenbridge
Kent TN8 6QP
England
Telephone: + 44 (0) 1732 866111
Fax: + 44 (0) 1732 867223
Biography: Ron McMillan has been an advertising photographer for over twenty years. He recently custom built a new studio, converting a 200 year old barn on a farm site, on the Surrey/Kent borders. This rare opportunity to design his new drive-in studio from scratch has allowed Ron to put all his experience to use in its layout and provision of facilities including a luxury fitted kitchen. Ron's work covers food, still life, people, and travel, and has taken him to numerous locations in Europe, the Middle East and the USA.

photographer **Michael Miller**
address PO Box 24347
London SW17 8WX
UK
telephone +44 (0)20 8767 9840
fax +44 (0)20 8767 9840
email michael_miller1@hotmail.com
website www.redstart.net
/michaelmiller/index.html
biography Michael Miller began his career in photography ten years ago. He studied Photography at the University of Westminster and now specialises in portrait and advertising shots.

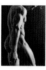

photographer **Art Minds**
address Art Minds Surf & Sport
Photography
319 Ohio Street ste. 9
Pasadena
CA 91106
USA
telephone +1 626 799 7129
fax +1 603 853 0173
email info@artminds.com
website www.artminds.com
biography Art Minds has degrees from both Pennsylvania State University and Duke University School of Law, but his photography education has come through workshops and home study. He works exclusively with male athletes.

photographer: **Jordi Morgadas**
Address: Diputación 317
lo 08009 Barcelona, Spain
and Los Nelees S/N
22145 Radiquero
Huesca, Spain
Telephone: + 34 (0) 3 488 25 68
Fax: + 34 (0) 3 488 34 65
Biography: Born in April 1946. At 19, he decided to concentrate totally on photography. Self-taught, like many of his generation, he found work in many fields from portraiture to industrial photography to magazine photography as a correspondence for the EFE agency. Later, his nude photography appeared in such magazines as Playboy, Penthouse and Interviù, including a number of cover pictures. Now, he works exclusively in advertising, specializing in beach wear, lingerie and nudes.

photographer	**Antony Nettle**
address	19 Regent Street
	Leamington Spa
	CV32 5HG, UK
telephone	+44 (0)831 771762
biography	A self-taught freelancer, Antony Nettle's initial work was in aviation photography. More recently Antony has been working in fashion and beauty, shooting portfolio material for many of England's model agencies.

photographer	**Salvio Parisi**
address 1	Via XX Settembre, 127
	20099 Sesto S.Giovanni
	Milano, Italy
address 2	Via di San Crisogno, 40
	00153 Roma, Italy
Address 3	Via Miliscola 2a trav., 31
	80072 Arco Felice
	Napoli, Italy
telephone 1	+39 (336) 694739
telephone 2	+39 (81) 8663553
telephone 3	+39 (2) 22472559
fax	+39 (81) 8661241
biography	I like to take only a few strong elements into every shoot for a straight and essential suggestion of femininity, style and fashion or trend. Basically, I like studio shots because that is the best way for me to assemble: manipulation of lights, a spaceless and timeless appeal, as well as an ironic and sexy atmosphere!

photographer	**Maurizio Polverelli**
address	Via Ennio 75
	57813-16EA Marina (RN)
	Italy
telephone	+39 (541) 330 881
fax	+39 (541) 330 881
ISDN	39 541 338 627
email	mpolverelli@iper.net
URL	http://www.iper.net/polverelli
biography	Born in Rimini 30 years ago, he studied photography in Milan at the European Institute of Design. He worked in Milan for some years with works for Mondadori and Rusconi. In 1990 he opened his own studio in Rimini. Since then he has begun to work in advertising and had some important commissions such as Mario Formica calendar, Haleko advertising, etc. Some images from this were exhibited in the Modern Art Gallery in Bergamo, and in London and Buenos Aires. At present he works mainly in Rimini and Milan. He works with some American agencies via the world wide web. His studio is equipped for digital shots and electronic elaboration.

photographer	**Renata Ratajczyk**
address	Light Vision
	323 Rusholme Road
	ste. 1403
	Toronto ON
	M6H 2Z2
	Canada
telephone	+1 416 538 1087
email	renatara@ica.net or
website	http://ncphoto.com/lightvision
biography	Renata Ratajczyk specialises in photo illustration, fine art portraiture, nudes, fashion and editorial. Renata uses paint and digital manipulation to create mythological-looking, fairy-tale images and produces work for book and magazine covers.

photographer	**Michael Riedel**
address	6192 NE Carlin Ct
	Kingston
	WA 98346-9408
	USA
telephone	+1 360 297 5563
fax	+1 360 297 5473
email	mar@accessone.com
website	www.accessone.com/~mar
biography	Michael Riedel's clients include Politx men's boutique, Carlton's of Beverley Hills, Taboo hair salon and Vidal Sassoon, England. His work has been published in American Photo, Modern Hair and Santa Barbara News Press.

photographer	**Chris Rout**
address	9 Heythrop Drive
	Acklam
	Middlesborough
	Cleveland TS5 8QA
telephone	+44 (0)1642 819 774
mobile	0374 402 675
biography	A trained commercial diver at 21, Chris went on to train as an underwater photographer. He progressed into freelance photography eight years ago. A successful professional photographer specialising in fashion and lifestyle stock photography, he is based in the north-east of England. Chris has his own studio and regularly takes commissions from magazines, advertising and commercial clients.

photographer	**Gianni Russo**
address	GFR Studio –
	Fashion & Advertising
	Photography
	Dalimilova 13
	130 00 Prague 3
	Czech Republic
telephone	+42 (0)2 6975525
mobile	0603 347773
fax	+42 (0)2 6975525
biography	Gianni Russo worked as a photographer in his native country, Italy, before relocating to Prague. He specialises in portrait and fashion photography and works for advertising and model agencies.

photographer:	**Terry Ryan**
Studio:	Terry Ryan Photography
Address:	193 Charles Street
	Leicester LE1 1LA
	England
Telephone:	+ 44 (0) 116 254 46 61
Fax:	+ 44 (0) 116 247 0933
Biography:	Terry Ryan is one of those photographers whose work is constantly seen by a discerning public without receiving the credit it deserves. Terry's clients include The Boots Company Ltd., British Midlands Airways, Britvic, Grattans, Pedigree Petfoods, the Regent Belt Company, Volkswagen and Weetabix to name but a few.
	The dominating factors in his work are an imaginative and original approach. His style has no bounds and he can turn his hand equally to indoor and outdoor settings. He is meticulous in composition, differential focus and precise cropping, but equally, he uses space generously where the layout permits a pictorial composition. His work shows the cohesion one would expect from a versatile artist: he is never a jack of all trades, and his pictures are always exciting.

photographer	**Gérard de Saint-Maxent**
address	8, rue de Pierre l'Homme
	92400 Courberoie
	France
telephone	+31 (1) 4788 4060
biography	Gérard de Saint-Maxent has worked in advertising and publicity since 1970, specialising in black and white photography.

photographer	**Suza Scalora**
address	222 West 23rd Street No.410
	New York City
	NY 10011
	USA
telephone	+1 212 929 9322
fax	+1 212 243 3700
email	suza@artomatic.com
biography	Suza Scalora graduated from the Art Center College of Design, Pasadena, with a BA in Photography, and has won the respect of the design community with her imaginative websites, www.myth.com and www.suza.com.

photographer	**Craig Scoffone**
studio	Craig Scoffone Studios
address	P.O. Box 8426
	San Jose, California
	USA 95155
telephone	(408) 295 0519
fax	(408) 975 0519
email	csoff@best.com
url	www.erotic-fine-art.com
biography	Craig Scoffone has been producing top level photographic images for San Francisco Bay Area clients for over 15 years. Besides producing innovative fashion images, Craig has also supplied many Silicon Valley based companies with excellent product photography services. Craig also has an on-line gallery which can be found at the following address: www.best.com~cscoff/craig.html.

photographer: **Bob Shell**
Studio: Bob Shell Photography
Address: 1601 Grove Avenue
Radford
VA 24141
USA
Telephone: +1 (0) 540 639 4393
Fax: +1 (0) 540 633 1710
Biography: Bob is editor of Shutterbug, the world's third largest monthly photo magazine, and is on the technical staff of Color Foto, Germany's major photo magazine. He has also been editor and publisher of a major UK photo magazine. His photographs and his writings about photography have been published in books and magazines all over the world, and he is the author of fourteen books on photographic topics. He holds several workshops a year for professional and amateur photographers, both in the studio and in a variety of outdoor locations.

photographer **Andrew John Sherriff**
address 8a Red Lion Shops
Liverpool Road North
Maghull L31 2PN
UK
telephone +44 (0)157 527 2065
fax +44 (0)157 527 2065
biography Andrew John Sherriff studied art, photography and graphic design at art college. His numerous awards include the prestigious Kodak Portrait Photographer of the Year.

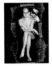

photographer **Dima Smelyantsev**
address 1111 River Road No. B27
Edgewater
New Jersey 07020
USA
telephone +1 1 224 4317
fax +1 201 224 4317
biography After living in Azerbaijan for most of his life, Dima Smelyantsev moved to New Jersey during the 1990 Armenian conflict. He now regularly exibits in New York's Synchronicity Space gallery.

photographer **Clint Adam Smyth**
address Clint Adam Smyth Photography
419 Markham Street
Toronto
Ontario M6G 2L1
Canada
telephone +1 416 722 0593
email clint@clintphoto.com
biography Clint Adam Smyth graduated from Alberta College of Art and Design and gained a scholarship to study in Florence, Italy. He is a successful commercial and fine art photographer shooting anything from fashion to album covers.

photographer **Stephen Speller**
address 8 New Parade
Worthing BN11 2BQ
UK
telephone +44 (0)1903 539119
fax +44 (0)1903 539119
mobile 0411 360091
biography Stephen Speller worked in London for designers, record companies and magazines before moving to Worthing. He continues to work mainly for London clients and has gained a reputation for his use of vibrant colour.

photographer **Ray Spence**
address 11 Headland Close
Welford-on-Avon CV37 8EU
UK
telephone +44 (0)1789 750195
biography Ray Spence is a fine-art photographer and lecturer. He is author of Form and Fantasy and Beyond Monochrome and his work is held in private collections across Europe and the USA.

photographer **Michael Stanley**
address Magic Moments Photography
200 West 34th Av. No. 414
Anchorage
Alaska 99503
telephone +1 907 248 7823
fax +1 907 248 8594
website www.alaskagirl.com/magic
biography Michael Stanley specialises in photographing the female form, including fine-art figure and glamour. He actively shoots all year round and produces his own calendar.

photographer:	**Struan**
Address:	60 Herbert Avenue
	Toronto
	Ontario M4L 3P9
	Canada
Telephone:	+1 (0) 416 698 6768
Fax:	+1 (0) 416 698 3338
Biography:	"Intuition, simplicity and pas-

sion – these are the ingredients I use to create the images that keep me on the edge."
The early part of Struan's life was spent mostly in Europe: London, Paris and Geneva. After a year at Toronto's Ryerson University in 1969, he opened his own studio in Toronto in 1970, but in 1989 he gave up his large studio and full time staff, the better to operate on an international level. He has constantly been in the forefront of beauty and fashion photography, both advertising and editorial, and since 1982 he has also been directing television commercials. He has won numerous awards: Clios for advertising in the US, Studio Magazine awards, National Hasselblad awards, awards in the National Capic Awards Show. His work appeared in magazines in Japan, the United States, Germany and Britain as well as Canada.

photographer	**Björn Thomassen**
address	37 Boslowick Road
	Falmouth TR11 4EZ
	UK
telephone	+44 (0)1326 211343
fax	+44 (0)1326 211343
biography	Born in Cornwall, Björn

Thomassen moved to Scandinavia as a young boy. He became a professional photographer eleven years ago and is now back on the English south coast working out of his own studio.

photographer	**Antonio Traza**
address	8 St. Paul's Ave.
	London NW2 5SX
	England
telephone	+44 (0)181 459 7374
mobile	+44 (0)468 077 044
fax	+44 (0)181 459 7374
biography	Antonio Traza specialises in

photography for advertising, editorial and design groups. His images include work in portraiture, fashion and fine art.

photographer:	**Günther Uttendorfer**
Address:	Gèlieu Straße 9
	12203 Berlin,
	Germany
Telephone:	+ 49 (0) 30 834 1214
Biography:	Self-employed since 1987.

Shooting mainly fashion (especially lingerie and bathing suits) but with many other clients. Studio is 250 square metres in an old factory. He used to shoot still life, but got awfully bored with it – he has to work with people, which is much more fun.

photographer	**Robert van de Voort**
address	Albany Studios
	PO Box 31211
	Milford
	Auckland
	New Zealand
telephone	+64 9 4444117
mobile	025 974237
fax	+64 9 4444212
email	hotshot@ihug.co.nz
website	www.albanystudios.co.nz
biography	Trained in Holland, Robert van

de Voort now lives in Auckland with his dog, cat and doves. He has contributed to over twenty books and written some of his own.

photographer	**Nopphadol Viwatkamolwat**
studio	New Visions
address	185/2 Krungkasem Rd.
	Rongmaung, Patumwan
	Bangkok 10330
	Thailand
telephone	661 919 4944
fax	662 221 0798
biography	Graduated media major in 1996 from Brooks Institute of Photography, Santa Barbara, California. A freelance photographer based in Bangkok for a year. I have specialised in advertising, portrait, fashion and underwater photographer. My work has been published in local and international publications for the past three years.

Photographer:	**Frank P. Wartenberg**
Address:	Leverkusenstrasse 25
	Hamburg
	Germany
Telephone:	+ 49 (0) 40 850 83 31
Fax:	+ 49 (0) 40 850 39 91
Biography:	He began his career in photography alongside his law degree, when he was employed as a freelance photographer to do concert photos. He was one of the first photographers to take pictures of Police, The Cure and Pink Floyd in Hamburg. After finishing the first exam of his degree, he moved into the area of fashion, working for two years as an assistant photographer. Since 1990 he has run his own studio and is active in international advertising and fashion markets. He specializes in lighting effects in my photography and also produces black and white portraits and erotic prints.

photographer:	**Stu Williamson**
Address:	Chapel Cottage
	Coventry Road
	Flushing
	Cornwall TR11 5TX
	England
Phone/Fax:	+ 44 (0) 1326 373 885
Mobile Phone:	+ 44 (0) 860 210 052
Biography:	A former session drummer, Stu became a professional photographer in 1981 and has since won most of the major photographic awards in the UK as well as lecturing worldwide for Ilford, Kodak, KJP (Bowens), Pentax, Contax, Lastolite, BIPP and the MPA. In the late 1980s he became very well known for his "Hollywood" makeover style using the Lastolite Triflector which he invented, working in both monochrome and colour. He now works almost exclusively in monochrome, both commercially and in fine art photography – his clients value his unique way of seeing – and sells to European calendar companies via his London agents.

photographer:	**Nick Wright**
Studio:	Studio Six
Address:	9 Park Hill
	London SW4 9NS
	England
Telephone:	+ 44 (0) 171 622 5223
Fax:	+ 44 (0) 171 720 1533
Biography:	After twenty years in photography, he can turn his hand to most subjects though he is probably best known for his pictures of people and for still lifes. He has photographed many celebrities, and clients have included Which? magazine, W.H. Smith, Nestlé and E.M.I. Like any self-employed photographer, he is always looking for new and challenging commissions, especially in landscape: he has illustrated several books, wholly or in part, most notably Daphne du Maurier's Enchanted Cornwall.

ACKNOWLEDGMENTS

First and foremost, many thanks to the photographers and their assistants who kindly shared their pictures, patiently supplied information and explained secrets, and generously responded with enthusiasm for the project. It would be invidious, not to say impossible, to single out individuals, since all have been helpful and professional, and a pleasure to work with.

We should like to thank the manufacturers who supplied the lighting equipment illustrated at the beginning of the book: Elinchrom, Photon Beard, Strobex, and Linhof and Professional Sales (importers of Hensel flash) as well as the other manufacturers who support and sponsor many of the photographers in this and other books.

Thanks also to Brian Morris at Rotovision.